O N T H E E D G E O F A M E R I C A

UNIVERSITY OF CALIFORNIA PRESS BERKELEY LOS ANGELES LONDON

IN ASSOCIATION WITH THE ARCHIVES OF AMERICAN ART, SMITHSONIAN INSTITUTION

AND THE FINE ARTS MUSEUMS OF SAN FRANCISCO

ON THE EDGE OF AMERICA

California Modernist Art, 1900–1950

Edited by

PAUL J. KARLSTROM

This publication is made possible in part by support from the Ednah Root Foundation, through the Fine Arts Museums of San Francisco. The publisher gratefully acknowledges the contributions provided by Mr. and Mrs. Stuart Denenberg, Bente and Gerald E. Buck, and Geoffrey C. Beaumont and by the Art Book Endowment of the Associates of the University of California Press, which is supported by a major gift from the Ahmanson Foundation.

For Ann and Clea

University of California Press

Berkeley and Los Angeles, California

University of California Press, Ltd.

London, England

© 1996 by

The Regents of the University of California

Library of Congress Cataloging-in-Publication Data

On the edge of America : California modernist art,
 1900–1950 / edited by Paul J. Karlstrom.
 p. cm.
 "In association with the Archives of American Art,
 Smithsonian Institution and the Fine Arts Museums
 of San Francisco."
 Includes bibliographical references and index.
 ISBN 0-520-08850-6
 1. Modernism (Art)—California. 2. Art,
 American—California. 3. Art, Modern—20th
 century—California. I. Karlstrom, Paul J.
 N6530.C2O55 1996
 709'.794'09041—dc20 95-35237

Printed in Singapore

9 8 7 6 5 4 3 2 1

CONTENTS

The idea for this book grew directly and logically out of the work of the Archives of American Art on the West Coast. In 1986 Stella Paul, the Archives area collector based at the Southern California Research Center, located at the Huntington Library in San Marino, organized a symposium entitled "The Visual Arts and the Myth of Southern California, 1900–1950." This groundbreaking conference brought together seven scholars and critics who initiated a discussion of primarily modernist art, artists, and institutions in Southern California before the emergence of the younger generation of avant-gardists associated with the legendary Ferus Gallery in Los Angeles. By the early 1960s these and a handful of other artists, including Edward Kienholz, Edward Ruscha, Robert Irwin, Ron Davis, Billy Al Bengston, Richard Diebenkorn, Wayne Thiebaud, and Sam Francis, had attracted national—and would shortly thereafter attract international —attention to the California artistic scene.

It was as if modern art had appeared full-blown, without antecedents. Part of the "myth" of Southern California was the notion that no creative activity took place there during the first half of the century. This perception would have astonished the pioneer modernists who, along with the distinguished émigrés who gravitated to Hollywood during the 1930s, were dedicating themselves to new ideas and forms.

The success of the Huntington conference inspired a second Archives symposium, which I organized, on Northern California during the same period. Held in 1988 at San Francisco's California Palace of the Legion of Honor, "Earthquake to Albright: Modernism in Northern California, 1906–1945" convened twelve authorities who provided the other half of the story for the period prior to mid-century. (Thomas Albright continues it in his admirable *Art in the San Francisco Bay Area, 1945–1980* [University of California Press, 1985]).

The original symposia contributors had not been required to address the issues of modernism, regionalism, neglect, and opportunity in the story of California art. Nonetheless, these topics emerged as the central themes of the dialogue. For this book four

of the original symposia presenters were asked to focus (or refocus) their essays accordingly, and seven other contributors were invited to deal with topics that seemed essential to the study as it evolved.

As is the case with any multiauthor project that develops over several years, this book and I, as its editor, have incurred a debt of gratitude to a number of institutions and individuals. Chief among these are the four organizations directly involved. I am particularly grateful that the Archives of American Art saw the importance of the original symposia and the value of a publication based on the ideas generated. Especially supportive at various stages were the former director, Richard N. Murray; the current director, Richard J. Wattenmaker; and the deputy director, Susan Hamilton. Each one understood that this complex endeavor would take a significant amount of my time.

With a generous grant from the Ednah Root Foundation, the Fine Arts Museums of San Francisco provided essential support for the preparation and production of the manuscript. These funds made possible the services of an editorial assistant. Furthermore, through their Publications Department, the Museums served as the link between the Archives and the University of California Press. The former director of the Museums, Ian McKibbin White; his successor, Harry S. Parker III; and the associate director, Steven A. Nash, were instrumental in fostering this three-party relationship.

Two other individuals deserve special mention. The project especially benefited from the involvement of Derrick Cartwright. His participation—including the creation of the chronology—went well beyond that of editorial assistant. The other person most closely involved with the project from the beginning was my wife, Ann Heath Karlstrom. As director of publications at the Fine Arts Museums of San Francisco, she played a critical role in preparing the manuscript for submission to the Press. The authors deserve both congratulations and thanks for their patience and cooperation throughout this long editorial process.

Many other individuals and institutions deserve thanks for special favors and services. Most prominent among these is the Huntington Library, Art Collection, and Botanical Gardens, the primary home of the Archives of American Art on the West Coast. Much of the editorial work was conducted at the Huntington with the encouragement (and critical suggestions) of colleagues among the distinguished group of scholars I met there. In this regard Allan Casebier, Elizabeth Goodenough, Barry Menikoff, Marjorie Perloff, and Richard Cándida Smith should be singled out for special appreciation. Others who provided assistance and extended various courtesies are James Bednarz, Paul Bockhorst, David Brigham, Gerald Buck, Wanda Corn, Stuart and Beverly Denenberg, Charles Eldredge, Neil Harris, Michael Kammen, Stella Paul, the late Ednah Root, Naomi Sawelson Gorse, and Donald Stover. Among the Archives staff, special assistance was provided by Peggy Feerick in Washington and Barbara Bishop, Caroline B. Jones, and Laela Weisbaum in San Marino. At the University of

California Press, Fine Arts Editor Deborah Kirshman was involved from the earliest stages of the project, expressing her continued enthusiasm and helping to guide and shape the book at critical junctures. Others at the Press whose efforts contributed so much to the final product were Stephanie Fay, Steve Renick, and Danette Davis.

Paul J. Karlstrom
West Coast Regional Director
Archives of American Art, Smithsonian Institution

Paul J. Karlstrom

INTRODUCTION

California, from an eastern perspective, has generally been seen as another country on the far edge of America, only tenuously attached to what is understood as Western civilization. Carey McWilliams's famous characterization of Southern California as "an island on the land" captures some of this psychological and cultural distance.[1] Identified almost exclusively with Hollywood and popular culture, California has even been denied a meaningful relationship to twentieth-century modernism. Viewed through a mid-century critical lens, earlier California art may indeed appear to have little significance in connection with the prevalent European and East Coast understanding of modernism. Carefully observed, however, twentieth-century California may well offer the most useful paradigm of a "postmodernist" culture reflecting contemporary experience, desire, and fantasy, both in pictorial images (Fig. 1) and in the built environment (Fig. 2). This collection of essays represents an effort to deal with the art of California in its own aesthetic and sociological terms.

The issue of regionalism in American art is central to this study. How can we build a cultural portrait of California that reveals both what is distinctive about it and what links it to the national culture? Some essays, such as those by Bram Dijkstra, William Moritz, Margarita Nieto, David Gebhard, and Therese Thau Heyman, elucidate the unusually fecund environment for artists in California, one that invites and clearly warrants scholarly attention. Others, among them Peter Selz, Susan M. Anderson, and Susan Landauer, treat their subjects as parts of a larger whole, placing California developments in a national and even international setting.

These essays, whatever their differences, accept the role of geography in forming local culture and that of regionalism in determining how art and artists are perceived and how their historical significance is assessed. The eastern perspective plays a large part in the story. It was succinctly stated by the leading critic of his day, Edmund Wilson, who noted the West Coast's deficiencies of climate and landscape and its

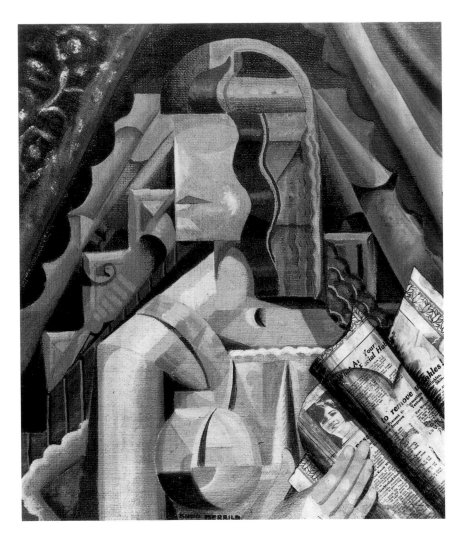

remoteness from the East and . . . farther remoteness from Europe. New York has its own insubstantiality that is due to the impermanence of its people, of its business, of its thoughts; but all the wires of our western civilization are buzzing and crossing here. California looks away from Europe, and out upon a wider ocean and an Orient with which, for white Americans, the cultural communication is slight.[2]

In light of such a dismissal, it is not surprising to find regionalism a unifying element in a collection of essays on the art and culture of an area far from such established centers of creative activity as Paris and New York. Implicit in this discussion is the concept of a new colonialism and the way California artists came to see themselves in

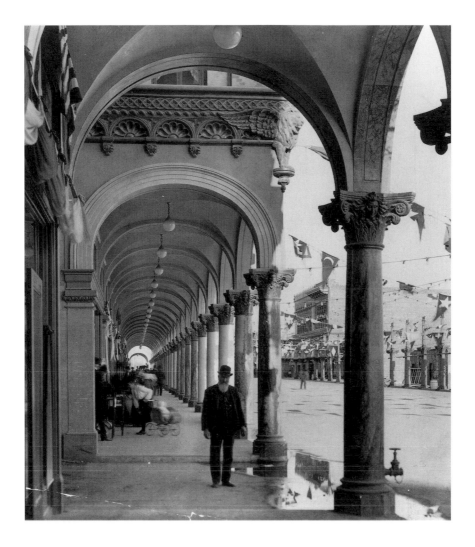

FIGURE 1
Opposite: Knud Merrild, *American Beauty, or the Movie Star,* 1928. Oil and collage, 19 × 16 in. The Oakland Museum, Oakland, California, gift of Else Merrild.

FIGURE 2
Norman Marsh and C. H. Russell, Arcades at Venice, California, ca. 1906. California Historical Society, Title Insurance and Trust Photo Collection, Department of Special Collections, University of Southern California Library (neg. 2067).

relationship to ideas, individuals, and events associated with the centers. Accordingly, each author has taken these issues into account. The essays in this volume concentrate on "progressive" developments, thereby narrowing the selection of artists, works, and events. At least by the end of the period under consideration the narrative focuses on the counterculture—but more than that, on an alternative culture that transforms the ideas and examples of modernism according to regional imperatives. In so doing, it provides a model for late-twentieth-century self-discovery.

Several related themes, reflected throughout the book, suggest a distinguishing cultural zeitgeist. Chief among these is a sense of distance and the consequent need to reinvent traditions for a new landscape and society. The historian Kevin Starr, in his series *Americans and the California Dream,* discusses this need as a powerful formative force. For him California's story is an imaginative journey to identity—a fair description of the artistic activity of the period. Casting a broader net, Michael Kammen offers similar insights in his *Mystic Chords of Memory: The Transformation of Tradition in American Culture.* Young societies *invent* traditions, the symbolic evidence of a past, not only to give meaning to the present, but also to foster individual and community identity. Although this dynamic is not restricted to California, circumstances in the state exaggerated it and thus produced here a distinct, parallel American culture.[3]

Dore Ashton has pointed out that the critical and historical effort to locate and explain modernism theoretically is a fairly recent phenomenon.[4] To give art a modern identity separate from that of the past, critics have aligned it with literary criticism and philosophy. But in the hands of such intellectuals as Clement Greenberg and Harold Rosenberg what were once fairly simple ideas that could be grasped "intuitively" have been turned into complex and, ironically, delimited theoretical systems. In the Greenbergian view, for example, unity and purity through and in abstraction became primary—if not exclusive—modernist goals. According to one observer, Greenberg's writings actually "constitute the locus of present modernism in the visual arts."[5]

Before World War II theory played a far less prominent role; critics discussed modernism as the "art of the new," setting up a fairly clear antagonism between what looked forward and what clung to the past. For many, a machine aesthetic expressed the crucial link between art and scientific progress. For some, nonobjectivity became the issue. So Henry McBride wrote in 1930, "There are other attributes to modern art but the ability to feel the abstract is the real test."[6] Without necessarily embracing abstraction, California critics such as Alfred Frankenstein, Arthur Millier, Jehanne Bietry Salinger, Sonia Wolfson, Grace Clements, Merle Armitage, Florence Lehre, and Porter Garnett thought and wrote of art and artists as progressive and conservative, one camp open and receptive, the other closed and doctrinaire.[7]

The debate was seldom more complex until critics developed their responses to abstract expressionism in New York in 1945. Up to that point, modernism embraced a fairly wide variety of styles and expressions originating in different parts of the country. But as abstract expressionist art and theory came into prominence, New York assumed

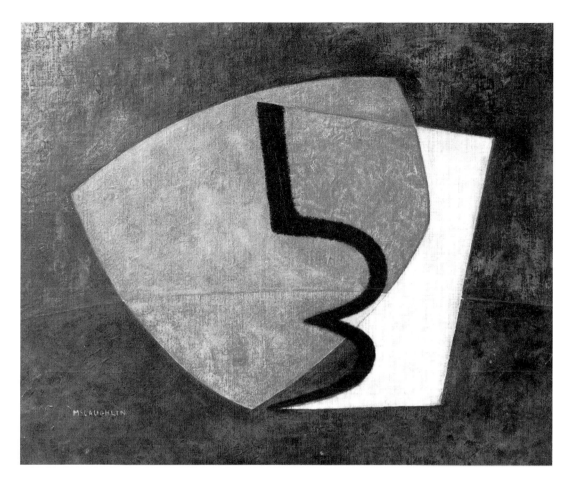

FIGURE 3
John McLaughlin, *Untitled,* 1949.
Oil on Masonite, 19½ × 23½ in.
Tobey C. Moss Gallery, Los Angeles.

the pivotal role it holds to this day. This situation is relevant to our subject, the preceding half-century, because the expanding field of art history at American universities in the 1960s in effect simplified the phenomenon of modern art and located it almost exclusively in New York. In the process, regional art and art history were, if not ignored, relegated to the margins. Among the casualties have been artists as original as Ben Berlin (Plate 1) and as profound as John McLaughlin, surely one of this country's most thoughtful geometric abstractionists (Fig. 3).

The task of locating and describing modernism in California is further complicated by uncharted terrain and an incomplete cast of characters. An intriguing case in point is the little-known modernist Edward Hagedorn, born in San Francisco in 1902. Hage-

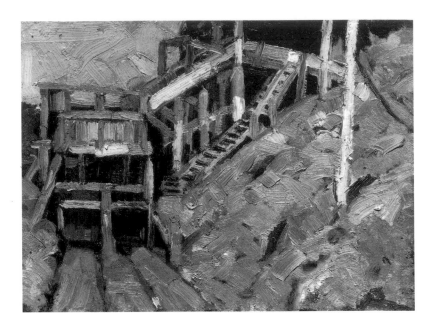

dorn is among the handful of artists one could turn to for an "indigenous" expression of the modernist impulse. His images, in their sophisticated dialogue with European (notably German) modern art, rank among the more advanced work being done in California in the 1920s, work perhaps as "radical" as that of the highly touted Society of Six. Among the Six, only Louis Siegriest (Fig. 4) advanced beyond the hybrid fauve/postimpressionist landscape paintings that then constituted progressive art in the Bay Area.[8] Judging from work that has only recently come to light, Hagedorn by 1926—the year of Galka Scheyer's exhibition of her Blue Four group at the Oakland Art Gallery—had absorbed not only the forms but also some of the spirit of German expressionism (Plate 2). Apparently this mainly self-taught artist enjoyed Scheyer's support and encouragement, even (according to one source) being invited to join Lyonel Feininger, Alexei Jawlensky, Wassily Kandinsky, and Paul Klee as a fifth member of the group.[9]

Many of Hagedorn's paintings effectively incorporate European modernist devices to serve individual expression, a noteworthy accomplishment, especially since Hagedorn—unlike Marsden Hartley and several other Americans who worked abroad, with whom he may productively be compared—had to satisfy himself with sources imported to his home state. Despite his remarkable "modernist" achievement, Hagedorn's name, insofar as I can determine, appears in none but the most recent literature on California art of the period. The same may be said of other accomplished progressives, for example, Yun Gee (Fig. 5) and Hisako Hibi, or even the surprising Swedish émigré Anders Aldrin (Fig. 6). In his relative anonymity Hagedorn is far from unique, either in California or elsewhere in the country.

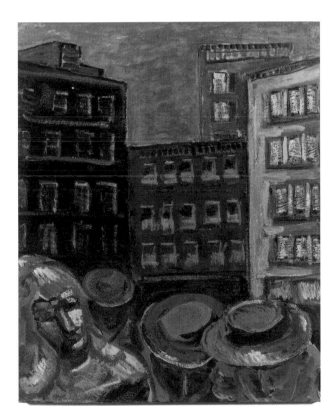

FIGURE 4
Opposite: Louis Siegriest, *Oakland Quarry,* 1920. Oil on cardboard, 12 × 16¼ in. The Oakland Museum, Oakland, California, gift of the artist. Photograph by M. Lee Fatherree.

FIGURE 5
Left: Yun Gee in Otis Oldfield's "Monkey Block" studio, ca. 1925. Otis Oldfield papers (on microfilm at Archives of American Art, Smithsonian Institution). Photograph courtesy of Jayne Blatchly Trust / Otis Oldfield Estate.

FIGURE 6
Anders Aldrin, *The Three Shoppers (Downtown Los Angeles),* 1935. Oil on canvas, 34¼ × 28¼ in. Anders Aldrin Estate.

Among the few exceptions to this prevailing obscurity, Stanton Macdonald-Wright is easily the most prominent. His activities in Paris, notably the founding with Morgan Russell of synchromism, made him an acknowledged participant in the early story of international modernism. Back in Los Angeles, he assembled in 1920 an exhibition of American modernists at the Museum of History, Science and Art in Exposition Park. In the foreword to the exhibition brochure, in his characteristic style, he announces the arrival of modern art on the West Coast:

> Today knowledge travels fast, and the idea, once engendered, speeds by electricity and steam, where once it trudged on foot, and finds fertile ground in the brains of thousands who, with one voice, proclaim its virility. Thus modern painting is not the isolated effort of a few men but another story added to the always growing edifice of art.
> . . . now at last we present ourselves at that far-distant frontier of our native land.[10]

The correspondence of several Californians—among them Macdonald-Wright and the postsurrealists in Los Angeles, and artists such as Lucien Labaudt in San Francisco—reveals by this time both a vital interest in avant-garde art and a fairly sophisticated knowledge of its forms, issues, and movements in Europe. In fact, even in the early years California artists were less isolated from colleagues in New York and Europe than has been assumed. Many saw themselves involved in and contributing to the important work of establishing the new art. Annita Delano (Fig. 7), a founding member of the art faculty at the University of California at Los Angeles, wrote in 1929 to her friend Sonia Delaunay in Paris:

> He [Stanton Macdonald-Wright] said to tell you he is hiding away in a cave in Santa Monica by the sea. I will tell you he's painting some splendid things. . . . in architecture here in Los Angeles there are a few leaders. Quite a number of buildings by Frank Lloyd Wright and some by his son. There are two men, R. M. Schindler and Richard Neutra who represent tendencies similar to Corbusier & Gropius. . . . So you see we have a miniature group pounding at the conservatives. The architectural clubs and the painters and sculptors are all debating about the modern trend—but they are so slow. I believe the greatest influence felt here is that of the Orient, and I suppose next to that the great raw country—so new, so provincial in some ways—but waking up.[11]

This letter is of particular interest in revealing the self-conception of at least some California artists and their understanding of the international modernist "project." There is a clear sense of participation and connectedness—of "being modern." Beyond that, Delano displays an awareness of the centrality of architecture and design, arguably California's greatest contribution to the unfolding of modernism in America (Fig. 8). In this correspondence, moreover, Delaunay describes her husband's current paintings

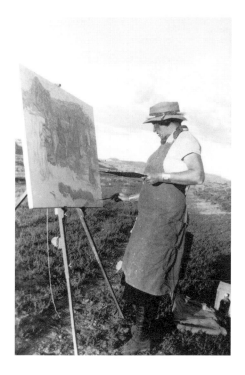

FIGURE 7
Annita Delano painting at Gallup, New Mexico, 1934. Annita Delano papers, Archives of American Art, Smithsonian Institution.

FIGURE 8
Richard Neutra, Lovell House, Los Angeles, 1929. Photograph by Julius Shulman.

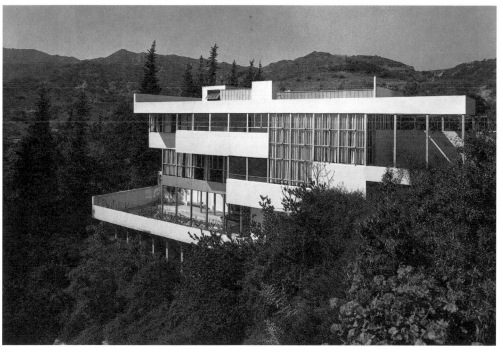

and encloses photographs of her own recent designs. Albert Barnes had introduced Delano to Henri Matisse; she became his close friend and regular visitor during the 1920s and 1930s. According to her own account, she would consult the French modernist master about color, taking careful notes that she would then use at a Parisian art supply store to obtain pigments unavailable to her at home. Apparently, she even transported several of Matisse's palettes back to Los Angeles.[12] It becomes clear in these and similar examples that despite California's seeming isolation, there were close contacts between Europe and the West Coast.

It may still be argued, however, that regional manifestations of modernist art are imitative rather than authentic, that the substance is lost in transmission over distance. If that is so, the conviction of Delano, Hagedorn, or even Feitelson and Macdonald-Wright (Plate 3) that they were participants in the "modern trend" may be regarded as self-delusionary. But typically and perhaps inevitably, California artists have "reconceptualized" European movements over distance and time. Because they viewed art and cultural achievements through a nostalgic haze, the result of a sense of loss (an important psychological component of the émigré experience), they were led to revisit and rework and thus recapture them. Under such circumstances, distance and isolation become virtues, the agents of transformative innovation rather than imitation.

All the essays in this volume ask what distinguishes the California experience—including art and culture—from that of the rest of the country. No author offers a conclusive answer. Thus the question lingers and attaches itself to notions of reinvention, self-discovery, appropriation, and creative legacy. These ideas are most fully developed in Richard Cándida Smith's adoption of Sabato Rodia into the modernist "fraternity"—an audacious but appropriate, even inspired, socio-aesthetic statement that Cándida Smith takes further by asserting that the challenge of modern life in California is different from that of most of the rest of the world. In such circumstances, the possibility existed for Rodia to re-create himself as a modern artist.

In another context, Margarita Nieto suggests that California modernism may, like Mexican art, incorporate sources from an "imagined, created" past. Similarly, David Gebhard argues that from an early date California developed an aberrant modernism responsive to local history and a set of particular social and environmental myths. In this respect, architecture's "game of images" presents an apt and revealing symbology of the dynamics and strategies involved in California's self-invention. One of the main points of Gray Brechin's chapter is the disjunction between San Francisco's historical self-image and the social and political realities Anton Refregier incorporated into his Rincon Annex murals. The modernist subtext to this stylistically conventional project (aside from its avant-garde politics) may be the open-ended possibilities and the struggle of conflicting identities in a fine arts forum. Finally, Therese Heyman looks at modernist photography in California in connection with a psychology of neglect. A medium without a history, photography embodies the ideas of invention and creation. Heyman recalls Edward Weston's belief that in an uprooted society the camera is a means of self-

development. Indeed, for the members of f.64 the power of photography as an instrument of personal expression was an article of faith, providing the road to self-discovery in an invigorating modernist context.

In 1963, just ten years after the House of Representatives debated the Rincon Annex murals, a French artist sat in a gallery at the Pasadena Art Museum facing his nude female opponent (the writer Eve Babitz) across a chessboard. This image, part of a series of now famous photographs, symbolizes several key features of the California creative situation, including the central theme of self-invention. Despite his friendship with the Arensbergs and Beatrice Wood, Marcel Duchamp is not particularly associated with California, nor should he necessarily be. Nonetheless, a recent book is devoted entirely to Duchamp in California, a nonsubject in the literature of modern art.[13] Among the guests at the 1963 opening of Duchamp's first retrospective was Andy Warhol, who had been given his first commercial show the previous year at Los Angeles's Ferus Gallery. We can draw several lessons from these art-historical "anomalies" that may clarify the circumstances in which art in California developed and was received.

The philosopher-critic Arthur Danto has noted that the position artists and works of art attain depends on their presence in, and contribution to, an ongoing critical discourse.[14] Regional art may be minimized or ignored altogether in this discourse, so that it is denied status and ultimately excluded from art history. Do such events as the Duchamp retrospective and the early Warhol exhibition demonstrate California's meaningful participation in American art and perhaps even in the transition from modernism to postmodernism? At the very least, the show in Pasadena may be seen as a challenge to New York hegemony. As such it represents a central problem in dealing with modernist culture in the regions: most of its recognizable manifestations were in fact imported.

But more important for our purposes is the positive creative situation embodied in the (self-created) image of Duchamp. Whatever his actual influence on Californians from John Cage and Clay Spohn to Bruce Nauman or Edward Ruscha, Duchamp provides a metaphoric presence in the California alternative modernist narrative, one that was well established before the 1963 retrospective. Above all, he represents the option of withdrawal from the art world, together with a sense of irony and distance and an eagerness to subvert certain high art assumptions, and thus embodies attitudes characteristic of Californians. The artist, excluded from full participation in a broader discourse, turns inward, seeking both validation and meaning in the relationship between self and the work of art.

In her own way the sculptor Claire Falkenstein fits this model. Despite her international experience in Paris during the 1950s as a member of Art Autre, the group that gathered around the critic and theorist Michel Tapié, she developed and maintained a modernist expression that depended very little on the work of her contemporaries. Her innovative use of materials, unconventional aesthetic decisions, and imaginative formal arrangements were already evident in her work of the early 1940s, when she was still in

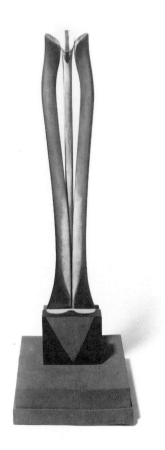

San Francisco (Fig. 9). And she continued in the same independent vein after her return to California some two decades later, ultimately developing a sculptural method and an aesthetic that were entirely her own. When asked recently who her artistic influences were, she responded that her own earliest works were her "mentors." [15]

The essays in this volume reinforce the idea that California artists worked in a peculiar situation that practically guaranteed an art of individuality and self-determination. California modernist art was different from that of the East Coast and contributed to a creative culture both removed from main developments elsewhere and linked to them. In such circumstances, as Cándida Smith argues, this art anticipated the end of modernism through a creative synthesis that transcended it. This idea of an unstable, even artificial, relationship to Eurocentric culture is echoed by some of the other authors.

Bram Dijkstra's is the most insistent voice raised in support of California's artistic independence. He understands modernism as embracing the "regionalist" work of Phil Dike and even Millard Sheets, two artists representative of the group usually cast in opposition to the modernists. In so doing, Dijkstra focuses on other qualities that manifest a "modernist spirit" identified with the "linear expressionism"—as in the paintings of Charles Reiffel or Ejnar Hansen—adumbrated in Rex Slinkard's "sensuous perception of the material world." Above all, Dijkstra credits his regional modernists with both sophistication and an independence so genuine that for them California's isolation was congenial. To reinforce his point, Dijkstra focuses on less well known Southern California painters, avoiding leading figures such as Feitelson and Macdonald-Wright who more easily fit the established art-historical modernist profile.

William Moritz also looks at several "idiosyncratic" creators working at the margins of Hollywood film, California's only internationally recognized contribution to modern culture. He discusses visual music and experimental cinema as significant elements of the California avant-garde that provide a bridge between the worlds of high art and popular entertainment. Oskar Fischinger and Frederick Schwankovsky, in particular, emerge as emblems of the imaginative latitude and inventive opportunity afforded by an unstructured creative environment. Moritz even proposes that the influence of kinetic abstraction, in his view a mainly California phenomenon, extended to New York and affected, among others, Schwankovsky's former student Jackson Pollock. Moritz joins the other authors in identifying qualities that distinguish creative activity in California.

Even the chapters addressing international connections suggest that the local response is qualified by independence, reflecting the distinctive character and different needs of the regional society. Selz and Nieto are instructive on international presence and influence. Selz introduces us to representatives of old-world culture and modern art, including Lyonel Feininger, Fernand Léger, Max Beckmann, and László Moholy-Nagy. Furthermore, he recounts the contributions of émigré teachers such as Alfred Neumeyer, who made Mills College in Oakland a vital center for modernist ideas. But Selz finally acknowledges that the impact was less direct than might be expected given the cast of characters, suggesting that the region was evolving its own response to modernism. Conversely, as Nieto demonstrates, the influence from south of the border was considerable. In part because of its shared history with Mexico, California never developed a fully European modernist vision. Nieto's investigations of cross-cultural connections indicate a significant West Coast, particularly Southern California, role in more broadly understood modernist developments.

Susan Anderson brings a similar view to her assessment of the limited influence of French surrealism. Automatism, for example, was practically inimical to the artistic beliefs and practices of Lorser Feitelson. In fact, the postsurrealists and other California modernists reinvented surrealism to suit what they perceived as national cultural needs and goals. As Anderson points out, modern art is transformed in the hands and minds

of progressive artists working in a regional society to create for it an appropriate but distinctive culture. This basic theme appears and reappears throughout the essays in this volume.

In the same spirit of fresh inquiry, Susan Landauer examines the impact of World War II on American artists and their work. She considers several prominent California modernists and their individual responses to the war in a way that clearly sets them apart from their contemporaries in the East. In the process, she brings well-deserved attention to the works of, most notably, Clay Spohn and Hans Burkhardt. Burkhardt's war paintings are, in fact, a revelation that should call into question the prevailing view of postwar American art. Landauer insists that West Coast gestural painting is neither identical with, nor posterior to, that of the New York School. Extending her analysis beyond style, scale, and the "heroic myth," she looks at the possible effects of the war on individuals, drawing an important distinction between the westerners who served in the war and the mostly nonparticipant New Yorkers. Refusing to view California art merely as a regional reflection of modernist art elsewhere, Landauer joins the other authors in staking claim to a disparate, independent avant-garde and an art history reflecting the different experiences of life in the West.

Current historical revisionism and critical theory challenge many modernist assumptions about progress and hierarchy in art. As a result, ideas about the mainstream (primary, central) and the regional (secondary, peripheral) unavoidably come up for reconsideration. This anthology states some of the issues involved and encourages an approach to the art of California as more than a reflection or imitation of developments elsewhere. If David Harvey is correct in noting that the "complex historical geography of modernism [is] a tale yet to be fully written and explained,"[16] this volume represents a step on that particular path of inquiry.

In a postmodernist era when most critics and historians recognize the complexity of creative activity and diversity of expressive conditions that have both defined and enriched the broader American experience, it is no longer possible to support art-historical hegemony and all it implies for regional culture. We are suspicious of oversimplified, singular "readings" of cultural phenomena—or of history, for that matter. Under these circumstances, a repositioning of the elements of American art history is not only appropriate but imperative. For those of us involved in the creation of this book, California seems particularly well suited to the formulation of a truly national cultural narrative, one that embraces the edges as well as the center of American creative life.

Notes

1. Carey McWilliams, *Southern California: An Island on the Land* (Salt Lake City: Peregrine Smith, 1973). In his introduction McWilliams reinforces the idea of Los Angeles as "other," as different from the rest of the country. He reflects on his personal experiences from 1922 to 1951, when the region began to "make a real impact on national and world opinion" (xxi).

2. Edmund Wilson, *The Boys in the Back Room: Notes on California Novelists* (San Francisco: Colt Press, 1941), 58. No wonder California writers, and artists too, felt excluded by an unsympathetic eastern critical establishment. For example, writing in 1931, Arthur Millier asked: "Where does the western [meaning California] artist come in? He certainly doesn't figure very largely in the press barrage from the East. What's the matter, is he no good? . . . Why wait for New York to o.k. our artists then? They live here, in our environment and express it as well as we let them. How about getting behind them and backing our own little Renaissance, right here?" ("American Renaissance Hailed as Paris Flops," *Los Angeles Times,* November 29, 1931, 16).

3. See Kevin Starr, *Inventing the Dream: California through the Progressive Era* (New York: Oxford University Press, 1985); and Michael Kammen, *Mystic Chords of Memory: The Transformation of Tradition in American Culture* (New York: Knopf, 1991). Kammen's most relevant observation in connection with California may be that the concept of invention applies more productively to "developing nations" than to "established ones" (693). Relative youth combined with phenomenal growth, as in California, carries with it significant social and cultural stress. Acquiring stability through the re-creation of the trappings of civilization as expeditiously as possible is a familiar remedial pattern. In such cases, there is no time to let the traditions appear "naturally."

4. Dore Ashton, *American Art since 1945* (New York: Oxford University Press, 1982), 35.

5. Victor Burgin, "Modernism in the *Work* of Art," in *The End of Art Theory: Criticism and Postmodernity* (Atlantic Highlands, N.J.: Humanities Press International, 1986), 1. Our view of twentieth-century American art has largely been determined by the ascendancy of abstract expressionism and the concurrent rise of criticism as a separate intellectual discipline, the objective of which was to discover significant meaning in works of art. Greenberg's influential role in establishing the formalist model as both the objective and the measure of modernist art is also reprised in Hal Foster's essay "Re: Post," in *Art after Modernism: Rethinking Representation,* ed. Brian Wallis (New York: New Museum of Contemporary Art, 1984), 189–91.

6. Henry McBride, "Modern Art," *Creative Art 6,* no. 3 (March 1930), Supplement 1; reprinted in Daniel Catton Rich, *The Flow of Art: Essays and Criticisms of Henry McBride* (New York: Atheneum, 1975), 262–66. For a contemporaneous view of art's liberation from "realistic and representational shackles," see Oliver M. Sayler, *Revolt in the Arts* (New York: Brentano's, 1930), 113–21. John Sloan, in *Gist of Art* (New York: American Artists Group, 1939), put it this way: "The ultra-modern movement is a medicine for the disease of imitating appearances" (44). And Sheldon Cheney, throughout *A Primer of Modern Art* (1924; New York: Tudor, 1939), defines modern art in terms of expressive form as opposed to representation and imitation (36).

7. In Southern California, the inherent hostility between the conservative plein-air painters and the "progressives" (including regionalists and California watercolorists, as well as modernists) was played out in the Laguna Beach Art Association in the 1930s. By 1938, following a campaign to prevent Laguna from becoming an "artistic suburb" of Los Angeles, the modernists had been expelled and the art gallery shows had reverted to traditional landscapes and even Disney animation art. See Nancy Dustin Wall Moure, "Laguna Beach Art Association 1918–1955," in *A History of the Laguna Art Museum 1918–1993* (Laguna Art Museum, 1993), 15–19. Acknowledging the political nature of the conflict, Arthur Millier wrote that "Americans should naturally rejoice to see their artists at last receiving the attention they deserve, [but] it is not necessary to be misled

by the witchbaiting chorus against 'French Modernism' which is now in full blast" ("American Renaissance Hailed as Paris Flops" [as in note 2]).

8. See Nancy Boas, *The Society of Six: California Colorists* (San Francisco: Bedford Arts, 1988). The central role of postimpressionist colorism in determining the "style" of early modernist painting in North America is convincingly asserted in Peter Morrin et al., *The Advent of Modernism: Post-Impressionism and North American Art, 1900–1918* (Atlanta: High Museum of Art, 1986). Although the Society of Six did not come together until 1917 (and did not exhibit as a group until 1923), these artists clearly should be viewed as early modernists, despite the (typical) time lag for such developments in California.

9. In a conversation with me, the artist Paul Carey (with whom Hagedorn shared a studio in San Francisco's "Monkey Block" building—at Montgomery and Washington Streets—in the 1920s) said Hagedorn turned down Scheyer's invitation to join the Blue Four. He described Hagedorn as among the first California artists influenced by German expressionism. Appropriately, Hagedorn is represented in the Scheyer bequest, now at the Norton Simon Museum of Art in Pasadena.

10. The brochure for the *Exhibition of Paintings of American Modernists* is in the Stanton Macdonald-Wright papers, Archives of American Art. Beginning with the Panama-Pacific International Exposition there were opportunities to see modern art in California. Macdonald-Wright and Lucien Labaudt both organized important modernist exhibitions in the 1920s, drawing upon contacts on the East Coast and in France. Labaudt's correspondence with André Lhôte about the San Francisco exhibition is preserved in his papers at the Archives of American Art.

11. Annita Delano to Sonia Delaunay, March 11, 1929, Annita Delano papers, Archives of American Art, Smithsonian Institution, roll 2999, frames 238–40.

12. Delano, "Southwest Artist and Educator," interview by James V. Mink, 1971, 75 and 214–15, Oral History Program, University of California, Los Angeles. This information was brought to my attention by Richard Cándida Smith, formerly of the UCLA Oral History Program.

13. Bonnie Clearwater, ed., *West Coast Duchamp* (Miami Beach, Fla.: Grassfield Press, 1991). Beginning with the acquisition of *Nude Descending a Staircase, No. 2* by the San Francisco dealer Frederick C. Torrey in 1913, the authors skillfully trace Duchamp's influence on the developing West Coast art world. Through the Arensbergs, his work and ideas influenced the emerging modernist community from the 1920s to the time of his Pasadena retrospective. The most telling point for this discussion is that Duchamp "preferred to remain on the margins of the art world" (6). This attitude and position provide an analogue for the modernist activity that now appears most characteristic of California art.

14. Danto's failure to mention the Ferus exhibition in his discussion of the chronology of Warhol's reception seems worth mentioning in this context. That Warhol's first one-person show took place in Los Angeles in 1962 is not just ignored; the "honor" is transferred to the Stable Gallery in New York, whose director, Eleanor Ward, is said to have given "him his first main show when *no other dealer* [emphasis mine] was willing to do that" (*Beyond the Brillo Box: The Visual Arts in Post-Historical Perspective* [New York: Farrar, Straus and Giroux, 1992], 40). For Danto, it may be that an exhibition on the West Coast could not possibly be a "main show," one that figures in the meaningful "discourse" that conveys status and significance in the art world. History actually begins, then, only when the events are located in proper relation to the main stage and principal players.

15. I interviewed Claire Falkenstein March 2 and 21, 1995, in her studio in Venice, California. The transcript of the interview is in the Archives of American Art, Smithsonian Institution, 7, 14, 21. Despite the community of contemporary artists that assembled in her Venice neighborhood in the early 1960s, Falkenstein claims to have few artist friends and no influences. She chose Los Angeles when she returned from Paris because of what she perceived as a freedom from the constraints of tradition unparalleled among large cities, particularly those with significant cultural growth and activity. In this respect she found (and still finds) Los Angeles more sympathetic than even San Francisco. The extent to which Falkenstein's ideas—and the development of her work—reflect her European experience and parallel the theories of Michel Tapié and the doctrine of Art Autre is examined in an important article by Michael Plante: "Sculpture's *Autre,* Falkenstein's Direct Metal Sculpture and the Art Autre Aesthetic," *Art Journal* 53, no. 4 (winter 1994): 66–72.

16. David Harvey, *The Condition of Postmodernity* (Oxford: Basil Blackwell, 1990), 24.

THE REGIONAL IMAGINATION

Richard Cándida Smith

THE ELUSIVE QUEST

OF THE MODERNS

Before we can speak of "modernism" in the arts of California, we must confront the semantic muddle of the term itself. David Hollinger compared talking about modernism to walking through a room of multisided mirrors, each reflecting light differently, so as to prevent a clear view of any object in the room.[1] Conclusions about modernism depend on how we identify the most significant markers, a task, complicated enough when we are dealing with the major modernist creative figures, that becomes nearly impossible when we shift attention to developments on the periphery. For however talented California writers, artists, and architects were in the first half of this century, none played a critical role in shaping either national or international conceptions of the modern. Those like Irving Gill who have achieved retrospective importance did so only long after the height of their careers.

If, however, we count the Hollywood motion picture industry as quintessentially modernist, as Daniel Joseph Singal does, then Los Angeles becomes as central to the development of modernist culture as Paris. Singal's view of modernism clearly places the fine arts to the side, at least in the United States, where, he argues, the most important developments occurred in the mass media and advertising. Singal defines modernism as a set of cultural values that expressed people's admiration for "the vitality and inventiveness of technological progress while decrying the dehumanization it appears to bring in its wake."[2] Continuous discoveries in the sciences overthrew traditional belief structures and undermined the epistemological certainty they had given everyday life. In compensation, modernist pioneers extolled experience over knowledge: Learning through doing provided a more secure key to a rapidly changing environment than mastering the archives of human learning. In Singal's view, popular commercial entertainment was of greater importance in spreading these new values than elite experimentalism, which was often a rearguard effort to reconcile the new outlook with an outmoded humanist tradition.[3]

The common definition of modernism that focuses on the fine arts simply gathers together all the new art, music, architecture, and literature of the first half of the twentieth century. Even if such cultural productions followed opposing strategies, we can still portray them as united, in the words of Henri Lefebvre, "by a rupture with the classical and traditional vocabulary."[4] For Renato Poggioli in *The Theory of the Avant-Garde,* the distinguishing feature of modernist aesthetics was linguistic creativity, a "necessary reaction to the flat, opaque, and prosaic nature of our public speech, where the practical end of quantitative communication spoils the quality of expressive means." The "cult of novelty" was a corrective to the "degeneration afflicting common language through conventional habits."[5]

Despite superficial contradictions, Singal's approach can fruitfully be integrated with the more traditional aesthetic approach. The image of modernism as a broad-based middle-class culture working on multiple levels suspends the awkward isolation of fine arts experimentalists. To posit a shared epistemological crisis can help explain why elitist concerns diffused into the broader culture. An integrated approach also underscores the poignancy of the struggles of the aesthetic avant-gardes. Modernist attitudes have never triumphed completely or unconditionally. "Residual" beliefs in, and yearnings for, absolute knowledge and absolute values have continually welled up to challenge reigning epistemological conventions.[6]

Common to both approaches is a view of modernism as a response to the scientific method. For many at the beginning of the twentieth century, the most distinctive feature of the modern age was the rapid, apparently unending expansion of knowledge from scientific investigation. Millennia-old beliefs crumbled; new theories multiplied. The universe science revealed—its cosmological structure, the chemical and atomic building blocks of matter and energy, the earth's history, the evolution of biological species, and human psychology—was one that had been invisible; it had simply not existed for most men and women.

Even if the modern era was one of revolutionary change, when long-held beliefs were overturned and the social, cultural, and intellectual structures from which most people drew their identity weakened, it was also a time when scientific discoveries seemed like a return to original truths that had been obscured by superstition and ignorance. Skepticism did not necessarily lead to cynicism, since positivist scientific methodology relied on a faith that all experience sprang from unchanging universals. "God does not play dice with the universe," Albert Einstein said, convinced that the basic laws patterning natural phenomena were uncoverable through an accumulative process of hypothesis and controlled experiment.

This pervasive faith in what Raymond Williams has called the "modern absolute," in which particular historical practices assume the aura of eternal universal validity, entered the arts as the basis for a poetics of the scientific method.[7] The desire to emulate men of learning provided artists and poets with an elusive and unstable but fruitful goal of transforming aesthetic creation into a form of research on the means of communi-

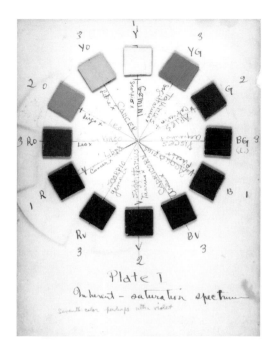

FIGURE 10
Stanton Macdonald-Wright, Color
Wheel. Stanton Macdonald-Wright
papers, Archives of American Art,
Smithsonian Institution.

cation. Ezra Pound proposed that poets uncover the rules governing the relation between connotation and denotation in language and use this knowledge to apply standards of machine efficiency to their work. His college friend William Carlos Williams likewise described a poem as a "machine made of words," a phrase that parallels Corbusier's famous dictum that houses were machines for living in.

The emphasis on machinery reflected an optimism that knowledge led automatically to practical know-how. But first, artists had to treat their work as basic research into the components of aesthetic expression and reception. They had to isolate and specify the effects of shape, line, color, texture, perspective—all the individual elements at play in the languages particular to the various media—in experiments that isolated the elementals of perception. They needed to examine the possibilities for recombining these elementals to define more precisely the process of cognition and the translation of sensory experiences into ideas and emotions. Having uncovered laws governing experience, artists could bring forth work that surpassed representation of what already existed by actually creating experiences never before known to humanity and impossible to duplicate in any other human endeavor.

This model of the arts as an analogue to scientific investigation conforms to the conscious goals of several prominent modernist painters and critics in California. Stanton Macdonald-Wright, who moved to Los Angeles in 1918, led his students through a series of exercises that focused on the process of vision more than the craft of painting (Fig. 10). He told his students that once they had mastered the nuances of his

theories of color harmony, they could produce specific sensations for the spectator.[8] In 1935 the art critic Arthur Millier defined modern art as a poetics of scientific method when he defended the work of the postsurrealists, a group of six painters in Los Angeles and San Francisco whose work focused on the processes of cognitive association. "The characteristic creations of our time are completed in the brain before an ounce of construction material is mined," Millier began. "Ours is the age of pre-calculations so exact that their objectifications seem miraculous." To express the dominant facts of the twentieth century, art must parallel science's "precision of theory and method. It must be as precise as the intricately calculated balance of a steel bridge, as absolute in the relationship of its parts as the element of a chemical compound." The experimental method applied to the arts would reveal the workings of the mind, a claim that Millier made without any hesitation or qualifications for the postsurrealists. Yet he hesitated to erase completely all distinctions between imagination and rationality. "The artist need not be an engineer," he conceded. "But he must create poems for an engineering age."[9]

Another particularly clear expression of a scientistic view of art came from the Austrian surrealist dissident painter Wolfgang Paalen, who settled in San Francisco after World War II and became one of the key figures in the short-lived Dynaton movement. The modern movements in the arts, Paalen wrote in 1942, during the first year of his exile to the western hemisphere, had spent half a century struggling toward an "esthetic science." The roots of such a science were present in the artistic production of archaic and non-Western societies, but traditional European ideals of order and beauty had blocked true experimentation and continued to hinder the development of modern art by focusing experiments on superficial forms of spectacle.

Paalen noted that the sculptors of the Pacific Northwest peoples spoke of their work as "right" or "wrong" rather than as "beautiful" or "ugly." Such a conception, he argued, showed that art had originated as a form of problem solving that trained the mind to approach all types of problems with a vision uncluttered by preconceptions. Art, science, and religion were "inseparably interwoven with the growth and development of human intelligence."[10] In the classical European tradition, this original function of art had given way to representing decoratively the worldviews of elites. Artists who continued to work in defined representational traditions helped to maintain a decaying system of social differentiation and prestige. The end of that system and the beginnings of a more inclusive, democratic society would free artists to return to their unique and truly creative functions.

According to Paalen, the artist, as a creative person, had an ethical obligation to expand the ways open to other citizens to examine and test the world:

> The true value of the image, through which artistic activity is connected with human development, lies in its capacity to *project* a new realization which does *not* have to be referred for its meaning to an object already existing. . . . [T]he true value of the artistic image does not depend upon its capacity to *represent,* but upon its capacity to *prefigure,* i.e., upon its

capacity to express potentially a *new order* of things. In order to distinguish between reactionary and revolutionary painting, it is enough to distinguish between what I shall call the *representative image* and the *prefigurative image*.[11]

Paalen defined the "representative image" as a realistic one that claimed to give the only significant truth of what was presented. If artists approached their subjects with clear hierarchies of values, they would produce dull work, which, however masterly its technique, would ultimately be of little use to their fellow citizens. The "prefigurative image," even if ostensibly realist, never represents what exists, "but potentially anticipates some features of what will exist . . . spontaneously answered by hints related to the most crucial preoccupation of the times."[12]

As a surrealist, Paalen groped toward a view of art as a science of the unconscious and the preconscious, but this scientistic, rationalist model of modernism does not conform at all with the romantic, largely literary view that came to dominate the discussion of modernism after 1945. The modernist canon privileges D. H. Lawrence's irrational union with the cosmos, T. S. Eliot's defense of a Christian humanist tradition, or Martin Heidegger's claim that Western philosophy took a disastrous turn with Plato. This version of modernism, however rigorous its method, denied that scientific procedure could provide any meaningful system of values. Investigation might lead to useful facts, but science provided a morally bankrupt interpretive scheme for determining what people should do with them. This form of cultural modernism corresponds to a defense of premodern, prescientific knowledge occurring when enthusiasm for the scientific method entered a field.

The antimodernists, whose views overdetermine current discussions of modernism, criticized science for artificially dividing the world into the knower and the known, the subject and the object. Antiscientific modernists believed that only the reintegration of the self into the world would dispel the horror of scientific "progress." A vision of the world was always a vision of oneself, so that humans defined their individual values, fundamental characteristics, and fate in the process of describing and therefore creating the world in which they lived.

This subject-subject view of artistic creation permeated the experimentation of the fauves, the expressionists, and the surrealists and the work of Mondrian and Klee as well as the abstract expressionist revolution of the 1940s. The same works that we can describe easily as investigations into the formal characteristics of visual communication also created autonomous worlds of pure subjectivity.

There is no single, correct interpretation of modernism that we must choose. What is more important is the view that specific creators, critics, and publics brought at given times in given places to cultural production and reception. Equally interesting is the degree to which creative people combined a scientific model with antiscientific assumptions. There was no rigid dichotomy, even in individuals. Professionalism required of

artists an attention to method as precise as that of scientists, but ultimately artists and scientists "know" the world in very different ways. A poetics of the scientific method had to come into conflict with the factors that make art a distinct human practice.

One painter who struggled with scientific and antiscientific views of art was Mabel Alvarez (Fig. 11), a founding member of the Los Angeles Modern Art Society in 1916. She believed that rigorous investigation of the effects of color could help demonstrate the actuality of "harmony." The world *appeared* to be in strife and to consist of opposites. She was convinced, however, that under the temporary forms of social custom was a basic order, which, if brought into daily life, would help orient people to work for moral and cultural progress. Alvarez hoped that by exploring the effects of color, her paintings showed viewers the fundamental reality of harmony. "I want to take all this beauty," she had confided to her diary in 1918, "and pour it out on canvas with such radiance that all who are lost in the darkness may feel the wonder and lift to it." [13]

In remarks similar, even if less systematic, to those propounded soon after by the Bauhaus in Germany, Alvarez noted that painting as a decorative art entered into people's daily lives. By helping to structure perceptual outlooks, paintings could reorient their viewers' relation to the world. In a diary entry from 1919, Alvarez noted that she and her sister had spent an evening discussing how to implement the principles of harmony the painter studied: "Perfect Harmony would be Heaven but we decided we would have as much as possible in everything around us and in whatever we thot [*sic*] and said and did. Carmen decided to change the Disorder in her little room to Harmony, and that when we wash and put away the dishes in the kitchen we are bringing Order and Harmony out of Disorder." [14]

Moved by a memorial exhibition of Rex Slinkard's work in mid-1919, Alvarez wrote of her fellow experimental painter, who had died prematurely, that his work was "all emotion—a dream world of the spirit—Nothing of the material physical world. Strange and lovely color and compositions and subjects. He worked entirely from within and said lovely things that were all his own." [15] In Alvarez's attempt to come to grips with the sources of abstract painting, two ideas clashed: modern art sprang from inner vision and therefore was entirely individual in its form of expression, but as the work became more personal it revealed patterns of perception and cognition that correspond to universal laws working on every level of reality.

This dichotomy between the personal and the universal engaged and frustrated artists. However "experimental" they were, their work was only an imaginative re-creation of the investigatory method, not an actual scientific procedure. [16] The finished works presented viewers with irreducible, unique experiences. A successful work of art was entirely unpredictable, no matter how logical it seemed. Artists, themselves caught between the practical requirements of crafting work and the theoretical model they followed, frequently questioned the path they had chosen. Mabel Alvarez complained one evening after returning from a class with Stanton Macdonald-Wright, "I have always doubted that pure abstractions in color would be very successful judging from the way

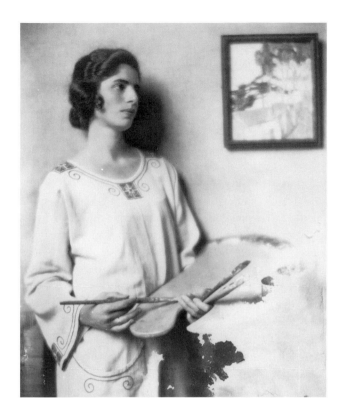

FIGURE 11
Mabel Alvarez, 1925. Mabel Alvarez
papers, Archives of American Art,
Smithsonian Institution.

the 'moderns' have tried it. We are told we should get certain sensations from them but we don't." [17]

Modern artists could imitate the ideal of the scientist-engineer, but only by surrendering subjective freedom without gaining the objective increments of knowledge that were the source of scientific authority. The poetics of the scientific method combined opposites in a desire to discover in personal vision the necessity of universal law. Modernist goals were elusive because two contradictory ideas of power collided to leave only the tragic ashes of an aspiration. For a time, the explosion generated significant work, but eventually artists had to confront the specific nature of their power as artists and find a way of constituting the ideal artist as a type meriting the recognition and respect given the scientist. To say that a poem or a painting or a house was a machine enunciated a desire to appropriate the powers of technology and science on which contemporary social hierarchy seemed to rest. Modernism from the subjective point of view was then fundamentally a statement of desire rather than of method or epistemology. The modernist grappled with science and technology to become one of those who mastered the world and had a place of respect in it.

To understand how this aspect of the modern movement in California played itself out, I want to explore a well-known example that stretches the model of modernism as normally understood. By rethinking Sabato Rodia's Watts Towers in South-Central Los Angeles (Fig. 12) as a distinctively Californian expression of modern art, we can help to define the unique contribution of California to the modern art movement in terms that do not force us continually to define the periphery solely in its relationship to the cosmopolitan center.

Rodia was born, most likely in 1879, in Rivatoli, Italy, a peasant community twenty miles east of Naples. The family immigrated to the United States in the early 1890s and settled in central Pennsylvania, where Rodia's older brother worked as a coal miner. In his late teens Rodia moved to the West Coast, working over the years as an itinerant laborer in rock quarries and logging and railroad camps and as a construction worker and tile setter. He spoke Spanish fluently and probably lived in Mexico sometime during the first forty years of his life.

In 1921 Rodia, estranged from his wife and children, purchased a large triangular lot in the working-class community of Watts, some eight miles south of downtown Los Angeles. He immediately began to work on a large assemblage structure that he called Nuestro Pueblo, Spanish for "our town." He first built scalloped masonry walls and then constructed seven towers, the tallest nearly one hundred feet high, out of steel rods and reinforced cement. At the base of the triangle, nearest his house, he put the most parklike elements of his project: a gazebo-arbor, stalagmite groupings, fountains, birdbaths, and benches. At the narrowest point of the lot, Rodia built a galleon that he called Marco Polo's Ship. He decorated his structures with mosaics made from tile shards, broken dishes, seashells, and pieces of bottles. The walls are covered with impressions of hands, work tools, automobile parts, corncobs, wheat stalks, and various types of fruit. He incised his initials into the wet cement, as well as recurrent heart and rosette shapes.[18]

He told William Hale, who made a documentary film on the towers in 1952, "I was going to do something big, and I did."[19] His goal was to leave a monument: "You have to be good good or bad bad to be remembered."[20] His heroes were Copernicus, Galileo, and Columbus, and he felt that scientists were truly the greatest heroes, for they had changed the world more profoundly than any other group. He also told interviewers that he had started working on his project to keep himself busy after he quit drinking.

Rodia used artistic production to create a place of respect for himself, something he could do only through the exercise of imaginative freedom, for in his aspect as a laborer in an industrial society his individuality had little significance. Art gave him a way to establish his presence in the contemporary world. His project allowed him to change the world by claiming the right to narrate, and thus interpret, his own experiences and traditions. Possible folk roots for elements of his creation are the ceremonial towers of wood and ribbon used for the Festa dei Gigli (Festival of the Lilies), celebrating San Gennaro, the patron saint of his birthplace. Rodia's forms, colors, and techniques,

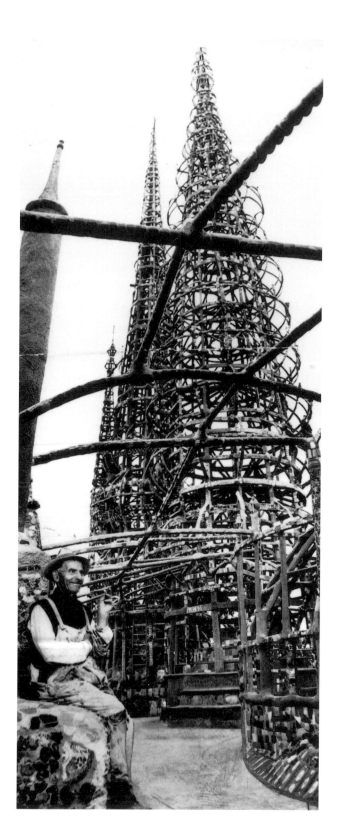

FIGURE 12
Sabato Rodia at his Nuestro Pueblo
(Watts Towers). *Los Angeles Times*
photo.

however, are unique. Not a single element in the composition corresponds to traditional Italian folk art forms. Rather than nostalgically re-create memories from his early childhood, he refracted them through complex images reflecting on the rapidly changing world of the laboring immigrant.

Rodia's use of the assemblage form was key to the effect of linking past, present, and future. In assemblage, the artist uses found or constructed objects as basic materials, putting them together so that they retain some of their original identity.[21] Peter Bürger has argued that assemblage and montage are the fundamental principles of modern art: "The 'fitted' work calls attention to the fact that it is made up of reality fragments; it breaks through the appearance of totality."[22] Two corollaries follow from Bürger's argument: First, the insertion of "reality fragments" into a work of art destroys its unity and any possibility of illusion. The viewers' perceptions of the piece constantly shift between what they know was created and what was found. A sense of the work's totality emerges through the enjoyment of contradictory details rather than through appreciation of a preconceived pattern. Second, the authority of the artist's vision is undermined because the viewer sees more clearly the "constructed," arbitrary nature of the completed piece. The artist cannot claim to represent nature or to have created an alternative world. Loss of authority is compensated for by greater emphasis upon the subjectivity of the artist. The work of art is clearly an interpretation of a reality external to both creator and spectator. The aesthetic effect comes as an emotional and intellectual response to the contradictions of existence (be they individual, social, or metaphysical), rather than as a reconciliation of those contradictions in the artificial unity of an "organic" work of art.[23]

Modernist works reveal the fictional nature of representational aesthetic strategies. Nuestro Pueblo is not a town, but a set of ideas about living in industrial, urban America. Representational work helped establish a cognitive reality for members of a society by reifying its ideologies into sensory experiences that seemed lawfully necessary. Modernist works, on the other hand, helped clarify that the essential act in asserting individual autonomy in a complex society was advancing an interpretation of the apparent facts of one's life, which begin to appear more complex and ambiguous and therefore demand further investigation.[24]

Rodia's composition is a true "constructed" work because he intended the basic materials to remain visible for what they are—steel, cement, broken bottles, broken tiles, corncobs, dishes, silverware, and so forth—and the forms, while suggestive, do not insist upon a univocal reading; the towers, for example, can be viewed simultaneously as church spires, skyscrapers, garden arbor, and so forth. Rodia's own ambivalence about the specific content of individual sections of the work is indicated by the multiplicity of names and descriptions he used over the years with various interviewers.

Ernesto De Martino, a cultural historian who studied the transformation of the southern Italian peasantry over the last century, noted that when the working classes modernize, they do not throw away their traditional culture and replace it lock, stock,

and barrel with the "scientific" values of the commercial and intellectual elite. The crisis of the modern world, he argued, lies in the unresolved conflict between two distinct but interlocked modernizing worldviews, one based on power, wealth, and the monopoly of scientific knowledge, the other located in the subordinate world of work, poverty, and poor education.[25]

Modernization in both cases involves (but is not limited to) remaking earlier cultural forms into values, beliefs, and customs consistent with the facts of machinery and the increased power of the leaders of human societies. Neither was free of fear of what the future would bring, but both popular and elite cultures also wanted the benefits that increased knowledge of the world provides. The elite looked back on 2,500 years of art, literature, and philosophy to invent a tradition that made the contemporary world seem an inevitable, progressive culmination of the march of history itself. Popular culture looked back to folk arts and crafts, to ritualistic religion and magic.[26] Modern art or literature could come from either culture, but the traditions referenced were different, as were the social claims of the creative work.

We can see Nuestro Pueblo as a magical act that appropriates the powers of the modern city for Rodia and his neighbors by imitating them and transforming them into a more spiritualized form. De Martino argued that the magical process of imitation had a function more profound than the naive belief that power resides in form: "Imitation directed to an end configures itself as an additional ideological 'superimposition'" that coexists with ideological conceptions of the dominant classes.[27] Arguments over the efficacy of magic have overlooked the primary function of magic in popular culture: to provide space for ideas reflecting the integrity and self-interest of the lower classes.

Rodia's towers question and refigure the ideology of the modern city so that it can become an imaginative home for all its residents, not just those with money. For most of the thirty-three years he lived in Watts, Rodia encouraged his neighbors to visit and use his project. Weddings and baptisms were celebrated under the towers; as festive as these uses might be, the setting nonetheless offered no escape from urban reality. Nuestro Pueblo confronts its visitors with images of the jumble of urban life: the towers reflect both church spire and the modern skyscraper and the stalagmites, both a cactus garden and apartment buildings rising up from the ground; the arbor with its incised designs speaks interchangeably of parks, the industrial worlds of automobile parts and construction tools, agricultural products, and pure purposeless beauty.

What we know about the prices of real estate, we find confirmed mythically: Nuestro Pueblo could have been created only in Watts, the Ultima Thule of Los Angeles. If Rodia had had the money to own property in more affluent sections of the city, he would have built real estate developments (or oil derricks) like Edward Doheny, the Irish immigrant teamster fortunate enough to be in the right place at the right time and become the founder of Union Oil. The towers create a reason for being there (in Watts), a metaphor that applies to human existence as well as to geography. The meta-

phor has particular pertinence to working people, whose legacies to subsequent genera-
tions are almost always anonymous. In building the towers, Rodia redeemed not only
his own humanity, but also that of others like him, the poorly paid, seldom recognized
working people who pass their lives in places like Watts. He showed that creativity does
not depend on social privilege.

This brief look at Nuestro Pueblo as a blend of material and ideological culture
returns us to the idea of Rodia's creation as a modernist exercise. An ambition to build
something like Nuestro Pueblo develops only when working people can accumulate a
modest amount of property and can count on leisure time to plan and execute the
project. Democratic values must have spread through society so it is neither ridiculous
nor dangerously presumptuous for a poor man to plan, as Rodia did, on doing "some-
thing big." Yet at the same time, social stratification based on wealth must be so all-
encompassing that poor people might feel the need to assert their egos against the forces
controlling the larger environment by building a microenvironment that challenges
through its very idealism a world built on money. The magic of imagination challenges
the magic of money (without incurring the penalties for social rebellion).

By describing Rodia's labors in mythical terms—critics have noted how Rodia
worked spontaneously on the towers, almost like a beaver or a spider, without precon-
ceived plan—we avoid considering his project as an action directed toward an end (the
affirmative aspect of magic). Nuestro Pueblo is a mythic imitation of a metropolis, but
it is also a psychological and social statement that affirms through its very grandeur that
a human built this. To deny that statement in favor of the timeless beauty of the myth
is to deny Rodia his humanity and to make him an aimless wanderer on the edges of
our society, of it but not to be integrated into it. It is in this sense that De Martino
defined the magical act as a constant attempt to declare one's humanity so as to achieve
a recognizable place in the world: "In reality, the problem of magic is not one of 'un-
derstanding' or of 'modifying' the world, but above all of guaranteeing a world in which
a being can become present." Magic is a form for asserting the "transcendental unity of
self-consciousness"[28] in the face of a world based on social fragmentation and compe-
tition. But in modern societies, the tools and conditions for self-expression become
more powerful and are in effect democratized, even if they coexist with a hierarchy of
prestige and status.

An aesthetics of magic and an aesthetics of scientism were two phases of the same
phenomenon, as the modernist fascination with the tarot, Kabbalah, I Ching, Tao, and
all forms of mythology attests. For most people science and magic work in unknown,
mysterious ways but provide cognitive maps; their prestige is based on their apparent
power to predict results. The working methodology of scientific procedure is so differ-
ent from aesthetic process that the effort of modern artists to appropriate the powers of
science functioned as a form of magic, deployed to seize power by narratively redefining
the artist's place and function in society. Modernist exploration in the visual arts re-
created in a new framework the powers of the modern era, but the effort left unspecified
the practical contributions artists hoped to offer their fellow citizens.

For all the powers that science demonstrated throughout the nineteenth century and has continued to demonstrate with even greater effectiveness through the twentieth, there is a fundamental contradiction in the expansion of scientific process in social life, a split that tends to produce a fragmentation of identity and a virtual schizophrenia. In the area of practical contribution to social life, the individual voluntarily becomes the slave of the requirements of the system of purposive rational action. Desired results flow by following predetermined procedures. Yet the expanded powers of science and technology provide increasing numbers of people with the means to pursue their fantasies unhampered by the inefficiencies of pretechnological organization and distribution. Desire in the area of consumption could find more direct satisfaction. Nathaniel Hawthorne, in an extraordinarily perceptive phrase, recognized this interiorizing aspect of the machine age in 1851 when he had a character in *The House of the Seven Gables* make the at first astonishing claim, "Trains are the spiritualization of travel!" [29]

Science and the machine age had expanded and problematized the question of freedom. The Declaration of Independence and the United States Constitution enshrined the classical idea that freedom devolved from the ability of free-holding individuals to participate in political decisions affecting their communities; this idea was now transformed into an existential question: how might inhabitants of a structured society both achieve practical goals and explore the possibilities inherent in personal fantasies? The scientific method offered no help in answering this question, but religion and humanism did, even if their answers had developed in societies with more rigid limitations on the potential of human action.

The dangers that scientific knowledge posed for humanity became inescapable for Europeans in 1914. Rational organization in the service of equally brutal autocrats and democrats led to the largest bloodbath in history. The frenetic enthusiasm of the futurists and the cheerfully optimistic experiments of the cubists and fauves did not survive the war. After 1918 new European avant-gardes, such as the surrealists and expressionists, looked for alternatives to rationality to give vent to their fear that the continued primacy of reasonable men would lead to even greater horrors. Americans retreated into isolation and maintained, despite social problems, the hope that the liberation of individual creativity would lead to a better world. The depression of the 1930s undermined that confidence, but Americans did not truly confront the ambiguities of progress until 1945, when the blood guilt of Hiroshima and Nagasaki and the revelation of the Holocaust proved that technology served evil as readily as good. As in Europe twenty-five years earlier, the shock of war opened the gates to a mistrust of rationality. In the changed postwar environment a new vital role for the arts appeared. Art stood, not as an icon for the necessity of personal vision, but as a process that symbolized the freedom of the unique and the irrational. This transformation required little stylistic change, simply a realignment of interpretive value. Instead of casting investigations of visual experience as cognitive experiments, artists found in their work proof of an interior reality that persisted despite external conditions.

Perry Anderson has argued that the critical synthesis of avant-garde cultural move-

ments into a unity marked by the term modern*ism* occurred only after 1945, when the basic impetus of those movements was already moribund. He concluded that modernism as a concept involves an inherent sense of nostalgia for a classic age one has missed.[30] The word "modernism" entered the culture of the post–World War II era as a ghost that haunts those who have followed because it speaks of a classic age of creativity, one equal to the Renaissance in the scope, vitality, and fluidity of the work produced. The greatness of this work springs from the determination of men and women of this period to come to grips with the challenge of science and create a place for themselves in a new world ceaselessly flowing into being. Modernism has been an elusive, muddled concept because it could have no set meaning. The responses to the simultaneous expansion of knowledge and imagination varied across time, place, and position.

As Rodia's work suggests, the challenge of modern life in California was considerably different from that in much of the rest of the world. The Second World War hastened the state's transformation from a provincial society into a metropolitan center. Cold war military spending brought prosperity, and the state's population boom created a new middle class, most of them migrants to the state, many of them young men and women from lower-income backgrounds who benefited from the new opportunities modern society seemed to provide. Freed from limiting if identity-giving geographic, family, and class roots, many during the postwar boom had to create their own lives in a complex world that was often indifferent, if not openly hostile or derisive. The ultimate universal that the arts in California proposed was the ability of each individual to define the meaning of his or her own existence in the relative isolation a new society provided.

Isolated from, but not ignorant of, the main developments of world culture, California's modern artists and poets provided a model for a creative synthesis that could lead to a new contemporary culture transcending modernism. The California modern movement had been so removed geographically, if not in time, from the social problematics of European modernism that men and women interested in European cultural debates in the 1920s and 1930s had already constituted modernism as a whole for themselves. The painter Lorser Feitelson declared himself both surrealist and futurist, even though he knew the movements were antagonistic, in order to create for himself what he considered the essence of the modern approach to art. The critic Lawrence Hart "deconstructed" the work of Eliot, Pound, and the French surrealists into a theory of poetry he called activism. We can view these experiments as evidence of a provincial pseudo-surrealism irrelevant to the "main line" of avant-garde thought, but such a judgment would naively accept the modernist assumption that art was in fact the source of universal, ahistorical truths.

The work California's moderns created often spoke wistfully of dreams to maintain the delicate balance between individuality and membership in a powerful, often anonymous and overpowering, social organization. In 1947, after winning first prize in the

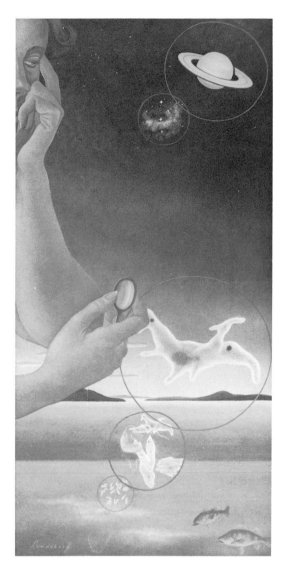

FIGURE 13
Helen Lundeberg, *Microcosm and Macrocosm*, 1937. Oil on Masonite, 28½ × 14 in. Private collection. Photograph courtesy Tobey C. Moss Gallery, Los Angeles.

annual Los Angeles County Museum art show, Helen Lundeberg (Fig. 13) received a letter from an admirer, who wrote that she saw in Lundeberg's paintings

> a sense of humility as well as awe before the majesty of things. There is also, or so it seems to me, an acceptance of the solitariness of the individual in your work. . . . A togetherness between two people is an impossibility, and where it seems nevertheless to exist—it robs either one or both of his fullest freedom of development but once the realization is accepted that even between the closest of human beings infinite distances continue to exist, a wonderful living side by side can grow up.[31]

The powers that created the modern world augmented and diminished the individual. The poetics of the experimental method ebbed into a celebration of what the lone individual felt. Elegy often marks the transitional work at the end of high modernism, for freedom was achieved by giving up faith in a technological utopia. When modernism passed, the scientific method and engineering were firmly at the heart of the contemporary world, so firmly that the public needed a counterweight. The artist in the post–World War II period then could shed the costume of scientific investigator uncovering universal law and appear as the figure defending desire, imagination, and irrationality in a world shaped by science. As became evident by mid-century, artifice for the sake of pleasure alone could claim to be every bit as important as the accumulation of knowledge. With that transformation, the quest to be modern could end, for the separation from the ancients and from the sacred stability of tradition was complete.

Notes

1. David Hollinger, "The Knower and the Artificer," *American Quarterly* 39 (1987): 37.

2. Daniel Joseph Singal, "Towards a Definition of American Modernism," *American Quarterly* 39 (1987): 8.

3. In *The War Within: From Victorian to Modernist Thought in the South, 1919–1945* (Chapel Hill: University of North Carolina Press, 1982), Singal studies a small group of American intellectuals and writers from the South who made the transition from Victorian to modernist culture. Other historians, however, counter Singal's view of modernism as relativizing and skeptical; they find the basis of modernist philosophies in the belief that the operations of the universe are known and that this knowledge can be applied to social behavior. Brief expositions of modernism as a cultural system can be found in Malcolm Bradbury and James McFarlane, "The Name and Nature of Modernism," in *Modernism, 1890–1930,* ed. Bradbury and McFarlane (New York: Penguin Books, 1976), 20–49; and Bruce Robbins, "Modernism in History, Modernism in Power," in *Modernism Reconsidered,* ed. Robert Kiely (Cambridge: MIT Press, 1983), 231–39.

4. Henri Lefebvre, "Modernity and Modernism," in *Modernism and Modernity: The Vancouver Conference Papers,* ed. Benjamin H. D. Buchloh et al. (Halifax: Press of the Nova Scotia College of Art and Design, 1983), 1–2.

5. Renato Poggioli, *The Theory of the Avant-Garde* (Cambridge: Harvard University Press, 1968), 37, 80.

6. The term "residual" refers to Raymond Williams's 1973 essay "Base and Superstructure in Marxist Cultural Theory," *New Left Review* 82 (November–December 1973): 3–16. Williams modified Antonio Gramsci's concept of hegemony to explain continued cultural contests by postulating the existence of multiple worldviews in society. Residual cultures represented older ways of life that had not entirely died out but had lost legitimacy and power. Dominant and emergent cultures reflected the outlooks of those groups contending for power.

7. Raymond Williams, *The Politics of Modernism: Against the New Conformists* (London: Verso, 1989), 38.

8. Journal entry, May 2, 1928, Mabel Alvarez papers, Archives of American Art, Smithsonian Institution.

9. Arthur Millier, "Postsurrealism or Subjective Classicism: A Means to a Genuinely Contemporary Art," in Ferdinand Perret papers, Notebooks on California Artists, Lorser Feitelson file, roll 3856, Archives of American Art, Smithsonian Institution.

10. Wolfgang Paalen, "The New Image," *Dyn,* no. 1 (April–May 1942): 7–8.

11. Ibid., 9.

12. Ibid., 13, 15.

13. Entry for December 10, 1918, Mabel Alvarez papers, Archives of American Art, Smithsonian Institution.

14. Diary entry March 18 [1919?], Mabel Alvarez papers, Archives of American Art, Smithsonian Institution.

15. Entry for June 8, 1919.

16. In 1916 Ezra Pound proposed a distinction between perceptual and cognitive art that influenced poets and critics of the interwar period. Writing on the sculptor Henri Gaudier-Brzeska, Pound argued that artists who focus on the act of perception operate as receivers of impressions, from which they derive meaning. Such artists accept the external world as the dominant reality and see the human being as a product of circumstances. The artist who focuses on cognitive process directs "a certain fluid force against circumstance, as *conceiving* instead of merely reflecting and observing." External reality was a jumble of meaningless events until an intelligent mind imposed order through the creation of images. See *Gaudier-Brzeska: A Memoir* (New York: New Directions, 1970; first published 1916), 89–90.

17. Journal entry, May 2, 1928, Mabel Alvarez papers (as in note 8).

18. Biographical data on Sabato Rodia (also known as Simon Rodia) are based on David Johnston, "Towering Indifference," *Los Angeles Times,* Calendar Section, August 14, 1984; Jules Langsner, "Simon of Watts," *Arts and Architecture* (July 1951); *Simon Rodia's Towers in Watts,* exh. cat. (Los Angeles County Museum of Art, 1962); Calvin Trillin, "I Know I Want to Do Something," *New Yorker,* May 29, 1965; "The Watts Towers," pamphlet published by the Committee for Simon Rodia's Towers in Watts, ca. 1960; and Leon Whiteson, *The Watts Towers of Los Angeles* (Oakville, Ontario: Mosaic Press, 1989).

19. Quoted in *Simon Rodia's Towers in Watts,* 11.

20. Langsner, "Simon of Watts," 25.

21. William C. Seitz, *The Art of Assemblage* (New York: Museum of Modern Art, 1961), 6.

22. Peter Bürger, *Theory of the Avant-Garde* (Minneapolis: University of Minnesota Press, 1984), 72.

23. Ibid., 77–78.

24. See Jürgen Wissmann, "Collagen oder die Integration von Realität im Kunstwerk," in *Immanente Ästhetik: Ästhetische Reflexion* (Munich: Wilhelm Fink Verlag, 1966), 327–60, for the distinction between organic and constructed work in the development of modernism.

25. Ernesto De Martino, *Mondo popolare e magia in Lucania* (Rome: Matera, 1975), 39.

26. This summary is drawn from De Martino's *Mondo popolare e magia in Lucania,* particularly

the first chapter, "Intorno a una storia del mondo popolare subalterno," and his *La fine del mondo: Contributo all'analisi delle apocalissi culturali* (Turin: Giulio Einauldi, 1977), 212–82.

27. Ibid., 136.

28. "Being," translated from the Italian word *esserci,* the word Italians use to translate the German philosophical term *Dasein,* often untranslated in English or translated as "Being-there." *Esserci* refers to a being conscious of itself as a subject, whose most fundamental nature involves awareness that it has a relationship to Being. The quotations are from Ernesto De Martino, *Il Mondo magico* (Turin: Giulio Einauldi, 1948), 145.

29. Nathaniel Hawthorne, *The House of the Seven Gables* (New York: Airmont, 1963), 209.

30. Perry Anderson, "Modernity and Revolution," *New Left Review* 144 (March–April 1984): 96–113.

31. Letter to Helen Lundeberg, December 11, 1947, Lorser Feitelson and Helen Lundeberg papers, Archives of American Art, Smithsonian Institution, rolls 1103–4.

Susan Landauer

PAINTING UNDER THE SHADOW:

CALIFORNIA MODERNISM AND

THE SECOND WORLD WAR

Modernism, as Malcolm Bradbury and James McFarlane tell us, is born of "cataclysmic upheavals of culture, those fundamental convulsions of the creative human spirit. . . . It is the one [artistic impulse] that responds to the scenario of our chaos."[1] Behind these words is an understanding that war is among the defining themes of modernism in Europe and America. Despite Virginia Woolf's oft-quoted line about the world changing in 1910, it was the First World War that proved such a great catalyst for modernism across the arts. The explosion of modernism—whether the dada performances in Zurich, the poetry of T. S. Eliot, the drawings of George Grosz, or the plays of Bertolt Brecht—was clearly a response to the war, even when artists abandoned the themes of battle and violence for those related to social structure or the human psyche. Perhaps because of the immense jolt of the First World War, the modernist burst after World War II was less intense than that of the teens and twenties. But this second surge of modernism was indeed significant, bringing us the introspection of French existentialism, the nightmare visions of Francis Bacon, and the absurdist plays of Samuel Beckett.

In California, however, the sequence of events was reversed. In contrast to the European capitals or New York, the modernist explosion after the Second World War was far more extensive than that following the First. As the essays in this volume attest, there were pockets of modernist activity in California well before the 1940s. But the number of modernists was small by comparison to that in New York, where precisionism dominated the artistic discourse of the 1920s and where abstractionists such as Stuart Davis could thrive even during the aesthetically conservative 1930s. For California, it took World War II to initiate the first great burst of modernism. The catalyst was not only the horror of the war, but also the explosive transformation of the state. More than half of all army cargo and troops bound for the Pacific theater passed through San Francisco's Golden "Victory" Gate.[2] In the space of a few years, several million people moved to the West Coast to work in the country's largest centers of shipbuilding

and aircraft construction—mostly in and around San Francisco and Los Angeles. By the late 1940s the *San Francisco Chronicle* was boasting that the massive westward migration "dwarfs the crusades and makes the Gold Rush seem like a boy scout outing."[3]

Mirroring these sweeping demographic changes, California's artistic community grew as the war brought artists—returning veterans—from all parts of the country, many arriving through the ports of Los Angeles and San Francisco. In addition, with the influx of refugees from fascism came European avant-garde ideas. Although New York was the center for European artists in exile during the war, Los Angeles drew a sizable number of artists, writers, musicians, and composers, including Thomas Mann, Bertolt Brecht, Arnold Schoenberg, Salvador Dalí, Man Ray, and Igor Stravinsky.[4] San Francisco attracted fewer émigrés than Los Angeles, but artists such as Stanley William Hayter, Gordon Onslow-Ford, Wolfgang Paalen, Jean Varda, and Max Beckmann—and returning expatriates like Charles Howard and Henry Miller—helped to expand the cultural horizons of the state.

Also adding to California's newfound cosmopolitanism was the wartime museum policy of circulating exhibitions of contemporary painting from coast to coast—initiated in part to offset the removal of art treasures inland for safekeeping. The director of the San Francisco Museum of Art, Grace McCann Morley, embraced the policy enthusiastically. Morley's exhibitions, many of them loan shows from the Museum of Modern Art in New York, brought to Bay Area audiences the latest work of Max Ernst, Roberto Matta, André Masson, Yves Tanguy, Piet Mondrian, and many other European émigrés then in New York. Indeed, the first major survey to include contemporary painting by European refugees in America, *Abstract and Surrealist Art in the United States,* was organized by Morley with the help of the New York art dealer Sidney Janis in 1944 for travel on the West Coast. The exhibition featured, among others, the little-known painters Mark Rothko, Arshile Gorky, Robert Motherwell, and Jackson Pollock.

The impact of all this activity was immediate and profound. By the end of the war, California artists found themselves at work in national and international contexts that pulled them out of their provincial preoccupations and toward broader worldviews. Although in 1939 the critic Alfred Frankenstein observed a nearly exclusive focus on "the more or less objective recording of native themes and situations,"[5] by the war's close in 1945 the *Montgomery Street Skylight* was reporting "a mass conversion to abstraction," even among "veterans of the picturesque flowerpot."[6] The forms California modernism took reflected more or less those found elsewhere in the country: surrealism, abstraction, and expressionism, fusing toward the end of the forties in the movement known variously in San Francisco as "free-form," "first sensation," and, in less sympathetic quarters, the "drip and drool school." Abstract expressionism was slower to attract adherents in Southern California. While San Francisco's most forceful presence was Clyfford Still, Los Angeles's modernism was dominated by the hard-edge abstraction of Lorser Feitelson and John McLaughlin and the tempestuous figuration of Rico Lebrun.

As different as their aesthetics may have been, these artists shared a double-hermed response to the war. On the one hand, their embrace of modernism was itself a turning outward, a manifestation of a new global perspective that deemed regionalism irrelevant. Modernism, as the cultural lingua franca of the free world, represented a repudiation of totalitarianism and its brutal curtailment of artistic expression. At the same time, this modernism—and herein lies its most significant departure from the machine aesthetic of much post–World War I art in America—was deeply inner-directed. Expressionists, surrealists, and abstractionists alike responded to the ferment by turning inward, away from social and political reality, to the realm of individual imagination. It is in part an index of their revulsion from the mass destruction made possible by modern industry and technology that so many modernists in California, like their counterparts elsewhere in the country, concentrated on such un-modern phenomena as dreams, myth, and magic. The depth and breadth of this primitivist impulse can be measured by its grip on such relatively conservative painters as Matthew Barnes. The tendency cut across political and aesthetic lines.

Despite such pervasive subjectivism, many California modernists wanted to contribute to the war effort. The Works Progress Administration (WPA) Southern California Art Project, until it closed in 1942, hired artists to paint murals for troops in training—to produce "fighting art to inspire fighting soldiers," in the words of Feitelson, the project's design supervisor.[7] Most modernists, however, drew the line at creating propaganda for the Office of War Information (despite tempting offers of employment), letting more traditional artists and Hollywood filmmakers take on the work of boosting homefront morale. Their view conformed with Duncan Phillips's in his classic mandarin exhortation not to press art into the service of any social, political, or religious idea, since "art is a social communication and a national asset, but never more so than when it is a miracle of personal expression."[8]

The majority of California modernists were thus content to express their subjective responses rather than comment overtly on the conflict. Most registered the impact of the war through dramatic changes in the content or style of their work. There is little in the San Francisco Museum of Art's painting and sculpture annual of 1941 to suggest that a global conflagration was taking place. A year later, however, Robert Howard and Adaline Kent were alluding to the war through titles such as *Combat* and *Victory*. Palettes also darkened to suggest a gloomy despondency. Artists of various aesthetic persuasions, from Ruth Armer to Hans Burkhardt, expressed the prevailing atmosphere of dread by painting in deep reds and blacks. This color combination, a favorite of Still's, became a mainstay for Bay Area abstract expressionists well into the 1950s.

Another, more familiar, modernist strategy for expressing the mood of the period was through compositional fragmentation. This approach can be found in the twisted automobile carcasses of Howard Warshaw (Fig. 14), the decomposing anatomies of Lebrun, and the colliding razor-edged shards of Feitelson, each expressing the flux, instability, and dislocation of the period.

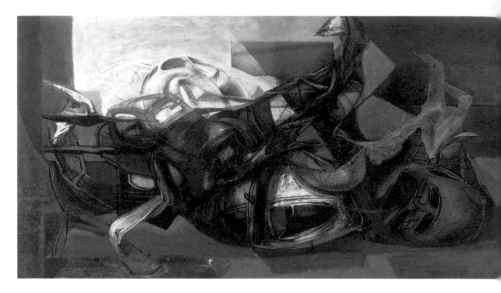

FIGURE 14
Howard Warshaw, *Wrecked Automobiles,* 1949. Gouache on canvas, 23 × 47 in. Los Angeles County Museum of Art, Los Angeles County Funds.

At the other extreme, but just as much a response to the upheaval, were the meticulously controlled abstractions of James McCray, Frederick Hammersley, and Peter Krasnow. Krasnow's work in particular demonstrates what Austin Warren called the "rage for order," the urge to impose some measure of control on a chaotic world (see Plate 4).[9] Krasnow's perfectly axial bricks of radiant color were intended as a soothing balm in turbulent times: "When tragedy was at the deepest point," he later said, "my paintings breathed joy and light—color structure instead of battle scenes, symmetry to repair broken worlds."[10]

The painting of John McLaughlin presents an interesting bridge between these opposing strategies for dealing with the trauma of the war and its aftermath. While at first glance the neat contours and streamlined surfaces of McLaughlin's geometric abstractions communicate a universe of order and stability, their ambiguous spatial relationships effectively undermine the initial impression of harmony. Although Susan Larsen's interpretation of McLaughlin's abstractions as profoundly anticlassical may be an overstatement, these works do provide a subtle commentary on the psychological climate of the era.[11]

Most California modernists approached the theme of war iconographically rather than through such oblique indices of style. Following Rufino Tamayo's lead, they depicted beasts locked in battle to convey the savagery of military aggression or, like Ernst, painted ruins crumbling under relentless vegetation to suggest civilization's moral decay.

It is interesting to see how closely realists and abstractionists converged thematically during the 1940s. Both were consumed with allegories of strife and despair, differing primarily in their degree of literalism.

Amid the passion and suffering of the war, it is not surprising that the crucifix became a common metaphor, treated by figurative and abstract painters alike. Lebrun's ambitious *Crucifix* cycle (1947–50), comprising over two hundred drawings and a large triptych, is perhaps the best-known example, but Burkhardt and Eugene Berman also treated the subject. Their paintings are among the few modernist attempts to bestow a measure of nobility on those who fought and suffered in the war. As an emblem of the soldier's heroic sacrifice, the crucifix had been invoked in the war poetry of Siegfried Sassoon, Wilfred Owen, and Randall Jarrell. The historian Paul Fussell has traced the image to the trenches of World War I, where rumors circulated about Germans' crucifying captured soldiers, rumors the press sensationalized to rally public support for the war. A crucifix incident at the front lines during World War II also made its way into American newspapers—testimony to the power of the image.[12] As general a part of the culture as the crucifix is, Frank Lobdell's later ascending spread-eagles—which also suggest the Resurrection—probably had their source in the wartime adoption of religious allegory.

Although modernists in California expressed their emotional reactions to the war, and in some cases dealt with the moral, psychological, and physical costs of the conflict, the indirection and nonspecificity of their work generally took the political bite out of it. The Second World War provoked few overt protests or attacks on society, and certainly nothing as combative as the angry denunciations of the dadaists or the Weimar expressionists. Curiously, one of the most scathing condemnations of World War II came not from the liberal modernist quarter, as one might expect, but from the conservative Midwest regionalist Thomas Hart Benton.[13] Benton's murals of burning farms and soldiers blown to pieces stirred up far more controversy than such noncommittal paintings as Charles Howard's *First War Winter* (1939–40). Howard's painting carries no more political freight than a December rainstorm by the realist Millard Sheets. Not until the mid-1950s, with the rise of Bay Area funk art, would California modernists in significant numbers become conspicuously political in their art.

In fact there was little clear-cut opposition to the war among modernists anywhere in the country until after it had ended and the mind-bending human toll from the death camps and atomic explosions was tabulated. Although the overwhelming majority of modernists in California harbored pacifist sentiments, most believed, like the American population as a whole, in the necessity of U.S. involvement in this particular war. Such support did not dampen the agony and horror so many California modernists incorporated into their art. But the war engendered greatly varied artistic expressions, from the highly aestheticized anger of Burkhardt to the whimsical escapism of Clay Spohn's *War Machines* and the ominous impastoed canvases of many San Francisco abstract expressionists.

Hans Burkhardt stands apart among modernists in California, not only for his opposition to World War II at its very outset, but also for his willingness to confront political reality directly in his art. Burkhardt's more than forty antiwar paintings, begun several years before America entered the conflict, were virtually the only modernist protests in California. Paintings such as *One Way Road* (1945), with its imagery of limitless, incalculable destruction, or *Iwo Jima* (1945), with its bloody mutilation, contrasted dramatically with the popular media's sanitized portrayal of the war in the 1940s, when even novelists were admonished not to write of combat as an unpleasant affair.[14] Burkhardt's works were intended to jolt viewers out of their apathy, and indeed, they sometimes provoked heated reactions. Even his *War, Agony in Death* (1939–40; Fig. 15), which condemned the German bombing of the Basque town of Guernica, inflamed Los Angeles viewers in 1944. One woman attacked it with a cane and had to be forcibly removed from a gallery on Sunset Boulevard.

Burkhardt spent the late 1920s and 1930s receiving private tutorials from Arshile Gorky in New York, where, along with Gorky's other informal pupil, Willem de Kooning, he developed a relatively sophisticated understanding of French abstraction from Cézanne to Miró. Burkhardt's thematic concerns, however, soon diverged from those of de Kooning and Gorky, both of whom kept their distance from the political arena. As early as 1937, after Burkhardt had moved to Los Angeles, his work began to reflect the growing turmoil in Europe. In 1938 he initiated a series of canvases on the theme of the Spanish Civil War, culminating in *War, Agony in Death,* the first of his mural-sized antiwar paintings. Burkhardt claimed to have been unaware of Picasso's *Guernica,* and indeed, the final product synthesizes expressionist and surrealist styles in a very un-Picasso-like manner, with slashing brushwork and a palette of lurid reds reminiscent of Chaim Soutine's. Unlike Picasso, Burkhardt does not attempt to evoke the actual bombardment but presents a generalized image of devastation. Although the painting is dominated by a back-thrust head with mouth open wide that recalls Picasso's shrieking figures as well as such earlier antecedents as Hieronymus Bosch's gaping jaws of hell, Burkhardt's head is less easily identified. Half-human, half–armored tank, its twisted, dripping mouth emits a cry that powerfully expresses the collective anguish of Guernica. The destruction of life is indicated by the profusion of crosses—so numerous that they topple over one another in competition for space, an allusion perhaps to the mass graves that were then a largely unpublicized fact of war.

Burkhardt's knowledge of collective graves could not have come from firsthand combat experience. Beyond the draft age, he had spent the early part of World War II in a Southern California defense plant building airplane parts and the remainder finishing furniture for a film studio in Hollywood. His closest personal contact with war was observing, as a child in Switzerland, the eerie red glow produced by bombs bursting over the border mountains during World War I. This image is often conjured in his paintings,[15] but the crimson sky as a backdrop for battle has a long tradition in poetry

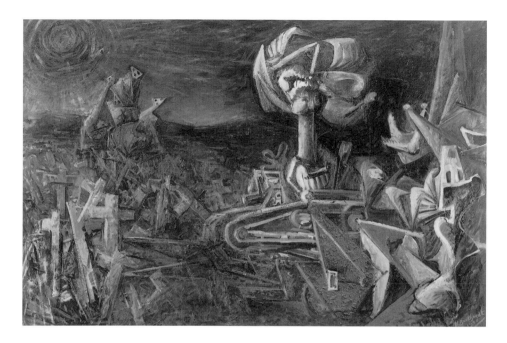

FIGURE 15
Hans Burkhardt, *War, Agony in Death,* 1939–40. Oil on canvas, 78 × 114 in. California State University at Northridge. Photograph courtesy Jack Rutberg Fine Arts, Los Angeles.

and painting, from Eugène Delacroix to Edmund Blunden.[16] For the most part, then, Burkhardt's vision of war drew primarily on his imagination, as well as cumulative associations from literature, the popular media, and the work of other artists. His work is best understood, not as an expression of the "reality" of war, but as a response to antecedent, technique, actual events, and, above all, his own intense feelings about the destruction and violence of war.[17]

Burkhardt's antipathy cannot be traced to any involvement with organized religion or politics; his preoccupation with death and suffering had much more personal roots. He spent his early childhood in Basel's industrial quarter, where his family's home stood in the shadow of a chemical factory and across the street from a rat-infested junkyard.[18] When Burkhardt was three, his father abandoned the family for America; a few years later, when his mother died of tuberculosis, he and his sister went to live in an orphanage. Years later, after moving to New York to join his father and stepmother, he lost both within a year, one to illness and the other to an automobile accident.

The theme of abandonment can be found in one of Burkhardt's first war paintings, *The Parting* (1939; Fig. 16). Although highly abstract, the image can be read as a man leaving his family to go to war. On the left, several children cry out, while on the right, their parents embrace for a final parting kiss.[19] This painting provides a template for

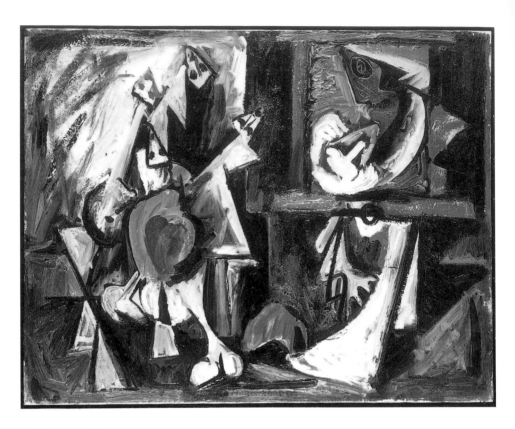

FIGURE 16
Hans Burkhardt, *The Parting,* 1939. Photograph courtesy Jack Rutberg
Oil on canvas, 22 × 28 in. Fine Arts, Los Angeles.

many of Burkhardt's later works, notably *War, Agony in Death,* where the "children" reappear as a personal shorthand for suffering. But there the "father-mother" configuration has metamorphosed into a monstrous weapon of war. The image projects Burkhardt's conflicted feelings of anger and loss toward his parents while doubling as a metaphor for the demonic forces of technology. On both levels of parable, victim and oppressor are conflated.

Burkhardt has been described as Goya's spiritual heir, and it is true that few artists since Goya have been as consumed by the brutality of war. But unlike Goya's *Disasters of War* (1810), Burkhardt's paintings dwell on the innocent victims rather than those responsible for war's atrocities.[20] Among his most horrific renderings of suffering are the concentration camp paintings, of which he made at least four during the course of the war. The first, painted in 1941, suggests two skeletal figures locked in an embrace. The threat of death is near, symbolized by two crosses at their heads. By 1942, the figures have collapsed into an undifferentiated heap, with only the most tentative characteristics of humanity to define them. Burkhardt unleashes some of his most savage

brushwork in this painting and its companion of the same year, with ragged, slashing strokes that express the full force of his fury. These paintings, however, are most remarkable, not for their emotional intensity, but for their prophetic imaging. Although it was common knowledge in America at the time that the Nazis had confined European Jews to concentration camps, the details of Hitler's gas chambers and crematoria were made public only in 1943. Even in 1944 most Americans remained oblivious to the genocide. According to the historian John Morton Blum, a poll taken in December 1944 revealed that much of the general public "knew Hitler had killed some Jews but could not believe that even the Nazis had methodically murdered millions."[21]

Skeletal forms appear in Burkhardt's paintings with increasing frequency toward the end of the war, culminating in one of his most harrowing paintings, *VE Day* (1945; Plate 5). The subject of victory in Europe might suggest something celebratory, but Burkhardt confronts the appalling cost of the armistice by presenting a panorama of horror that recalls the hellscapes of Bosch. The dead and wounded are shown in such profusion that they appear to rise ad infinitum beyond the canvas. In some cases, their bodies appear torn and mutilated. One disembodied member actually appears to pierce another, causing a cascade of blood. This painting, however, constitutes one of the rare instances in which Burkhardt specifies the gruesome details of war. Although he often implies an abundance of blood through a liberal use of red, Burkhardt largely excludes the horror of battle from his paintings. Nowhere do we find the rotting maggot-infested cadavers of Otto Dix, who painted the German battlefields of World War I. Compared with Dix's nauseating body-littered trenches, Burkhardt's *VE Day* provides a pleasure to the eye.

It is a paradox of Burkhardt's work—and indeed, of many modernist attempts to treat the theme of war—that a concern with technique often resulted in the artful rendering of a profoundly ugly subject. Many of Burkhardt's paintings present an unsettling conjunction of sensuality and death. Burkhardt certainly did not intend to aestheticize violence or to use his war paintings as vehicles for virtuosity, but that is precisely what he did. His paintings of atomic explosions, with their radiant colors and masterful handling of line, are especially dazzling.

Burkhardt embraced not only the aesthetic devotion of modernism but also its aversion to narrative, which precluded the concrete treatment of war found in the work of Dix or Goya. Although his paintings are for the most part tied to specific events, they show some of the same striving for universality that one finds in abstract expressionism. In most of Burkhardt's paintings, people appear, not as individuals, but as archetypes of humanity. Burkhardt shared abstract expressionism's ambition to express a content generic to all cultures, to speak what Elmer Bischoff called a pictorial Esperanto.[22]

Burkhardt's desire for unity, the flip side of his obsession with war, could at times verge on utopianism, as in *One World* (1945), a painting that exceeds even the idealism of Wendell Willkie's best-selling book of the same title published two years earlier. Going well beyond Willkie's call for global democracy, Burkhardt imagines a world in

which all the races have blended to form a single unified culture, symbolized by an abstraction of interlocking planes of color. A strain of optimism runs through much of Burkhardt's work. Many of his darkest war paintings of the 1940s contain a glimmer of hope, often suggested by the conventional landscape allegory of storm clouds beginning to break. Occasionally, Burkhardt's paintings serve as an arena for enacting his fantasies of political justice. As early as 1939 he painted Hitler hanging from a noose over the ruins of Germany. In later decades he would bury Lyndon Johnson for his complicity in the Vietnam War and Richard Nixon for his corruption of the government. But if Burkhardt occasionally found imaginative release through his art, the seriousness of political injustice was never far from his mind. His brand of escapism was not intended for amusement or diversion. Burkhardt's sober response to World War II was worlds apart from Clay Spohn's whimsical flights of fantasy.

Clay Spohn's Fantastic War Machines

In the summer of 1941, some six months before the bombing of Pearl Harbor, the San Francisco artist Clay Spohn began having recurring dreams about battling the Axis powers with fantastic weapons of war. "They were not nightmares," he recalled, "but like great spectacles of color." [23] Spohn took profuse notes on these dreams, waking in the middle of the night to make elaborate annotated "obsession drawings." Most of his more than two hundred ideas for war-related paintings never evolved beyond scrap paper, but at the urging of his good friend Charles Howard, Spohn produced enough finished works for an exhibition. A notorious procrastinator, Spohn worked on them until the very eve of their presentation. On February 22, 1942, two months after America entered the Second World War, Spohn's *Fantastic War Machines and Guerragraphs* premiered at the San Francisco Museum of Art.

The critical reaction to Spohn's exhibition was alternately baffled and bemused. It was difficult to say whether the artist was ridiculing the war effort or merely indulging in escapist fantasy. The show consisted of nine meticulously drawn, elaborately captioned gouache renderings of weaponry, which, as one critic quipped, illustrated some very unorthodox ways of winning the war. [24] *Hover Machine* (Fig. 17), for example, showed a device that could snare enemy vessels from both sea and air at lightning speed with the grappling hooks it ejected on cables from lubricated windlasses. *Tornado Machine* depicted an electronically controlled cyclone; *Spy Detector* showed an ornately decorated vehicle with outsize spy glasses; *Balloonic Uplifters* represented brassiere-shaped nets to entrap enemy aircraft; and the mammoth *Rolling Fort* (Fig. 18) featured

FIGURE 17
Opposite, top: Clay Spohn, *Hover Machine*, 1942. Gouache on paper, 15 × 20 in. The Oakland Museum, gift of the Estate of Peggy Nelson Dixon. Photograph by M. Lee Fatherree.

FIGURE 18
Opposite: Clay Spohn, *The Rolling Fort*, 1942. Watercolor on matboard, 18¾ × 26⅛ in. Nora Eccles Harrison Museum of Art, Utah State University, Logan, Utah. Gift of the Marie Eccles Caine Foundation.

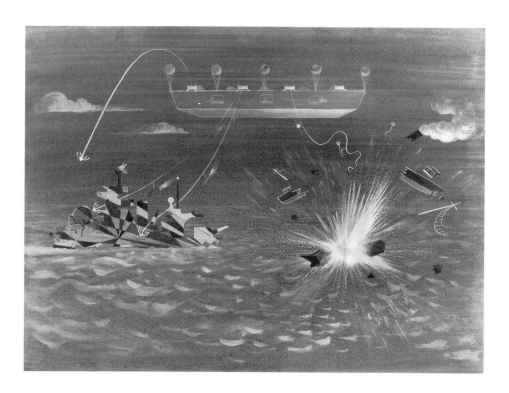

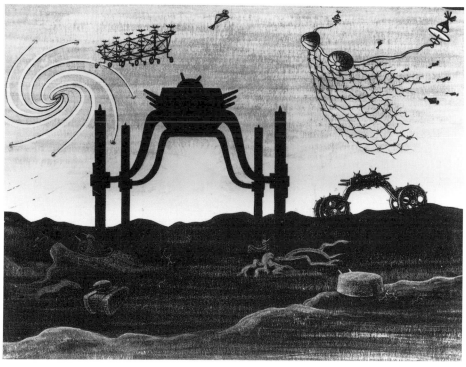

a chassis one hundred and twenty feet above the ground. Spohn's exhibition also included eleven drawings and gouaches of various war-related subjects, for which Douglas MacAgy, the show's curator, coined the term *Guerragraph,* from the Spanish word for war. At least one of the *Guerragraphs* anticipated the "Spy vs. Spy" cartoons of *Mad Magazine,* showing spies engaged in various ludicrous operations, such as peering at each other from around the corners of buildings and from other conspicuous hiding places.[25]

Spohn's *War Machines* and *Guerragraphs* have often been classified as surrealist, and indeed, Spohn borrowed liberally from that movement.[26] Stylistically, his approach was closest to that of René Magritte, Dalí, and Tanguy, who sought to fix dream-inspired images by illusionistic means. Spohn's work resembles that of these artists in its crisp delineation and smooth, unmodulated colors as well as in the artist's tendency, particularly in the *Guerragraphs,* to suspend forms weightlessly in a dreamlike landscape (Fig. 19). But Spohn's variety of madcap comedy is unusual in surrealism. His playful antics seem blissfully naive compared with the black humor of Magritte or Dalí. When the Europeans dealt explicitly with the subject of war, there was little lighthearted humor. Magritte's *Black Flag* (1937), for example, makes a striking contrast with Spohn's renditions. Magritte's war machines are equally fantastic and irrational, but their dark silhouettes are ominous and funereal. Hovering above a colorless landscape depleted of life, they could be, as Sidra Stich has suggested, the futuristic relics of a dead civilization.[27] Spohn was less concerned with the sinister implications of war, in large part because he did not subscribe to surrealism's Freudian view of humanity as inherently barbaric. Spohn preferred to focus on the positive elements of human nature, and he did not share the surrealist ambition to discommode the social status quo by revealing the dark and unruly workings of the mind. If, like the surrealists, Spohn hoped to short-circuit the intellect through humor and fantasy, it was rather to intensify the pleasure of life.[28]

In this sense, Spohn's approach was closer to Alexander Calder's than to that of any of the surrealists. Calder's whimsical mechanical sculptures may in fact have been an important stimulus for Spohn, since the two artists had known each other since their days at the Art Students League in New York and had worked in adjacent studios in Paris during the 1920s. It was apparently Spohn whose suggestion that Calder work with wire ultimately led him to invent the mobile.[29] Spohn's colorful kites and streamers and his kinetic *Wind Machine* for San Francisco's Open Air Show in 1941 were very much in the spirit of Calder's fanciful mobiles and circus toys.

Yet Spohn's *War Machines* were perhaps closer still to the preposterous contraptions of Rube Goldberg, then a popular cartoonist for the *New York Evening Sun.* Goldberg's mural *Automatic Hitler Kicking Machine* (1942) was as filled with impossible gadgetry as Spohn's inventions.[30] It would hardly be surprising if Spohn had admired Goldberg, since Spohn had also begun as a cartoonist.[31] Although he quickly abandoned cartoon work to pursue a career in painting, he continued to amuse himself and others with his

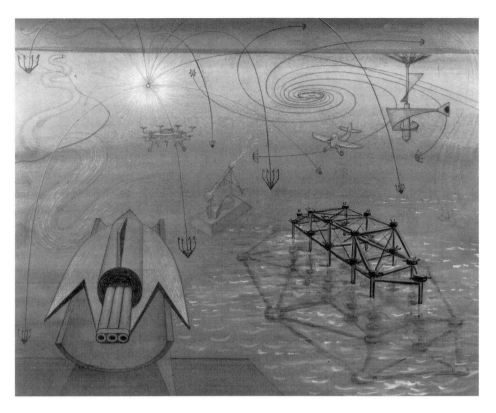

FIGURE 19

Clay Spohn, *The Unsinkable Fort,*
1942. Gouache, pencil, and crayon on
paper, 17¾ × 21 in. Collection of

John P. Axelrod, Boston. Photograph
by Michael Korol.

considerable comedic talent. Spohn was acclaimed in San Francisco in the 1940s particularly for his zany assemblages—the best known being his *Museum of Unknown and Little-Known Objects* (1949), which featured such whimsical exhibits as *Bedroom Fluff,* a collection of dust balls Spohn gathered from under a friend's bed; *Old Embryo,* a rubber Halloween mask floating eerily in a chemist's flask; and *Mouse Seeds,* a jar of mildewed rice. Spohn described these creations as "prankisms," acknowledging that they lacked the intellectual underpinnings of dada or surrealism.[32] Like many American modernists, Spohn approached art instinctually rather than theoretically.[33] Indeed, he was attracted to humor precisely because it afforded "a kind of free release from the bondage of dogma."[34]

The moment when Spohn's *Fantastic War Machines* debuted at the San Francisco Museum of Art could hardly have been more tense. In early 1942 the Japanese were rapidly overpowering the small, ill-equipped American garrisons on Pacific islands. The

fall of Bataan in the first few months of 1942 was probably the nadir of the war for the Allies, coming shortly after the loss of Singapore and Hong Kong and the sinking of the great British battleships the *Prince of Wales* and the *Repulse*.[35] Although most San Franciscans experienced these events only in news reports, the war was difficult to forget with such daily reminders as the convoys of warships filing steadily through the Golden Gate, with Angel Island overflowing with German and Japanese prisoners of war, and with such strange sights as the enormous Kaiser Shipyards, so busy producing Liberty ships that, as Dos Passos reported, they glowed all night long like forest fires.[36] Not only was San Francisco the major supply port for troops and munitions fueling the war effort, but it was also America's lifeline. The daily plasma drives and Red Cross blood banks springing up in such places as the California School of Fine Arts on Russian Hill were a grisly reminder that a massive war was on.

The anxiety was particularly acute in the months just after the bombing of Pearl Harbor. As the most strategically important port in the country, and hence America's front line, San Francisco was consumed by fear of becoming the next target. Blackouts were nightly events, and posters around the city warned civilians and soldiers alike to "zip your lip" since "loose lips sink ships." The paranoia can be measured by the rumors that filled the local newspapers. One story accused Japanese-born farmers of planting their tomatoes in the shape of an arrow to guide enemy bombers.[37] Another claimed that the Italian residents of North Beach were protecting their homes from air attack by painting swastikas on their roofs.[38]

Spohn's humorous spies and fantastic weaponry thus clearly ministered to a desperate need to relieve the tension.[39] Yet while Spohn certainly intended that the *War Machines* and *Guerragraphs* amuse, he also meant them as provocative satire. As Spohn's biographer, David Beasley, has written, these paintings "mocked imaginatively their original unworkableness as much as they mocked the seriousness of war."[40] They suggested the fiction of the government's and the media's grandiose claims that American weapons were invincible. The critic who described Spohn's *War Machines* as "*Popular Science* gone nuts"[41] had clearly not picked up a recent issue of the magazine, or he would have known that Spohn's ideas were not so distant from some of the armament designs seriously proposed at the start of the war, such as John Hodgdon's "Gyroscope Torpedo" and George Walker's flying "Mosquito Boat."[42] Spohn's *War Machines,* for which he concocted elaborate deadpan captions, deftly parodied such hopeful inventions. But it was not necessary to look at magazines specializing in science and industry; publications like *Time* and *Newsweek* were filled with praise for the ingenuity of American war technology, with the sort of bravado voiced in an advertisement for Corsair bombers that appeared in the December 1942 issue of the *Saturday Evening Post:* "Woe to any Jap or Nazi that tries to slip away! This new Navy fighter has 'got the drop' on everything under the axis sun!"[43]

As a veteran of the First World War, Spohn was somewhat skeptical of Allied slogans about swift victory. His assemblage *Wake Up and Live,* constructed around the same

time as the *War Machines,* expressed his concern that, as he later explained, "if we didn't wake up to the real facts that were going on with the war in Europe and so on, we might find ourselves in a bad way."[44] *Wake Up and Live,* consisting of a painted fly in a shadow box that could be swatted by pulling a chain, offered a graphic image of what could happen if America merely remained "a fly on the wall" during the conflict. By ridiculing America's claims to military prowess, the *War Machines* and *Guerragraphs* conveyed a similar warning about the need for preparedness. Spohn could scarcely have known how close to the truth he was. Only the military elite and those who did the actual fighting knew the deadly inefficiency of such highly touted war machines as the B-17 Flying Fortresses.[45] As Paul Fussell observed, few could have predicted that "before the war ended the burnt and twisted bits of almost 22,000 of these Allied bombers would strew the fields of Europe and Asia, attended by the pieces of almost 110,000 airmen."[46]

The GIs and the Canvas: The Artists of the California School of Fine Arts

Abstract expressionism is often interpreted as a response to such horrific revelations as the Nazi death camps, Hiroshima, and the threat of global holocaust. The standard art-historical account describes the rejection of identifiable subject matter as a corollary to the acute anxiety produced by these events, coupled with profound disillusionment with the political systems that made them possible. Recently, a number of scholars have carried the argument further to suggest that the decision to paint abstractly reflected a political neutrality born of this disillusionment. With social realism tied to outworn Marxist ideologies, and American Scene painting linked with the conservative "America Firsters," abstraction represented a noncommittal middle ground. Some art historians have interpreted this disengagement as an unwitting collusion with cold war centrism,[47] while others have explained it as a demonstration of anarchist sympathies.[48]

It is illuminating to test these hypotheses against the San Francisco abstract expressionists, who were far more forthcoming about their political views than their East Coast counterparts. The San Francisco group presents a profile strikingly different from that of the New York School. Clyfford Still, probably the best known of the San Francisco abstract expressionists, apparently joined the Right after the war, while a number of others remained faithful to the Left, including Hassel Smith, Robert McChesney, Ronald Bladen, and Edward Corbett. Although the Bay Area had been a center for anarchist activity since Alexander Berkman published his radical labor paper the *Blast* during the teens, none of the abstract expressionists ever became involved with that movement, or with any of its libertarian offshoots that flourished among the West Coast literary avant-garde during the 1940s.[49] Yet there can be no denying that the war was the shaping factor in their art. Unlike the New York School, most of the San Francisco artists had firsthand experience with the war. Of the best-known New York abstractionists, by contrast, only Ad Reinhardt served in uniform.[50] But to

see their painting as the product of alienation and angst is to simplify a complex phe-
nomenon. Although such an argument could be made for Frank Lobdell, it would not
hold for Richard Diebenkorn, or for Smith.[51] Yet the work of each cannot be under-
stood without taking into account the war, which fundamentally shaped their art and
their worldview.

John Grillo's painting had little to do with disillusionment but a good deal to do
with the war. He was among the first of the veterans to arrive, in 1946, at the California
School of Fine Arts, which was soon to become the center of abstraction on the West
Coast. Douglas MacAgy, the school's director, remembered Grillo vividly as a "fiery
young sailor" who showed up at the school, still in uniform, bearing a portfolio of
tattered paintings from overseas. After looking at Grillo's work, MacAgy concluded:
"Far from the blunt detachment represented by the *Time-Life-Fortune* type of war
record, these fragments expressed the searching experiences of an individual in the
hands of war."[52] Yet even though Grillo had been stationed on Okinawa, among the
bloodiest combat sites of the war, his paintings remained decidedly cheerful. Grillo's
painting virtually exploded with high spirits on his arrival in San Francisco after the
war, when he became something of a legend for executing his canvases from across the
room. These paintings have none of the anguish of Pollock or the mystery of Rothko.
Instead, they exude a sensuality and delight in the manipulation of paint, with colors
that are radiant, in some cases phosphorescent.

Perhaps more than any other San Francisco abstract expressionist, Grillo expressed
the euphoria that briefly accompanied the war's end. Although some of the artists came
out of the war harboring feelings of guilt and unease—notably those who, like Corbett
and Lobdell, had experienced too much violence firsthand—the tenor of the period
immediately following the founding of the United Nations was one of tremendous
optimism. Most exhilarating for the veterans was being free at last from the bondage of
the military. For many, the end of the war represented less an escape from mortal danger
than a liberation from what Leonard Woolf called the "negative emptiness and desola-
tion of personal and cosmic boredom."[53] Only a fraction had actually served in com-
bat; the rest were consigned to the tedious tasks of administration, transportation, and
supply, where waiting itself became the primary activity.[54] Most, like Elmer Bischoff,
experienced the war as little more than "repugnant minute to minute, day in day out
imprisonment."[55] Perhaps more devastating than the sheer boredom was the suppres-
sion of individual personality. As one of sixteen million GIs, the soldier in the Second
World War was even more anonymous than his counterpart in the First.[56] The mili-
tary's rigid hierarchy instilled a powerful antagonism toward bureaucracies of any kind.
George Stillman spoke for many at the California School of Fine Arts when he said,
"We had all been fed up with regimentation, with being put in a uniform and told what
to do. We were looking for a way out of that discipline—a way to be individual, a way
to be human."[57]

The antiauthoritarian ethos was especially strong at the California School of Fine Arts, where the traditional student-instructor roles were blurred by the leveling experience of the war. As Bischoff remarked, because they had all been in the service together, "There were not really instructors and students as much as there were older artists and younger artists."[58] Douglas MacAgy was fully aware of the returning veterans' aversion to institutional environments. As director from 1945 to 1950, he was determined that the school not "impose a ready-made set of visual arrangements or prescribed meanings," but instead pay respect "at all times to the ultimate integrity of the individual artist."[59] Rather than provide a set of a priori standards, MacAgy's instructors encouraged experimentation. Clyfford Still may have been draconian on matters of artistic conscience, but he refused to judge individual paintings.[60] Similarly, Clay Spohn implored his students never to follow the precepts of a master, but to leave open an infinite range of possibilities: "Art is not only free of anything that has to do with the dogmatic, but it is the essence and spirit of freedom. It can be developed only when the mind and spirit are completely free and released. Limitation is the enemy of free expression."[61]

Grillo's spontaneous method of painting was one way for the veterans to release their pent-up desire for personal expression. Smith, Diebenkorn, Bischoff, and David Park were among those who found release in explosive canvases that employed the drip, the splatter, the smear, and the gesture. Although not every artist worked in a rapid-fire fashion—Corbett, Still, and Lobdell are the notable exceptions—all the San Francisco painters rejected the impersonality of geometric abstraction. Whether in the form of cubism, neoplasticism, or Bauhaus design, such abstraction seemed incapable of commenting on the world. Geometry was also associated with a sympathetic view of technology and science that was no longer tenable after the war.[62] By the late 1940s, the machine aesthetic, as a subset of classicism, had come to signify the forces of tyranny and oppression. Thus, for Diebenkorn, geometric abstraction "equalled sterility"; for Corbett, it represented a "straitjacket"; and for Still, it meant nothing less than "totalitarian hegemony."[63]

The aesthetic consequences of this anticlassicism among the San Francisco abstract expressionists involved more than a refusal to paint geometric shapes. Indeed, nearly every aspect of their sensibility can be seen as antithetical to the ideals of classicism. They rejected clean, smooth surfaces and clear hues in favor of rugged textures and earthen, sometimes muddy, colors. In their works clarity, order, and stasis gave way to the contrary romantic qualities of dynamism, ambiguity, and imprecision. This distaste for static forms included a reluctance to fix edges with delineating lines. As MacAgy observed, the quantitative, delimiting function of the enclosing line made it a paramount symbol of classicist rationality.[64] Even the borders of a frame were considered too confining. Still was especially adamant in this regard, declaring: "To be stopped by a frame's edge was intolerable; a Euclidean prison. It had to be annihilated, its authoritarian implications repudiated."[65]

There is a powerful aura of protest around much of Still's work that appealed to the former GIs in San Francisco. It was his "anti-color" and his "willingness to use something really raw and brutal," as Jack Jefferson put it, that won him so many admirers.[66] As the 1940s came to a close, a number of events transpired to make a dark, forbidding variant of abstraction more relevant to the times than Grillo's joyful expressionism.[67] The rising threat of global atomic warfare and the beginning of the Korean War in 1950 contributed to a general malaise and to a growing sense of betrayal among the veterans. "We felt we had been betrayed by words and by the wordsmiths," John Hultberg recalled. "We had won the war and that was supposed to bring happiness, but we weren't sure things were [getting] any better."[68] The war had been sanitized and Norman Rockwellized for the troops and particularly for the homefront, and now the cycle was beginning again.[69]

Disillusionment in the 1950s was especially acute among those who had sacrificed the most during the war, the few who had experienced the devastating psychological impact of combat. Compared with the pastel confections of Diebenkorn, who remained in relative comfort as an art student at Stanford and the University of California for most of the war, the canvases of Jefferson, who served on Guadalcanal at the height of action, are dark and morose, mostly in grim shades of gray, brown, and black. The black enamel paintings of Corbett, who nearly lost his life in the Battle of the Coral Sea, are among the angriest abstract expressionist paintings from the early 1950s (Fig. 20). Corbett, who had registered his horror of the Holocaust with a chilling drawing of bodies stacked like cordwood,[70] described his black paintings as the "expressive complement" of "vast conglomerates of evil."[71]

But of all the San Francisco abstract expressionists, the one who became most obsessed with the hypocrisy and brutality of the war, translating this obsession into powerful paintings of personal anguish, was Lobdell. From an essentially formal preoccupation with the innovations of Klee and Picasso, Lobdell developed toward the end of the 1940s an aesthetic that had no room for beauty or sentimentality—which in his opinion served only to cloak the harsh realities of postwar society.[72] Lobdell's work began to take on a disturbing cast around 1948, with a group of paintings and lithographs that recall bones, tendons, and intestinal coils.[73] As a lieutenant in the infantry in Germany, he had witnessed horrific slaughter on the front lines.[74] Fellow California School of Fine Arts artist Walter Kuhlman remembered Lobdell's recurring nightmares about "blood and guts spilling out of men."[75] The horror and nausea of such experiences are powerfully conveyed in an untitled work circa 1948 that suggests torn limbs dripping with blood.

As the 1950s progressed, Lobdell's paintings became increasingly ominous and brooding. The chalky white grounds of his earlier work gave way to dense and impenetrable blacks and grays in agitated impastos. As in the work of Still, these impastos are divested of all the sensuality usually associated with the technique: they are the product of slow accretion rather than of oil-laden brush strokes. Often, as in the Oakland

FIGURE 20
Edward Corbett, *Untitled,* ca. 1950–
51. Oil and enamel on canvas, 60 ×
50 in. Collection of William M. Roth.

Museum's *January, 1955* (Fig. 21), Lobdell's surfaces are as dry and parched as cinder. This painting evokes a fire-charred hell, the blackness pierced by flickering streaks of orange and red, suggesting flames as well as mouths open wide in agonizing screams. As we have seen, the cry of anguish was a theme that had earlier occupied Burkhardt, as it had Lebrun, Picasso, and Bacon. It is one of many war-engendered motifs—along with the crucifix, the savage beast, and the shadowy woods—that typify the painting of the period both in Europe and America, whether one looks to London, Paris, New York, Los Angeles, or San Francisco.

Conclusion

The years from 1941 to 1951 fundamentally transformed the art of California, no less than that of the country as a whole. In that decade, regionalism and other realist tendencies antagonistic to European influence gave way to a powerful tide of modernism that ultimately swept them off the stage entirely. New York is generally regarded as the generative site for this phenomenon, but in fact the trend toward abstraction was remarkably broad, apparent not only in galleries and studios in Manhattan, but in art schools and regional exhibitions across the country.[76] California's participation in the rise of modernism during the postwar era, then, should not be understood as a passive absorption of trends initiated elsewhere, but rather as a profound response to historical pressures brought about by the war. Although most of the strategies Californians found for expressing themselves had counterparts on the East Coast and in Europe, their art was by no means imitative or homogeneous. While it conformed to the categories of style found in other parts of the country—mostly surrealism, cubism, expressionism, and various admixtures—the range of expression was as varied as the population. Of interest here, however, as throughout much of the present volume, is not merely the concurrency of California modernism during the 1940s, but the question of its distinguishing characteristics. Was there anything singular about it that might be attributed to the physical and psychological environment?

Regionalism is a particularly complex issue for the period in question, because the very notion conflicts with the premise of internationalism that underlay modernist painting. And certainly modernism was never so zealous in crusading against cultural chauvinism as it was during the war years. To embrace the "international idiom of twentieth-century painting," as abstraction was commonly conceived then, was to con-

FIGURE 21
Opposite: Frank Lobdell, *January, 1955,* 1955. Oil on canvas, 69⅝ × 53½ in. The Oakland Museum, gift of Mrs. Robert Chamberlain. Photograph by M. Lee Fatherree.

demn localism in art as well as politics.[77] As Mark Tobey remarked in 1946, the regional could be stressed only "at the expense of the inner world" and "the understanding of this single earth."[78] As different as their aesthetics were, Burkhardt, Spohn, and Lobdell would each doubtless have agreed with Robert Motherwell that "to fail to overcome one's initial environment is never to reach the human."[79]

Given this prevailing viewpoint, California modernists strove, not to emulate local traditions, but rather to transcend the particulars of time and place. Paradoxically, by reacting against indigenous conventions, Bay Area artists such as Corbett, Still, Smith, and Lobdell produced a kind of reactionary regionalism. During the late 1940s, they deliberately emptied their work of the bright, sunny colors associated with West Coast painting, notably the popular California watercolor school, which concentrated on western agrarian and coastal scenes. Los Angeles modernists also rejected local references. Burkhardt and Feitelson, McLaughlin and Lebrun—each sought a timeless, transcendent modernism that had little to do with the milieu of Southern California.

Yet in spite of the attempts to universalize, certain idiomatic traits took hold; certain strains of modernism became more prevalent in California than elsewhere. Abstract expressionism caught on more quickly in San Francisco than in other parts of the country, while Los Angeles became a center for figurative expressionism and hard-edge abstraction.[80] To some extent, these variations were due to the extraordinary force of individual personalities: Still's in San Francisco, Lebrun's and Feitelson's in Los Angeles. As the 1950s progressed, the differences between Northern and Southern California became ever more pronounced. By the 1960s the abstract classicism of Feitelson and McLaughlin had given birth to what became known as the L.A. look—Southern California's ultraslick, squeaky-clean variety of formalist abstraction. In Northern California an entirely different sensibility had taken hold: the determinedly individualistic, romantic antiformalism typified by the work of William Wiley, Joan Brown, and Robert Arneson. Ultimately, however, we must acknowledge that even if lineages can be traced to artists such as Still and Feitelson, a psychology of place, rather than the impress of a few innovators, encouraged the polarities of the 1960s and continues to inform the various regionalisms existing today.

Notes

1. Malcolm Bradbury and James McFarlane, *Modernism, 1890–1930* (New York: Penguin Books, 1976), 19, 27.

2. For a discussion of the activities of the San Francisco Port of Embarkation, see Captain James W. Hamilton and First Lieutenant William J. Bolce, Jr., *Gateway to Victory* (Stanford, Calif.: Stanford University Press, 1946).

3. Editorial, *San Francisco Chronicle,* September 8, 1946.

4. For more on the impact of the European émigrés in Los Angeles, see Paul J. Karlstrom, "Modernism in Southern California, 1920–1956," in Karlstrom and Susan Ehrlich, *Turning the Tide: Early Los Angeles Modernists, 1920–1956* (Santa Barbara Museum of Art, 1990), 13–42.

5. Alfred Frankenstein, quoted in *From Exposition to Exposition: Progressive and Conservative Northern California Painting, 1915–1939,* ed. Joseph Armstrong Baird, Jr. (Sacramento: Crocker Art Museum, 1981), 63.

6. G. P. Hitchcock, "Annual Drunkenly Abstract," *Montgomery Street Skylight* 2 (November 2, 1945): 1.

7. "The Role of the Artist in Wartime—Cultural Question Number One," *Art Digest* 16 (January 1, 1942): 14.

8. Duncan Phillips, quoted in "The Role of the Artist," 14.

9. Austin Warren, *Rage for Order: Essays in Criticism* (Ann Arbor: University of Michigan Press, 1948). Warren was referring to poetry, but his observations are equally applicable to the visual arts.

10. Peter Krasnow, quoted in Susan Ehrlich, "Peter Krasnow (1887–1979)," in Karlstrom and Ehrlich, *Turning the Tide,* 74.

11. Susan Larsen, "John McLaughlin," *Art International* 22 (January 1978): 8.

12. Paul Fussell, *The Great War and Modern Memory* (Cambridge: Oxford University Press, 1975), 117–20.

13. See Manny Farber, "Thomas Benton's War Paintings," *New Republic* (April 20, 1942): 542–43.

14. See Paul Fussell, *Wartime: Understanding and Behavior in the Second World War* (Cambridge: Oxford University Press, 1989), 180–95.

15. Jack Rutberg, telephone interview by the author, June 8, 1992.

16. For an insightful discussion of this image in art and literature, see Fussell, *The Great War,* 51–63.

17. Cf. Eugene N. Anderson, "Essay," in Jack V. Rutberg, *Hans Burkhardt: The War Paintings, a Catalogue Raisonné* (Northridge: Santa Susana Press, California State University, 1984), 30–31.

18. Hans Burkhardt, interviewed by Colin Gardner, in Rutberg, *Hans Burkhardt,* 9.

19. Jack Rutberg, telephone interview by the author, June 8, 1992; information based on Rutberg's conversation with Burkhardt.

20. Anderson, "Essay," 30.

21. John Morton Blum, *V Was for Victory: Politics and American Culture during World War II* (New York: Harcourt Brace Jovanovich, 1976), 181.

22. Susan Klein [Landauer], "Elmer Bischoff," *Issue* (Fall 1985): 11.

23. Clay Spohn, letter to Thomas Albright, April 1, 1976, unfilmed Clay Spohn papers, Archives of American Art, Smithsonian Institution.

24. Gerald Cullinan, "Blackout Business Proves Bright for Courvoisier," *San Francisco Call-Bulletin,* March 21, 1942.

25. Titles for these *Guerragraphs,* whose whereabouts are for the most part unknown, include *Fifth Column Listening Post, The Dictators,* and *Combat between Two War Machines.* A checklist of the exhibition can be found in the Louise Sloss Ackerman Fine Arts Library, San Francisco Museum of Modern Art. Specifics about the paintings are from an article by Douglas MacAgy (see n. 26).

26. See, for example, Douglas MacAgy, "Clay Spohn's War Machines," *Circle* 5 (1945): 38–43 (including Spohn's captions for the works discussed).

27. Sidra Stich, *Anxious Visions: Surrealist Art* (New York: Abbeville Press, 1990), 125.

28. In 1940 Spohn stated that "good art should intensify life. The bottom line is giving pleasure" (Oakland Museum Arts Research Bicentennial Document, November 24, 1940, Archives of California Art, Oakland Museum).

29. Mary Fuller [McChesney], "Portrait: Clay Spohn," *Art in America* 51 (December 1963): 80.

30. Rube Goldberg's *Automatic Hitler Kicking Machine* was among the feature attractions of his first solo exhibition in New York at John Pierpont Morgan's mansion, December 1942.

31. Spohn began his career as an illustrator and editor for the *Pelican,* the humorous student magazine at the University of California at Berkeley; in the early 1920s he joined the *New York Evening World* as a staff cartoonist and illustrator.

32. Clay Spohn, letter to Mary Fuller [McChesney], April 25, 1963, Clay Spohn papers, roll D-169, frame 1226, Archives of American Art, Smithsonian Institution.

33. See Michael Leonard, "The Dada and Surrealist Roots of Art in California," *Art of California* 5 (May 1992): 8–12.

34. Clay Spohn, letter to Mary Fuller McChesney, June 26, 1977, private collection.

35. Fussell, *Wartime* (as in note 14), 235.

36. John Dos Passos, "San Francisco Looks West: The City in Wartime," *Harper's Magazine* 188 (March 1944): 333.

37. Rudolph S. Rauch, "Internment," *Constitution* 4 (Winter 1992): 35.

38. Hamilton and Bolce, *Gateway to Victory* (as in note 2), 39.

39. Indeed, there was a great demand for such diversion. The cartoon book enjoyed greater popularity than ever during the war, among civilians as well as the troops (see Fussell, *Wartime,* 250). The enormous popularity of *Sawdust and Spangles,* an exhibition Douglas MacAgy organized at the San Francisco Museum of Art in 1942, further testifies to the need for wartime levity. Devoted to the theme of the circus, with sections on clowns, acrobats, "freaks," and the ring, the exhibition featured many of the Bay Area's leading modernists, including Adaline Kent, Madge Knight, Charles and Robert Howard, David Park, and of course Clay Spohn. See "Sawdust and Spangles in San Francisco," *Art Digest* 15 (May 1, 1942): 16.

40. David Beasley, "Life of a Painter: Clay Spohn Remembered," *Bulletin of Research in the Humanities* 86 (Summer 1983): 201.

41. Cullinan, "Blackout Business" (as in note 24). Another reviewer, however, took Spohn's designs seriously enough to report that they had been submitted to the War Office in Washington. See "Fantastic War Machines to Go on Display," *Oakland Tribune,* March 8, 1942. While it is highly unlikely that the *War Machines* were formally submitted to the government for consideration, Spohn recalls that military officials were nervous about them: "The Army and Navy people were there (one of each) as soon as the museum doors opened, just to check, I expect, that no important secrets or probable secret weapons were being shown. But when they saw the show was practically all based upon the imagination and a dream-like war they finally left—peacefully!" (letter from Spohn to Thomas Albright, April 1, 1976, unfilmed papers of Clay Spohn, Archives of American Art, Smithsonian Institution).

42. See "America's Newest Birds of War," section entitled "Streamline Designs for New War Machines," in *Popular Mechanics* 76 (December 1941): 26, 27.

43. *Saturday Evening Post* 215 (December 26, 1942): front cover verso.

44. Fuller, "Portrait" (as in note 29), 80.

45. Fussell, *Wartime* (as in note 14), 13.

46. Ibid., 14.

47. See the essays by Max Kozloff, Eva Cockcroft, and David and Cecil Shapiro, in *Pollock and After: The Critical Debate,* ed. Francis Frascina (New York: Harper and Row, 1985); and Serge Guilbaut, *How New York Stole the Idea of Modern Art: Abstract Expressionism, Freedom, and the Cold War* (Chicago: University of Chicago Press, 1983).

48. See David Craven, "Abstract Expressionism, Automatism, and the Age of Automation," *Art History* 13 (March 1990): 72–103.

49. See Philip Lamantia, "Letter from San Francisco," *Horizon* 93–94 (October 1947): 118–23; and, for a sensationalized account of the Bay Area's postwar anarchist movement, see Mildred Edie Brady, "The New Cult of Sex and Anarchy," *Harper's Magazine* 144 (April 1947): 312–22.

50. Most of the better-known New York abstract expressionists were draftable—that is, they were between twenty and forty-five at the time of America's entry into the war—but were exempted for having either dependents or disabilities, physical or psychological.

51. Hassel Smith explicitly denied that abstract expressionism was a product of postwar angst and disillusionment (annotations to an undated letter from Jeffrey Wechsler, Hassel Smith papers, roll 2008, frame 500, Archives of American Art, Smithsonian Institution).

52. Douglas MacAgy, *John Grillo: Oils and Watercolors* (Berkeley: Daliel's Gallery, 1947), n.p.

53. Leonard Woolf, quoted in Fussell, *Wartime* (as in note 14), 76.

54. For more on this aspect of the World War II military experience, see Fussell, *Wartime,* 75–78.

55. Elmer Bischoff, lecture presented to the Oakland Museum, October 27, 1973, transcript in Archives of the Anne Bremer Memorial Library, San Francisco Art Institute.

56. Fussell, *Wartime,* 66.

57. George Stillman, interviewed by the author, July 12, 1988.

58. Elmer Bischoff, interviewed by Paul Karlstrom, August 10, 1977, transcript in Archives of American Art, Smithsonian Institution.

59. Douglas MacAgy, "The Contemporary Art School," *Arts and Architecture* 65 (November 1948): 25.

60. Still's students recalled that he encouraged them to follow their personal whims and did not make value judgments about their work. Hubert Crehan, for example, remembered: "He was approachable on almost any subject so long as it had nothing to do with how to make a painting. Still was deft in turning aside such questions. . . . He decided to be the silent witness, keeping his own counsel, noncommittal" (Hubert Crehan, "Art Schools Smell Alike," *San Francisco Sunday Examiner and Chronicle,* October 4, 1970). For more on Still's teaching, see Mary Fuller McChesney, *A Period of Exploration: San Francisco, 1945–1950* (Oakland Museum, 1973), 35–51.

61. Clay Spohn, teaching notes for watercolor painting, California School of Fine Arts, summer session, June 22, 1948, unfilmed Clay Spohn papers, Archives of American Art, Smithsonian Institution.

62. Edward Corbett expressed the common feeling of disillusionment with science when he wrote: "Since learning that science is the tool of any grasping goof that comes along I've revised my notions of its usefulness. I'm now inclined to believe that science is the most dangerous discovery of man's intellect. In the name of scientific method, man can now behave completely without reference to his moral conscience. The makers of atomic weapons have shown us how this can be so" (undated notes, ca. late 1940s, unfilmed papers of Edward Corbett and Rosamond Walling Tirana Corbett, Archives of American Art, Smithsonian Institution).

63. Richard Diebenkorn, quoted in Robert T. Buck, Jr., *Richard Diebenkorn: Paintings and Drawings, 1943–1976* (Buffalo, N.Y.: Albright-Knox Art Gallery, 1976), 12; Edward Corbett, interviewed by Mary Fuller McChesney, May 16, 1966, transcript in private collection; Clyfford Still, quoted by Betty Freeman, undated notes, Betty Freeman papers, roll 4060, Archives of American Art, Smithsonian Institution.

64. Douglas MacAgy, "Contemporary Painting," lecture, Dominican College, San Rafael, Calif., February 17, 1947, transcript in Archives of the Anne Bremer Memorial Library, San Francisco Art Institute.

65. Clyfford Still, quoted in *Clyfford Still*, ed. Henry Hopkins (San Francisco Museum of Modern Art, 1976), 123–24.

66. Jack Jefferson, quoted in McChesney, *A Period of Exploration*, 44.

67. Ironically, Still's own work became more affirmative after 1950; his color brightened and he used less rough texturing. This shift may reflect in part Still's conservative politics (he supported Senator Joseph McCarthy's anti-Communist activities). See Susan Landauer, "Clyfford Still and Abstract Expressionism in San Francisco," in *Clyfford Still: The Buffalo and San Francisco Collections,* ed. Thomas Kellein (Munich: Prestel, 1992), 93.

68. John Hultberg, quoted in Shirley Jacks, *John Hultberg, Painter of the In-Between: Selected Paintings, 1953–1984* (Clinton, N.Y.: Fred L. Emerson Gallery, 1985), 33.

69. On the war experience being "Norman Rockwellized," see Fussell, *Wartime* (as in note 14), 268.

70. This drawing, now in a private collection, was initially created as an illustration for an edition of *The Communist Manifesto* published in 1947. For reasons unknown, it was rejected. Hassel Smith's and Robert McChesney's illustrations were, however, accepted; see *The Communist Manifesto in Pictures* (San Francisco: International Book Store, 1948).

71. Edward Corbett, statement in *San Francisco Art Association Bulletin* (January 1951): n.p.

72. Frank Lobdell, interviewed by the author, June 20, 1988.

73. Caroline A. Jones dates Lobdell's expression of his painful wartime experience to the mid-1950s; see Jones, *Frank Lobdell: Works, 1947–1992* (Stanford University Museum of Art, 1993), 6.

74. See Jones, *Frank Lobdell,* 7.

75. Walter Kuhlman, telephone interview by the author, February 15, 1991.

76. For example, in a survey of American painting conducted in 1947, the Art Institute of Chicago found that an expressive abstraction, drawing some of its vocabulary from surrealism, could be seen from Louisville, Kentucky, to Walnut Creek, California. The institute's director, Daniel Catton Rich, reported: "Today, men and women throughout America are working vigorously with abstract means, attempting to convey their personal emotion through lines, colors,

effects of light and texture rather than through transcriptions of nature" (Daniel Catton Rich, "Freedom of the Brush," *Atlantic Monthly* [February 1948]: 48).

77. Harold Rosenberg, "Introduction to Six American Artists," *Possibilities* 1 (Winter 1947–48): 75.

78. Mark Tobey, statement in Dorothy Miller, *Fourteen Americans* (New York: Museum of Modern Art, 1946), 24.

79. Robert Motherwell, statement in Miller, *Fourteen Americans,* 36.

80. In the view of the editors of *Art Digest,* San Francisco was more inclined toward abstraction than New York as early as 1941: "While the art trend in the East continues toward an assimilated union of modernism and conservatism, with middle-of-the-road works taking the bulk of exhibition honors, across the continent in San Francisco the more radical phases of aesthetic experience maintain their hold. Until stronger competition comes, San Francisco may well be called the capital of ultra-modern art in America" ("Abstraction Wins San Francisco Honor," *Art Digest* 15 [January 1, 1941]: 21).

Gray Brechin

POLITICS AND MODERNISM:

THE TRIAL OF THE

RINCON ANNEX MURALS

On the morning of May 1, 1953, the House Committee on Public Works convened in Washington, D.C., to debate the destruction of one of the largest and most expensive artworks ever commissioned by the federal government.[1] The artist Anton Refregier, according to Republican Representative Hubert Scudder of Sebastopol, California, had foisted upon the American taxpayer propaganda designed to slander the state's pioneers and convert patrons at San Francisco's main post office to communism.[2] In its daylong deliberations, the committee put history, as well as art, on trial.

Refregier was too modern, according to his accusers, for whom "modern art" was an imprecise but pejorative term covering form, or content, or both, as it served their purposes. Modern art was alternately incomprehensible and reprehensible, degenerate, or left-wing. Because they admitted at times that they were not sure just what it was, they felt safer saying what it was *not*; modern art was not academic and thus did not support the social order and the state. In his subject matter, at least, Refregier had transgressed the official canon.[3]

To comprehend that day's strange events, one must understand not only the paranoia of the cold war but the near-Confucian reverence descendants of the California pioneers lavished on their ancestors. Ever since the Bear Flag Revolt of 1846 Anglo-Californians had envisioned their land as a mountain-walled principality, more nation than state. By California's fiftieth anniversary, in 1900, press and orators often compared the argonauts of 1849 to the founders of Rome. Artists were commissioned to pay them homage. In 1905 Daniel Burnham proposed a colossal monument for the summit of Telegraph Hill. For the 1915 world's fair, a permanent 850-foot Tower of the Pioneers was planned for Land's End. The tower was scrapped for lack of funds, but the exposition, as Secretary of the Interior Franklin Lane noted, was itself a monument to the superhuman valor and energy of the state's early settlers.

That the West was a place of unusual rapacity and violence and gold more a curse than blessing had been noted by visitors from the opening of the Gold Rush. The

banker William Tecumseh Sherman observed sourly in 1856 that "the very nature of the country begets speculation, extravagance, failures, and rascality." Frederick Law Olmsted told San Franciscans in 1866 that a great public park would help to "overcome the dead weight of indifference to all municipal improvements which is characteristic of the transient speculative class." Joshua Speed, a close friend of Abraham Lincoln, recorded while traveling in California in 1876 that money was the universal yardstick of worth: "They measure everything by the gold standard, men as well as mules. You never hear of Mr. Smith as a good man, or Mr. Brown as an honest man, or Mr. Jones as a Christian, but Mr. S has twenty thousand million and so on. The more he has, the better he is—and it matters not how he got it, so he has it." [4]

Such harsh judgments were drowned by the percussion and brass of official civic mythmaking. The industrialist Joseph Donohue Grant, son of a pioneer dry goods magnate, answered all would-be knockers in his 1931 autobiography. Of empire builders such as his father, he wrote:

> Alert, high-spirited, warmhearted—those who constituted the population of early San Francisco were gentlemen adventurers outshining in brilliance similar coteries in older communities. What a libel to speak of a greed for gold bringing such men to California! They came as searchers after larger opportunities, to a new land abundantly rich because they made it so. No more openhanded people ever lived. [5]

In the heroic generosity, intelligence, and virility of the pioneers, Grant and his set found ample proof of the survival of the fittest and thus of their rightful place at the apex of the West's financial and social pyramid. In their traditional role as patrons, such aristocrats expected artists to reflect and support their certainty according to the academic tradition, in which history was depicted as a triumphal march undeterred by border skirmishes. Among a growing number of artists who rejected that tradition after the trauma of the Great War was Anton Refregier.

Although even the depression could not shake Grant's granitic confidence, the foundation myths crumbled for millions of Americans who suddenly found themselves near starvation in the Promised Land. By 1934 the socialist Upton Sinclair's grassroots campaign for governor had grown so serious that an unprecedented (and pioneering) smear campaign was required to defeat him and to elect the unpopular Frank Merriam in his place. [6] In the same year, conditions along the waterfronts of the West Coast grew so desperate that longshoremen walked out on what little work they had. Governor Merriam placed San Francisco under martial law and sent tanks to patrol the Embarcadero. The Pacific Maritime Strike culminated in a pitched battle in San Francisco between pickets and police (Fig. 22). Two workers were shot and killed in a fusillade at the foot of Rincon Hill. Within days, forty thousand men marched silently down Market Street (Fig. 23) in one of the largest funeral processions in city history. [7]

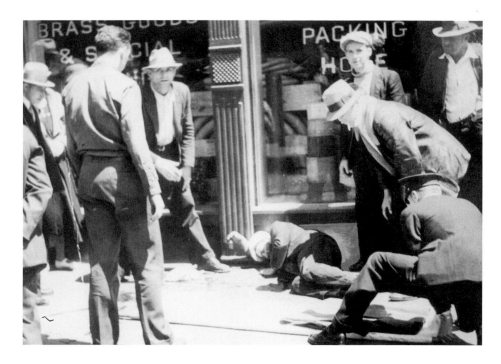

FIGURE 22
Above: Unidentified striker, shot by
police opposite the site of the Rincon
Annex Post Office, July 5, 1934.
Photograph courtesy San Francisco
History Room, San Francisco Public
Library.

FIGURE 23
Left: Bits Hayden, *Labor Buries Its
Dead,* 1934. Lithograph.

The general strike that followed shut down the city for four days, precipitating a rain of phone calls and telegrams to Washington claiming that revolution had begun on the Pacific Coast. The alarms helped persuade President Roosevelt and his brain trust to accelerate their public works programs to short-circuit any such possibility. No one has ever inventoried the New Deal's legacy of public works for the Bay Area alone, but it would include paved roads, sewers, forests, parks, schools, and theaters, as well as a myriad of federal art projects.[8]

Prior to the crash, virtually all public art had endorsed the benignity and legitimacy of the American Dream. No market existed for artists who might question it. But in 1934, in the depth of the depression, President Franklin Roosevelt opened a window for those who might dissent, giving them both patronage and exhibition space without precedent in the United States.

Roosevelt's experiment in federal art sponsorship began at the suggestion of his Groton and Harvard classmate George Biddle. A painter himself, Biddle first proposed to the president in 1933 that the government provide relief for American artists. Biddle hoped to create the seedbed for an American renaissance. He later wrote of the Works Progress Administration Federal Art Project: "Its credo is that if one creates a cultural background, art will follow. It wasn't Michelangelo who created the 15th century but the 15th century that created Michelangelo."[9] The conservative Commission of Fine Arts, created by Congress in 1910 to advise the government on artistic matters, recommended against Biddle's proposal in a report to the president, fearing trouble from modern muralists who professed "a general faith which the public does not share," one that ignored "the established tradition . . . fostered by the American Academy at Rome."[10]

The Public Works of Art Project (PWAP) and the other programs that followed it initiated controversies that outlived Roosevelt by many years as a minority of left-wing artists tested the First Amendment and reactionaries, in turn, cited the right of taxpayers not to be insulted or indoctrinated by "radicals." Guardians of tradition and morality like the National Society for Sanity in Art, founded by the Chicago socialite Josephine Hancock Logan, along with its regional affiliates and the Hearst press, carefully scrutinized the new public art for symptoms of modernist "decadence" or the un-American content usually equated with it.[11]

The federal art projects never received the popular support Roosevelt himself enjoyed. The president created them by executive fiat, leaving representatives to deal with their irate constituents.[12] Nor did Biddle help. The aristocratic artist enjoyed needling powerful domestic opponents: "The most serious threat to the success of life of the Project," he wrote after much experience, "is the high emotional level and the low mental caliber of our Congressmen."[13]

Biddle looked to Mexico for a model of government art patronage, but in doing so he ignored the radically different political climate of the neighboring nation. By 1934 privately commissioned works by two Mexican muralists had amply demonstrated the

uproar that allegedly subversive subject matter could cause in the United States. In 1930 José Clemente Orozco completed his mural *Prometheus* in the Pomona College dining hall, despite vigorous attacks from college trustees and local newspapers alarmed by what they perceived as their revolutionary content. Four years later, Nelson Rockefeller ordered stripped from the lobby at Rockefeller Center Diego Rivera's mural *Man at the Crossroads,* whose numerous unorthodoxies included a portrait of Lenin as well as syphilis spirochetes swimming toward a swank dinner party in what was intended to be a cathedral of capitalism.

On an extended visit to paint murals in San Francisco during the early 1930s, Rivera had strongly influenced many of the artists whom the government would later commission to decorate the walls of the new Coit Memorial Tower on Telegraph Hill. Edward Bruce, head of the PWAP, hoped that the tower's murals would serve as a pilot demonstration of how federal patronage could enrich the nation's cultural life. Their theme was "Aspects of Life in California, 1934"—a bad year, as it turned out, for officially sanctioned subject matter.[14]

In mid-February, the San Francisco Artists' and Writers' Union met at the unfinished tower to protest "the outrageous vandalism and political bigotry" represented by the destruction of Rivera's New York mural. Their activism only drew attention to what they themselves were creating. Reporters from the major press quickly discovered subtle heresies in the tower's murals meant to undermine the national faith. In a large street scene, for example, Victor Arnautoff had replaced the *San Francisco Chronicle* with the *Daily Worker* and the *Masses.* Browsers in Bernard Zakheim's *Library* were choosing *Das Kapital* rather than *The Wealth of Nations.* Worst of all, Clifford Wight had included, without permission from the regional PWAP chairman, Dr. Walter Heil, a hammer and sickle as emblematic of one economic choice available to Americans in the 1930s.

In his capacity as director of the M. H. de Young Memorial Museum, Heil was unaccustomed to the controversies of art in action. He wired Washington that "editors of influential newspapers . . . have warned us they would take [a] hostile attitude towards [the] whole project unless these details be removed." Edward Bruce responded that he hoped the artists "don't fool around with this Socialistic thing any longer," and advised Heil to "wipe the damn painting out of the Tower."[15] Making good on its promise to Heil, the Hearst-owned *San Francisco Examiner* carried a nationally syndicated photograph of Wight's symbol crudely spliced onto Zakheim's *Library.*[16] The doctored photo appeared on July 5, 1934, the day the strikers were killed at Rincon Hill. So intense did the controversy become, and so closely linked was it to the events on the waterfront below Telegraph Hill, that the city Park Commission ordered Coit Tower locked, ostensibly to prevent vandalism. It was reopened on October 20, 1934, after passions had cooled. By that time, Wight's symbol had mysteriously vanished.

Evelyn Seeley, reporting on the Coit controversy, felt it was a tempest in a teapot. "In the main, [the artists] presented California as powerful and productive, its machines

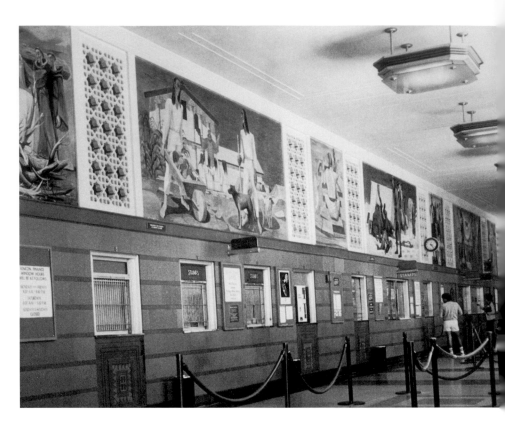

FIGURE 24
Rincon Annex lobby with Refregier
murals. Photograph courtesy San
Francisco History Room, San
Francisco Public Library.

well-oiled, its fields and orchards bountiful, its people happy in the sun." In a comment prophetic of those made in the thick of the Rincon Annex controversy, she added, "They have left out of the picture, as some realists have mentioned, such aspects as the Mooney case, or strikes or lynchings." [17]

The Coit Tower controversy did not end government patronage. Rather, New Deal programs proliferated in the years that followed. Of the art bureaucracies that followed the PWAP, the Treasury Section of Painting and Sculpture (known simply as the Section) offered the most prestigious and lucrative prize. [18] Created by executive order of Treasury Secretary Henry Morgenthau on October 14, 1934, the Section would ensure high-caliber work in public buildings by selecting artists in juried competitions. In 1940 a Section jury chose Anton Refregier, of Woodstock, New York, from among eighty-two contestants, to decorate a new post office in San Francisco (Fig. 24). The government agreed to pay Refregier $26,000 to design and paint a chronological history of

the city in twenty-seven panels totaling 2,574 square feet. A delighted Refregier told reporters that he had worked five solid months preparing his designs. What he did not tell them was that he would paint just those "realist" subjects that Evelyn Seeley said had been left out of Coit Tower.

A strong-minded outsider, Refregier also told the *Chronicle* when he arrived in San Francisco that he wanted to paint the past, not as a romantic backdrop, but as part of the living present, a present shaped by the trauma of depression, strikes, and impending war. He did not, he added, believe that the miners of 1849 wore gardenias, and he saw no reason to paint them as if they did.[19] In *these* desires and beliefs Refregier was modern, differing sharply from both working-class patriots and ancestor-proud patricians such as Joseph Donohue Grant. World War II, however, interrupted the Rincon Annex project, while Roosevelt's death virtually ended the brief experiment in federal patronage. By the time Refregier returned to San Francisco in 1946, the Section was being phased out and responsibility for its outstanding projects transferred to the Public Buildings Administration.

Refregier's highly ambitious program was traditional enough. He envisioned representing the entire span of human civilization in the brief history of San Francisco. In the cycle as originally conceived in 1940, the artist had intended to begin with a California Indian creating a primitive work of art and to proceed through a sequence of conflicts to the 1939 Treasure Island world's fair celebrating peace in the Pacific. Following the armistice, he changed the last panel to a three-part composition representing the war, the Four Freedoms, and the founding of the United Nations. Refregier had covered the latter event in San Francisco for *Fortune* magazine.

Controversy began before the Rincon paintings were finished (Fig. 25).[20] The Catholic Church protested that a friar preaching to Indians at Mission Dolores was too fat; Refregier slimmed him. In 1947 the Public Buildings Administration ordered Refregier to take President Roosevelt out of his panel *The Four Freedoms*. The artist claimed that a Republican Congress had initiated a campaign to discredit the late president and the legacy of his New Deal.[21] Although he called on the people of San Francisco to support his refusal to carry out the order, he eventually complied.[22] His troubles had only begun.

By the spring of 1948 the Veterans of Foreign Wars were protesting Refregier's depiction of the maritime strike and the funeral for the strikers killed across the street from the Rincon Annex Post Office. Fourteen years after the strike and killings, those events were still raw in local memory. According to the VFW, the strike leader rallying massed workers in Refregier's painting appeared to be the suspected communist Harry Bridges (Fig. 26). He points accusingly at a hiring boss taking bribes in the notorious "shape-up system" that prevailed before the strike won longshoremen the right to a union hiring hall.[23] The artist may as well have tossed gasoline onto a guttering campfire. "The stories in the Hearst press," he later wrote, "brought out gangs of hoodlums who were constantly under my scaffolding and I no longer worked after the sun set."[24]

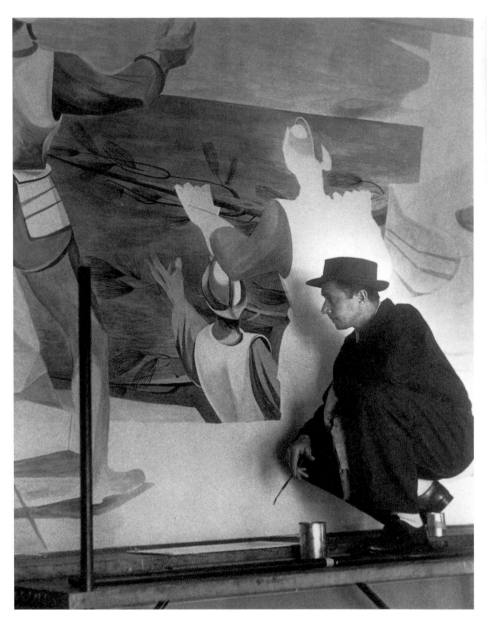

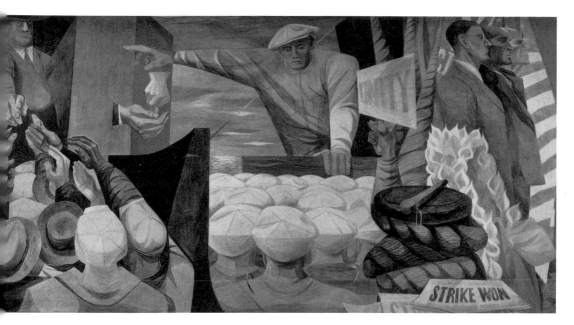

FIGURE 26

Anton Refregier, *The Waterfront—*
1934. Refregier's controversial pro-
labor mural. The panel, based on an
Otto Hahn photograph, shows men,
at left, begging for jobs from a corrupt
hiring boss. The figure at center could

be Harry Bridges organizing the
union, and the figures at right mourn
two strikers killed by police on
"Bloody Thursday," July 5, 1934, the
day the police fired at strikers on
Rincon Hill.

Despite a national outcry by artists and labor unions, the Public Buildings Admin-
istration ordered the offending panel covered until specified changes were made. Refre-
gier wrote that "it was a most telling coincidence that on the day the men came to cover
up this panel, I was at work on a mural depicting the burning of the books by the
Nazis."[25] He told the *People's World* that "this attack is clearly a part of the whole
thought control campaign" to censor history.[26] The artist was supported by the Con-
gress of Industrial Organizations and the International Longshoremen's and Ware-
housemen's Union, which denounced the "Hearst-inspired attempt to suppress the
work of art."[27] In Refregier's paintings, instead of the standard vindication of the status
quo, union members found the theme of class struggle. On May 14, 1948, they joined
artists in a picket line at Rincon Annex to defend the murals (Fig. 27).

When the painting was unveiled with minor changes, the Grand Parlor of the Na-
tive Sons of the Golden West declared itself unmollified. The attorney Waldo Postel
announced that the NSGW would scrutinize the artist's background as well as the

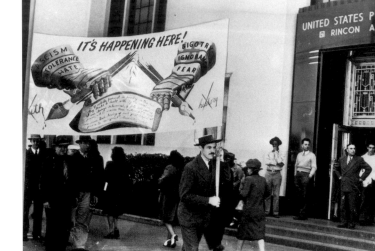

FIGURE 27
Artists and union workers picket to
protest modifications demanded by
the Public Buildings Administration
in the Rincon Annex murals, May 14,
1948. Photograph courtesy San
Francisco History Room, San
Francisco Public Library.

"Marxian interpretation" of the entire cycle. True to his word, Postel analyzed Re-
fregier's work closely and noted numerous transgressions. He accused the artist, for
example, of "memorializing the Federal Art Program of 1932–41 [in the panel *Cul-
tural Life*], although what connection it had with San Francisco's cultural history I
don't know."[28]

Refregier's murals elicited enmity in high places. On July 18, 1949, Representative
Richard Nixon of California responded to a concerned American Legionnaire:

> As to whether anything can be done about the removal of Communist art in your Federal
> Building [Rincon Annex] . . . at such time as we may have a change in administration and a
> majority in Congress, I believe a committee should make a thorough investigation of this
> type of art in government buildings with the view to obtaining the removal of all that is
> found to be inconsistent with American ideals and principles.[29]

As cold war paranoia grew, so too did a passionate debate over what some felt to be
subversive themes concealed in public art sponsored by the Roosevelt administration.
Michigan Representative George Dondero, in particular, launched a campaign against
all that was "modern" in art, a term which he defined as "communistic because it is
distorted and ugly, because it does not glorify our beautiful country, our cheerful and
smiling people."[30]

The Republican Party in 1953 took control of both the White House and the Capi-
tol. With Richard Nixon as vice president and Representative Dondero as chairman of

the House Committee on Public Works, Congress prepared to undo the New Deal and to roll back the red tide of modernism in Nixon's home state.[31] Anton Refregier's murals were the first works to be tried for themes "inconsistent with American ideals and principles."

Representative Scudder opened the hearing by telling his committee that Refregier had been born in Moscow and that his office had been flooded with complaints from the American Legion, Daughters of the American Revolution, Veterans of Foreign Wars, the Sailors' Union of the Pacific, and other patriotic organizations. The Young Democrats of San Francisco charged the murals with being "little short of treason." The Society of Western Artists, a regional affiliate of Logan's Sanity in Art,[32] declared them "artistically bad, historically absurd, and politically corrupt." A letter from the California Department of the American Legion expressed its members' concern that the murals would expose thousands of school children who toured the facility to scenes that unfairly depicted what it believed was "the true history of our State."

The operative statement that recurred, verbatim, in nearly every protest that Scudder read into the *Congressional Record* was that "said murals do not truly depict the romance and glory of early California history, but on the contrary cast a most derogatory and improper reflection upon the character of the pioneers, and the other murals are definitely subversive and designed to spread communistic propaganda and *tend to promote racial hatred and class warfare*" (emphasis added).[33]

Scudder then yielded the floor to California Representative Donald L. Jackson, who insisted that his testimony "should not be construed as representing the results of an investigation" by the House Un-American Activities Committee (HUAC), of which he was a member. Jackson's seven-page account of Anton Refregier's participation in communist front and peace organizations took forty-five minutes to read. The painter, he said, had defended such fellow travelers as Dalton Trumbo, Pablo Neruda, Harry Bridges, and the Rosenbergs and, as a member of the suspect American Peace Crusade, had once given a reception to honor the Los Angeles painter Charles White, "a Negro artist."[34] He had taught at the John Reed School in New York and the California Labor School in San Francisco.[35] The list went on.

Under questioning by Chairman James C. Auchincloss, Congressman Jackson admitted he had not seen the San Francisco murals but asserted, "If they were in the Capitol of the United States, I would join in protesting them." When Scudder revealed that Refregier had won the Section competition because of favorable votes from the artists Victor Arnautoff and Arnold Blanch, Jackson read *their* HUAC dossiers into the *Record*. Philip Guston had favored another entry and was spared embarrassment.[36]

Congressman Scudder then detailed, panel by panel, what he found objectionable in Refregier's cycle.[37] California Indians were depicted as vigorous and strong, the Spanish and English explorers as warlike and conquering. The monks building Mission Dolores appeared cadaverous in one panel and big-bellied in the next, where their In-

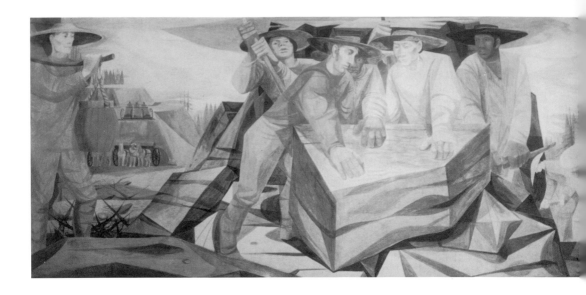

FIGURE 28
Above: Anton Refregier, *Building the Railroad.* Representative Scudder protested that the mural's portrayal of the Chinese workers "would give the impression that they were brought over more as slave laborers than anything else."

FIGURE 29
Right: Anton Refregier, *Sand Lot Riots.* Representative Scudder objected that the scene was not realistic, nor did it "represent the development of the Golden West."

FIGURE 30
Opposite: Anton Refregier, *Preparedness Day Bombing and Mooney Trial.* Perjured jurors, right of center, accuse Mooney and Billings, at far right.

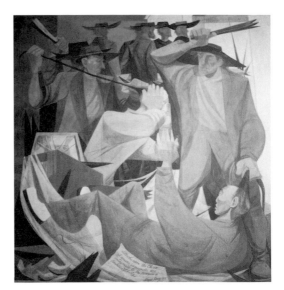

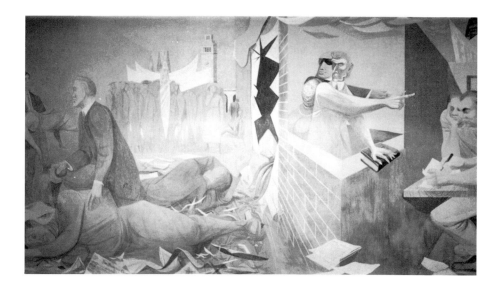

dian wards appeared to be starving. The pioneers on *The Overland Trail* also appeared "cadaverous and soulless." In *Discovery of Gold,* the miners seemed to thank God for the metal they had found, suggesting that Californians were materialists, as the communists claimed. In the panel showing the building of the transcontinental railroad (Fig. 28), Scudder thought Refregier was saying that the Chinese had done most of the work—which was, in fact, common knowledge in California.

In a dark corner, Refregier had painted two riots. Scudder felt that *The Civil War* unnecessarily depicted regional strife in a public building. In the adjacent *Sand Lot Riots* (Fig. 29), Refregier had shown Irish laborers beating the Chinese. Scudder protested, "I do not believe that this ugly scene had a bearing on the development of California. . . . If it did happen, it is similar to the riots that happen every day in some country." Furthermore, the congressman complained, the rioters were sporting "peculiar clothes and funny hats which were not commonly worn in the days of early California." He felt that the depiction of the 1906 earthquake unnecessarily aggrandized tragedy and implied that it took a great disaster to make Americans work together.

Scudder inexplicably paid little attention to one panel that conflated the mysterious bombing of a Preparedness Day parade in 1916 with the perjured testimony of witnesses that subsequently sent labor leaders Tom Mooney and Warren Billings to prison for the crime (Fig. 30). His omission was curious, for the Mooney trial had provoked an international furor and long served as a flash point in confrontations between conservatives and liberals. Scudder moved on, instead, to the panel that had begun the brouhaha. *The Waterfront—1934* showed "strikes and various other disturbances" that were not, the congressman charged, "the things that make California great." Nor did the men in the next panel, which showed the building the Golden Gate Bridge, resemble those

he had observed at work on the structure. Scudder also repeated the allegation of the Hearst newspapers that Refregier had included in *The Four Freedoms* a figure resembling Gilbert Stanley Underwood—the architect of the post office—with "long mule ears."

Scudder's final criticism was demonstrably mistaken on three points: the controversial figure was *not* Underwood, it occupied the adjacent *United Nations* panel, and the suspect "ears" were, in fact, a garland of laurel leaves Refregier had seen decorating the stage when he covered the signing of the U.N. charter for *Fortune* magazine. Scudder's confusion suggested that he, like Representative Jackson, had never seen the murals that he sought to have destroyed.[38] He summed up by saying,

> There seems to be nothing in these pictures that would be anything but depressing. I do not believe that one of the murals conveys a smile, or the indication of a smile, or contentment, or encouragement. What the artist was endeavoring to convey is beyond me, except that we are unemotional and unsympathetic in the development of the State of California and the building of the West.

The attack on the murals continued after the lunch break when Fred Drexler, a retired newspaper reporter, testified that a postal worker at Rincon Annex had told him that "the Government ought to increase his pay to make up for his suffering in seeing these murals." Gordon A. Lyons, the department adjutant of the American Legion of California, submitted more demands for the removal of the murals, from organizations ranging from the Associated Farmers of California to the South of Market Boys Association. The discerning eye of the attorney Waldo Postel had meanwhile discovered heresies in *The Four Freedoms* more subtle and dangerous than Refregier's tribute to the New Deal art projects; Postel informed the committee that "the head of the family there shown wears a red tie, while the boy reads a large red-covered book. The predominating color in these three panels is red." He concluded: "These murals are definitely subversive and designed to spread communistic propaganda."

Late in the afternoon Congressman John Shelley of San Francisco rose to rebut his colleague from Sebastopol. As he spoke, Shelley—who was to be elected mayor of the city in 1964—gradually established his bona fides. He was a descendant of Irish pioneers, his father was a longshoreman, he himself was a member in good standing of the Native Sons of the Golden West, with which, he added, he respectfully disagreed on this one issue. He was also active in the labor movement. His grandfather, he said, like most California men of the time, had worn one of the "funny hats" to which Scudder had objected. Moreover, as a Catholic, Shelley found nothing objectionable in Refregier's paintings, nor did any prelate that he knew. Similarly, he could testify to the reality of the waterfront shape-ups and the payoffs to corrupt gang bosses. Shelley believed that mature citizens of a democracy were entitled to see and hear provocative subject

matter: "The cold factual portrayal of history . . . may be pleasing to some and repugnant to others, but if it is factual you cannot change history or a picture of history or a portrayal of it by saying 'But I do not like that.' If we get into that, Mr. Chairman, then we are definitely contributing to thought control and trying to build a Nation of conformists."

Scudder riposted that Refregier *could* have shown the grape industry, stock raising, or industrial development: "We know the history of the world has not always been sweet, but I do feel that we should glorify the best in life." Shelley shot back, "Mr. Scudder, I do not wish to argue with you about it, but I can certainly appreciate your feeling about wishing to portray the sweet things, because by nature you are so sweet and generous yourself."

Congressman William Maillard, scion of an old San Francisco family, took the stand next. Whereas Shelley had spoken for labor, Maillard spoke for the patriciate. He informed the committee that the *Chronicle*'s art critic, Alfred Frankenstein, supported the murals, as did the principal art associations and museums and their boards of directors, "who are among our most highly respected and responsible citizens." When Congressman Will E. Neal asked him, "What percentage of the people who view these paintings today would be inspired in any way whatsoever to become sympathetic to communistic ideas?" Maillard replied, "I should think none at all." Tensions were running high in the hearing room; when Congressman Harry McGregor of Ohio ventured, "I do not think it is art, but I am no artist," Maillard rejoined, "A great many people will agree with you about that."

By the end of the afternoon, a procession of distinguished witnesses had spoken or provided written testimony in favor of the San Francisco paintings. The respected antiquarian bookseller Warren Howell countered charges that Refregier's murals were "historically absurd" by insisting they were not only truthful but based on careful research. Refregier had done his homework. The attorney Chauncey McKeever said that the proper judges should be, "not Legion posts, not marching and chowder clubs, but experts." John Hay Whitney, chairman of the New York Museum of Modern Art's governing board, wrote on behalf of the murals. So did the Artists Equity Association. Congressman Scudder read into the *Record* a statement revealing the communist sympathies of Equity's founders.

When Hudson Walker of Artists Equity attempted to read a letter from the eminent British scientist and former director of UNESCO Julian Huxley, Congressman McGregor ordered it struck from the *Record*. McGregor did not like, he said, "to have people from Great Britain putting things in a hearing and making statements like that against a Member of Congress when the person making the statements is not here to answer a few questions that we would like to ask him. Certainly our colleague [Scudder] is a good American and believes in law and order and is a defender of American freedom."[39] In the official *Record* seven asterisks accordingly replaced Huxley's letter.

Fortunately, Huxley's letter to Refregier was preserved in the National Archives.[40]

Huxley commended the artist for a "remarkable work of art and an outstanding example of modern American painting." He and the officials at UNESCO were alarmed, he said, "by the growing tendency in your country to try to exert political control over freedom of thought and expression." The lamentable state of biology and philosophy and the arts in Stalin's USSR "shows what happens when creative thought and expression is subjected to control on political or ideological grounds." Huxley thought it ironic that even as the free world was protesting tyranny in the Iron Curtain countries, "actions like that of Representative Scudder are trying to introduce a similar tyranny into your own great country." It was apparently this last statement that provoked Congressman McGregor to have Huxley's letter deleted, for what made Refregier's art so dangerously "modern" to his critics was precisely its dissent from official mythology.

The directors of all three San Francisco museums entered their protests in turn.[41] Thomas Carr Howe, director of the California Palace of the Legion of Honor, defended the murals and called Scudder's resolution "a shameful measure, in its essence, vandalism." He told the committee that "the three great art museums of San Francisco are solidly against this resolution and the two leading historical societies have not seen fit to support this resolution in any way."[42] Asked by Representative Tom Steed to tell the committee what made him an expert, Howe replied that he had received his doctorate from Harvard. He added that his great-grandfather had arrived in California in 1848, placing him decisively among the state's ancien régime.

Howe's pedigree mattered, for photographs of one mural troubled congressmen sufficiently to engage the director in lengthy cross-examination over a historical detail. The dark neck of a figure about to be lynched by vigilantes (Fig. 31) strongly suggested to Representative Gordon Scherer of Ohio that the man was a Negro, but since "there were none in California during the vigilante days," added Myron George of Kansas, critics saw in the neck yet another indication of the artist's subversive intentions. When Hubert Scudder noticed that Refregier was not present to clarify the point, his attorney replied that the artist was too busy painting a synagogue to attend. The congressmen were doubly mistaken, for blacks had, in fact, come with the Gold Rush, but the suspicious figure was clearly not one of them.

Grace L. McCann Morley, director of the San Francisco Museum of Art (later the San Francisco Museum of Modern Art), sent written testimony ranking Refregier's murals "high among the distinguished American murals of recent years." Though she lacked Howe's pedigree, Morley assured the committee that "as a second generation Californian . . . I find nothing derogatory nor offensive in the subject matter, and there is no evidence of subversive symbolism or reference."[43]

At the hearing's close, attorney Chauncey McKeever inserted into the *Record* the names of hundreds of citizens who protested the Scudder resolution, among them many of San Francisco's business and professional leaders and philanthropists. Three days after the hearing, the president of the San Francisco Chamber of Commerce, J. W. Maillard III, cabled his son, Congressman W. S. Maillard, denying Scudder's claim that

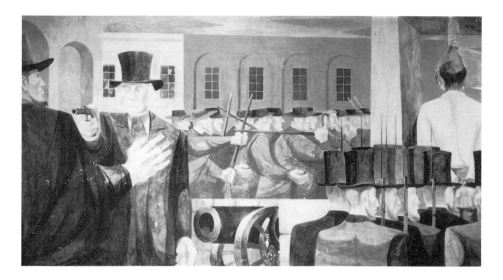

FIGURE 31
Anton Refregier, *Vigilante Days.* suspected that the man being lynched
Representatives Scherer and George was a "Negro."

his organization supported the resolution. His telegram was inserted into the *Record.*

Five weeks after the congressional hearing, the California Senate voted overwhelmingly to urge Congress to destroy the Rincon murals.[44] The Hearst-owned *Examiner* recommended their removal if "loyal American citizens" found them subversive.[45] Nevertheless, Scudder's motion never made it out of committee. The murals stayed.

The figures Congressman Scudder saw as "cadaverous and soulless" were, in fact, painted in Refregier's own distinctive style. They may well have been his reaction to the plump pink shepherds in the fake Bouchers and speakeasy murals he and Willem de Kooning had painted for an interior decorator prior to the crash.[46] Congressman George Dondero had already attacked Refregier's lanky figures as examples of "so-called modern art." Representative Myron George of Kansas, like others, was disturbed by Refregier's angular style and said that "in viewing the picture I cannot get over the distortion of the people of that early period, even those of California." Representative Scherer explained, "It is modern art."[47]

The federal art projects never, in fact, encouraged abstraction in public places; Edward Bruce and the Section of Fine Arts advocated a "middle course" in which abstraction had as little place as social protest. Though Refregier's figures and backgrounds were stylized, they were easily recognizable. Far more genuinely modern than Refregier's paintings was Hilaire Hiler's surreal and stylized submarine panorama in San Francisco's Aquatic Park casino, built by the Works Progress Administration (WPA); Hiler's

art elicited none of the outrage caused by the Coit Tower and Rincon Annex murals and was even admired by the conservative *San Francisco Chronicle* and *Time* magazine.[48] However "modern" in form, the Aquatic Park murals had no modern political content.

Though he had studied with Hans Hofmann, Anton Refregier had little sympathy for nonfigurative art in communal places. To educate a broad public, he had to communicate with it.[49] What he had to say and the place where he said it provoked the unprecedented hearings in Washington.

But if he eschewed a modern style, Refregier also vowed not to paint official subject matter. "We rejected long ago, while on the Federal arts projects," he wrote to the *Chronicle*'s art critic, Alfred Frankenstein, in 1952, "the meaningless type of mural painting where the pioneer dressed in Hollywood fashions, shaven and manicured, would be briskly walking along guided by a 'spirit' of one thing or another, its Grecian garments floating in the wind. This concept pays disrespect to the vitality, power, and labor of those who came before us."[50] Refregier expressed that vitality in two riots, a terrorist bombing, a lynching, several murders, a frame-up, a landgrab, an earthquake, and a world war—not normal fare for a federal post office. In Refregier's gritty, if stylized, realism, Scudder and his colleagues were right to sense danger to received wisdom. In content, rather than in style, Refregier was too "modern."

It is hardly surprising, then, that Scudder first objected to Refregier's depiction of the California Indians as strong and vigorous before the white man's advent. Textbooks and public art had long taught Californians that nature had fated the original inhabitants of their state to vanish before the superior races, and that natives carried little significance except as symbols of brutish humanity from which civilization had risen. Most New Deal art perpetuated the progressive conventions inherited from academic painters such as Arthur Mathews, who in 1914 had painted a mural cycle in the California State Capitol strikingly different from Refregier's (Fig. 32).

In Sacramento, Mathews had depicted Indians living in childlike innocence until kindly padres arrived to teach them to work. Allegories of Victory and Civilization then led consecutive waves of immigrants past sidelined Indians toward a city of the future, a new Athens on Pacific shores, where Anglo-Saxon maidens dance in flowery meadows.[51] What Mathews expressed visually, the novelist Gertrude Atherton reiterated in a popular history of the state: "Month after month, year after year, [Father Junipero Serra] traveled over these terrible roads . . . making sure that his idle, thieving, stupid, but affectionate Indians would pass the portals of heaven."[52]

Refregier was well aware of how and why the Indians had passed heaven's portals suddenly, in large numbers, but he censored himself: "Obviously, I could not go into this and get away with it," he wrote. His own cycle begins instead with a California Indian creating art, a sign of intelligence inevitably denied him by the conquerors, followed in the next panel by a mother cradling her child.

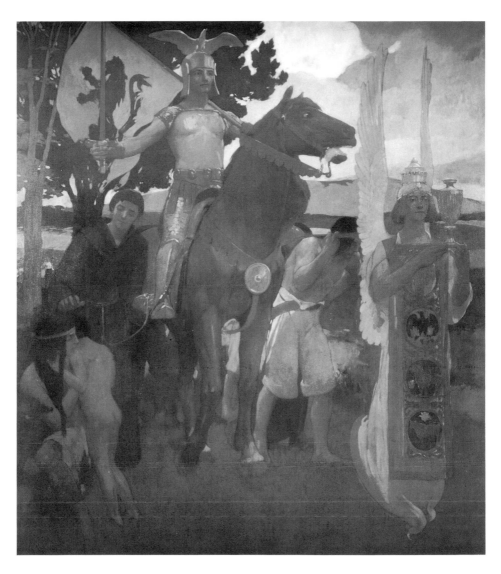

FIGURE 32
Arthur Mathews, *Adventure,* 1914.
California history cycle, rotunda of
the State Capitol, Sacramento.
Allegories of Civilization and Victory
enter California, while missionary
friars Christianize Native Americans
and teach them how to work.
Photograph courtesy Historical State
Capitol Commission, California State
Capitol.

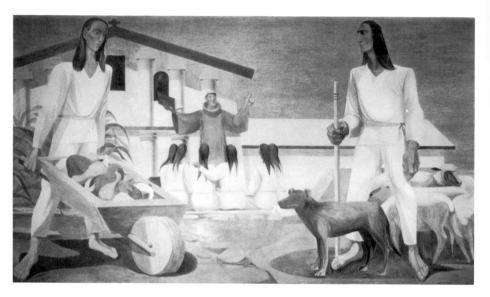

That Refregier showed two Indians as strong and dignified workers, standing in the foreground of Mission Dolores with the friar in the background was in itself extraordinary (Fig. 33). Though sympathetic to Refregier, Congressman Shelley had trouble understanding what the artist intended. Answering Scudder's charge that the Indians were excessively vigorous, Shelley said that he did not know whether the Indians were strong, muscular, and sinewy but "had always heard that they were very lazy people who were not taken over much by conquest because very little conquest was needed."[53]

Refregier's depiction of California's natives was only the beginning of the remarkable and subtle shift in emphasis he gave San Francisco history. Although his accusers repeatedly charged him with promoting racial hatred, Refregier, throughout his cycle, depicted people of all races working, and occasionally fighting, to build the city. Twenty-six panels formed the prologue to the last, a triptych depicting the catastrophic consequences of racial and national hatreds in the Second World War, Roosevelt's declaration of the Four Freedoms, and men and women of all nations and races sitting together at a round table to guarantee those freedoms.

Perhaps only an outsider could have shown local history with such breadth, depth, and empathy. As Warren Howell and others testified, Refregier knew San Francisco history better than his accusers. He had, furthermore, endowed it with universality. In his complex depiction of "the vitality, power, and labor of those who came before us,"[54] he had painfully pricked the myth of civilization's harmonious forward march. The

hearing in Washington had put history, as well as art, on trial, and had shown how inseparable they were in the minds of Refregier's conservative critics.

Shortly after completing the cycle, during the heightened controversy over his murals, the artist noted his fears for what he considered his masterpiece: "Some night, perhaps, men will come with buckets of white paint and it will take very little time to destroy that which took me so long to make. And in the morning it will be just like it was three years ago. White walls without colors, without ideas, ideas that make some people so mad and so afraid."[55]

As it turned out, the passage of time would make vandalism unnecessary.

Despite allegations that the murals promoted class warfare, San Francisco's elite in fact rallied to save them. Certainly, that support was based on principle: to destroy nonconforming art would have been a most un-American activity, one unworthy of San Francisco's claim to be the cultural center of the Far West. But the city's leaders were also too sophisticated to see any real threat to the foundations of American institutions in Refregier's art. Thomas Carr Howe testified that his colleague at the de Young Museum, Dr. Walter Heil, had watched while as many as eight hundred people used the post office. "Not one person," Heil said regretfully, "even looked at the murals."[56]

In 1979 artists and preservationists, led by Refregier's friend Emmy Lou Packard, rallied once more to save his murals when the postal service abandoned its building.[57] Today, the Rincon Annex lobby is a designated city landmark. It serves as the foyer to an upscale mixed-use office complex called Rincon Center. The murals were restored in 1987 by Thomas Portué.

Of the hundreds who pass through it, few pause to look at the paintings that once provoked such heated debate. Fewer still can identify the incendiary events—the waterfront strike, the Mooney trial, or the Sand Lot Riots—and almost no one, except a few aging union members, visits the Longshoremen's Monument across the street where two men were killed in 1934. In Rincon Center's soaring atrium, office workers lunch around a dramatic forty-foot water curtain, below trompe-l'oeil murals created during the Reagan years by the New York artist Richard Haas.[58] Painted to resemble a pastel bas-relief, those murals depict scenes of agricultural abundance, industrial harmony, and financial success. In both style and content, Haas's murals are as much pre- as postmodern. They are exactly what Hubert Scudder said he wanted.

Notes

1. U.S. Congress, Committee on Public Works, Subcommittee on Public Buildings and Grounds, Rincon Annex murals, San Francisco, Hearing, 83rd Congress, first session, May 1, 1953, 1–87.

2. Scudder's accomplishments in the Capitol, detailed in a thin volume entitled *Memorial Addresses and Eulogies in the Congress of the United States on the Life and Contributions of Hubert*

Baxter Scudder (Washington: U.S. Government Printing Office, 1968), consist chiefly of water projects for his home district, though his successor, Representative Don Clausen, wrote in his introduction to the volume that Scudder's greatest achievement was "to put Sebastopol on the map."

3. Though Refregier was accused of political radicalism, his figurative and narrative style was fundamentally conservative. While working on murals for the 1939–40 New York World's Fair with Philip Guston and others, Refregier wrote in his diary that the studio was "the closest to the Renaissance of anything, I am sure, that has ever happened before in the States," a paraphrase of Augustus Saint-Gaudens's similar remark about the gathering of artists that produced the Columbian Exposition of 1893 in Chicago. Though the events depicted at Rincon Annex are occasionally provocative, the programmatic narrative remains academic and firmly rooted in Renaissance precedent. Refregier's diary is quoted in Francis V. O'Connor's introduction to *Art for the Millions* (Greenwich, Conn.: New York Graphic Society, 1973), 22–23. For other post office projects, see Karal Ann Marling, *Wall-to-Wall America: A Cultural History of Post Office Murals in the Great Depression* (Minneapolis: University of Minnesota Press, 1982); and Marlene Park and Gerald E. Markowitz, *Democratic Vistas: Post Offices and Public Art in the New Deal* (Philadelphia: Temple University Press, 1984). For the academic tradition, see Fikret K. Yegül, *Gentlemen of Instinct and Breeding: Architecture at the American Academy in Rome, 1894–1940* (New York: Oxford University Press, 1991).

4. Dwight Clarke, *William Tecumseh Sherman, Gold Rush Banker* (San Francisco: California Historical Society, 1969), 305; Victoria Post Ranney, ed., *The Papers of Frederick Law Olmsted,* Vol. 5, *The California Frontier, 1863–1865* (Baltimore: Johns Hopkins University Press, 1990); Joshua Speed, *Reminiscences of Abraham Lincoln and Notes of a Visit to California* (Louisville, Ky.: John P. Morton and Co., 1884), 65.

5. Joseph Donohue Grant, *Redwoods and Reminiscences* (San Francisco: Save-the-Redwoods League and Menninger Foundation, 1973), 11.

6. Greg Mitchell, *The Campaign of the Century: Upton Sinclair's Race for Governor of California and the Birth of Media Politics* (New York: Random House, 1992).

7. Mike Quin [pseud.], *The Big Strike* (Olema, Calif.: Olema Publishing Co., 1949).

8. The material for such an inventory and appraisal is on index cards and in other primary sources in the National Archives.

9. George Biddle, "Art under Five Years of Federal Patronage," *American Scholar* 9, no. 3 (Summer 1940): 333.

10. William F. McDonald, *Federal Relief Administration and the Arts: The Origins and Administrative History of the Arts Projects of the Works Progress Administration* (Columbus: Ohio State University Press, 1969), 359. For the academic tradition against which artists like Refregier were reacting, see the catalogue *The American Renaissance, 1876–1917* (New York: Brooklyn Museum and Pantheon Books, 1979).

11. Logan's campaign against un-American modernism resembles contemporary attacks against "degenerate" art in Germany. See the editorial "Art Is Sick" from *Munich Illustrated Press* (e.g., "Only when art returns to a proclamation of beauty and becomes once more a vehicle of sanity and naturalness, will it become possible to speak again of German art"), cited in Josephine

Hancock Logan, *Sanity in Art* (Chicago: A. Kroch, 1937), as well as the illustrations of "good" versus "bad" art in the same volume.

12. Gerald M. Monroe, "The Thirties: Art, Ideology, and the WPA," *Art in America* 63, no. 6 (November–December 1975): 67.

13. Biddle, "Art under Five Years of Federal Patronage," 335.

14. The political controversy surrounding the Coit Tower project is related in Masha Zakheim Jewett, *Coit Tower, San Francisco: Its History and Art* (San Francisco: Volcano Press, 1983).

15. Richard D. McKinzie, *The New Deal for Artists* (Princeton, N.J.: Princeton University Press, 1973), 25.

16. Joseph Danysh gives a personal account of how the *Examiner* doctored the photograph, in "The WPA and the Great Coit Tower Controversy," *City of San Francisco* 10, no. 30 (February 4, 1976): 20–21.

17. Evelyn Seeley, "A Frescoed Tower Clangs Shut amid Gasps," *Literary Digest* 118, no. 8 (August 25, 1934): 24.

18. Its official name changed to the Treasury Section of Fine Arts in 1938 and later to the Section of Fine Arts of the Public Buildings Administration of the Federal Works Agency. It died along with its director, Edward Bruce, in 1943. See Karal Ann Marling (as in note 3) for an anecdotal history of art controversies that preceded the Rincon Annex hearings.

19. *San Francisco Chronicle,* November 15, 1942.

20. Anton Refregier's account of his experiences working on the Rincon Annex murals is in a typed, undated [ca. 1949] manuscript in the ACA [American Contemporary Art] Gallery papers, Archives of American Art, Smithsonian Institution, roll D304, frames 1099–1106.

21. Ibid., frame 1105 (p. 7).

22. *People's World,* March 19, 1948; *San Francisco Examiner,* November 14, 1947.

23. See *San Francisco Examiner,* April 16, 1948.

24. Refregier account, frame 1104 (p. 6).

25. Ibid.

26. *People's World,* March 19, 1948.

27. *People's World,* March 28, 1948.

28. *San Francisco Examiner,* October 26, 1948.

29. George F. Sherman, "Dick Nixon: Art Commissar," *Nation* 176, no. 2 (January 10, 1953): 21.

30. Dondero is quoted in Mathew Josephson, "The Vandals Are Here: Art Is Not for Burning," *Nation* 177, no. 13 (September 26, 1953): 244.

31. "The intellectual-moral achievements of the Roosevelt-Truman era are now to be liquidated; its paintings along with its social plans are to be consigned to the rubbish heap. The 'inquisition' of New Deal artists and their works was begun promptly after the conservatives took over in 1953, with Anton Refregier as first defendant" (ibid., 247).

32. See Logan (as in note 11), and catalogues for the Society of Western Artists in the Archives of American Art, Smithsonian Institution.

33. Official art in California, at least prior to the Second World War, was often promotional; thus it must be understood in terms of what was *not* depicted. The Edenic image of the state was designed to attract as many desirable immigrants as possible.

34. Charles White's papers are in the Archives of American Art, Smithsonian Institution.

35. *People's World,* September 2, 1947. Refregier taught classes at the Labor School while working on the Rincon Annex murals.

36. Guston's reasoning was equivocal. See *Congressional Record* (as in note 1), 20.

37. *Congressional Record,* 29–33.

38. Refregier's assistant, Louise Gilbert, concluded a letter of June 25, 1953, to the *San Francisco Chronicle* by saying, "The most charitable thing to be said of Rep. Hubert Scudder, who aired the mistaken charges against the murals in Congress, is that he has never seen them."

39. To indicate the international furor caused by the hearings, Mathew Josephson noted that even "the London *Times* voiced its disgust at this latest atrocity of the American heresy hunters" (Josephson [as in note 30], 247).

40. Letter from Julian Huxley to Anton Refregier, April 18, 1953.

41. The Archives of American Art has the papers of the museum directors Walter Heil and Thomas Carr Howe, as well as the *Chronicle* art critic Alfred Frankenstein, all of which may contain further information on the Rincon Annex controversy.

42. *Congressional Record,* 61.

43. Ibid., 64. In response to Representative Scudder's resolution, Dr. Morley organized the Citizen's Committee to Protect the Rincon Annex Murals.

44. *San Francisco Examiner,* June 11, 1953.

45. Editorial, *San Francisco Examiner,* May 18, 1953.

46. McKinzie (as in note 15), 176.

47. *Congressional Record,* 56. Representative Maillard rejoined that "an artist is entitled to a certain amount of license as far as portrayal is concerned" and that "you are not asking the artist to put on the wall a photographic representation."

48. Henry Miller wrote of Hiler's murals: "Though the decor was distinctly Freudian, it was also gay, stimulating, and superlatively healthy." See Stephen A. Haller, "From the Outside In: Art and Architecture in the Bathhouse," *California History* 64, no. 4 (Fall 1985): 283; and Steven Gelber, "Working to Prosperity: California's New Deal Murals," *California History* 58, no. 2 (Summer 1979).

49. Representative Will E. Neal felt that "the pictures represent the cartoonist's way of doing things" and were therefore most dangerous to impressionable minds (*Congressional Record,* 59).

50. *San Francisco Chronicle,* March 8, 1952.

51. Mathews's little magazine *Philopolis* contains numerous articles (many written by Mathews himself) that approvingly cite the "natural" subjugation or extermination of the weaker races by the stronger.

52. Gertrude Atherton, *California: An Intimate History* (New York: Harper, 1914), 30.

53. *Congressional Record,* 43.

54. Ibid.

55. Refregier (as in note 20), frame 1106.

56. *Congressional Record,* 69.

57. Emmy Lou Packard's papers are in the Archives of American Art, Smithsonian Institution.

58. Douglas Frantz, *From the Ground Up: The Business of Building in the Age of Money* (New York: Holt, 1991). Frantz implies that Haas was unhappy with the final product.

SOURCES AND TRADITIONS

Peter Selz

THE IMPACT FROM ABROAD:

FOREIGN GUESTS AND VISITORS

Marcel Duchamp's *Nude Descending a Staircase, No. 2* found its first private home in an expansive brown-shingle house in Berkeley (Fig. 34). Frederick C. Torrey, a San Francisco antique and print dealer, had seen it at the Armory Show in New York and purchased it in May 1913 for $324.[1] When Torrey visited Duchamp in Paris soon after, the artist made him a gift of a preparatory sketch. The canvas, Duchamp's chef d'oeuvre up to that time, was the work at the Armory that defined modernist painting. Torrey displayed it in his Berkeley home near the University of California campus, where it served as a background for debates by the Berkeley faculty, often invited for Sunday discussion sessions. A man with a profound understanding of contemporary art, Torrey lectured on new developments in European art in general and on Duchamp and Francis Picabia in particular. Only recently have historians begun to acknowledge his influential role in the story of California modernism. He "should now be remembered for the valiant battle he waged—in the face of resistance and adversity—to foster a better understanding and acceptance of modern art on the West Coast."[2]

Torrey was primarily a businessman, however: in 1919, when the painting had trebled in value, he sold it to Walter Arensberg in New York. Two years later *Nude Descending a Staircase, No. 2* returned to California with other major works by Duchamp, Constantin Brancusi, and other modern masters, when the Arensbergs moved to Hollywood. There they made their important collection of mainly European modern art accessible to many visitors until the early 1950s, when it entered the Philadelphia Museum of Art.

Through the Arensbergs (and other former New York friends such as Beatrice Wood), Duchamp established a California connection. A frequent guest of the Arensbergs in Hollywood (Fig. 35), he also visited San Francisco, taking part in 1949 in the historic "Western Round Table on Modern Art." This symposium, organized by Douglas MacAgy, the perspicacious director of the San Francisco Art Institute, brought together some of the leading thinkers and makers of modern art: Gregory Bateson, George Boas, Kenneth Burke, Alfred Frankenstein, Robert Goldwater, Darius Milhaud, Andrew Ritchie, and Frank Lloyd Wright, in addition to Duchamp.

This essay describes how international (primarily European) modern art made its way
to California: the forms it took, the conduits, and the most significant responses. In
other words, what influences were available to interested California artists, and how did
they incorporate them into their work? In the history of American art, the Armory
Show is generally cited as modernism's "wake-up call." Although the Armory Show
itself did not travel west of Chicago, San Francisco organized a much larger, if less
radical, exhibition of modern art: the Panama-Pacific International Exposition of 1915
displayed no fewer than 11,400 works in Bernard Maybeck's resplendent Palace of Fine
Arts.[3] Although most of the work was conservative and *retardataire,* there was a sam-
pling of paintings by the impressionists and the Nabis; a group of works by Edvard
Munch; and, surprisingly, a section of forty-nine futurist paintings sent from Italy.
Because the futurists insisted on showing all together, their works were not exhibited at
the armory in New York. Instead, they made their American debut in San Francisco.

The Bay Area painter Gottardo Piazzoni said of futurism: "I have been associated with the movement since its beginnings and am acquainted and in correspondence with the man [*sic*] who started it in Italy"[4]—a truly amazing statement from an artist whose work is characterized by muted tonalism. Piazzoni, who was born in Switzerland, came to California in 1886 and studied at the California Institute of Design; but he returned to Europe, studying in Paris, before settling in San Francisco. His large expansive landscapes in the former San Francisco Public Library (George Kelham, architect, 1916) are the essence of calm, in total contrast to the dynamic explosions of the futurist painters.

The Americans Ralph Stackpole and Otis Oldfield had also gone to study in Paris, where they remained for some time during the early part of the century. Like many of their countrymen, both artists came under the influence of the modernist trends they encountered there. The large decorative sculptures Stackpole carved for the 1939 World's Fair at Treasure Island and for the San Francisco Stock Exchange were stylized

figures, owing a good deal to the cubism of André Lhôte. Paris-born Lucien Labaudt, who settled in San Francisco in 1911, had also been influenced by Lhôte, with whom he remained in close contact. Lhôte and Labaudt collaborated in the exhibition *Ecole de Paris,* mounted at the East West Gallery of Fine Arts in San Francisco in 1928, which included paintings by Picasso, Georges Braque, Georges Rouault, and André Derain, among others, and thus made works by contemporary French masters accessible to the Bay Area audience. In 1930, when Matisse stopped in San Francisco on his way to Tahiti, Labaudt was host to him. The Lucien Labaudt papers in the Archives of American Art indicate a "serious professional exchange between Paris and the American West Coast." [5] With his wife, Marcelle, Lucien Labaudt established the Labaudt Gallery, important for young and emerging artists like Richard Diebenkorn, who had his first solo exhibition there. The "flexibility" of the creative situation in California is suggested by Laubaudt's, Oldfield's, and Stackpole's work in both the modernist and social realist idioms, as in their contribution to the Coit Tower murals of 1930.

Somewhat related to Stackpole's work in style, but typically more exotic in subject matter, was the work of Maurice Sterne. Sterne, born in Latvia and brought to New York by his mother, had studied at the National Academy of Design. He went to live in Italy and Greece and traveled to Egypt and Bali, returning to the United States during World War I. He settled in New Mexico, where he was married for a time to the legendary Mabel Dodge, who served as the catalyst for the colorful artists' and writers' colony in Taos. In 1933 he was the first American artist to have a solo show at the Museum of Modern Art in New York. Subsequently he came to San Francisco to teach at the California School of Fine Arts. Sterne brought a cosmopolitan spirit as well as a modern idiom to the school. As Hassel Smith, a student there at the time, recalled: "Sterne's approach to drawing from the model (nature) was a revelation. I have no hesitation to saying that to whatever extent my intellect has been engaged in the joys and mysteries of transferring visual observations in three dimensions into meaningful two dimensional marks and shapes I owe to Sterne." [6]

William Clapp, who was born in Montreal, had gone to Paris to study at the Académie Julian as well as the Académie de la Grande Chaumière before settling in Oakland in 1917. He became a member of the Society of Six, whose small colorful paintings were open to a wide range of influences, from French and American impressionism to the visual abstractions of Kandinsky. In 1918 Clapp, who was probably the most conservative member of the Six, was appointed curator and later director of the Oakland Art Gallery, a city museum housed in the Municipal Auditorium; when it moved to its present quarters, it became the Oakland Museum. It was without a doubt the most adventurous exhibition space in the Bay Area until Grace McCann Morley founded the San Francisco Museum of Art in 1935.

In his enthusiasm for the avant-garde, Clapp was receptive to Galka Scheyer. Scheyer, born in Braunschweig, had come in 1924 to New York, where she had little success in promoting the work of four German modernists—Wassily Kandinsky, Alexei

FIGURE 36
Alexander Hammid, portrait of Galka
Scheyer. Photograph courtesy Norton
Simon Museum.

Jawlensky, Lyonel Feininger, and Paul Klee—whom she designated the Blue Four. In 1925 she traveled to the West Coast, where she encountered a more favorable response to the German artists. Ironically, none of them was actually German: Kandinsky and Jawlensky were Russian, Klee was Swiss, and Feininger American-born—but they worked in Germany. Scheyer (Fig. 36) had become an apostle of modern art during World War I after seeing Jawlensky's work and falling in love with the artist. After

visiting Feininger, Klee, and Kandinsky at the Bauhaus in Weimar, she decided to bring the work of all four artists to the New World. She came to the Bay Area hoping to obtain a lecturer's position at the University of California, but Eugen Neuhaus, who headed the art department, was no friend of modern art. By 1927, however, she seems to have been a highly successful teacher at the Anna Head School, which was then in Berkeley. She was befriended by Clapp, who appointed her the European representative of the Oakland Art Gallery. The first Blue Four exhibition opened in Oakland in 1926 and went from there to Stanford. Galka Scheyer wrote her artists in Germany that they were being shown "in the most distinguished university in California. . . . Stanford University is worth its weight in gold."[7] But apparently she had miscalculated, for she sold one of Jawlensky's pictures for only twenty-five dollars.

In 1929 the Oakland Art Gallery organized an exhibition including works by Kandinsky that was circulated by the Western Association of Art Museums. With these exhibitions Scheyer offered an ambitious (and expensive) lecture series, titled "From Prehistoric Art to the Blue Four." She would show some five hundred lantern slides, charging those who attended $250 for the series. The fee for the exhibition to the participating museums was at times as low as twenty dollars. When expenses in one instance ran higher than expected, Scheyer suggested a small additional charge, but Clapp explained to her, "If one makes changes in arrangements either financial or otherwise, it irritates those who plan an exhibition. It costs money and entails labor to make changes and if it happens more than once, an art gallery director is apt to become disgusted and to avoid in the future all such exhibitions."[8]

Another exhibition presented by the Oakland Art Gallery in 1929 was entitled *European Modernists*. It included, not the work of French painters, as it surely would have on the East Coast, but that of Emil Nolde, Carl Hofer, Erich Heckel, Karl Schmidt-Rottluff, Max Pechstein, Oskar Kokoschka, and Feininger. While modernist art both in Southern California and on the East Coast looked almost entirely to France, that of Northern California, especially the East Bay, looked to Germany.

The largest exhibition of works by the Blue Four opened at the California Palace of the Legion of Honor in the spring of 1931 and then moved to Oakland, where additional works were included in the show. It attracted considerable attention and caused a great deal of controversy. Among those inspired by it was Howard Putzel, who was particularly keen on Feininger's work, discerning his sensitized fusion of the human figure into a precisely structured abstract design.[9] It is evident that Putzel recognized the significance of formal qualities in works of contemporary art. A few years later, in 1934, he organized the first Miró exhibition on the West Coast in San Francisco's East West Gallery of Fine Arts, followed by other surrealist exhibitions at the Paul Elder Gallery on Post Street. In 1935 Putzel moved to Los Angeles, became a major critic, a promoter of modern art, a dealer in it, and eventually the chief advisor to Peggy Guggenheim's Art of This Century gallery. In New York, he also became a passionate advocate of abstract expressionism; it was he who first brought Jackson Pollock to Peggy

Guggenheim's attention. Galka Scheyer, meanwhile, had gone to Mexico, where she established contact with the painters there, curated an exhibition of works by Carlos Mérida, and became friends with Diego Rivera and Rufino Tamayo. Rivera, his own work of social and political significance notwithstanding, indicated his full understanding of Kandinsky's works when he wrote:

> The painting of Kandinsky is not an image of life—it is life itself. If there is a painter who merits the name creator, that painter is Wassily Kandinsky. He organizes his matter as the matter of the Universe was organized in order that the Universe might exist. I know nothing more true and nothing more beautiful.[10]

Filled with admiration, Rivera arranged for a Blue Four exhibition at the Biblioteca Nacional in Mexico City in 1931. For some time the great muralist had wanted to come to the United States to see the feats of engineering—the skyscrapers, highways, and bridges. He was known north of the border as the master artist, able to combine progressive politics with a significant modern style of mural painting, accessible to the general public. However radical his politics, his first project in the United States was a large fresco in the new building of the San Francisco Stock Exchange, designed by Timothy Pflueger. At first Rivera, a member of the Communist Party in Mexico, was refused entry by the State Department, which feared to admit radicals. When he was finally allowed to enter the country, Maynard Dixon, the well-known painter of western landscapes as well as social realist urban scenes, told the press:

> The stock exchange could look the world over without finding a man more inappropriate for the part than Rivera. He is a professed Communist and has publicly caricatured American financial institutions. I believe he is the greatest living artist in the world and we would do well to have an example of his work in a public building in S.F. But he is not the man for the Stock Exchange.[11]

When the Mexican painter and his wife, Frida Kahlo, arrived in San Francisco, they were feted and lionized. In 1930 he was given a one-man show at the California Palace of the Legion of Honor. The exhibition traveled to Los Angeles, where his work was also exhibited at the Dalzell-Hatfield Gallery and at Jake Zeitlin's famous bookstore. In fact, Rivera exhibitions took place throughout the state, and the artist was offered substantial lecture fees at the University of California at Berkeley as well as at Mills College. Living in Ralph Stackpole's studio, he completed the mural for the stairwell of the Stock Exchange Lunch Club, which occupies the tenth and eleventh floors of the Stock Exchange Tower. Almost thirty feet high, it represents the productive resources of California, its agricultural and industrial workers, its ranchers and miners and gold prospectors, and a large allegorical figure of California, modeled after the famed tennis champion Helen Wills Moody.

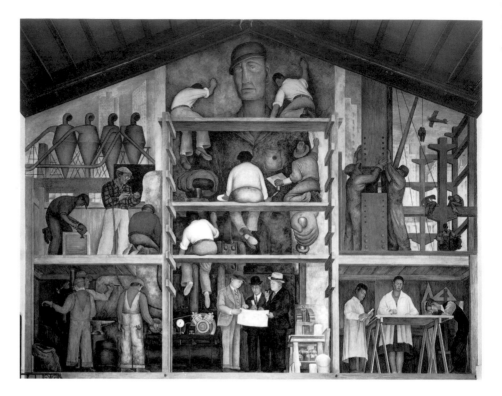

FIGURE 37
Diego Rivera, *The Making of a Fresco*
Showing the Building of a City, 1931.

Fresco. San Francisco Art Institute.
Photograph by David Wakely.

Rivera's next mural was the fresco (Fig. 37) at the California School of Fine Arts (now the San Francisco Art Institute). Here the artist subdivided the painting into cells, separated by a scaffolding—the symbol of architectural construction. On the bottom we see Pflueger, the architect of the Stock Exchange; Arthur Brown, Jr., who had designed the school; and William Gerstle, the donor of Rivera's $1,500 fee for the fresco. Engineers, mechanics, painters, and masons are seen at work, with a gigantic figure of a worker gazing out at the apex. The artist portrayed himself sitting on a plank in the very center, a feature some found objectionable. The Seattle painter Kenneth Callahan complained about the artist's "flat rear . . . hanging over the scaffolding in the center. Many San Franciscans chose to see in this gesture a direct insult, premeditated, as indeed it appears to be. If it is a joke, it is a rather amusing one, but in bad taste."[12]

Neither Rivera's rear nor his politics but rather his conviction that modern art had to be abstract prompted Douglas MacAgy, the brilliant, forward-looking, but autocratic director of the California School of Fine Arts, to find the mural too representational

and too conservative. But that was fifteen years later. Back in the 1930s Rivera's work had a great impact on the paintings of the twenty-five artists who decorated the newly built Coit Tower, the "simple fluted shaft" designed by Arthur Brown's firm for the top of Telegraph Hill. Rivera became the role model, both stylistically and ideologically. It was he, together with his great colleagues José Clemente Orozco and David Alfaro Siqueiros, who inspired the Philadelphia painter George Biddle to persuade his former Harvard classmate and friend Franklin Delano Roosevelt to establish the Public Works of Art Project (PWAP) that was the predecessor of the Works Progress Administration (WPA). Biddle wrote to the president that the younger artists of America, like the Mexican muralists, were conscious of the

> social revolution that our country and civilization are going through and . . . would be eager to express these ideals in a permanent art form if they were given the government's cooperation. They would be contributing to and expressing in living monuments the social ideals that you are struggling to achieve.[13]

The PWAP was put in place throughout the country. In San Francisco the Coit Tower murals were its first and most important achievement. Victor Arnautoff, the project director, had worked with Rivera in Mexico City and Cuernavaca in 1930 and 1931. Other Californians, including Clifford Wight and Bernard Zakheim, had also worked with Rivera on various walls. In Coit Tower they followed the old Italian tradition of *fresco buono* as interpreted by Rivera and his colleagues. Arnautoff's *Metropolitan Life* (Fig. 38) is closely related in its general composition to Rivera's murals at Mexico's National Palace, while Stackpole's *Industries of California* (1934) resembles the great murals Rivera had completed at the Detroit Institute of Arts a year earlier. The physical types of the striking workers in *California Industrial Scenes,* by John Langley Howard, also have their source in Rivera's paintings. The bold modeling of figures and the chromatic scheme of subdued earth colors is clearly indebted to Rivera's work. Finally, the frescoes in the tower embody Rivera's belief that the new mural art could help in the revolutionary struggle to create a more equitable social and political system.

In 1934, when Diego Rivera's mural at Rockefeller Center in New York was destroyed, primarily because of objections to the inclusion of a portrait of Lenin, the newly formed San Francisco Artists' and Writers' Union joined a nationwide protest against this act of political vandalism. During the Pacific Maritime Strike, which occurred later that year, the Hearst press in San Francisco started a red-baiting campaign against the Coit Tower murals, which indeed included radical passages: Arnautoff's newsstands displayed the *Masses* and the *Daily Worker* but no *San Francisco Chronicle;* Bernard Zakheim's *Library* includes a copy of *Das Kapital;* and, most irritating to conservatives, a hammer and sickle appeared next to the National Recovery Administration's blue eagle in the mural by Clifford Wight.

An extended battle ensued, and eventually the Recreation and Park Department

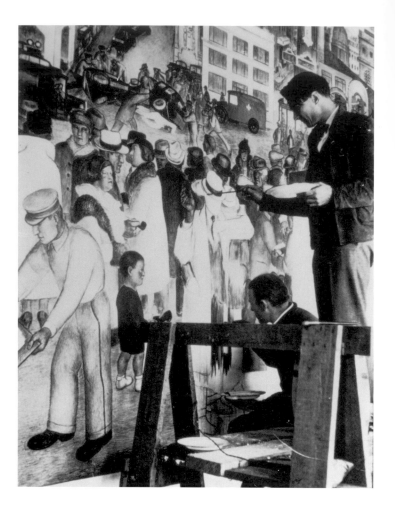

and the Art Commission locked up Coit Tower, calling the works of the muralists a "typical Rivera stunt." The most offensive element, Wight's Soviet emblem and its accompanying slogan, "Workers of the World Unite," were overpainted, and eventually the tower reopened.

By 1930 the influence of the Mexican muralists was firmly established in California. Even before Rivera was commissioned to paint his mural in the Stock Exchange Tower, Orozco had gone to Los Angeles to execute the dramatic and powerful *Prometheus* fresco (1930) at Pomona College. Orozco's monumental work in Frary Hall on that campus came to inspire Rico Lebrun to create his mural *Genesis* (1966) in the loggia of the same building. In 1932 Siqueiros, the third member of Los Tres Grandes, completed a large outdoor mural on Olvera Street in the center of the old Mexican section of Los Angeles. The mural, *Tropical America,* represents a man crucified on a double cross

with the U.S. eagle perched on top.[14] Soon disparaged as "Communist propaganda," it was covered over with whitewash within a few years and began to deteriorate. The Friends of Mexico Foundation, working with the Getty Conservation Institute, is now trying to preserve it, even if it cannot be restored to its original state.

The political and social message of the Mexican muralists seems to have had less impact in Southern California than in the labor-oriented and unionized city of San Francisco. The American murals that sprang up in Southern California were typified by the work of Millard Sheets, who, after his original contact with Siqueiros, turned toward pleasing ornamental wall decorations.

Because of the Mexican mural movement, California modernism was split along ideological lines. During the debate about the Coit Tower murals in San Francisco, Glenn Wessels voiced the opposition's view. He praised the communal spirit of the enterprise, but also hoped that the public mural artist would remain "upon the plane of high generalities with which the majority can agree, unless his purpose is dissension."[15] In other words, art should stay aloof in matters of politics.

Born in Capetown, South Africa, Wessels had also studied with André Lhôte in Paris and had gone to Munich in the late 1920s to enroll in the school founded by Hans Hofmann. Hofmann had lived and worked in Paris before World War I and participated in the artistic revolution there. He was well acquainted with Matisse as well as Picasso, Braque, Sonia Delaunay, and Fernand Léger. But coming from Munich, to which he returned when the war broke out, he was equally aware of the avant-garde movements in Germany, especially the Blue Rider group led by Kandinsky, who believed in the spiritual quality of art. Hofmann's art school, founded in 1915, may have been the best place to learn the new approaches to painting; it attracted students from all over the world. Louise Nevelson, Alfred Jensen, and Vaclav Vytlačil, as well as Wessels, were among those who came from America. Wessels gave English lessons to Hofmann in exchange for his art classes.

At about the same time, the American painter Worth Ryder was a student at the Royal Bavarian Art Academy in Munich. When he met Hofmann in the summer of 1926 at the Blue Grotto in Capri, where the German painter had taken his summer students, Ryder was impressed with his ideas. Appointed to the faculty at the University of California in 1927, Ryder immediately set himself in opposition to the conservative Eugen Neuhaus. To strengthen his position, he invited Hofmann's student Vytlačil to teach at Berkeley and in 1930 asked Hofmann himself to teach summer school there. Wessels accompanied Hofmann on the boat and train and served as his interpreter; he also translated the original version of Hofmann's textbook on the teaching of modern art, *Creation in Form and Color*. While teaching, Hofmann made some brisk and lively drawings of the Bay Area. He accepted an invitation to return to Berkeley in 1931 to teach, and he also exhibited his paintings and drawings, first on the campus and then at the California Palace of the Legion of Honor in San Francisco. The works in this,

his first American show, were very much in the School of Paris style, heavily influenced by Cézanne, Matisse, and Dufy. Only in the mid-1930s did Hofmann again seriously develop his own work as a painter.

Hans Hofmann returned to Germany once more, but, with the political situation there deteriorating, he was glad to accept an appointment to the faculty of the Art Students League in New York in 1932. A year later he started his own school, presiding as a father figure over a generation of abstract expressionist painters.

Rivera and Hofmann had arrived in the Bay Area in the same year, 1930,[16] and both had a profound impact on the art of the region. But there could be no greater contrast than that between the social realists, for whom art was a weapon to change the social order, and Hofmann's teaching of art as pure form and vibrant colors interacting on the picture plane (Fig. 39). Hofmann changed the teaching of art at Berkeley. Erle Loran, John Haley, and Karl Kasten, all Hofmann's disciples, joined Ryder and Wessels on the faculty. Among those they taught was Sam Francis, who received his master's degree from Berkeley in 1950 before leaving for Paris and becoming famous. Years later, Hofmann gave a significant number of paintings to Berkeley. They are displayed at the University Art Museum,[17] which now has fifty paintings by Hofmann. San Francisco is the site of three major murals by Rivera.

In 1935 the San Francisco Museum of Art opened in the War Memorial Veterans Building. Its primary goal was to present contemporary art and its sources, a task for which its first director, Grace McCann Morley, was eminently suited. Feeling that the city needed to catch up on the early stages of modernism, she presented an exhibition of impressionist and postimpressionist art for the premiere of the new institution. This was followed in rapid succession by the Rivera retrospective and the Blue Four show already mentioned. During the late 1930s, before computers allegedly made things so much easier and quicker, Morley and her small staff organized as many as one hundred shows annually. Of particular importance was a large 1936 exhibition of paintings, sculpture, and graphics by Matisse, largely borrowed from Michael and Sara Stein, who had recently returned from Paris to the Bay Area, bringing their collection with them. The San Francisco Museum, modeled after New York's Museum of Modern Art, saw itself as the western outpost of the slightly older institution and showed many of MoMA's most consequential exhibitions. Between 1935 and 1940 these included *African and Negro Art; Cubism and Abstract Art; Fantastic Art, Dada, and Surrealism;* and *Picasso: Forty Years of His Art.* Clearly, an active East-West art axis, one that had important ramifications for the development of California art over subsequent decades, had been established.

It is well known that before and during the war, many of the leading European artists—Piet Mondrian, Léger, Jacques Lipchitz, and most of the surrealists—migrated to New York, giving a major impetus to the incipient New York School. But it is less well known that many of the major European artists also came to the Bay Area, primarily

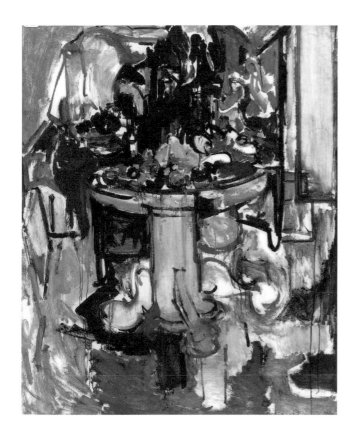

FIGURE 39
Hans Hofmann, *Table with Fruit and Coffeepot,* 1936. Casein and oil on plywood, 60⅛ × 48⅛ in. University Art Museum, University of California, Berkeley, gift of the artist.

because of Alfred Neumeyer, a man of astounding knowledge and cultural breadth. Born in Munich, Neumeyer had studied art history at the University of Munich with Heinrich Wölfflin before becoming Adolph Goldschmidt's student in Berlin and Aby Warburg's in Hamburg. He had received his doctorate from the University of Berlin and had worked at the Cabinet of Engravings in the Kaiser Friedrich Museum. Later he was appointed director of the Press Office of the Berlin museums, where he came in close contact with Germany's modern artists before they were defamed as degenerate. In 1935 he was offered a professorship at Mills College in Oakland. On the recommendation of his erstwhile fellow student Walter Heil, who had recently accepted the directorship of the M. H. de Young Memorial Museum, Neumeyer accepted the offer, becoming the first trained art historian to teach the discipline on the West Coast. The position was greatly reinforced by Walter Horn's appointment to the Berkeley faculty in 1938.

Neumeyer maintained his contact with European artists and intellectuals. In 1937 he invited Walter Gropius, who had just been appointed head of the Graduate School of Design at Harvard University, to teach a course in architecture in the Mills summer

session. Gropius had to decline, as did Thomas Mann, then living in Princeton, but the correspondence indicates that Mann considered giving a summer seminar on the Mills College campus in 1938 on humanism in the twentieth century or on art and democracy. Neumeyer built on the reputation Mills had achieved as a center of the humanities: the Russian-born sculptor Alexander Archipenko, who had immigrated to the United States in 1923, taught at the Mills summer session in 1933; his work was exhibited on the campus in 1934. Jules Romains had given a seminar on French culture there in 1936, as did André Maurois in 1941. In 1940, the year Darius Milhaud became professor of music composition, Neumeyer wrote a letter to the New York art dealer Pierre Matisse, suggesting that his father might want to leave France because of the war and consider coming to Mills,[18] but Matisse remained in Nice. As director of the Mills Gallery, a position he assumed a year after his arrival and held for many years, Neumeyer was able to bring in major artists to teach as well as to exhibit their work.

In 1936 Neumeyer organized an exhibition of Van Gogh's etchings. The same year he offered summer teaching and a show to Feininger (Fig. 40). The Bauhaus had been closed in 1933, and Feininger felt increasingly alienated and dispirited in his adopted country. He was glad to return to his native land after a fifty-year absence when the invitation from Mills arrived in his Berlin studio. With his wife, Julia, he sailed to New York and on through the Panama Canal to disembark in San Pedro. In Los Angeles he renewed his acquaintance with Galka Scheyer and Walter Arensberg, who owned some of his work, and then traveled on to Oakland, to teach at Mills. The exhibition of his work, lent mostly by his dealer, Karl Nierendorf, went on to the San Francisco Museum of Art, and some of his works were sold to San Francisco collectors. On his return to Germany, Feininger, who had been one of the country's most renowned artists, was featured in the infamous Nazi *Degenerate Art* exhibition, and 348 of his works were removed from German museums. Clearly his time in Germany had come to an end.

Neumeyer in the meantime had invited Oskar Kokoschka, who had fled to Prague, for the following summer. But when the Austrian painter was unable to come to California, Neumeyer invited Feininger for a second summer session. Feininger later wrote to his friend Alois Schardt, the former museum director, "One day it will be noted that at the age of 65 I arrived in New York Harbor with two dollars in my pocket and had to start life anew."[19] At Mills a second exhibition was held in his honor that included forty oils and one hundred watercolors. In a lecture at the opening, Neumeyer pointed out that "nothing vague and indefinite exists in these landscapes and seascapes of crystalline form and crystalline light except the undefinable creative musicality of the artist's mind, which reminds us of Redon." The crystal, he declared, is the "symbol of medieval alchemists and mathematicians. The hardest and clearest of all minerals becomes a magic sign in their dream to conquer and explain the divine world. The hardest, the clearest, the highest organized mineral is not by chance the elementary form and symbol of Feininger's art."[20] At the time of the exhibition, Feininger himself cited Caspar David Friedrich's dictum, which he undoubtedly used during his many years of teach-

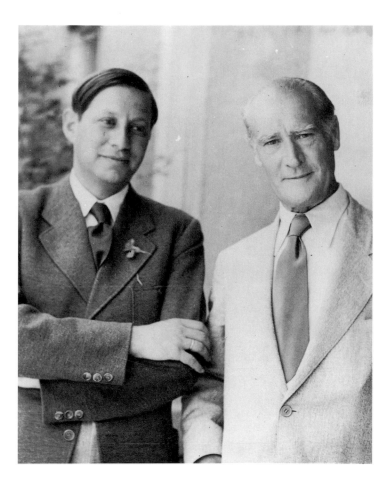

ing and which has lost none of its relevance: "The painter should not only paint what
he sees around him, but also what he sees within himself; but if he sees nothing within
himself, he should refrain from painting what he sees around him."[21]

This second Mills exhibition traveled along the West Coast to Seattle, Portland,
Santa Barbara, Los Angeles, and San Diego. Feininger was enraptured by San Francisco
and its rugged coast, where the remains of shipwrecks in the sea reminded him of his
own fantasy seascapes. He said he would love to have remained on the Pacific coast but
had to face the challenge of renewing his life as a working artist in New York. He arrived
there in September 1937 and experienced almost another twenty years as a productive
artist. This career "imperative," going to New York City, confronted virtually all serious
artists in California.

In 1938 Alfred Neumeyer organized an exhibition of the work of Karl Schmidt-
Rottluff, the important Brücke painter whose work, like Feininger's, was outlawed in

Germany. The artist wrote to Neumeyer that an exhibition in America at this time "reinforced his belief that there are still some places in the world with individual and nobler convictions."[22] A year later an exhibition of works by Kokoschka, who was then living in London, and a show of painting and graphics by Josef Albers, then teaching at Black Mountain College, were seen at the Mills College Gallery. Kokoschka presented the gallery with two crayon drawings, while Schmidt-Rottluff donated an early woodcut and the gallery also acquired a fine watercolor by him. A few years earlier two excellent Feininger watercolors had been added to the growing collection on the Mills College campus.

Neumeyer, however, was by no means interested solely in the rescue of German art and artists. He also sought out American artists, approaching those with the highest visibility at the time. He corresponded with Thomas Hart Benton, Grant Wood, Leon Kroll, Eugene Speicher, and Frederic Taubes, asking each whether he might agree to teach summer sessions at Mills. Taubes accepted. Almost forgotten now—he is not listed in the indexes of most books on twentieth-century American art—he was well known at the time, having published eight color reproductions in a single issue of *Life* magazine. Born in Poland, he had studied in Munich and was known primarily for his well-executed and colorful still-life paintings and portraits and for his books on the technique of oil painting. The major occurrence at Mills in the summer of 1939 was not the Taubes exhibition, however, but the presence of the Bennington School of Dance with Martha Graham, Doris Humphrey, Charles Wegman, and Hanya Holm.

The most significant event for art, design, architecture, and art education in California may have been the exhibition *The Bauhaus: How It Worked* in the spring of 1940 at the Mills College Gallery. Circulated by the Museum of Modern Art, it consisted of Bauhaus objects, paintings, graphics, stage design, typography, graphic design, posters, and photography—in other words, the whole range of design of this century's most influential art school. This exhibition was actually only the curtain-raiser for the 1940 summer session, which brought leading faculty from the School of Design established in Chicago by László Moholy-Nagy—it was originally called the New Bauhaus and later became the Institute of Design—to Oakland. Moholy-Nagy arrived with the photographer, theorist, and painter Gyorgy Kepes; the painter Robert Jay Wolff; the weaver Marli Ehrman; the furniture designer Charles Neidringhaus; and the artist, designer, and craftsman James Prestini. This high-powered faculty taught courses in drawing, painting, photography, weaving, paper cutting, metalwork, modeling, and casting, all based on the Bauhaus belief in combining intuition and discipline in work that was meaningful in a technological world.

A large exhibition of work by the visiting faculty that summer comprised twenty-two paintings by Moholy-Nagy, twenty-four paintings and watercolors by Wolff, twenty photographs by Kepes, eleven trays and bowls by Prestini, and a large wall hanging by Ehrman. The classes were extremely successful, attracting both well-established

artists like Adaline Kent and art teachers from all over the West Coast. In a letter to Neumeyer, Alice Schoelkopf, supervisor of art for the Oakland Public Schools, expressed her appreciation of the program as an important new experience for the teachers in her district.[23] Indeed, the presence of the New Bauhaus faculty had an indelible impact on the teaching of art and design in the Bay Area: the Institute of Design's philosophy of education became a reality when William Wurster was named dean of architecture at the University of California in 1950. He appointed Jesse Reichek from the institute to create the basic design curriculum along Bauhaus lines, and Reichek, in turn, invited Prestini to return to the East Bay to help restructure architectural training at the university.

A good many years later Sybil Moholy-Nagy recalled in her biography of her husband:

> By the time we arrived at Mills College, Moholy had lost most of his English vocabulary. During the trip he had insisted on speaking only German, which he loved. But even though he had lost his facility of speech, he had regained the spirit of high adventure which had been his most distinguished characteristic as a young instructor. He consented to a schedule of thirty teaching and lecturing hours a week. Together with five of his best teachers he put a group of eighty-three students through an intensified Bauhaus curriculum, including every workshop and every major exercise. Late at night or on the few free Sundays, we would drive into San Francisco. We loved this unusual town, its clean contemporary structure, the golden color of the wild oats on the hillsides and the red bark in the forest. In his painting *Mills #2, 1940* Moholy has translated color-light interplay of the Bay region into a composition of glowing transparency. For the first time since we had left Europe, the atmosphere of a city seemed filled with an enjoyment of non-material values—art, music, theatre—not as demonstrations of wealth and privilege but as group projects of young people and of the community. The museums, co-operative units, studios, and schools offered a hospitality of the spirit that had been unknown to us in America. "One day I'll come back," Moholy said as we drove over the Bay bridge for the last time. "One day I'll have $10,000 in the bank and I'll spend two years in San Francisco."[24]

When Moholy was asked, however, to return to Mills the following year, he declined, wanting to identify his school with Chicago. He recommended Frank Lloyd Wright, who, predictably, was not available. Amédée Ozenfant was seriously considered until Léger, who had come to America in 1940, expressed an interest in coming to Mills—his fourth trip to America. He loved America's engineering feats, called New York "the greatest spectacle on earth," and was captivated by Harlem jazz. To see the country, he took the bus from Manhattan to Oakland. The United States, he said in 1949, "is not a country . . . it's a world. . . . In America you are confronted with a power in movement, with a force in reserve without end. An unbelievable vitality—a perpetual movement. One has the impression that there is too much of everything."[25] At

Mills he taught summer classes but found his own greatest inspiration in the swimmers at the college's pool. He had been working on his *Divers* series for some time but now painted on with greater energy, turning toward a more definite modeling of the body. He wrote that he was

> struck by the intensity of movement. It's what I've tried to express in painting. . . . In America I painted in a much more realistic manner than before. I tried to translate the character of the human body evolving in space without any point of contact with the ground. I achieved it by studying the movement of swimmers diving into the water from very high.[26]

Léger made a number of interesting sketches and preliminary drawings during his stay at Mills, including a fine ink study he gave to the gallery, inscribing it, "Mills '41 en souvenir de mon séjour charmant ici. FLéger" (Fig. 41). He completed the final version on his return to New York, feeling the impact of Times Square. "I was struck," he wrote, "by the new advertisements flooding all over Broadway. You talk to someone and all of a sudden he turns blue. The color fades—another one comes and turns him red and yellow."[27]

An exhibition of Léger's work was installed in the Mills College Gallery and traveled to the San Francisco Museum of Art. On July 21, 1941, he gave a lecture, "L'Origine de l'Art Moderne," with ninety-four people in attendance. He expressed an interest in a permanent teaching position at Mills or, since there was no opening there, elsewhere in the country. Neumeyer wrote to university art departments and art schools from Seattle to Poughkeepsie on his behalf, but there was no opening anywhere for one of this century's greatest artists. A letter from the chairman of the art department at the University of Illinois is typical of the responses Neumeyer received:

> I think I ought to say, confidentially, that our general University Faculty and the towns-people are so conservative in their point of view in art that I am afraid a meeting point for sympathetic contacts between them and the artist would be almost impossible to establish. I dare say that this situation is not a new one to you but seems so widely prevalent among the general faculty in our colleges and universities.[28]

During World War II and the immediate postwar period, artists abroad were isolated from those in this country. The energy in vanguard activity here thus centered on the new wave of American artists. Major exhibitions of abstract expressionism were installed at the California Palace of the Legion of Honor, where Jermayne MacAgy was acting director, and at Grace McCann Morley's San Francisco Museum of Art. With the appointment of Clyfford Still to the faculty of the California School of Fine Arts, both the leading schools in the city and the Art Department at Berkeley were teaching

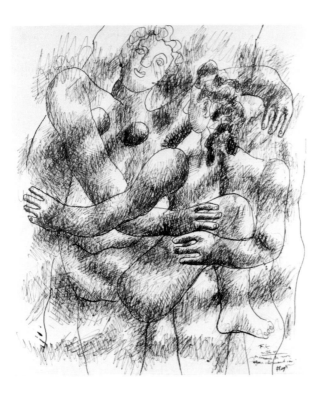

FIGURE 41
Fernand Léger, study for *The Divers,*
1941. Pen and ink, 17⅞ × 15 in. Mills
College Art Gallery, gift of the artist.

abstract expressionist painting, although Still's and Hofmann's disciples worked in a very different manner.

Not until 1950 did a major European artist once more appear to teach in the Bay Area. Max Beckmann, who had gone to St. Louis from his self-imposed exile in Amsterdam in 1947 and had moved to New York in 1949, accepted Neumeyer's invitation to teach the Mills summer session in 1950. A sizable exhibition of his work from the collection of Stephan Lackner, now living in Santa Barbara, was held while he was on his way to Oakland.

In his diaries of that summer Beckmann wrote as much about his depression and the new war that had just broken out in Korea as about his trip to California. He enjoyed spending evenings with Neumeyer, Milhaud, and Alfred Frankenstein, the art critic for the *San Francisco Chronicle,* as well as taking his breakfasts at an American drugstore near the campus. A heart condition made critiques in his classes difficult for him, but he was able to work.

Beckmann made sketches for three paintings while at Mills: *San Francisco, West-Park,* and *Mill in the Eucalyptus Grove,* the latter two of the campus. The pictures were completed after his return to his New York studio. Painted from a vantage point high

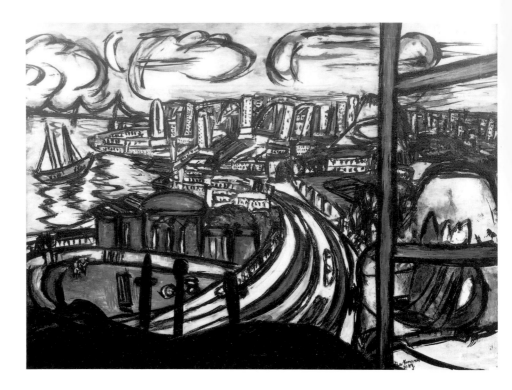

above the Golden Gate Bridge, *San Francisco* (Fig. 42) is a brilliantly colored dynamic painting with the curved arrow of Doyle Drive rushing past the Palace of Fine Arts toward the heart of the city, which appears to be vibrating. A crescent moon and a sunset appear in the eastern sky in this painting, which combines scenes of the city from different viewpoints. In the immediate foreground he has placed three black crosses, apparently stuck into the black earth of the curving ground. On the right above his signature is the fragment of a ladder,[29] a symbol he used frequently. Beckmann completed his greatest triptych, *Argonauts,* after his return to New York, where he died in December 1950.

Among the students who registered for the Mills summer session that year was Nathan Oliveira. Oliveira's solitary figures, silhouetted against an unlimited space that is activated by the artist's vigorous brush (Fig. 43), owe a particular debt to the expressionist tradition. For Oliveira,

> Beckmann symbolized the old world. Tradition, yes, but on the other hand renewing tradition—in the sense that the past was not being thrown away. It is as if he were saying, "This is it, this tradition, but I'm now dealing with my own reality." Beckmann starts out with a reality which is very fundamental. Over a period of years, and through many periods of transition, you see his work become more and more personalized, and the image becomes very particular. I picked that up and that's pretty much what I based my own work on.[30]

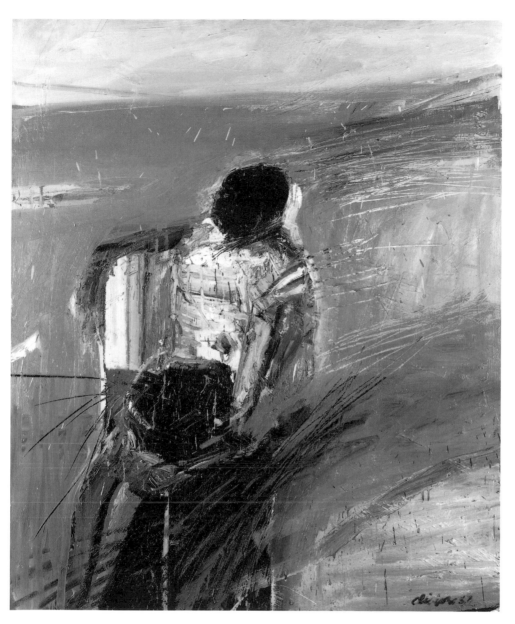

FIGURE 42
Opposite: Max Beckmann, *San Francisco,* 1950. Oil on canvas, 39¾ × 55⅛ in. Hessisches Landesmuseum, Darmstadt.

FIGURE 43
Above: Nathan Oliveira, *Seated Man with Object,* 1957. Oil on canvas, 60 × 49½ in. Yale University Art Gallery, gift of Richard Brown Baker, B.A. 1935. Photograph by Joseph Szaszfai.

Many California artists during the first half of this century, like artists elsewhere, decided to complete their training in Paris. What concerns us here, however, is the presence of European and Mexican art and artists and their impact on the art of California. It is safe to assume that the work of Duchamp and that of the futurists and expressionists elicited a response from California artists. Hans Hofmann at Berkeley and other major European artists like Feininger, Léger, and Beckmann at Mills College produced indelible, though not easily measurable, effects on California artists. And the brief stay of Moholy-Nagy and other members of the New Bauhaus faculty altered education and the praxis of the crafts, design, and architecture in the Golden State. Bay Area figurative painting is often seen as an indigenous development of the 1950s, but it was in fact part of an international movement to extend the emotional range and content of abstraction. As I have already noted, Nathan Oliveira acknowledges a direct debt to Max Beckmann. The two California artists who have achieved the greatest acclaim—Richard Diebenkorn and Sam Francis—were, though originally trained in the Bay Area, indebted to the pictorial condensation of sensations in the work of Henri Matisse. And the presence of Los Tres Grandes in California was continued in the widespread mural production in this state. These influences have fostered the pluralism of form and the multi-ethnic origins of current artistic production in the San Francisco Bay Area and throughout California.

Notes

1. Francis M. Naumann, "Frederick C. Torrey and Duchamp's *Nude Descending a Staircase*," in *West Coast Duchamp,* ed. Bonnie C. Clearwater (Miami Beach, Fla.: Grassfield Press, 1991). This essay by Naumann corrects previous accounts of the provenance of this painting.

2. Naumann, 21.

3. Official catalogue of the Department of Fine Art, Panama-Pacific International Exposition (San Francisco: Wahlgreen Co., 1915).

4. Gottardo Piazzoni, quoted in *Painting and Sculpture in California: The Modern Era,* ed. Henry Hopkins (San Francisco Museum of Art, 1977), 22.

5. Paul J. Karlstrom, "San Francisco," *Archives of American Art Journal* 16, no. 2 (1976): 24–25, and "West Coast," *Archives of American Art Journal* 24, no. 4 (1984): 39–40.

6. Hassel Smith, Chronology, written December 10, 1987, quoted in *Hassel Smith* (Belmont, Calif.: College of Notre Dame, Weigand Art Gallery, 1988), 27.

7. Galka Scheyer, collective letter to the Blue Four, October 19, 1925, in Galka Scheyer Blue Four Archive, Oakland Museum.

8. William Clapp, letter to Galka Scheyer, June 23, 1935, in Galka Scheyer Blue Four Archive.

9. Howard Putzel, in Galka Scheyer Blue Four Archive.

10. Diego Rivera, statement in *The Blue Four,* exh. cat. (San Francisco: California Palace of the Legion of Honor, 1931), n.p.

11. Maynard Dixon, cited in Bertram D. Wolfe, *The Fabulous Life of Diego Rivera* (New York: Stein and Day, 1963), 285.

12. Kenneth Callahan, letter in the *Town Crier* (Seattle), May 21, 1932.

13. George Biddle, letter to Franklin Delano Roosevelt, May 9, 1933, quoted in Biddle, *An American Artist's Story* (Boston: Little, Brown, 1939), 268.

14. Shifra M. Goldman, "Siqueiros and Three Early Murals in Los Angeles," *Art Journal* 33, no. 4 (Summer 1974): 321–27.

15. Glenn Wessels, in *San Francisco Argonaut,* July 13, 1934.

16. In 1930 Matisse also visited San Francisco. The three artists did not meet in the City by the Bay, but it is interesting to speculate on the discourse that might have taken place if they had.

17. Hans Hofmann offered to the University of California at Berkeley a donation of forty-seven paintings, selected by Erle Loran with my assistance. They represent the artist's work from 1935 to 1965. Hofmann also proffered a quarter of a million dollars on the condition that a proper art museum be constructed on the Berkeley campus; this gift was a major inducement to the establishment of the University Art Museum.

18. Alfred Neumeyer, letter to Pierre Matisse, September 17, 1940, Mills College Archive.

19. Lyonel Feininger, letter to Alois J. Schardt, February 5, 1942, Mills College Archive.

20. Neumeyer, press release, Mills College, Oakland, California, summer 1937, Mills College Archive.

21. Feininger, letter to Alfred Frankenstein, October 15, 1937, Mills College Archive.

22. Karl Schmidt-Rottluff, letter to Alfred Neumeyer, April 4, 1938, Mills College Archive.

23. Alice Schoelkopf, letter to Alfred Neumeyer, October 14, 1940, Mills College Archive.

24. Sybil Moholy-Nagy, *Moholy-Nagy: An Experiment in Totality* (New York: Harper, 1950), 180–82.

25. Fernand Léger, quoted in André Warnod, "America Isn't a Country—It's a World," *Architectural Forum* (April 1946): 54.

26. Léger, quoted in Warnod, 62.

27. Léger, quoted in Charlotte Kotik, "Léger and America," in *Léger* (Buffalo, N.Y.: Albright-Knox Art Gallery, 1982), 52.

28. James Grote Van Derpool, letter to Alfred Neumeyer, November 5, 1941, Mills College Archive.

29. Peter Selz, "The Years in America," in Carla Schulz-Hoffman and Judith C. Weiss, *Max Beckmann Retrospective* (Saint Louis, Mo.: Saint Louis Art Museum; and Munich: Prestel Verlag, 1948), 167.

30. Nathan Oliveira, afterword to Peter Selz, *Max Beckmann—Portrait of the Artist* (New York: Rizzoli, 1992), 108.

Margarita Nieto

MEXICAN ART AND

LOS ANGELES, 1920-1940

Relations between Mexico and the United States have been characterized by conflict and tension, territorial and political imbalance. Since 1850, when Mexico lost its northern territories as a result of the Mexican-American war, the historical narrative of the relationship has consistently favored the "Colossus of the North," according to the poet Rubén Darío. The artistic links between the two nations—the other history—however, pull in Mexico's direction. The country's three-thousand-year artistic history is one reason; another is Mexico's syncretic fusion of European and Mesoamerican cultures.

Mexico's controversial conception of modernity accounts for the richness of its visual language: along with European tendencies, currents, and aesthetics, Mexican art also incorporates the pre-Cortesian.[1] In contrast to the United States, whose art derives from Western, or European, sources, Mexico's fusion of the "other," pre Cortesian, tradition with the Western tradition has created an art whose proportions and concepts challenge the traditional Western sense of balance and purity. The synthesis of these two aesthetics is Mexico's contribution to twentieth-century art. Mexico's contribution to American art during the twenties and thirties, through an intriguing network of cross-cultural experiences involving Mexican and American artists, critics, gallery owners, museums, and collectors, brought about a new awareness of that aesthetic.

In Los Angeles, founded by settlers who had come to California from Mexico, complex bicultural and multicultural narratives were spun out decades before such narratives had acquired a postmodern significance. Though traditionally viewed as a city without a fine arts tradition, its film and television industries along with its popular art, public art, and muralism prepared a fertile ground for experimentation in the visual arts. Yet both critics and historians have long ignored the Los Angeles aesthetic, initially excluding or marginalizing, for example, the Chicano-Latino art movement of the sixties and seventies.

This history of cross-cultural influences is one of dichotomies and contradictions: on the one hand, the intellectual and aesthetic fascination with Mexican art and, on the other, the politics of discrimination against the Mexicans and Mexican Americans residing in the United States. It is also a history in which the passion for Mexican art coexists with an interest in economic development and investments in Mexico as a partial solution to the socio-economic problems arising in the United States during the Great Depression.

In the forties and fifties, the emergence of the New York School and abstract expressionism resulted in an about-face. With this original American art movement, not only did the interest in Mexican art fade, but American art history also seemingly chose to ignore the Mexican influences of the twenties and thirties. Moreover, although the United States had now assumed a new international importance as a political and economic power, the postwar period was also characterized by a nationalism bordering on xenophobia and a suspicion of things "foreign."

This xenophobic self-absorption was a reversal of the attitudes of the twenties and thirties, when the dynamism of the Mexican School of Painting served as a model for the artists and artistic movements in the United States. The government-sponsored muralist projects initiated in Mexico in the twenties were the example that George Biddle used in asking President Franklin Delano Roosevelt to fund the public arts project that became the Works Progress Administration. The American artists Ben Shahn, Philip Guston, and Jackson Pollock, among others, sought out the Mexican painters as teachers and masters.

The events, incidents, and exhibitions of the Mexican presence have been largely ignored or forgotten. What has remained are some references to muralism, the controversy over the Diego Rivera mural at Rockefeller Center in New York, and David Alfaro Siqueiros's Olvera Street mural in Los Angeles. Yet the presence of these artists, their work, and, most of all, this aesthetic is integral to the social and cultural history of American art: that presence was felt and reflected in the works of the artists Ben Shahn, Edward Weston, Jackson Pollock, Ralph Barton, and Philip Guston and the critics and writers Elie Faure, Walter Pach, Anita Brenner, Alma Reed, Frances Toor, and René d'Harnoncourt. It caught the interest of collectors and patrons such as Henry Ford, Abby Rockefeller, Nelson Rockefeller, Mrs. Sigmund Stern, and Mrs. Caesar Guggenheimer.

In Los Angeles, collectors and patrons of the Mexican artists included the screenwriters and directors John Huston, Dudley Murphy, Jo Swerling, Josef von Sternberg, and Jean Hersholt. Prominent art dealers including Earl Stendahl, Stanley Rose, Howard Putzel, and Jake Zeitlin showed the works of Rivera, Orozco, and Siqueiros as well as those of Jean Charlot, Roberto Montenegro, Rufino Tamayo, and Federico Cantú. While Los Tres Grandes, the three famous muralists, continue to be the artists most often identified with the period, the painters Alfredo Ramos Martínez, Jorge Juan Crespo de la Serna, Jean Charlot, Francisco Cornejo, Luis Ortiz Monasterio, and José Chávez Morado lived, studied, taught, and worked in Los Angeles during these years.

Moreover, the Mexican influence is evident in the works of the Los Angeles painters Alson Clarke, Phil Paradise, Phil Dike, Millard Sheets, Hugo Ballin, Leo Katz, Boris Deutsch, and Fletcher Martin.

But where did it all begin? Why did Americans invite Mexican artists north to adorn public and private buildings with murals, present workshops, teach in their institutions, and exhibit in local galleries—especially in light of the social and political interaction between Mexico and the United States, marked in the twenties in the Southwest by increasing bigotry and by disdain for Mexicans? The climate of hatred peaked in the thirties with a mass deportation of "Mexicans" that included American citizens, while the forties bore witness to the Sleepy Lagoon murder trial and the Zoot-suit riots, events deeply etched in the collective memory of the Mexican American community and later immortalized in Luis Valdez's musical dramas and films.

The enthusiasm for Mexican culture may be traced in part to two phenomena: the presence in Mexico of an American intellectual who has only recently been "rediscovered" by the United States, Walter Pach; and the American cultural climate, which separated theory and practice.[2]

Pach, a respected and well-established art historian, critic, and painter, served as a bridge between the School of Mexico artists—indeed, Mexican art in general—and North American art institutions. The American intelligentsia, moreover, savored both the social changes wrought by European upheavals in philosophy and aesthetics and the results of the socialist revolution in the Soviet Union. That what the intelligentsia learned from events in Europe could not always be applied to the deepest strata of American society is evident. Mexican art in the 1920s was avidly received while Mexican nationals in general were not—a contrast that suggests the difference in power between the cultural and the political establishment in the United States.

Walter Pach, according to William C. Agee, was "a catalyst, an advocate and spokesman for modern art and artists at a time when the modern movement was sorely in need of figures who could nurture it."[3] Born in New York to a well-to-do family of commercial photographers who did much of the work for the Metropolitan Museum of Art, he earned a degree in art at the City College of New York. After studying painting with Robert Henri and William Merritt Chase, he moved to France in 1907 and became part of Leo and Gertrude Stein's circle. Pivotal in organizing the European portion of the 1913 Armory Show, he also became a lifelong friend and translator of the French art historian and critic Elie Faure; it was through him that Pach's curiosity about Mexican art was stimulated.

More important for our purposes, Pach served as a link between New York and California, where interest in, and support for, the Mexican muralist movement and for Mexican art were greatest. He also taught at the University of California, Berkeley, and corresponded with West Coast artists in Pasadena and Los Angeles.

Elie Faure's article on Jean Charlot and "Mechanisme" set off the chain of events, documented in the correspondence between Faure and Pach, that culminated in Pach's initial visit to Mexico in 1922, where he introduced Charlot to Diego Rivera. Faure had

known Rivera in Paris and, upon learning Pach was to go to Mexico, advised him to seek out Rivera.

Pach had already been in contact with Mexican intellectuals. As early as 1918 he had been visited by the Mexican philosopher and diplomat Samuel Ramos. Moreover, a letter of appointment and invitation to teach at the National University of Mexico was extended by the then secretary of the university, Pedro Henríquez Ureña, one of the outstanding Latin American intellectuals of the period. Pach visited Mexico during the execution of the Ministry of Public Education murals, mostly by Diego Rivera, and became acquainted with the entire body of Mexican muralists and painters. During that visit he began relationships with Rivera, Orozco, and Charlot and, later, the art dealers Alberto Misrachi and Inés Amor as well as the philosophers and cultural essayists Octavio G. Barreda and Alfonso Reyes.

Following Pach's 1922 visit, the Society of Independent Artists in New York, of which Pach was a founding member, along with Walter Arensberg and Marcel Duchamp, invited the "newly born" Society of Mexican Artists to show in New York. In a letter to Pach dated December 7, 1922, Diego Rivera thanked him in advance, outlined the spatial needs of the exhibition, and listed the names of the artists:

> The group will consist—according to your wishes, we have made a list of thirteen names leaving two spaces (we are counting on fifteen spaces in terms of the 15 meters of wall that you've indicated) for the works by the children. [Apparently works by Mexican school children, most probably students of Ramos Martínez's Open Air Schools, were to be included in the exhibition.] We have decided on the following: [He then draws a sketch.] We shall each have 80 centimeters so that in any case there can be 20 centimeters between each canvas. We will also use the wooden rods that you mentioned.
> The artists will be=Orozco José
> Clemente=Charlot=Revueltas Alfaro
> Siqueiros=Leal=Alba=Cahero=Bolaños=Ugarte=Cano=Nahui
> Ollin=Atl=Rivera.[4]

This exhibition offered the Mexican artists an opportunity to show their work under the sponsorship of an established organization with connections to the European avant-garde. But it marked only the beginning of Pach's advocacy of Mexican art. In 1924 Pach published an article in *Harper's,* "The Greatest American Masters," on the pre-Hispanic art of Mexico. He defended Rivera, both in the Rockefeller debacle of the thirties (with articles in the *New York Times* and *Harper's*) and again when protests were launched against Rivera's Detroit Institute of Arts murals. He wrote articles on Mexican art for *Art in America* and introduced American intellectuals to the literary magazines *Hijo Pródigo* and *Cuadernos Americanos,* to which he contributed articles. He was the first foreign critic to write on the nineteenth-century painter Hermenegildo Bustos, and in 1951 he published a book on Rivera.

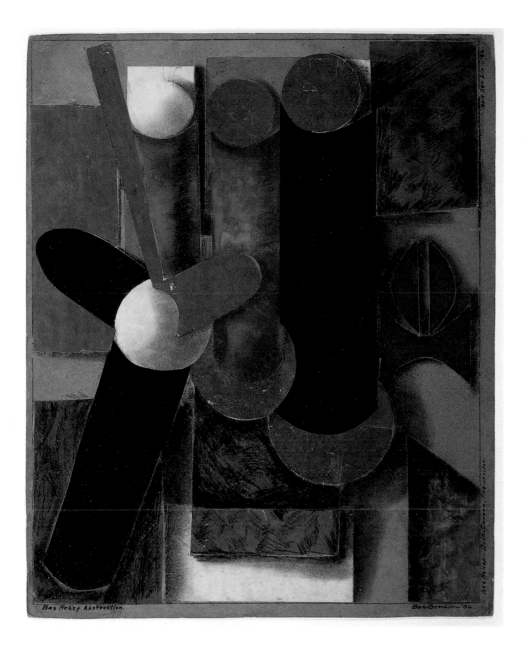

PLATE I
Ben Berlin, *Duck-Cannon-Firecrackers,* 1936. Paper and foil collage on board, 19⅞ × 16 in. The Buck Collection, Laguna Hills, California.

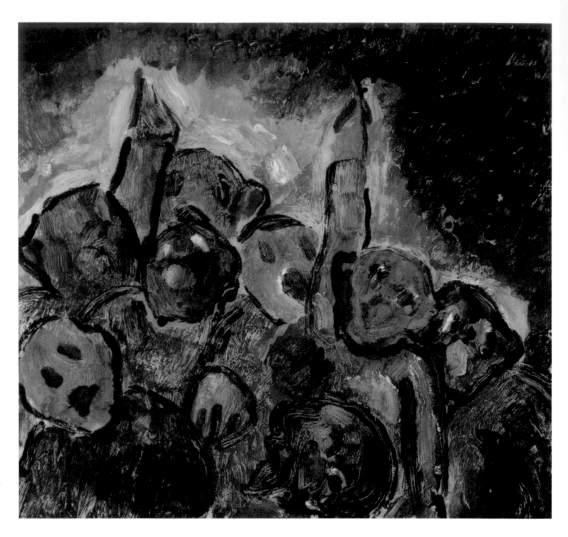

PLATE 2
Edward Hagedorn, *The Crowd,* n.d.
Monoprint /oil on paper, 11 × 15 in.
Getty Center for the History of Art
and the Humanities. © Denenberg
Fine Arts, Inc., San Francisco.

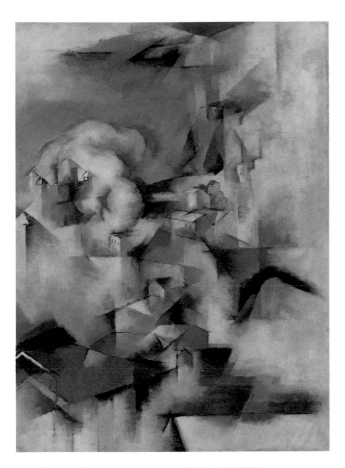

PLATE 3
Stanton Macdonald-Wright,
California Landscape, ca. 1919. Oil
on canvas, 30 × 22⅛ in. Columbus
Museum of Art, Ohio. Gift of
Ferdinand Howald.

PLATE 4
Peter Krasnow, *K-1,* 1944. Oil on
board, 48 × 36 in. San Francisco
Museum of Modern Art, gift of the
artist. Photograph by Ben Blackwell.

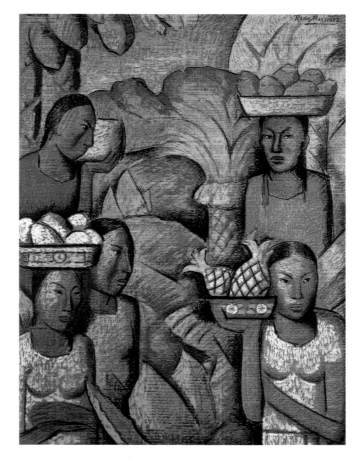

PLATE 5
Above: Hans Burkhardt, *VE Day,*
1945. Oil on canvas, 42 × 52 in.
Photograph courtesy Jack Rutberg
Fine Arts, Los Angeles.

PLATE 6
Right: Alfredo Ramos Martínez,
Vendedora de Frutas (Fruit Seller),
1938. Tempera on newsprint, 21 ×
16 in. Mimi Rogers Collection,
Los Angeles, courtesy Louis Stern
Galleries.

PLATE 7
Opposite: Belle Baranceanu, *The
Yellow Robe,* 1927. Oil on canvas,
44⅛ × 34 in. San Diego Museum
of Art, gift of the artist.

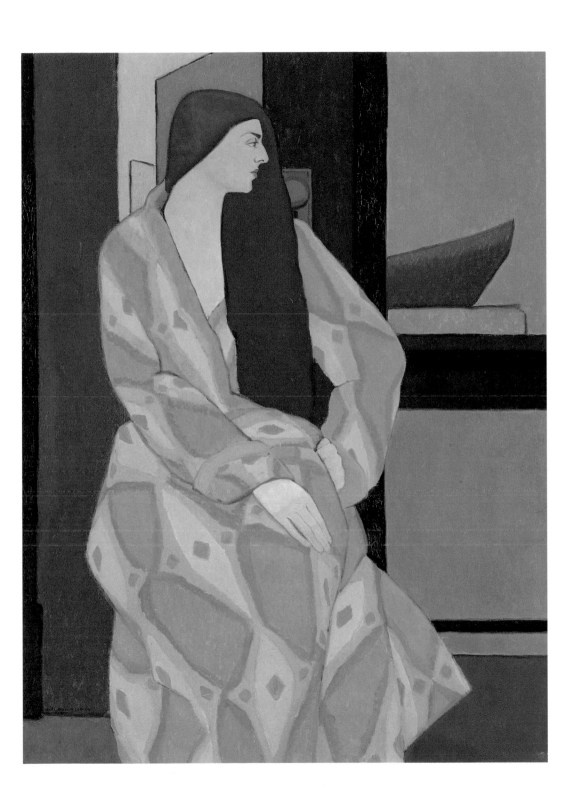

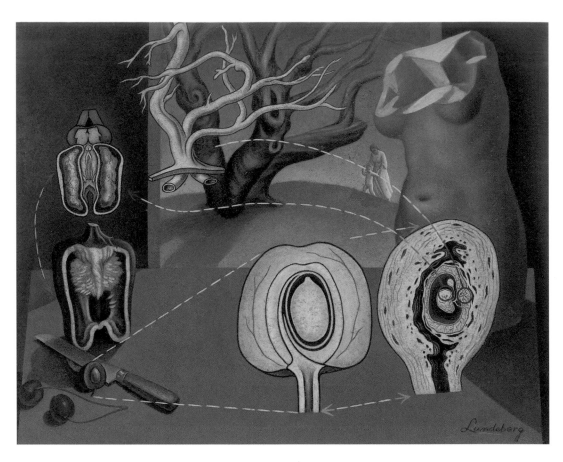

PLATE 8
Helen Lundeberg, *Plant and Animal Analogies,* 1934–35. Oil on celotex, 24 × 30 in. The Buck Collection, Laguna Hills, California.

PLATE 9
Edward Biberman, *The Hollywood
Palladium,* ca. 1955. Oil on celotex
on board, 36 × 48 in. Private collec-
tion, Los Angeles. Photograph ©
Douglas M. Parker Studio, Los
Angeles, courtesy Tobey C. Moss
Gallery, Los Angeles.

PLATE 10
Charles Howard, *The Progenitors,*
1947. Oil on canvas, 24⅜ × 34½ in.
Fine Arts Museums of San Francisco,
Mildred Anna Williams Collection.

Pach and his wife spent the academic year 1942–43 in Mexico, where Pach lectured under the auspices of the Institute for International Education. While his reasons for leaving New York may have been partly financial, Pach was warmly received in Mexico. Shortly after his arrival, the artist Carlos Mérida broadcast a radio essay publicly welcoming him to Mexico and giving a synopsis of Pach's article on Bustos. Letters to Pach from Jean Lipman of *Art in America,* John Strasser, and the painters John Sloan and Marcel Duchamp allude to his activity among the Mexican intelligentsia and artists. After returning to the United States, Pach delivered a lecture in Los Angeles, at the Earl Stendahl Galleries, on ancient and modern Mexican art.

In 1943, as Pach organized an exhibition of Rivera's work, scheduled for February 1944, at the Arts Club of Chicago, a group—consisting of Inés Amor, director of the Galería de Artes Mexicanas; Francisco Orozco Muñoz, director of the National Museum; Eduardo Villaseñor, director of the Bank of Mexico; Diego Rivera; José Clemente Orozco; Alfonso Noriega, Jr., secretary of the National University; and Octavio G. Barreda, editor of the magazine *Hijo Pródigo*—addressed a letter, dated June 9, 1943, to the Minister of Foreign Affairs, Ezequiel Padilla, asking that he name Walter Pach Mexico's cultural representative in the United States. They cited both the urgent need for cultural representation in the United States, given that "the American Government (. . . seems to be interested in better relations and there are indications that they are ready to appropriate funding for this purpose)," and Pach's reputation there. As "a native he could develop cultural propaganda without it being viewed as a paid assignment or as a foreign view; he could address his audience not as 'you,' but rather, as 'we.'" They underscored Pach's importance as a supporter of Mexican art in the United States:

> Mr. Walter Pach, a famous painter, . . . author of nine books on art, as well as 200 articles, a student of the ancient art of Mexico for more than a quarter century, came to our National University by special invitation of Pedro Henríquez Urena. . . .
>
> Upon his return to New York, he immediately organized a Mexican exhibition which for the first time, presented painters such as Diego Rivera, José Clemente Orozco and David Alfaro Siqueiros and it must be said that it was he who successfully introduced our contemporary school of painting in the United States.[5]

Unfortunately for both American and Mexican art, nothing came of this petition.

The Walter Pach papers contain Pach's correspondence with Rivera, Orozco, and Charlot, among others. The letters Pach received from Mexico from 1922 to 1945 suggest the affection and respect the Mexican artists felt for him and show how he acted as an agent and cultural emissary for them. In the late forties the correspondence from Mexico diminished. After Pach's death his writing and critical approach went out of fashion and he was largely forgotten.

Pach's activity as a patron and advocate of Mexican art in the United States demands further investigation, for his wide-ranging interests and correspondence offer tantalizing glimpses into the relationships between Mexican artists and the international art scene. He was, moreover, an independent emissary, a person involved with art and artists for their sake alone. Although he was a friend of the Rockefellers, he was not involved with the foundations or with those institutions whose interest in Mexican art usually developed because of a political or economic self-interest.

Finally, Pach's bicoastal activities—his contacts with the California scene—indicate his awareness of the aesthetic differences between New York and the West Coast. As scholars explore the art scene in California during the twenties and thirties, it becomes increasingly evident from the lively gallery activity and the number of artists working in the state that art in Los Angeles was not dormant, or dull and provincial. Gallery spaces included the Biltmore Gallery, Barker Brothers, the Kanst Gallery, the Assistance League Gallery, the Friday Morning Club, the Ebell Club, Jake Zeitlin's Gallery Bookstore, Stanley Rose's Centaur Gallery, the Howard Putzel Gallery, the Frances Webb Gallery, and the Stendahl Galleries. In 1932 *California Arts and Architecture* magazine published a directory of California artists, craftsmen, designers, and art teachers.

A major contrast between the two coasts, however, and one that is still being assessed, involves the differences between the two areas as a result of California's shared history with Mexico and her geographical proximity, both issues in the interest shown by local artists in things Mexican. During the twenties in particular, some of these artists traveled to Mexico on painting trips, and local exhibitions often featured the works that resulted.[6]

But a contradiction remained between this appreciation of Mexico and its culture and the harsh reality of the discrimination against the Mexican population in California. Nonetheless, in 1923 Los Angeles was host to the first exhibition of Mexican art in the United States, a show organized by Xavier Guerrero, an artist who worked with Diego Rivera on the government-sponsored mural projects. Entitled *The Arts and Crafts of Mexico,* and sponsored by the Mexican government, the exhibition was held at the McDowell Club on Hill Street. It featured watercolors and drawings by Guerrero, Adolfo Best Maugard, and pupils of the art schools of Mexico. Originally it was to tour the United States, but because of problems with the United States Customs Office, it returned directly to Mexico from Los Angeles.

As a result of this exhibition, Guerrero first met Tina Modotti, who was then living in Los Angeles. Married to Roubaix de L'Abrie Richey, a French-Canadian poet, Modotti was performing minor roles in Hollywood films. Their studio was a center of bohemian life, frequented by the photographer Edward Weston, the writer Sadakichi Hartmann (who sometimes used the pseudonym Sidney Allan), and, in 1921, the Mexican archaeologist Ricardo Gómez Robledo. The relationship between Guerrero and Modotti was to flourish in Mexico after her separation from Edward Weston and during the time that she posed as a model for Rivera's Chapingo murals.[7]

These glimpses into the connections of Mexican and California artists suggest the need for a broader view of art and social history. In 1925 the Los Angeles County Museum at Exposition Park inaugurated a new wing with the *First Pan American Exhibition of Oil Paintings.* Opening on November 2, it was scheduled to close on January 31, 1926, but was held over until the end of March because of its popularity. Eighteen thousand people visited it on the first Sunday it was open to the public. It presented 230 artists from the United States and Canada and 145 Latin Americans. The artists from the United States included Thomas Hart Benton, Conrad Buff, Mary Cassatt, Alson Clarke, Maynard Dixon, George Ennis, Childe Hassam, Robert Henri, Rockwell Kent, Guy Rose, John Sloan, and Ralph Stackpole. The twenty-nine Mexicans included Jean Charlot, Joaquín Clausell, Fernando Leal, Roberto Montenegro, Juan O'Gorman, and Diego Rivera.

Of the Latin Americans, the Mexicans were the most strongly represented, both in works displayed and in prizes awarded. The Los Angeles Museum Prize ($1,500) went to Diego Rivera for his painting *Día de Flores* (Fig. 44). The museum announcement says that "Sr. Rivera is a leader of a modern group in Mexico—'Syndicate of Painters.' Walter Pach, the critic, calls him one of the greatest living artists." The Earl Stendahl Prize for landscapes in the Latin American section was divided between Manuel Villareal (Mexico) and Manuel Cabré (Venezuela). The Bivouac Art Club of the Otis Art Institute Prize for portrait or figure painting in the Latin American section was shared by Luis Martínez (Mexico) and María Ramírez Bonfiglio (Mexico).

During the 1920s the painter, muralist, and sculptor Francisco Cornejo, a native Baja Californian who lived and worked in San Francisco in his "Aztec" Studio, and the sculptor Luis Ortiz Monasterio, the father of Mexican modernist sculpture, collaborated on a theatrical work, *Xochiquetzal.* Originally performed in San Francisco by the Denis-Shawn Company, the work was staged at the old Philharmonic Auditorium on the corner of Fifth and Hill Streets in 1925. Cornejo also executed one of the side stages of the Mayan Theatre, a landmark of downtown Los Angeles.

Six years later, after murals had been completed at Pomona and San Francisco (José Clemente Orozco's *Prometheus,* 1930, and Diego Rivera's *Allegory of California,* the Stern mural, and *Construction,* 1930–31), two more exhibitions of Mexican art were held in Los Angeles. The first, a city-sponsored show held in conjunction with the August 1931 Fiesta de Los Angeles, was housed in the Plaza Art Center (renovated by R. M. Schindler) on Olvera Street. Facilitated by the Delphic Studios and the Weyhe Galleries of New York, it was curated by F. K. Ferenc, the center's director, and Jorge Juan Crespo, who was then teaching art at the Chouinard Institute. The exhibition (135 works representing twenty-eight artists) included works by Cantú, Charlot, Clausell, Crespo, Pablo O'Higgins, Leal, Roberto García Maroto, Siqueiros, Orozco, Mérida, Atl, Rivera, Julio Castellanos, Manuel Rodríguez Lozano, and five mural panels by Cueva del Río.

The second show was the Mexican arts show organized by the Rockefeller Founda-

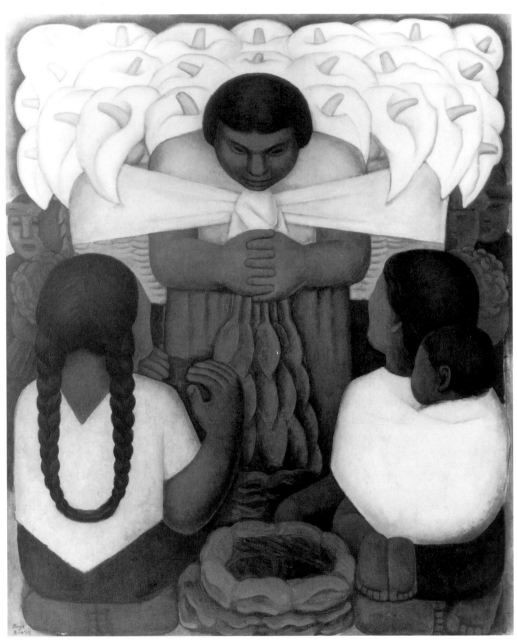

tion and former ambassador Dwight Morrow at the Metropolitan Museum of Art in 1930–31. Opening October 4, 1931, in Los Angeles, it featured lectures by the curator, René d'Harnoncourt, and by Homer Saint-Gaudens of the Carnegie Foundation and received a generous review in the *Los Angeles Times* by Arthur Millier.

The final "legitimizing" event for Mexican art in 1931 was a lecture, "The Revolution in Art Today," by the eminent French critic Elie Faure at the California Arts Club. In it, he recommended a new direction for American philanthropy:

> Much as I love Spain, . . . I can call her conquest of the Aztecs nothing less than brutal. Yet, after the conquest, popular and individual expression of art arose in delightful and gracious forms which continue to the present day.
>
> . . . I cannot understand why Americans who give millions for the restoration of Versailles, do not spend a few millions for the excavation of the . . . temples of Central America and for . . . museums which might be the greatest in the world. You have an obligation in that those Aztecs are your real ancestors, for people are related to the land they live in rather than to their racial stocks.

But the visual presence of Mexican art went beyond exhibitions and lectures. It involved a continuity of influence through artists who taught, wrote, and created art in Los Angeles, introducing modernist aesthetics as well as fresco painting and muralism. It is difficult, however, to assess the importance of such figures as Jorge Juan Crespo, Alfredo Ramos Martínez, Francisco Cornejo, and Jean Charlot in easel painting, muralism, and sculpture. Even the influence of more famous artists, such as David Alfaro Siqueiros, has only partially been studied.

Painter, muralist, and art writer Jorge Juan Crespo taught at Chouinard from 1930 to 1938 with, in 1931, Richard Neutra and Hans Hofmann. Also in 1931 he curated the exhibition of Mexican art at the Olvera Street Gallery and executed for the Sons of Italy Hall a series of murals that disappeared before they could be documented. His writings on emerging European modernists in such catalogues as those produced by the Earl Stendahl Galleries reveal another aspect of the Mexican influence. Most Mexican artists had lived or studied in Europe before coming to Los Angeles. Thus they provided for the West Coast an alternative view of modern art, one that differed from that of the Atlantic seaboard.

Two important figures, Alfredo Ramos Martínez and Jean Charlot, had played major roles in the Mexican visual renaissance before moving to Los Angeles in 1930. Ramos Martínez had studied, lived, and worked in Paris before returning to Mexico in 1910.[8] The Open Air Painting Schools he founded, based on the Barbizon School principle, were probably the single most important influence on the School of Mexican Painting, for through them the study of art became available to everyone. Indeed, one of Ramos's first pupils at the school, established in 1913, was David Alfaro Siqueiros, who never forgot the debt he owed this master. Ramos also served as director of the

National Academy of Fine Arts. He first visited Los Angeles in 1925, when he accompanied an international exhibition of works from his schools to the First Pan American Exhibition. There he met William Alanson Bryan, then the director of the Los Angeles Museum of History, Science and Arts; when he returned in 1930, it was Bryan who facilitated his first exhibition.

Upon arriving in Mexico from France in 1922, Jean Charlot, who had studied painting and lithography in his native country, was invited to begin a woodblock workshop at one of the Open Air Painting Schools in Chimalistac, a suburb of Mexico City. There he introduced his technique, which he had acquired from the German expressionists. In doing so, he gave new impetus to the Mexican graphic movement, which had begun with José Guadalupe Posada at the beginning of the century. He worked with Rivera on the murals at the Ministry of Education, but as Rivera became the dominant muralist, Charlot and others turned to other fields of activity.[9]

The sense of nationalism that pervaded Mexican painting by the mid-twenties may have motivated Charlot to come to the United States. It may have influenced Ramos as well, for José Clemente Orozco had criticized both the Open Air Painting Schools (because they were based on a European model) and Ramos himself. But the condition of his infant daughter may also have brought Ramos to the United States, for he had been advised that the region's dry climate was most suitable for the child. He arrived in Los Angeles with his wife and daughter in 1930, settled down, and began to work.

What is astonishing about Ramos's subsequent work is the shift in subject matter and technique. By experimenting with space and volume and exploring themes that had never before surfaced in his work, Ramos became a major exponent of the School of Mexico (see Plate 6). Even more intriguing is his acceptance by the art community in Los Angeles even as his contributions to the history of art in Mexico were being forgotten; they have only recently been reaffirmed. His first solo exhibition, at the Assistance League Gallery, featured works in the style that was to become associated with his name in California. They are characterized by a strong linear composition and reveal his preference for a palette rich in ochers and brownish tones in his portraits, in contrast with that of the flowers he sometimes included in his portraits and in his still lifes.

By 1933 Ramos had been commissioned to paint a mural at the home of the Hollywood screenwriter Jo Swerling. The year before, David Alfaro Siqueiros, at the invitation of Nelbert Chouinard, had come to Los Angeles to conduct mural workshops, and Ramos had taken him to meet F. K. Ferenc, the director of the Olvera Street Gallery. That meeting led to Siqueiros's commission to paint the notorious mural *Tropical America,* but beyond that, it brought both painters in contact with a group of Hollywood intellectuals, including Swerling, Dudley Murphy, and John Huston, who supported their work and, in Siqueiros's case, his philosophy of using art for social change and revolution. The Swerling mural attracted other patrons, including Corinne Griffith, Edith Head, Alfred Hitchcock, and Beulah Bondi. In 1934 Ramos executed a set of murals for the Santa Barbara Cemetery commissioned by Mrs. George Washington

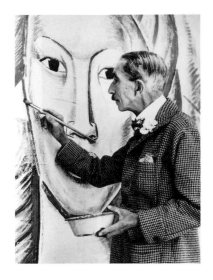

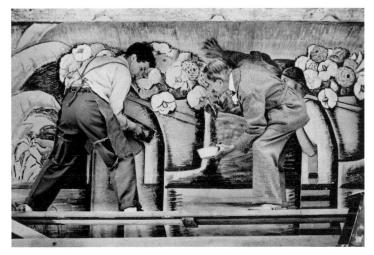

FIGURES 45–47
This page and next: Alfredo Ramos Martínez working on the mural in the Margaret Fowler Garden at Scripps College, 1946. Photographs by Max Yavno. Courtesy Millard Sheets Estate, lent by Paul Bockhorst.

Smith, the widow of the famous architect, and the violinist and composer Henry Eichman; and in 1936, he painted a mural for the oratory of the Chapman Park Hotel (now destroyed).

A quiet man, Ramos was befriended by his peers, who admired him. Hugo Ballin introduced Ramos at his exhibition in the Santa Monica Library in 1933, and one of the first artists to visit him upon his arrival in Los Angeles was Leo Katz. But the most important of Ramos's artist friends was Millard Sheets, with whom he had a lifelong friendship. It was Sheets who arranged the commission for the Margaret Fowler Memorial Garden mural at Scripps College in Claremont (Figs. 45–47). Ramos completed it shortly before his death.

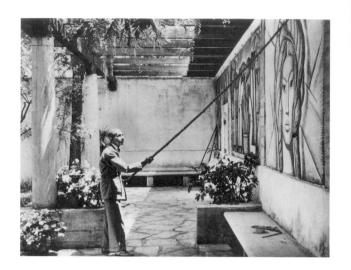

Charlot's stay in Los Angeles was much briefer than Ramos's, but during the years he was there, 1930–38, he worked steadily with the lithographer Lynton Kistler in his Culver City Studio (Fig. 48). In 1936 Charlot and Kistler presented an exhibition of prints at the Santa Barbara Library, showing works by Paul Landacre, Dan Lutz, Phil Paradise, Millard Sheets, and Henrietta Shore. The affection and esteem for Charlot in Los Angeles is evidenced by the farewell dinner arranged for him at Taix Restaurant, attended by the artists Lucille Lloyd, Sheets, Conrad Buff, Beatrice Wood, Alson Clarke, Paul Sample, Stanton Macdonald-Wright, and Kistler; the art writers and critics Rob Wagner, Harry Muir Kurzworth, and Arthur Millier; the gallery directors and owners Jake Zeitlin, William Alanson Bryan, and Dalzell Hatfield; and the collectors and patrons Jean Hersholt, Josef von Sternberg, and William Preston Harrison.

In his conception of both art and the aesthetic experience Jean Charlot foreshadowed contemporary aesthetics; he posited a historical continuity that originated with the pre-Columbian aesthetic. During his years in Mexico, he traveled extensively to the Yucatán, and his incorporation of Mayan concepts of minimalism and monumentality is apparent in his graphic line (Fig. 49). He explored these same ideas in his writings, and his book *The History of Art from the Mayas to Walt Disney* is an early attempt to incorporate non-Western and popular art forms into mainstream art history. A vigorous, energetic, and imaginative man, he eventually moved to Hawaii; he taught at the university there before his death in 1979.

David Alfaro Siqueiros executed three murals in the city that exemplified his aesthetic objective: to use art for social and political purposes. The most controversial, *Tropical America,* treated contemporary Latin American political life and denounced North American imperialism. Of all the controversies over works of art in California during the thirties, the one over this mural left the most lasting impression. The mural itself was whitewashed in 1934 and then covered over because the owner of the Sons of Italy Hall, the building on which it was painted, thought it "ugly." When it became a

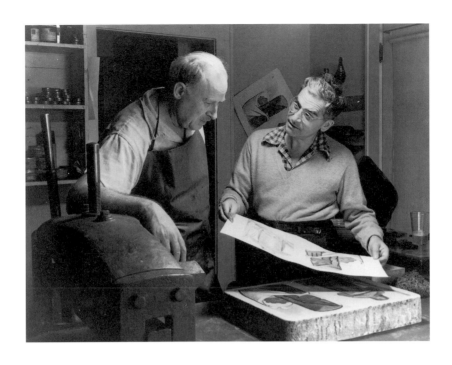

rallying point for the Chicano-Latino artists and community, efforts were made to preserve it, and it is now being restored.

Siqueiros's influence (as well as that of Orozco, Rivera, and Ramos Martínez) on the Los Angeles muralists, particularly Leo Katz, Boris Deutsch, Lucille Lloyd, Fletcher Martin, and Hugo Ballin, is undeniable. Murals executed by Katz (particularly the controversial Los Angeles Trade Technical School mural) include the socio-political themes common in the work of the Mexican muralists; Ballin's *Los Angeles Times* murals and those he painted for the old Department of Water and Power Building at 511 West Fifth Street reveal a careful analysis of Rivera's Detroit Institute of Arts frescoes in their linear construction and spatial composition as well as in the theme of workers in a new industrial age. Lucille Lloyd's *Origin and Development of the Name of the State of California* reveals similar modernist thematic and stylistic influences.

Siqueiros's political orientation gave impetus to the socio-political polemics that flourished in the Los Angeles art community around 1936, when there were sharp divisions between the Internationalists, who opposed the fascist threat in Europe, and the "American" artists, who were essentially isolationists. Passions were fueled by Siqueiros's workshops and by his 1934 lecture at the John Reed Club as well as by discussions at the 1936 American Artists Congress in New York. The "American" group, supported by the Stendahl Galleries, was led by Lorser Feitelson and Helen Lundeberg; the Internationalists, sponsored by the Stanley Rose Gallery, included Leo Katz, Edward Biberman, and Knud Merrild.

During the 1920s and 1930s the Mexican artists were never marginalized or ignored in Los Angeles. Instead, they contributed in a meaningful way to the vibrant local culture and shared a commitment to developing an aesthetics suited to the time. Influential as they were, however, they were themselves influenced by the Los Angeles aesthetic and cultural ambience—Ramos Martínez, in particular. He made an extraordinary shift in his conception of space and volume in his paintings in response to the works of the sculptor George Stanley (for example, the monumental Griffith Park *Astronomers* and the modernist-style Oscar statuette).

The last important Mexican exhibition of the twenties and thirties in Los Angeles was *The Indefinite Period* (1942), a traveling show organized by McKinley Helms at the Institute of Modern Art in Boston. In it were works by Rufino Tamayo, Antonio Ruiz, Carlos Orozco Romero, Dr. Atl, María Izquierdo, Frida Kahlo, Jesús Guerrero Galván, Federico Cantú, and Guillermo Meza, some of whom (Izquierdo, Meza) were exhibiting for the first time in Southern California.

The next exhibition was not until 1953. The migrants who came from the Midwest and the East Coast during the war years looking for work in the growing aircraft industry created a different climate, in which things Mexican were viewed with suspicion. Incidents such as the Zoot-suit riots and the Sleepy Lagoon murder case helped to eradicate the goodwill established during two decades of cross-cultural influences. The focus of American art, and thus American art history, shifted eastward. As it did, the Mexican artists and their work faded from memory, and an important part of Southern California's cultural history was almost forgotten.

Notes I am grateful to the Smithsonian Institution and to the Archives of American Art for granting me a Senior Postdoctoral Fellowship for 1990–91, which afforded me the opportunity to conduct the research for this essay. I would also like to express my appreciation to Paul Karlstrom and Barbara Bishop of the Archives West Coast Regional Center, Huntington Library, for their guidance and assistance.

My thanks also to Michael Marcellino, editor of *Latin American Art* magazine, who published a preliminary version of this essay in the fall of 1990, and to Louis Stern, who invited me to collaborate in his important retrospective of the works of Alfredo Ramos Martínez in 1991.

Unless otherwise noted, all documentation for this essay is to be found in the Walter Pach papers, Archives of American Art, Smithsonian Institution, and in the Ferdinand Perret papers on the history of art in California, also at the Archives.

1. Because Mexican twentieth-century art incorporates the country's indigenous past into its aesthetic, there has been a tendency to exclude Mexican and Latin American art in general from the modernist discourse, given that modernism has been viewed exclusively as a European and North American movement. Yet these premises of the "other" in themselves offer new possibilities for exploring the modernist aesthetic. Moreover, the term "modernism" was first used in Latin America during the final two decades of the nineteenth century. The first important twentieth-century literary movement in Latin America is "Modernismo," its origin marked by the 1888 publication of the Nicaraguan poet Rubén Darío's book *Azul*.

2. The contributions of the major Mexican muralists have been thoroughly covered in Laurence P. Hurlburt, *The Mexican Muralists in the United States* (Albuquerque: University of New Mexico Press, 1989).

3. William C. Agee, "Walter Pach and Modernism: A Sampler from New York, Paris, and Mexico City," *Archives of American Art Journal* 28, no. 3 (1988): 2–10; and Nancy Malloy, *Discovering Modernism: Selections from the Walter Pach Papers,* exh. cat., February 15–April 13, 1990, New York Regional Center, Archives of American Art, Smithsonian Institution.

4. Walter Pach papers, roll 532, frames 682–85.

5. Walter Pach papers, roll 4219, frames 82–87, letter dated June 9, 1943.

6. Alson Clarke and Garrett Hale made painting trips to Mexico in 1922, 1925, and 1931. They showed the works they produced on these trips in local galleries according to Alson Clarke, Jr., interviewed by Margarita Nieto, September 6, 1990.

7. See Mildred Constantine, *Tina Modotti: A Fragile Life* (New York: Rizzoli, 1983). A more recent and thorough source is Elena Poniatowska's *Tinísima* (Mexico: Ediciones Era, 1992).

8. Ramos Martínez was the subject of a major exhibition in October 1991 at the Louis Stern Gallery, Beverly Hills, California. The illustrated catalogue accompanying the show included essays by Jean Stern, María Ramos Bolster, and Margarita Nieto. Because of this show, a major retrospective of Ramos's work was organized in 1992 at the Museo Nacional de Arte, Mexico, D.F.; its catalogue included essays by Louis Stern, Margarita Nieto, and others. See also Margarita Nieto, "Art without Borders: Alfredo Ramos Martínez," *Antiques and Fine Arts* (November–December 1991).

9. Jean Charlot's contributions to the art history of Mexico have been covered in part in *Mexico en la obra de Jean Charlot,* a catalogue for an exhibition at the Colegio de San Ildefonso (Mexico, D.F.), spring 1994.

EXPRESSING A

CULTURAL IDENTITY

David Gebhard

WOOD STUDS, STUCCO, AND CONCRETE:

NATIVE AND IMPORTED IMAGES

California architecture has enjoyed an international renown since the early years of this century. A mention of California and its architecture brings to mind the work in Northern and Southern California of the 1920s through the 1950s of such modernist "name-brand" designers as R. M. Schindler, Richard J. Neutra, Lloyd Wright, and William W. Wurster. California's peculiar social and physical environment also inspired a number of nonregional figures—Bertram G. Goodhue, Frank Lloyd Wright, Eric Mendelsohn, and Louis I. Kahn—to design some of their most significant buildings within the state.

European and American architectural journals after World War II regularly discussed and illustrated the designs of the Bay Area architects Joseph Esherick and Charles Moore, and, in Southern California, John Entenza's *Arts and Architecture* Case Study House program elicited widely admired examples of modernist design. The work of Frank O. Gehry, Eric Owen Moss, and others, moreover, now garners as much attention worldwide as their modernist predecessors did from the twenties through the fifties.

In architecture the impact of the state's traditionalists has been as impressive as that of the modernists. The work of traditionalist architects like George Washington Smith and Wallace Neff firmly established the Spanish Colonial revival nationwide in the 1920s. And America's love of period revival was firmly asserted in the residential work of such California architects as Paul R. Williams, Gordon B. Kaufmann, Reginald D. Johnson, Roland E. Coate, and Gardner Dailey.

How these and other California architects have dealt with the relationship between structure, materials, and imagery constitutes yet another important contribution to twentieth-century architecture. In their writings about this relationship, these architects evoked images as complex and often as contradictory as their modernist and traditional architectural images.

In its August 14, 1936, issue the Los Angeles–based magazine *Southwest Builder and Contractor* published an excerpt from a talk given by Leicester B. Holland of the Division of Fine Arts, Library of Congress. Himself an architect, Holland wrote often on architecture during these years; he was a highly articulate opponent of modernist architecture, then emerging.[1] In his 1936 talk, he addressed the relation between the objective, functional element of architecture and the nonmeasurable aesthetic element:

> To the mathematician $6 + 2$ amounts to just as much as $5 + 3$; to the architect it may be considerably less; while $4 + 4$ may total up to a great deal more. Why it should be that the whole is something so much greater than the sum of all of the parts I cannot say, except that architecture is an art, and that is the nature of art.[2]

Holland equated mathematics, his frame of reference, with what is rational, objective, and measurable in architecture.

Holland was thinking not only of the game the modernists were then playing with the illusion of function and the fact of aesthetics, but of the whole European-American tradition of hiding aesthetic decision behind the notion of utility and function. From the late nineteenth century on, the architects of California not only participated in this game with great delight but also developed new ways to play it. Holland's reference to mathematics and the mathematician should be translated into those aspects of architecture which are measurable and factual—such architectural elements as structure, materials, construction technology, and a building's mechanical core as well as the response of a building and its site to the specific environment and the social, political, and economic conditions of the time.

The nonmathematical element in architecture—more important to Holland than utility and function—is the design of buildings, architecture as "art": the aesthetics of proportion and scale; the use of past architectural images; the use of architecture and siting to create illusions of place and connections to other places, distant in location or remote in time.

The creation of illusions of contrast and contradiction has always been part of architecture and became a staple of California architecture. Particularly in Southern California, architects seized the opportunity not only to project buildings onto a site but also, through the symbols embodied in architecture and landscape architecture, to transform a whole landscape. The illusions could be far-reaching. The first concerted effort in Southern California to transform buildings and the landscape into something specific to the place was the mission revival episode (ca. 1890–1920). Clients and their architects and landscape architects looked to the late-eighteenth- and early-nineteenth-century mission churches of California for an image. Their romantic view of the missions and of mission life often verged on fantasy, but then fantasy often is far more "real" than reality itself.

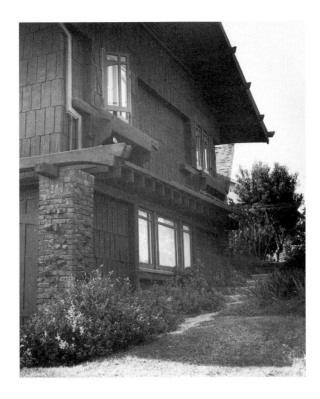

FIGURE 50
Albert Walker and John Vawter,
architects, Frank C. Hill Bungalow,
Los Angeles, 1911.

By about 1915 direct reference to the architecture of Mexico and of Spain had re-
placed the mission image. In the 1920s the whole of Southern California seemed about
to be transformed into a new, much improved, Mediterranean world. The interest of
both the public and the architectural community in the Mediterranean/Hispanic image
continued into the 1930s with the Monterey revival and on into the present with the
California ranch house. From moment to moment, certain exotic elements were incor-
porated into the Mediterranean/Hispanic revival, such as forms and details derived
from the pueblo or Santa Fe style of the American Southwest, the pre-Columbian of
Mexico and Central America, and the Islamic of southern Spain and North Africa.

The built-in complexity and even contradiction in the architectural manipulation
of image and place are apparent in the history of the bungalow in Southern California
(Fig. 50). While some elements of the bungalow had tenuous precedents in the tradi-
tional architecture of the state (the nineteenth-century Anglo board-and-batten ranch
houses and the earlier patio-oriented Hispanic adobe dwellings), their prime source was
the East Coast shingle houses, to which were added occasional references to traditional
Japanese architecture.

In the quasi-desert of Southern California these wood frame houses made no sense.
The lumber to build them came from Northern California or Oregon, and only their

wide overhanging roofs (and the planting of non-native vegetation) protected their exposed wood members in the dry, hot climate. Yet once introduced, these one- and two-story bungalows quickly seemed to imply that they were native to the place. With remarkable rapidity, the California bungalow became not only a national but also an international fashion.

In writing and talking about the bungalow and other images associated with California, architects and promoters argued that each of these Southern California styles developed, not because of aesthetic decisions, but because of purely logical, rational, and "mathematical" considerations. They pointed out, for instance, the logic of using cement stucco or concrete, claiming that these new materials both mirrored the past and spoke to the present needs of the region. They also referred to the informal life of the Southland, noting that this affected the arrangement of spaces and led to a breakdown in the distinction between indoor and outdoor spaces.

One of the best ways to see how Southern California played the game of the mathematical and nonmathematical would be to analyze the results of concrete construction, introduced in the first four decades of this century. What was the relation between the measurable, logical, and mathematical elements of this new structural material and their expression?

There are two ways to approach this question. The first is to look at the factual expression of materials, structure, and mechanical systems—to read how a building is put together; what its features and components are; and what plumbing, heating, and cooling systems are used. We can note how the building is to be used and how it responds to these utilitarian requirements. The second approach is to examine how the forms, surfaces, and details of a building symbolize what is measurable and utilitarian about it. For example, the thin structure of two-by-four-inch wood stud construction would be apparent to a viewer in the building's detailing.

Architectural history illustrates that a readable representation of the mathematical, factual, or symbolic is almost impossible. This has proved the case in most buildings constructed in this century, for although some materials and structures can be made apparent—say, the structural grid of a steel frame building—others cannot. The modernists were never able to solve the difficult problem of declaring a building's function. Thus designs for a public meeting hall, a commercial structure, or a multifamily unit seem always to turn out looking the same (architects have admitted their failure to articulate function by frequent recourse to signage).

The mission revival style and the bungalow, the first two self-conscious regional developments in California, illustrate the near-hopeless entanglement of fact and image. To be successful, a building in the mission style should convey the feel of masonry architecture (of adobe or rough fieldstone held together by lime mortar). While a few adobe structures have been built in California in the twentieth century, most mission revival buildings were not adobe. Instead, the revival had recourse to modern technology: a wood stud frame, hollow terra-cotta tile, or concrete was covered over with stucco, symbolically suggesting a relationship to the historical forms.

Symbolism—of materials, structure, and the arrangement of exposed building details—was a paramount theme of the California bungalow. Bungalow designs, ranging from the high-art versions of Charles and Henry Greene to the modest speculative dwellings of builders and development companies along many streets, delighted in playing the game of architectural symbolism. Exposed heavy timber members were often used throughout the building, as posts to hold up the roofs of porches or as projecting rafters to support the broad cantilevered roofs. In one way or another this use of exposed timbers was structurally fake. There was no need for timber posts of the size that was used. Nor did exposed rafter ends generally reflect the actual roof rafters, for they were normally attached as outriggers (the real rafters were modest timbers, 2×6 or 2×8 inches).

Inside these bungalows a proliferation of exposed wood members hints that we are seeing structure, but in most instances we are not; the wood is applied to the surface, hiding the actual structural members. Openly presented dovetail and pegged joints exist more often than not as symbol, not as fact. All this material and structural symbolism was effective in establishing the character of the bungalow. It was a problem only when morality in architecture became an issue, as when the Arts and Crafts movement pretended to argue for the "honest" expression of materials and structure.

In Southern California the give-and-take relationship between the mathematical and nonmathematical elements of architecture can be pointedly illustrated in the designs of Irving J. Gill. Over the years Gill has been presented as an early pioneering exponent of modernism, an architect in love with the technology of concrete.[3] His work has often been compared to that of the Viennese early modernist Adolf Loos. Indeed, in their common striving for a demanding puritanical simplicity, they have a strong kinship.[4]

Gill's experience with technology (the mathematical) demonstrates that his primary concern, like that of most exponents of the Arts and Crafts movement, was the symbolism of technology more than the fact. Gill's fascination with the new technology was essentially romantic. As Esther McCoy noted in her 1960 classic volume *Five California Architects,* Gill "was to bring concrete to the architectural importance of stone."[5] As an architect he coupled his focus on aesthetics with a desire that his building reflect what he conceived as the character of the region, in his case Southern California—both its environment and its history and myth.[6]

One new material that intrigued architects from 1900 on was concrete, especially its possibilities for use in domestic architecture.[7] Concrete, it was felt, would replace wood and both brick and stone masonry. Its potential was endless. It could be used for gravestones, for birdhouses, for ornamental dog kennels, as well as for concrete ships and large apartment buildings.[8] Francis S. Onderdonk, the engineer and advocate of reinforced concrete, wrote in 1928 that

the picturesque term "Liquid Stone" may have for many of us a shockingly unreasonable sound. Nevertheless it does express a combination of qualities that is to be found in cast

concrete. . . . When we add to this stone like result the reinforcing ribs of steel to carry our tensile stresses, we have indeed a material and method which may easily create a revolution in the architectural world.[9]

The potential of the new material was explored nationwide from 1900 through the 1920s. Thomas Edison spent a number of years trying to produce an inexpensive monolithic concrete house.[10] Concrete was employed by both traditionalist designers and the avant-garde. Frank Lloyd Wright experimented with concrete in several of his early-twentieth-century Prairie houses and in such monuments as the Larkin Building in Buffalo, New York (1904), and the Unity Temple in Oak Park, Illinois (1906).[11] Wright's fascination with concrete led him in the teens and twenties to develop textured concrete block, which he used in such buildings as the Midway Gardens in Chicago (1913) and the German Warehouse at Richland Center, Wisconsin (1915), and then in a series of concrete and concrete-block houses in the Los Angeles area, built from 1917 to 1924.

A number of buildings by traditionalist architects were technologically even more innovative than Wright's. The Beaux-Arts-trained New York architect Grosvenor Atterbury developed a complex method of manufacturing large-scale precast concrete panels for many of his buildings at Forest Hills Garden on Long Island from 1909 to 1913.[12] Cass Gilbert, the designer of New York's Gothic Woolworth Building, employed monolithic reinforced concrete to create a dramatic cubist play of forms and surfaces in the group of buildings he designed in 1918 for the U.S. Army Supply Base in Brooklyn, New York (Fig. 51).[13]

Concrete, and especially reinforced concrete, had been used for buildings and structures on the West Coast since the 1880s. Its early use in Northern California by Ernest L. Ransome has long been known and recognized.[14] Less well known was its introduction to Southern California, where from the late 1870s on it was employed for buildings ranging from powerhouses to meeting halls.[15]

Trade and technical journals published on the West Coast after 1900 contain numerous articles and advertisements advocating concrete construction. According to the architect Harris C. Allen, before 1930 concrete had emerged as a logical mode of construction exceptionally well fitted to "a style which now fairly [can] be called 'Californian,' [a style] based upon the traditional and appropriate Spanish-Colonial architecture of early California and Mexico, and finding much of congenial inspiration on the Mediterranean shores of Italy, France and Spain."[16] Concrete walls, covered with stucco or left exposed, were seen as a twentieth-century continuation of the traditional California architecture of the missions and adobe houses (Fig. 52).

Companies such as the Pacific Concrete Machinery Company produced the "Hercules" machine to mold block while the Concrete House Building Company constructed entire poured-in-place buildings.[17] These monolithic buildings were al-

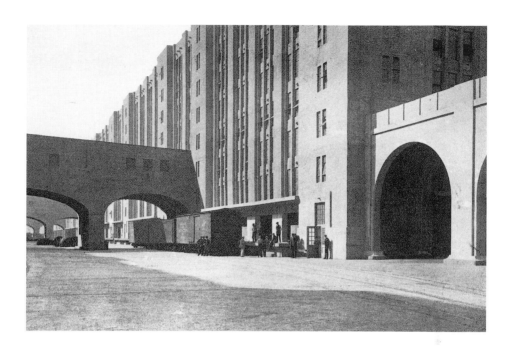

FIGURE 51
Above: Cass Gilbert, architect, U.S.
Army Supply Base, Brooklyn, 1918.
Photograph from *Architectural Forum,*
January 1921.

FIGURE 52
Henry L. Wilson, architect, "Design
for a Concrete Apartment House,"
Los Angeles, 1910. Photograph from
Concrete, April 1910.

ways far more expensive than structures of wood, hollow tile, or steel. In Southern California, its early use was restricted to commercial and industrial buildings and a few single-family houses for the upper-middle class and the wealthy. The architect Charles F. Whittlesey avidly promoted concrete construction (Fig. 53), using it in many of his hotels, railroad stations, and large houses in Los Angeles.[18] Other famous architects of the L.A. scene, Myron Hunt, Elmer Grey, and Arthur B. Benton, also designed concrete residences prior to 1910.[19]

One reason for the high cost of reinforced concrete construction was the need to erect wood or metal forms and then dismantle them after the concrete had been poured. Inventors, engineers, contractors, and architects proposed a wide array of solutions to this problem. Precast concrete blocks, of a size workers could handle, were one solution. Another, used by the engineer E. Duryee for his own 1909 house in Los Angeles, was the movable slip form. "Enough [forms] were used to build one foot of wall around the entire building and they were raised one foot daily after the first pouring."[20] In his J. Wesley Roberts House on Berkeley Square, Los Angeles (1910; Fig. 54), the architect B. Cooper Corbett used prebuilt reinforced concrete panels for his forms. It was noted that "these will not be removed but will become part of the permanent structure furnishing the finished surfaces."[21]

Still another method of erecting concrete walls was the lift-slab technique. A patent for one of its most widely known versions was issued in 1908 to Robert H. Aiken of

FIGURE 53
Opposite: Charles F. Whittlesey,
architect, Barttlett (Mrs. J. W. Walker)
House, Los Angeles, 1906.
Photograph from *Western Architect,*
November 1912.

FIGURE 54
Above: B. Cooper Corbett, architect,
J. Wesley Roberts House, Los Angeles,
1910. Photograph from *Southwest
Contractor and Manufacturer* 4
(January 1, 1910).

Winthrop, Illinois.[22] Thomas Fellows developed a variation on the Aiken system in Los Angeles in 1910 and used it to construct a low-cost demonstration house.[23] Fellows had the modular wall units cast horizontally on the ground; afterward, they were lifted into place by a mechanical crane. The interior side of each slab contained a row of eyebolts, through which a steel rod was inserted connecting each of the slab units. The narrow vertical space containing the eyebolts and steel rod was then grouted in.

On the West Coast, especially in and around Los Angeles, architects and engineers involved in concrete construction were eager to develop an economically viable system of hollow-wall construction. It would help to solve moisture problems, as well as those of heat loss and gain. By the early 1920s a myriad of solutions had been proposed (Fig. 55), ranging from the early Pelton Concrete Tile wall to the elaborate Hillman system, which was marketed by the Monolithic Hollow Concrete Form Corporation.[24]

"Concrete is not merely a product of raw materials," the structural engineer Homer M. Hadley wrote in 1931; "it incorporates the contractor's workmanship, the engineer's ideas of proportion and manufacture; the architect's conception of final shapes and forms."[25] Though Irving J. Gill's buildings were often cited as innovative technological (mathematical) applications of reinforced concrete, his real concern, as he himself made apparent, was the aesthetic realm "of final shapes and forms," coupled

with the stern morality associated with the Arts and Crafts movement and an intense interest in developing a new twentieth-century regionalism out of California's past.

Gill's use of concrete in fact had much more to do with appearance than with the latest technology. In a 1914 article on Gill's architecture, the writer Bertha H. Smith noted that Gill "had chosen concrete as his medium of expression. . . . To an incorrigible modern, the choice of concrete is a natural one." [26]

In a Gill building, it is almost impossible to discern the actual structure. Like many other architects throughout the country (especially in California), Gill used hollow terra-cotta tile blocks, sheathed in thick cement stucco, for many of his designs through the 1920s. [27] In some instances, such as the 1907 Laughton House in Los Angeles, the walls were entirely of hollow terra-cotta tile blocks, reinforced horizontally and vertically at key points by steel and concrete. After 1910 Gill often laid out a concrete frame and in-filled it with hollow tile. Finally, for several of his more expensive dwellings, like the well-known Dodge House in Hollywood (1916) and the Clark House at Santa Fe Springs (1919–22), he employed solid reinforced concrete walls and concrete floors and roofs.

Since all these walls were sheathed in stucco outside and plastered inside, a viewer cannot discern the actual structure, which looks like solid concrete. Similarly, the floor in his structures is always colored concrete. But in some cases it consists of a thin layer of concrete (held together with a wire mesh) poured over a wood floor; in others, it is a reinforced concrete slab.

The myth of Gill as an avant-garde technological innovator was perpetuated by many who wrote about his work in the teens and by Esther McCoy and others in the late 1950s and early 1960s. [28] McCoy pointed to Gill's early use of the Aiken lift-slab technology in the Banning House in Los Angeles in 1912 and in the large La Jolla Women's Club building of 1913. [29] In 1912 Gill purchased the patent rights of the bankrupt Aiken Reinforced Concrete Company and formed his own Concrete Building and Investment Company. But the Aiken lift-slab system turned out not to be very useful in concrete construction, and Gill did not employ it much after 1913. [30] It was technically difficult to carry out (Fig. 56), and its cost exceeded that of even normally expensive concrete construction.

Though Gill's structures had the look of modernist technology, his real interest was a purist's approach to design. In 1913 the editors of the *Independent* magazine caught the essence of his thinking in an article entitled "Concrete Curves and Cubes," describing him as "a Western architect who had deliberately limited himself to the cube, the hemisphere, the rectangle and the segment of a circle." [31] An article on his 1910 Lewis Court in Sierra Madre described his work in similar terms: "Although the houses are little more than cubes, they are set in such a way that they do not offend the eye, and their square towers cut into the blue sky of California with picturesque severity." [32]

No matter how often Gill and his supporters wrote and talked about technology (the mathematical) and about the virtue of pure forms, for viewers these buildings

FIGURE 56
Above: Irving J. Gill, architect, Aiken
system of concrete construction,
Scripps Recreation Center, La Jolla,
California, 1914–15. Photograph
courtesy Architectural Drawing
Collection, University of California at
Santa Barbara.

FIGURE 57
Opposite: Irving J. Gill, architect,
Ellen B. Scripps House, La Jolla,
California, 1914–15. Photograph
courtesy Architectural Drawing
Collection, University of California
at Santa Barbara.

carried references to the past and to the region. In relation to site and in the romantic contrast between rich foliage and white stucco walls, Gill's work fit in easily among the varied revivals of the time: mission, Spanish, and Mediterranean (Fig. 57). The English artist Maxwell Armfield, who encountered Gill's architecture in La Jolla, California, wrote, "He has ingeniously used his materials to include in its design shapes that recall the Spanish adobe building of the district without in any way copying their distinct method."[33] Gill was quite self-conscious about his relationship to California's past. In a 1916 article he noted that

> California is influenced, and rightly so, by the Spanish Missions. . . . The Missions are a
> part of its history and they should be preserved. . . . The facade of the San Diego Mission is
> a wonderful thing, something that deserves to be a revered model, something to which local
> building might safely and advantageously have been keyed [Fig. 58].[34]

While Gill's "gospel of the beauty of use, and the use of perfect simplicity" set him off from many other California architects of these years, still he shared with them more

points of common interest than of dissimilarity.[35] His hide-and-seek game with reinforced concrete structure; his interest in pure form, "the source of all architectural strength"; and his references to the past have also characterized the work of almost all the architects who practiced in the Southland from the late nineteenth century to the present.[36]

The gamesmanship of expressing or hiding the nature of a structure and its materials was also an essential ingredient of the avant-garde California designs of Frank Lloyd Wright, Bernard Maybeck, R. M. Schindler, and Richard J. Neutra. Wright, in his textured concrete block houses of the early twenties in Southern California, let his viewer know that the walls were of modular block, but he carefully concealed the structure of double walls tied together with metal, and he provided no clue whatsoever to the structure for his floor and roof planes. Maybeck's work—his Anthony House in

Los Angeles (1927), for example—sometimes made the use of concrete structural forms apparent, but usually did not. As avowed modernists, Schindler and Neutra cultivated the illusion that structure in their buildings exemplified the latest technology, but in truth this was only partially the case.

The hide, show, and tell character of structure in California's architecture continues in the present work of postmodernists and deconstructionists. Whereas Gill and other earlier California architects provided strong clues to the structural form of a building, for postmodernist architects like Frank O. Gehry, the Morphosis group, Eric Moss, and others, structure (and materials) are delightful playthings and nothing more. Here and there the postmodernists vary the structure they employ, but always for aesthetic reasons, not to reflect or even hint at how a building has been put together.

Again addressing the nonmathematical nature of architecture, Leicester Holland wrote that

> one may reasonably aim at expression of construction rather than exposure of construction, for certainly all objects in nature express their construction, though it is rarely literally exposed. . . . A quiet chat with an anatomical convive, lolling, as it were, in his viscera, would be very difficult for me.[37]

And so it was with the use of reinforced concrete in Southern California architecture. Its use in a building might indeed be revealed, but the final design of the structure ("the whole is sometimes much greater than the sum of all the parts") has always had more to do with a concern for form and historical reference than with the mathematical and technological ideals of modernist functionalism.[38]

Notes

1. Holland's other publications include "The Function of Functionalism," *Architect and Engineer* 125 (August 1936): 25–32, and "Nudism and Modern Architecture," *Architect and Engineer* 128 (March 1937): 39–42.

2. Leicester B. Holland, "Exaggeration of Functionalism in Current Architecture Criticised by Savant," *Southwest Builder and Contractor* 88 (August 14, 1936): 19.

3. See Esther McCoy, *Irving Gill, 1870–1936* (Los Angeles County Museum, 1958), and "Irving Gill," in her *Five California Architects* (New York: Reinhold, 1960), 59–101.

4. McCoy, *Five California Architects,* 71, 73; William H. Jordy, *American Buildings and Their Architects: Progressive and Academic Ideals at the Turn of the Century,* vol. 3 (Garden City, N.Y.: Doubleday, 1972), 256–58.

5. McCoy, *Five California Architects,* 97.

6. David Gebhard, "Irving Gill," in *California Design, 1910,* ed. Timothy J. Anderson, Eudorah M. Moore, and Robert W. Winter (Salt Lake City: Peregrine Smith, 1980), 112–18.

7. Joseph Bell, *From the Stone Age to the Space Age* (New York: National Concrete Masonry Association, 1969), 1–32.

8. "Concrete Grave Stones," *Concrete* 10 (January 1910): 43; "An Architect of Bird Residences," *Popular Mechanics* 21 (March 1914): 371; "Ornamental Dog Kennel Made of Concrete," *Popular Mechanics* 21 (January 1914): 105; "Concrete Shipbuilding Industry Organizing," *Southwest Builder and Contractor* 53 (January 17, 1919): 78; "Plan for Twelve-Suite Apartment House of Stucco Construction," *Concrete* 10 (April 1910): 65.

9. Francis S. Onderdonk, "Ferro-Concrete and Design," *Architecture* 57 (May 1928): 241.

10. "Beats Edison Concrete House," *Southwest Builder and Contractor* 26 (May 6, 1911): 21.

11. Frank Lloyd Wright, "A Fireproof House for $5000," *Ladies Home Journal* 24 (April 1907): 24; Russell Sturgis, "The Larkin Building in Buffalo," *Architectural Record* 15 (April 1908): 310–21; "Unity Temple and Unity House, Oak Park, Ill.," *Inland Architect and News Record* 52 (December 1908): 77.

12. Frederick Squires, "Houses at Forest Hills Garden," *Concrete-Cement Age* 6 (January 1915): 3–8; 53–56.

13. Francis S. Onderdonk, *The Ferro-Concrete Style* (New York: Architectural Book Publishing Company, 1928), 5.

14. C. W. Whitney, "Ransome Construction in California," *Architect and Engineer* 12 (April 1908): 49–57; "Tribute to Ernest L. Ransome," *Architect and Engineer* 49 (April 1917): 101–2.

15. "Early Reinforced Concrete Construction," *The Builder and Contractor,* no. 1106 (June 4, 1914): 1; David Gebhard and Harriette Von Breton, *Architecture in California, 1868–1968* (Santa Barbara: The Art Galleries, 1968), 16, fig. 37.

16. Harris C. Allen, "The Influence of Concrete on Design in California," *Journal of the American Institute of Architects* 16 (October 1928): 389.

17. Pacific Concrete Machinery Company advertisement, *Los Angeles Builder and Contractor* (February 1906): 5; Concrete House Building Company advertisement, *Los Angeles Builder and Contractor,* no. 568 (January 14, 1904): 8.

18. Charles F. Whittlesey, "Reinforced Concrete Construction—Why I Believe in It," *Architect and Engineer* 12 (March 1908): 37–67.

19. Myron Hunt and Elmer Grey, "Some Concrete Country Homes on the Pacific Coast—Concrete Residence of G. W. Wattles, Hollywood, Cal.," *Concrete* 10 (February 1910): 42–43; Arthur B. Benton, Contract Notice for the A. M. McClaughry House, Sierra Madre, a "12 room reinforced concrete residence" (*Southwest Contractor and Manufacturer* 4 [April 30, 1910]: 6).

20. "Monolithic Concrete House Built by Los Angeles Man," *Concrete* 10 (October 1910): 35.

21. "New Reinforced Concrete Residence Construction," *Southwest Contractor and Manufacturer* 4 (January 1, 1910): 14.

22. Roger Hatheway and John Chase, "Irving Gill and the Aiken System," in *Concrete in California* (Los Angeles: Carpenters/Contractors Cooperation Committee of Southern California, 1990), 21.

23. "Trying to Solve the Problem of Fireproof Construction for Small Residences," *Southwest Contractor and Manufacturer* 6 (April 15, 1911): 18–19.

24. *Southwest Builder and Contractor,* the Los Angeles trade journal, published a series of ten articles (vols. 56–58, November 12, 1920–September 2, 1921) presenting various concrete hollow-wall systems then in use in Los Angeles.

25. Homer M. Hadley, "Some Observations on Architectural Concrete," *Architect and Engineer* (February 1931): 51–52.

26. Bertha H. Smith, "Creating an American Style of Architecture," *House and Garden* 26 (July 1914): 19.

27. "Hollow Clay Blocks for Residential Construction," *Southwest Contractor and Manufacturer* 4 (November 13, 1909): 14–16; "Hollow Tile Popular for Residential Construction," *Southwest Contractor and Manufacturer* 4 (January 8, 1910): 14–15; "Growth of the Hollow Tile Industry," *Southwest Builder and Contractor* 53 (January 17, 1919): 7.

28. Roger Hatheway and John Chase, "Irving Gill and the Aiken System" (as in note 22), 22–29.

29. Esther McCoy, "Irving Gill," in *Five California Architects* (as in note 4), 75, 79.

30. Gill, however, as late as 1919 advocated the Aiken system. See "Pre-cast Walls for the Concrete House," *Keith's Magazine* 38 (October 1917): 223–26.

31. "Concrete Curves and Cubes," *Independent* 75 (August 28, 1913): 515.

32. "Garden Apartment Houses of the West," *Touchstone* 5 (April 1919): 24.

33. Maxwell Armfield, *An Artist in America* (London: Methuen, 1925), 75–76.

34. Irving J. Gill, "The Home of the Future: The New Architecture of the West: Small Homes for a Great Country," *Craftsman* 30 (May 1916): 148, 151.

35. Bertha H. Smith, "Creating an American Style of Architecture" (as in note 26), 18.

36. Gill, "The Home of the Future," 142.

37. Leicester B. Holland, "The Function of Functionalism" (as in note 1), 27.

38. Holland, "Exaggeration of Functionalism in Current Architecture Criticised by Savant" (as in note 2), 19.

Bram Dijkstra

EARLY MODERNISM IN

SOUTHERN CALIFORNIA:

PROVINCIALISM OR ECCENTRICITY?

An encounter between Lorser Feitelson and Edward Hopper in the mid-fifties pointedly illuminates the price an artist must pay for not living in New York City. "Jesus," said Hopper, startled at seeing Feitelson, "I thought you had died somewhere way out in California a long time ago!" "I did," replied Feitelson, "but I wanted to be buried in New York, so they shipped me back here."[1]

To the East Coast art establishment the West remains, even today, a frontier of oddness and incoherence, a world of holy rollers and sand castle artisans whose works, like dreadful revenants, appear from time to time in New York galleries to help convince the world of the inherent sanity of Manhattan, Inc.

The juju of place has ruled the American art world throughout the twentieth century. An uncritical admiration for everything Parisian made critics genuflect until 1950, and since then an equally odd critical conviction that merely being in New York confers talent, grace, and sophistication upon an artist has guided most of our arbiters of taste.

Moreover, by 1920 the stylish had come to regard the urge to paint nature as an impulse of endearing, almost folksy, eccentricity. After all, the European leaders of modernism had roundly proclaimed the primacy of art over nature. The California impressionists, who were, in fact, doing their best work around this time, seemed therefore to many East Coast observers to be largely out of touch with current reality. But if the cliff dwellers of New York had come to regard a concern with the beauty and the dangers of the natural world as quaint and out-of-date, West Coast artists, whether they lived in isolated deserts, or in the coastal hills, or even in the ever more densely populated canyons of Los Angeles and San Diego, still had to cope with nature on a daily basis.

In 1920 conventional forms of landscape "composition," the human intellect's traditional method of taming the wilderness, unquestionably still reigned supreme in Southern California. According to Arthur Millier, the area's leading art critic of the

twenties and thirties, seventy percent of these landscapes were bought by tourists as souvenirs.[2] But although the art market in California continued to be dominated by an imagery that celebrated the particularities of the western landscape in a largely orthodox fashion, the artists who supplied this market were not necessarily more provincial than their colleagues on the East Coast. Most, indeed, had come from the East Coast and the Midwest and were, by 1920, at the top of their profession. Often they had left behind them substantial reputations in their move to California.

The term "provincialism" suggests a narrow, formulaic approach to artistic expression—a dislike for those who diverge from the norm. Artists who choose to go their own way on the basis of a conscious choice among options are not provincial but eccentric. Critics, usually a rather conformist lot, are often unable to recognize the merits of work that diverges from the prevailing cultural norms. By insisting on a narrow interpretation of whatever happens to be the reigning conception of normalcy in art, such critics often prove to be the true provincials.

I stress this rather obvious point because the word "provincial" crops up constantly in discussions of the art produced in Southern California prior to 1950. The members of the eastern art establishment were by no means the only culprits in this pattern of dismissal. The younger California artists of the twenties and thirties complained just as bitterly about the "provincialism" of their older colleagues and about the lack of taste of the Southern California public in general. The generation of 1950 did the same.

In reality, however, the range of styles pursued by the artists of Southern California from at least 1915, the time of the Panama-Pacific International Exposition, to the present was no more provincial than anywhere else in the United States. Still, there was a significant difference in attitude between the painters who settled in Southern California in the period before the Second World War and those who might be seen as representative of the East Coast establishment. What distinguished them from the typical New York artists of this period was their fierce desire for personal independence and their disdain for the competitive infighting that had already become characteristic of the East Coast art environment.

It was as true during the twenties as it is today that artists who yearned for national fame must make their careers—or at least exhibit regularly—in New York. However, if you were a loner, if you saw the wide-open spaces of the West as the raw materials of the imagination rather than as a depressing range of empty bleachers in the vast stadium of potential fame—you might move to Southern California and settle in some (then still) outlandish place such as San Diego, Cathedral City, or Santa Monica. In such regions of true cultural isolation, a host of nonconformist artists settled during the first few decades of this century, determined to do their own thing—all the while, of course, muttering self-servingly about the miserable provincialism of the general public.

Lorser Feitelson, for instance, had this to say about the Southern California environment of the late twenties and early thirties:

For the few artists that were serious, when they came out here, they had no audience, no patronage, and if they liked it out here, they'd better paint for their own satisfaction! So they did their best work, because there was no competition. They didn't walk along Fifty-seventh Street or the equivalent, or rue Boetie in Paris or rue de Seine, to "see what is going on," or look in the art columns to see what is fashionable now, or who's getting the works, who's being lauded. It just didn't exist. You really had to love art. Therefore, you did the things for your own satisfaction, you worked on the same damn thing year in and year out until you got something to your satisfaction. And it ended there. This was the situation here. Therefore, we never had an art community like up in San Francisco.[3]

Hans Burkhardt, too, was well aware that, then as now, "you had to live in New York to get into the clique." Even though he knew that "you could be the greatest artist out here" and still be forgotten, he chose to settle in Los Angeles in 1937, finding in the relative isolation of his new environment an answer to the domestic and artistic confrontations of his New York years.[4]

For Edward Biberman the contradictory combination of personal isolation, wide-open spaces, and the developing cosmopolitanism of Los Angeles was an enticement rather than a detraction. "New York in the Thirties," he remarked, "was obviously a much more active area for the art experience than California." But Biberman was not looking for support groups: "By the time I decided to move to California, the very absence of what I had begun to feel as a kind of incestuous quality pervading the art scene in New York—the very absence of that in California became a plus factor." Biberman, in other words, was determined to escape the seemingly paradoxical pressure toward conformity always present among those who desire to be part of the "cutting edge" in art: "I was, very frankly, not interested in whether or not there were California painters whose work I admired. I was really much more interested in my feeling that this was for me a time of stocktaking, a period of gestation and the presence or absence of a large body of spectacular talents really didn't enter into my thinking."[5]

Stanton Macdonald-Wright was driven by similar motives to settle in Southern California. In 1934 Arthur Millier was able to report that this early champion of synchromist abstraction had resettled in Santa Monica because "neither Europe nor the East Coast pleased him anymore. He hates New York."[6] Macdonald-Wright, who moved restlessly between the poles of abstraction and realism, and who was as fascinated by traditional Asian forms of visual expression as by the Parisian avant-garde he had been a part of in the 1910s, had arrived in Los Angeles in 1919 thoroughly disgruntled by the New York establishment's unwillingness to be converted to the gospel of synchromism. Tired of "chasing art up the back alleys of New York," he "departed for the nut state," his good friend Thomas Hart Benton remarked in his 1937 memoir, *An Artist in America,* voicing the cultural establishment's prevailing opinion of California.[7]

Among the host of artists who settled in Southern California during the twenties and thirties, there were quite a few who did so because they found isolation congenial. These were artists who looked to their art, not to the art world, for support. Independent souls, they were clearly "eccentric." Born, bred, and trained in Europe, on the East Coast, or in the art schools of the Midwest, and usually keenly aware of what was being done by the most experimental painters of their time, they could hardly be accused of provincialism.

According to these loners there was even a significant difference between Southern California and San Francisco. Some were taken aback by the Bay Area's tendency to replicate a cultural scene they had deliberately chosen to escape. Lorser Feitelson, for instance, insisted that he had decided to live in Los Angeles rather than in the Bay Area because the close-knit art community in San Francisco reminded him of New York. He liked the fact that if you wanted to visit other artists in Southern California, "you had to take two or three days—one live[d] over here, another one very far in the opposite direction. Very few knew each other, or if they did, they never saw each other."[8] Though Feitelson overstated the diffusion of the actual art community of the region, his remarks indicate that many Southern California artists had clearly made a conscious choice to isolate themselves from their peers. Those who wanted to be part of a regional art community tended to gravitate toward the Bay Area.

The opposite was true for the determined "eccentrics." Even a San Francisco–born artist such as Helen Forbes early showed signs of restlessness within the framework of Bay Area art. Like most ambitious younger American modernist artists she had made a pilgrimage to Paris, where she had studied with André Lhôte. But unlike most she did not settle down easily in her native city afterward. Instead she often went in search of wild nature—painting in the Sierras, in Nevada, or in the mountains of Mexico. During the thirties, as a Works Progress Administration (WPA) artist, she returned time and again to Death Valley, painting its sensuous, anthropomorphic formations in a manner all her own (though stylistically related to the earth forms of Georgia O'Keeffe, as well as those of the Canadian Lawren Harris). Part of the time she would work, holed up alone in a ramshackle deserted inn, far from the art community of San Francisco, and part of the time she would spend in the Bay Area, an active member of the art community there and a co-founder of the San Francisco Society of Women Artists.

Dorr Bothwell, born in San Francisco in 1902 and brought to San Diego when she was nine, returned to the Bay Area to study art and subsequently followed a complex international trajectory quite similar to that of Helen Forbes, finally settling in Joshua Tree—but escaping to Mendocino for the summer. During the late thirties she painted remarkable, often haunting, enigmatic dreamscapes, and her abstract works on paper caught the attention of East Coast critics in the mid-forties.

Agnes Pelton was another of these notable eccentric itinerants. She was born in Germany of American parents, was trained in Europe, and exhibited at the Armory Show in 1913. She came to the Southland after another complex international travel

pattern. Arriving in California in 1931, she settled in Cathedral City, where the desert became the raw material for many of her eerie, surrealist, organic abstractions.

To settle in Southern California as an artist, then, you had to be, as Feitelson emphasized, quite sure you could live with your own art. It took self-confidence, independence, and an adventurous spirit to move here during the twenties and thirties, and the work of artists gifted with such characteristics was not likely to be dull and provincial. Our critics' preoccupation with New York–centric, and very narrowly defined, conceptions of American modernist art has left many of us with the mistaken impression that California's artists did not enter significantly into the realm of modernist experimentation until after the Second World War. But the artists themselves, by refusing to relinquish their independence of spirit, clearly also helped undermine their chances for wider recognition. A disinclination to self-promotion is as unprofitable in art as in business.

The year 1920 is an arbitrary but convenient dividing point between periods in American art. If the New York Armory Show of 1913 was a major influence on younger painters, so, for Californians, was the Panama-Pacific International Exposition of 1915. Though the art exhibited in San Francisco was considerably more conservative than that of the Armory Show, the fauvist pointillism of the Italian divisionists and the bravura brushwork of an international host of postimpressionist painters gave young California artists plenty to think about. But it took time for that influence to be digested.

By 1920 a new orientation toward visual expression, shaped by modernist concerns—though today not necessarily recognized as "modern art"—had become the norm among younger American painters. Influenced by the principles of abstraction, but rarely focusing on abstraction for its own sake, these painters continued to emphasize the expressive potentialities of content. The artists of Southern California appear to have been particularly receptive to this hybrid of styles.

In 1920 the modernist branch of the art world in New York was, in fact, all abuzz with discussions of the paintings of Rex Slinkard, a young Californian, son of a rancher in Newhall, who had died of influenza in New York City in 1918 at the age of thirty-one, while awaiting troop transport to Europe. Knoedler's was showing his work, and Marsden Hartley had already written a stirring memorial to the passing of this "ranchman, poet-painter, and man of the living world."

Slinkard, who had trained with Robert Henri, developed a lyrical, semiabstract form of symbolist painting in which he blended suggestions of music and dance into figural compositions. In Slinkard's paintings volume and outline alternately separated and blended to accentuate Wagnerian episodes of libidinal yearning. The highly original visual qualities of these works were effectively captured in Hartley's erotically charged description of Slinkard's method, written to accompany the Los Angeles Museum's 1919 memorial exhibition:

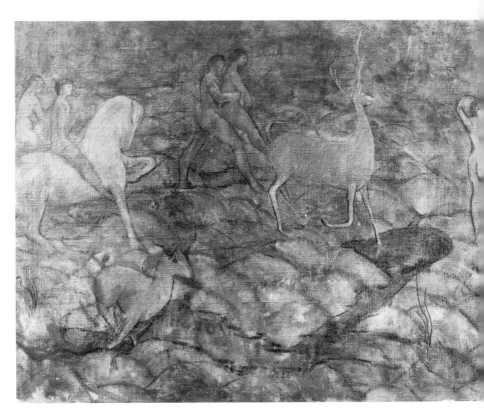

FIGURE 59
Rex Slinkard, *Young Rivers (Riders),*
ca. 1916. Oil on canvas, 38 × 51½ in.
Stanford University Museum of Art,
Estate of Florence Williams.

He felt everything joined together, shape to shape, by the harmonic insistence in life and
in nature. A flower held a face, and a face held a flowery substance for him. Bodies were
young trees in bloom, and trees were lines of human loveliness. The body of the man, the
body of the woman, beautiful male and female bodies, the ideal forms of everyone and
everything he encountered, he understood and made his own. They were all living radi-
ances against the dropped curtain of the world. He loved the light on flesh, and the shad-
ows on strong arms, legs, and breasts. He avoided theory, either philosophic or esthetic. He
had traveled through the ages of culture in his imagination, and was convinced that nothing
was new and nothing was old [Fig. 59].[9]

Slinkard's sensuous perception of the material world sets the stage for an under-
standing of the visual preoccupations of most of Southern California's independent

modernists. The first exhibition of the Group of Independent Artists of Los Angeles, held in February 1923, included, as a tribute to Slinkard's influence, a number of his works, as well as paintings by Stanton Macdonald-Wright, Nick Brigante, Charles Austin, Boris Deutsch, Peter Krasnow, Edouard Vysekal, and Morgan Russell, all of whom shared Slinkard's concern with the intermodulation of color, form, and content. Each made the visual field of the painting into a celebration of all the senses. Each resolved the technical problems involved in such a project in markedly different fashion, and with variable success, but the attempt, already noted by Marsden Hartley in Slinkard's work, to make the body and the landscape coextensive, and to make each into a sensuous reflection of the other, is common to all these painters.

This pursuit of the tactile-visual correspondences between the human body and its material environment is expressive of a predilection for topographical anthropomorphism quite common among the painters of California—a fascination that need not surprise us, given the state's natural beauty. But the postwar modernist critics, with their insistence on "pure art," on an art that was to be "nonobjective" and uncontaminated by recognizable forms, tended to denigrate such "materialistic" concerns.

The self-declared post–Armory Show modernists were by no means the only immigrants to California tinkering with the boundaries of the traditional modes of representation. The state's primal natural environment drew many whose work defied all forms of categorization. Foremost among these was Charles Reiffel, who settled in San Diego during the mid-twenties. Emphatically a loner and an original, he fits the characteristics of the early-twentieth-century Southern California art refugee perfectly. Only someone compelled by his art and unimpressed with public acclaim would abandon a major East Coast reputation at the age of sixty-four to live in the dry, and during the mid-twenties still thinly populated, canyons of San Diego.

In the ten or fifteen years before his arrival there, Reiffel had gained his East Coast reputation as a tempestuous and idiosyncratic, fiercely independent postimpressionist landscape painter, whose work had become a familiar presence at the Corcoran biennials, the National Academy exhibitions, and the yearly American painting shows of the Art Institute of Chicago. Conservative critics hated his work, but the more adventurous ones championed him and compared him favorably to such much younger figures as Ernest Lawson, George Bellows, or even Vaclav Vytlačil, a young Turk thirty years his junior, who was to become a major presence in the Abstract American Artists organization of the thirties. In the March 1922 issue of *Vanity Fair,* Peyton Boswell had appended an appreciation of Reiffel's "happy combination of talent," on exhibition at the Valentine Gallery, to his glowing review of an exhibition of recent Italian landscapes by André Derain at the Brummer Galleries in New York.[10]

Reiffel's work of this period inspired lively debate among exhibition goers, and he was cast as the American van Gogh—whose work was indeed one of Reiffel's major inspirations. Traces of it can still be found in such major works of his San Diego period as his *Morning, Nogales, Arizona* of 1928. This work typifies Reiffel's method. In it, the

landscape comes alive with elemental power. Vermicelli-like strands of paint rush and splash thinly but insistently over the canvas, creating uncanny suggestions of sentient tensions, not only in plants and trees, but even in the inanimate forms of buildings, mountains, rocks, and soil. No doubt, Edgar Allan Poe would have loved Reiffel's work.

True to the fate of the loner painter seeking the lure of nature and a personal vision in Southern California, Reiffel's status as a national figure in the world of art declined the moment he moved to San Diego, although he continued to paint many brilliant canvases there, making the southwestern landscape lope and surge with suggestions of elemental movement and an ominous, almost preternatural, tension. The wealthy middle-class citizens of San Diego who would have been the potential buyers of his work did not understand the meaning of these strange masses of paint turned into undulating waves of primal matter, and during the depression years Reiffel, notwithstanding the welter of official awards and prizes which had been—and continued to be—bestowed upon him, descended into a state of abject poverty.

In his late years, rescued from starvation only by the existence of the WPA's various art support programs, he painted numerous rolling "bodyscapes" of the hills around San Diego, and such moody masterpieces as *Rainy Evening* (1937; Fig. 60) in which dense rain and lingering clouds transform the usually-too-hot concrete, brick, and asphalt of a parched city into the shimmering membrane of a restless organism bent on overpowering whatever might be merely human. Such paintings were commentaries on Reiffel's own tempestuous yearning. They are documents of his stoic yet unquiet sense of his own isolation from the rest of civilization. His restricted palette, dominated by blues and greens and yellows, combined with his fascination for long, seemingly uncontrollably trailing tendrils of organic form, has often caused his work to be naively misread as itself uncontrolled or "unsophisticated," even though the artist intentionally used paint and texture in a fashion directly in anticipation of the postwar concerns of the abstract expressionists. He apparently experimented (much as Knud Merrild did in Los Angeles a few years later) with a form of "drip-trail" abstraction well before Jackson Pollock. These abstractions were included in the 1942 Reiffel memorial exhibition at the San Diego Fine Arts Gallery but have not resurfaced since.

The narrow redefinition of what was "modern," and what not, that took hold in this country after World War II has, until recently, precluded serious reexamination of Reiffel's work, as well as that of many other stylistically eccentric American painters of the period between the wars. The postwar modernist aesthetic thus succeeded in trivializing the achievements of many strikingly independent and experimental artists whose work happened to be conceptually and stylistically incorrect within the context of the new criteria.

The experimental mood of the artists of the early twentieth century had, in contrast (as can easily be verified by the very wide spectrum of styles exhibited at the Armory Show), expressed itself through a broad-based, and stylistically variegated, set of skirmishes against the technical conventions of academic realism and its insistence

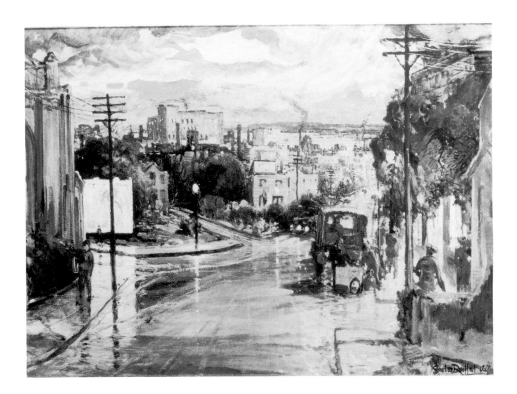

FIGURE 60
Charles Reiffel, *Rainy Evening,* 1937.
Oil on board, 36 × 48 in. Charles and
Estelle Milch collection, San Diego.

on "pedagogic content"—on the facile depiction of "philosophic" subject matter expressive of middle-class values. Among these early modernists, the exploration of raw emotion in its most essential forms, through the innovative use of paint, color, *and* content (through figural expressionism, in other words, instead of abstraction for its own sake), was as frequently considered an integral part of the revolt against tradition as the notion that art should exist merely "as art." However, the move away from traditional forms of representation very early brought with it also the beginnings of the exclusivist mentality that was to come to full prominence after the Second World War. The remarkable early flowering of the Stieglitz group in the American cultural consciousness, and its continuing (and almost certainly still exaggerated) position of absolute prominence in our histories of American modernism, is a dramatic case in point.

But loners traditionally have been more important in the flowering of American art than movements and cliques. The early American modernists are very much a part of that tradition. It is therefore by no means surprising that some of the best among them

recoiled from the incipient dogmatism of the New York art world of the years between the wars.

As Feitelson, Biberman, and others have emphasized eloquently, these motives brought an unusual number of self-defined loners to the as yet culturally undefined reaches of Southern California during the earlier decades of this century. Some painters whose work is not in tune with the prevailing fashions are lucky enough to be able to survive in the more competitive art centers. Their work may subsequently, as the fashion changes, catch the attention of critics or dealers who have the power and the will to bring them to national prominence. Other artists have learned to promote their own work vociferously to gain the interest of those who are able to lead them to fame. Some artists are able to tolerate the conditions of the art marketplace; others cannot. Whether they are able or unable to do so has in itself nothing to do with the inherent quality of their work—but clearly artists who stay in the art centers, or who have been lucky enough to find a Stieglitz or a Clement Greenberg to promote them, have a much better chance of ending up in the histories of American art than those who, like Reiffel, are driven by personal demons and an all-pervasive preoccupation with the demands of their art. In consequence women and men who choose to pursue their work in outlandish isolation (such as that represented by Southern California's prewar art environment), almost inevitably end up being ignored by art history. The critics, unable to categorize their work, extrapolate from that a lack of direction or sophistication, and reward them consequently with casual dismissal.

During the twenties and thirties there were several other painters in California who, like Reiffel, were loosely associated with impressionism but whose work actually blended divisionistic techniques, fauvist color, and a modernist concern for essential form. Among these perhaps the most influential was Clarence Hinkle, who, having been appointed in 1921 as one of the first instructors of painting of the just-opened Chouinard School of Art in Los Angeles, became a mentor to such major California regionalists as Millard Sheets, Phil Paradise, and Phil Dike.

Though Hinkle was uneven, his best paintings tended toward an integration of broad, rhythmic patterns of line and bright fields of color. Often, at least in the manipulation of paint, they proved to be a good deal more adventurous than those of his students. His *Laguna Beach* (1929) gains authority from a superbly integrated architecture of color and ground, and a contagious delight in the calligraphic potentialities of line.

Another painter whose links with the California impressionists are at best rather tenuous is Thomas Lorraine Hunt, who was born in Ontario, Canada. Hunt painted complex ideograms of mood, which turned what would have remained ordinary landscape scenes in the eyes of lesser talents into visual messages about the links between the natural environment and our states of mind. Hunt was able to turn the scratch, dab, and dash of the brush into a language of elemental equivalences between nature and the emotions. In a painting such as *Fog in the Harbor,* the heavy, dark tones of

boats and their shadows become the matrix upon which bright strokes of paint flash abstract points of color to countermand the pall of stasis established by the weight of the fog. In his broadly painted *Grape Arbor,* horizontal bands of paint are cross-hatched with dark stakes and a spare grape-stalk vermicelli that overtakes the top quarter of the painting to undermine the potential artificiality of the horizontals with a chaos of organic dribbles, dashes, and gobs of paint. It is a remarkable example of Hunt's ability to turn essential form into a passionate dialectic between the values of color and ground. Works such as this, with their evident concern for the abstract inter-action of color, movement, and mood, show Hunt to have been, like Reiffel, in search of painterly principles not unlike the visual language that was to be codified as abstract expressionism in the postwar years.

The 1920s were a period of consolidation and reconsideration in American art. The avant-garde's move, during the 1910s, into experiments with cubism and related forms, and the pure color abstraction of Stanton Macdonald-Wright's synchromism, had attracted the attention of most of the talented younger painters. These pro-ceeded—not to imitate these styles to the letter—but rather to adapt them to their own purposes. Clearly the younger California painters were as knowledgeable about the varieties of early modernism as their East Coast counterparts. Elements of fauvism, postimpressionism, cubism, and futurism pervade their work. Sometimes their experi-ments were indeed clearly "cutting edge," as in the case of Ben Berlin's work of the early twenties, which forms an interesting analogue to the visual music of Kandinsky, and carried such dada-inspired titles as *Vudu Futhmique* and *Owngz.* The same is true of Boris Deutsch's ventures into the realm of organic abstraction in works such as *Rock of Ages*—shown, like Berlin's paintings, at the first exhibition of the Los Angeles Independents in 1923. Berlin's whimsical pencil-drawn *Portrait* of that year is an excel-lent example of these experiments (Fig. 61).

Newly rediscovered styles, about which the artists might first have read in such magazines as the *International Studio, Arts,* or *Parnassus,* also influenced the work of the American painters of the twenties and thirties. Thus, along with adaptations of the work of Cézanne, Gauguin, Picasso, and Braque, the younger Californians absorbed lessons from the work of Giotto, El Greco, and the Mannerists. The word "primitiv-ism" lost its association with the notion of "technical inadequacy," imposed on it by the academic artists of the nineteenth century, and came to stand for expressive spontaneity. African and Asian art and the folk art of Western Europe and America were finally being taken seriously.

If we accept the term "modernism" as descriptive of an aesthetic of formal experi-mentation, and "postmodernism" as representative of the eclectic reinterpretation and synthesis of the results of such experimentation, in conjunction with the exploration of stylistic impulses taken from earlier styles of art, we can easily identify the period of the twenties as the first postmodernist era in American art.

The eclectic tonality of the art environment of the twenties was further enhanced

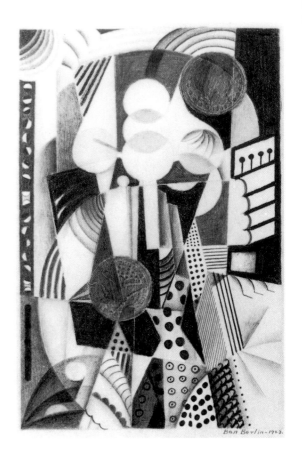

FIGURE 61
Ben Berlin, *Portrait,* 1923. Pencil with
embossing, 7¹¹⁄₁₆ × 5 in. Private
collection. Photograph courtesy
Tobey C. Moss Gallery, Los Angeles.

by the activities of numerous immigrant artists. They brought with them the expressive traditions of Russia, Eastern Europe, Scandinavia, and Italy and added these to the welter of styles that characterized the American art of that decade. One of the most striking results of this eclectic mixture of styles is the linear expressionism of a group of New York and Chicago immigrant painters. It is a style that to a certain extent overlaps with the cooler, much less impassioned—and hence more purely "modern"—precisionism of Charles Sheeler, Charles Demuth, and Georgia O'Keeffe. But where the latter group was primarily concerned with the shapes and outlines of the city or the forms of nature, the work of the linear expressionists also focuses on the psychological dimensions of the human figure. Their work resembles precisionism in its pursuit of hard-edged, stylized delineations of natural and architectural forms.

This linear expressionism is strikingly characterized by the early work of Peter Krasnow, which insistently explores the interplay between flattened volumes and line.

Krasnow was born in the Ukraine and immigrated to the United States when he was seventeen. In Los Angeles, in 1925, three years after his arrival there, he painted a strikingly expressive portrait of an elderly man. The "kinetic properties" of the semicubist, semi–three-dimensional work of Albert Gleizes, with its emphasis on "shifting and moving volumes," that had much impressed Lorser Feitelson and numerous other young American painters at the Armory Show, would seem to have impressed Krasnow as well. In this expressionist portrait, for instance, flat planes of color are bounded by hard-edged patterns of line and molded into casual simulacra of three-dimensionality by perfunctory shading. But Krasnow's line seems unwilling to maintain its integrity as a marker of separation between visual entities: a mountain abruptly becomes a chair, which turns into a blanket in support of an old man's body. The folds of the man's clothing have become a gauze that reveals the tuberous musculature of his ebbing flesh. There is a harsh, disconcerting element of cynicism and doubt in the face of this man. It leaves us with the impression that his sense of the meaning of being may be as disequilibrious as his pose and his semisunken, off-center position in the image.

The lower right corner of the painting is virtually a separate still life, emblematic of unquiet resignation, echoing in this respect the mood of existential doubt that courses through the entire painting. Had Krasnow continued to paint in this vein he would undoubtedly have become a central figure in the history of prewar Southern California art. Unfortunately, Krasnow's restless eclecticism led him to try his hand at so many different styles and modes of visual expression that he ultimately failed to gain a truly significant voice in any, except when, in his later years, he developed a densely patterned, kaleidoscopic style of abstraction—works that are brilliantly executed and as intricate and intriguing as oriental rugs, but with primarily a decorative, rather than an expressionistic, emotionally focused, intensity.

The precisionist tendency dominant in the American visual aesthetic of the twenties had actually arrived quite early in Los Angeles in the work of Henrietta Shore, who was born in Toronto, Canada, and was trained in New York and London. From 1915 until 1920 she lived in Los Angeles, but even after she moved to New York, she returned to California every summer, and in this manner she maintained a very active presence in the local art world until at least 1928, when she settled in Carmel. An effective, though still relatively conventional Los Angeles cityscape of around 1918 shows the manner in which the local contact between nature and the city may have suggested the "precisionist" linearity of industrial architecture to her. It was, in any case, a linearity she rapidly proceeded to incorporate into her work. A nude she painted the following year already strikingly combines line and volume in a linear expressionist fashion. The subtle molding of the background in this painting brings to mind the tonalities and shading of O'Keeffe's landscapes of the same period and helps to establish the sharply delineated sensuous weight of the figure in the foreground. Helena Dunlap is thought to be the subject of Shore's resplendently erotic scrutiny in this painting.

Shore was a close friend of Dunlap, another Los Angeles painter who was considered

a modernist by her contemporaries. Dunlap, a few years Shore's senior, tended toward postimpressionism in her work. Like so many other Americans of this period, she had studied with André Lhôte in Paris. Together with Shore she was given a two-person show at the Los Angeles Museum in 1918.

During the early 1920s, Shore continued to explore the expressive properties of simplified form in works that emphasized sharply delineated contrasts of color and line. Her *Waterfall* of 1922 is a remarkable example of her adventurous experiments of this period, which by 1927 had yielded to an equally adventurous hard-edged organic surrealism in such paintings as *California Data,* in which she surveys the sensuous qualities of the state's floral wealth.

The twenties and thirties produced an array of superb women painters whose work was often at least as rich and imaginative as that of their male counterparts, although one is hardly likely to discover this from a casual reading of the histories of American early modernist art, which seem to hold to the proposition that Georgia O'Keeffe was the only woman worth consideration in the field of painting during the period before 1945. Among these largely forgotten women painters, Belle (Goldschlager) Baranceanu figures prominently. Born in Chicago a few months after her parents' arrival there from Rumania, Baranceanu trained at the Minneapolis Art Institute and the Art Institute of Chicago. She came to live in Los Angeles in 1927 and 1928 and, after returning to Chicago, finally settled in San Diego in 1933.

Baranceanu was strongly influenced by the linear expressionism of Anthony Angarola, a leading Chicago modernist of the twenties whose student she had been. However, she soon developed a personal style emphasizing the juxtaposition of flat fields of color and strongly accentuated, essential line. Her work was considerably less busy, less three-dimensional, and more concerned with color values than his. Baranceanu had an uncanny ability to reduce the forms and structures of the material world to their sensory essence. In early works, such as her *Leaf-Bud* of 1925, she brought her work close to abstraction. *Leaf-Bud* combines the close-up sensibility of O'Keeffe's flower studies of the same period with a forceful interest in the abstract compositional properties of color, plane, and line.

But Baranceanu's love for the essential shapes of nature made her turn away from complete abstraction and toward the creation of carefully organized compositions, which in controlled sequences of line mapped the volumes, hues, and textures of sensuous experience. Equally adept at landscape, figure painting, and still life, Baranceanu brought her determinedly modernist yet very personal sense of style to bear upon *The Yellow Robe,* a portrait of her sister painted in Los Angeles in 1927 and shown that same year at the Los Angeles Museum's annual *American Painters and Sculptors* exhibition (see Plate 7). In this composition, the regal figure of the sitter gains strength and authority from carefully balanced horizontal and vertical rectangles of complementary color, which with only minor further simplification could have led the painter to a Mondrianesque exploration of pure geometric abstraction.

The following year Baranceanu exhibited a view of Los Angeles from the hilltop house in which she lived at the time, close to downtown. *From Everett Street* is remarkably European in sensibility, although Baranceanu never visited Europe. There is a striking stylistic affinity between this work and some of the angular, stylized, flattened cityscapes Egon Schiele had been painting during the 1910s. Since there is no indication and little likelihood that Baranceanu was familiar with these works when she painted *From Everett Street,* the similarity is most likely due to a correspondence between the visual sensibilities of the two painters rather than to direct influence.

From Everett Street is part of a splendid series of paintings and lithographs of Los Angeles created by the young painter during her sojourn there in 1927 and 1928. These works vary from Cézannesque explorations of the landscape as a series of receding planes to brilliantly colored industrial images such as her study of a brick factory in Elysian Park, whose subject matter parallels Charles Sheeler's explorations of the geometry of the American workplace. Other works in this series, such as *Sunset Boulevard at Everett Street,* bring an angular poetry to the streets of the city, and in *Hollywood Hills* Baranceanu pits the tensions of nature against the encroachment of city life by making patterns of color and form interact in a manner reminiscent of the organic semiabstractions of Arthur Dove.

During the thirties, strongly influenced by Diego Rivera, Baranceanu became San Diego's foremost mural painter, a figure of diminutive physical stature who boldly designed and executed gigantic visual narratives virtually single-handedly. This left her little time for easel painting, and thus her later work in this medium is relatively rare. Since her mural work was of necessity site specific, her art was rarely seen beyond San Diego, but in that city she was without doubt the most influential modernist presence until after World War II.

Baranceanu's paintings of 1927 and 1928, focusing on Los Angeles's Everett Street region, prefigure the expressive concerns to be found in the justly celebrated *Angel's Flight* of 1931, by Millard Sheets. This painting is one of the quintessential American urban images of the depression decade. But Sheets's flirtation with linear expressionism was regrettably brief, apparently not predating 1931 and giving way to a more decorous—and more decorative—form of stylized regionalism as early as 1933.

In *Angel's Flight* the extraordinary interplay of flat urban surfaces and an almost infinitely receding "abstract" pattern of perspectival planes helps to give the figures in the foreground a remarkably sensuous three-dimensionality. Unfortunately, examples of this expressionist-realist phase of Sheets's art are rare. Sheets was too "civilized," too much a tourist in the natural world, one is tempted to add, to be able to sustain the expressive intensity of *Angel's Flight.* In certain of his later paintings, as in the stately, somber rhythms of *Abandoned* (1934), he was still able to recapture the remarkable balance between form and content he had achieved in *Angel's Flight,* but he soon aligned himself with the artificial, patronizing populism of regionalist painters such as Thomas Hart Benton and moved inexorably toward the often cloyingly decorative qualities of his work after 1945.

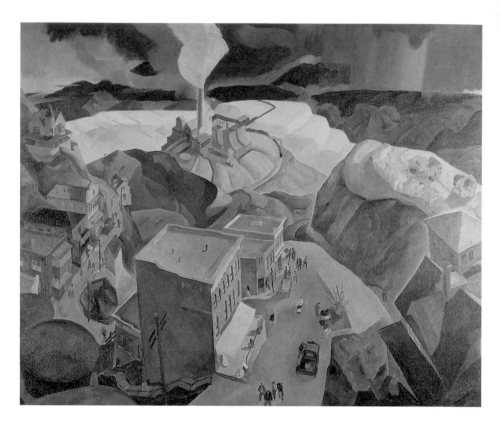

FIGURE 62
Phil Dike, *Copper,* 1937. Oil on
canvas, 30 × 40 in. Phoenix Art
Museum.

The linear expressionist quality lingered a bit longer in the work of some of Sheets's closest compatriots and followers at Chouinard. Paul Sample, Barse Miller, Phil Paradise, and especially Phil Dike (see Fig. 62) all did a great deal of work during the thirties that seems to have found its initial inspiration in the stylistic qualities of *Angel's Flight.*

Among the numerous artists who earned their living by working in the motion picture industry, some developed distinctive personal styles that often remained geared to the visual requirements of the movies even while attempting to break through the medium's oppressive demands for "realistic" imagery. The work of Warren Newcombe is particularly remarkable in this respect. He had studied painting in Boston under Joseph De Camp, and started out painting portraits in a style not unlike that of his teacher. By 1920 he was in Hollywood. His work moved through a phase in which he painted fuzzy symbolic landscapes similar to those of Claude Buck toward a Matisse-

inspired sense of line. By 1931 he had developed a strikingly individual, self-consciously antiacademic manner of painting landscapes, using flat planes of color and broad, heavy outlines to turn scenes seen from what would otherwise be a rather ordinary perspective, into wonderfully sinuous, semiabstracted dreamscapes. In these works echoes of the styles of Rockwell Kent, Marsden Hartley, Charles Reiffel, and even Vincent van Gogh bounce off against Newcombe's amusing sense of the organic world as the backdrop for a cosmic movie. Edward Weston described Newcombe's art perhaps most effectively: "He has emotion as well as intellect; he feels deeply the American scene. Into his canvases go exhilarating vitality, joy of life, intense drama. Essential forms rise starkly stripped, or swirl with energy. Color vibrates, is alive." [11]

Another figure who came to prominence in California during the depression years was Ejnar Hansen, who, after having lived in the Midwest since 1914, moved to Pasadena in 1925, where he painted startling character studies of tormented or eccentric men and world-weary young women on the edge of disintegration. These paintings, which capture much of the neurotic tension of modern life, are among the finest examples of twentieth-century portraiture. Hansen's extraordinary series of paintings documenting the physical decline of the important art critic Sadakichi Hartmann presents a chilling record of an intellect forced into gradual capitulation to the agonies of a decaying body.

Like many other early-twentieth-century American painters who had found their inspiration in modernism, Hansen almost completely abandoned the flattened, linear elements of expressionism in his work of the later thirties. Instead he began to explore a broadly painted yet quite accessible and "populist" imagery, very characteristic of the realist tendency in thirties art. This latter tendency was represented in California by a wide variety of poetic realists, including Emil Kosa, Jr., Edouard Vysekal, Sueo Serisawa, Everett Gee Jackson, and Dan Dickey.

Within the present context it is clearly impossible to give all the California artists who contributed to the adventurous modernist atmosphere of the interwar years the attention they deserve. I have deliberately moved away from discussing the work of major figures such as Feitelson, Macdonald-Wright, and others who have been invoked time and again by writers steeped in postwar critical values as proof that faint traces of "good" modernism could actually be discerned in Southern California even before 1950. The still relatively obscure artists I have chosen to feature here represent a selection that, though by no means arbitrary, could easily have been restructured to feature several other groups quite as deserving of our attention. A focus on Feitelson and his entourage might have been the subject of another approach. The Arensbergs, their Los Angeles circle, and the importance of their collection to the progressive artists of the region would have represented a more traditional focus.

In truth, the early modernist art of the area represents an embarrassment of riches. The work of Arthur Durston, who was a major formative influence on Morris Broderson, is always intriguing. His paintings of women stoically contemplating land-

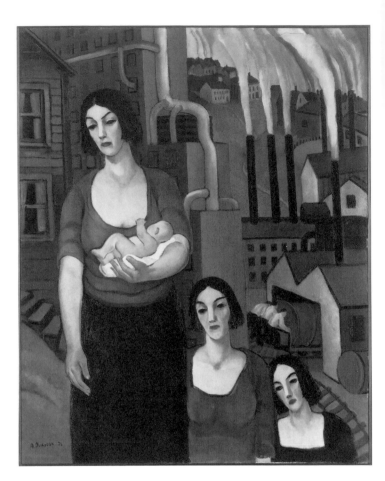

scapes ravaged by devastating floods and his *Industry* of 1934 (Fig. 63) give to average people the static, monumental dignity of the principals in a Sophoclean tragedy. Durston's paintings are exemplary of the manner in which some of the painters of the thirties were able to conjoin social commentary with modernist formal considerations.

Knud Merrild in his flux paintings of the forties, such as *Flux Bouquet* and *Sidereal Parturition* (Fig. 64), played on the viewer's tendency to turn abstract matter into "representation." The controlled accidents of paint-in-flux that formed the basis for his compositions take on a semblance of the essential forms of nature's flora and fauna in a reversal of the process Reiffel had used to turn his elemental earthscapes into near abstractions by exploiting the visual correspondences between our sense of what constitutes landscape and the organic suggestions always inherent in loosely controlled strands of paint.

Helen Lundeberg, in such paintings as *Plant and Animal Analogies* (see Plate 8), her dreamscapes of the mid-thirties through the forties, and her painting *Microcosm and*

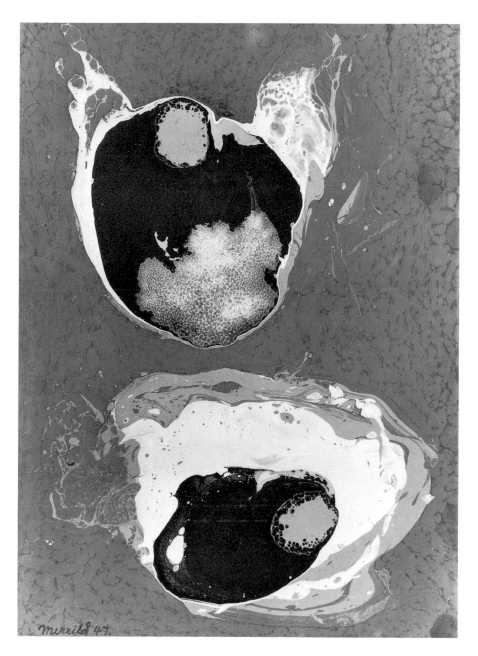

Macrocosm (see Fig. 13), produced some of the best images of myth and mystery art can hope to offer us, while the perfection of her *Self-Portrait* of 1933 is enough to startle any viewer with its ability to turn reality into a realm of magic.

Philip Goldstein had, well before he became Philip Guston, become expert at combining surreal and expressionist imagery. His documentation of fascist violence and its attendant human suffering in the extraordinary *Bombardment* of 1937–38 is a superb example of the visual complexity the California painters were capable of bringing to their work. In a similar fashion, Hans Burkhardt was able to portray the nightmarish dimensions of war in a manner that shocks, yet adds to, the viewer's humanity. Surreal, yet all too real, his paintings of the forties are among the world's most chilling evocations of the brutal carnage of the Second World War: the bloody screams of anger of a gentle soul (see Plate 5; Figs. 15, 16).

Much the same can be said of Boris Deutsch, who was able to capture the panic, anguish, and exasperation many felt when it became clear that the war had ended only to plunge the world into a new "cold war" of emotional terrorism. This is "What Atomic War Will Do to You," Deutsch told his viewers (Fig. 65).

Paintings such as these emphatically demonstrate the inaccuracy of the frequent assumption that before 1950 all West Coast art was "soft" and mired in sunlight fantasies of easy living. In fact, even painters such as Edward Biberman, who dealt with the everyday particularities of the social environment of Southern California, were often able to evoke complex emotional responses by combining realistic imagery with a modernist sensibility. Biberman was a visual poet, his work a West Coast analogue to that of Edward Hopper. At his best he turned Southern California's perpetual impulse toward an all-inclusive eclecticism—an abiding lust after visual stimuli—in upon itself.

Biberman, the Philadelphia-born son of Russian immigrants turned American industrialists, surely was the quintessential postmodernist, painting effectively in a style he had invented long before the conceptual framework for that style had even been conceived. He was able to evoke the various moods of Los Angeles in a sequence of paintings that expressed his anger at the region's casual wastefulness of human hopes and talents as well as his admiration for its recklessly inventive appropriation of architectural forms. In his paintings of the immediate postwar years Biberman captured the essence of urban Los Angeles perfectly. Here the squares of Josef Albers meet the empty city streets of Hopper and the hard-edged precisionism of Sheeler at, of all places, the Hollywood Palladium (see Plate 9). In paintings such as these Biberman effectively anticipated the productions of far better known postwar chroniclers of the "new" California, such as Edward Ruscha and David Hockney.

Our current myth about art in California posits a sudden flowering of artistic genius after 1945. But we would do well to remind ourselves that artists such as Yasuo Kuniyoshi, Philip Guston, and Jackson Pollock did not merely pass through California; they received part of their early impetus and art education here. Not all the perceived stars of American art were touched by genius only after they arrived in New York—in

most cases, one suspects, the "discovery" of their genius was predicated upon their dutiful pilgrimage to the city. The many loners hostile to the trappings of self-promotion among Southern California's artists of the pre-1945 era inevitably created a framework particularly conducive to their subsequent obscurity within the context of our national art-historical memory of the twenties and thirties.

Critics, like artists, tend to gain authority among the public the more they are obsessed by absolutist rules about art. Yet anyone who has ever heard two equally good artists with different convictions about the nature and function of art savage each other's work should know that the more absolute a critic's convictions are, the less they should be trusted. The postwar era fostered a narrowly defined dualist sensibility that spoke to the "us-against-them" cultural mentality of the cold war. It could be argued that there has never been a more simplistic and provincial period in American art criticism than the fifties.

The absolutist single-mindedness of the critics of the late forties and early fifties exerted such a powerful hold over the American art scene that many worthy dissident early modernists were banished from our public memory almost overnight. Their rediscovery has been slow and erratic, determined largely by the prevailing fashions in art. Fortunately things are now beginning to take a new turn. Eclecticism is in. The tide of fashion has turned toward an ever-broadening pluralism. This stylistic eclecticism or, as we fondly (but inaccurately) designate it, postmodernism, is now encouraging us to look with renewed interest to the artistic productions of the twenties and thirties, that first great age of postmodernism.

A wide-ranging freedom to choose among styles and expressive options is the key to any creative art environment. The diversity of qualities to be found among the works of the lone rangers of Southern California's art scene of the prewar years is testimony to these artists' true independence of spirit, and to their sophistication—for they knew very well what they were building upon and what they were fighting against. What separates their postmodernism from ours, however, is their sense of history, their conscious desire to forge a synthesis between the modern and what had come before. Without historical knowledge, artists are doomed to a parochialism that forces them to slam-dance blindly in a closed circle of options, and to remain stuck, as so many are today, in a world of disconnected sound bites, tape loops, and sampled music, a world of imitation and re-creation and parody—helpless waifs of an "avant-garde" that has nowhere to go because it has no idea where it came from.

Notes

1. Lorser Feitelson, interviewed by Fidel Danieli, Los Angeles Art Community, Group Portrait, Oral History Program, University of California at Los Angeles Art Library, 1982, 12. I have taken the liberty of streamlining this anecdote, without altering its intended significance.

2. Arthur Millier, "New Developments in Southern California Painting," *American Magazine of Art* 37, no. 5 (May 1934): 241.

3. Feitelson interview, UCLA, 4.

4. Hans Burkhardt, interviewed by Einstein (no first name given), Los Angeles Art Community, Group Portrait, Oral History Program, UCLA Art Library, 1982, 42.

5. Edward Biberman, interviewed by Emily Corey, Los Angeles Art Community, Group Portrait, Oral History Program, UCLA Art Library, 1977, 75–77.

6. Millier, "New Developments," 243.

7. Thomas Hart Benton, *An Artist in America* (New York: Robert M. McBride, 1937), 47, 48.

8. Feitelson interview, UCLA, 3.

9. Marsden Hartley, "Rex Slinkard," in *Adventures in the Arts* (New York: Boni and Liveright, 1921), 94. This essay was originally published in the catalogue of the 1919 *Rex Slinkard Memorial Exhibition,* Los Angeles Museum of History, Science and Art, Exposition Park. It was also reprinted in the 1929 *Slinkard Memorial Exhibition* catalogue, Los Angeles Museum.

10. Peyton Boswell, "Notes on Painting and Sculpture," *Vanity Fair* (March 1922): 15.

11. Edward Weston, quoted in the introduction to Merle Armitage, *Warren Newcombe* (New York: E. Weyhe, 1932), n.p.

Susan M. Anderson

JOURNEY INTO THE SUN:

CALIFORNIA ARTISTS AND

SURREALISM

Reminiscing about the 1940s, which he spent in Hollywood, the artist Man Ray said, "There was more Surrealism rampant in Hollywood than all the Surrealists could invent in a lifetime."[1] The peculiar and pervasive fantasy of Los Angeles, its illusion and promise of fame, made the city surrealist by nature. European dada and surrealist artists who visited California during the 1930s and 1940s felt both strangely at home and like fish out of water.

The international artistic movement most shaken by the events of World War II was surrealism. The war scattered the European surrealists and effectively ended the formal movement. Many of these artists subsequently passed through California; some decided to stay and make the state their home, at least for a while. Among the transients were Fernand Léger, Max Ernst, Marc Chagall, Roberto Matta, and Wolfgang Paalen. Besides Man Ray, others who spent considerable time in the state were Salvador Dalí, who invigorated the art scene on the Monterey Peninsula for several years; Hilaire Hiler, who lived in the Bay Area; and Gordon Onslow-Ford, who has resided in Northern California since 1947. These artists became conduits for the transmission of surrealist thought. The legacy they left behind in California is still being explored.

The quest for absolute freedom central to surrealism was also a hallmark of the California Dream. During the 1930s and 1940s artistic freedom was simultaneously real and paradoxical on the West Coast, where there were few long-standing social conventions, artistic traditions, or institutions to provoke rebellion. Artistic production at the time received its main stimulus in San Francisco from art schools and museums and in Los Angeles from a handful of well-managed private galleries.

The West Coast dealer Howard Putzel, together with the New York dealer Julian Levy, organized several shows of European surrealism in Los Angeles and the Bay Area in the mid to late 1930s at the Howard Putzel, Courvoisier, East West, and Paul Elder galleries. Stanley Rose's Centaur Gallery and Frederick Kann's Circle Gallery in Hollywood were also important venues. In the late 1940s Copley Galleries in Los Angeles,

run by the painter William Copley, showed the work of René Magritte, Joseph Cornell, Yves Tanguy, Man Ray, Matta, and Ernst. The Modern Institute of Art, started by the artist Frederick Kann, the actor Vincent Price, and others in 1947, exhibited Ernst, Klee, and Miró during its two years of existence.

San Francisco artists had little firsthand experience of advanced forms of modern art until 1935, with the opening of the San Francisco Museum of Art, directed by the forward-thinking Grace McCann Morley. Morley brought to San Francisco several of the exhibitions that New York's Museum of Modern Art organized under Alfred Barr, including, in 1937, *Fantastic Art, Dada, and Surrealism,* which led many Bay Area artists to experiment with surrealism.[2]

The only organized response to European surrealism in the United States emerged in Los Angeles in the 1930s, before the refugee European surrealists had arrived. Instigated in 1934 by Lorser Feitelson and Helen Lundeberg, Post-Surrealism, really an American critique of European surrealism, was deeply rooted in the social reality of 1930s America. Critics and artists were searching then for a truly American style, and there was a suspicion of experimentation and European influence. Post-Surrealism, however, succeeded in awakening an interest in surrealist models in the United States; it had far-reaching implications in the history of California art.

California underwent dramatic transformations when war broke out in Europe. The state was propelled into a war economy even prior to U.S. engagement, making Los Angeles and San Francisco major industrial as well as population centers. When California artists were called upon to turn their efforts toward the war, the nativist concerns of the American Scene school lost their grip on California art as well as on the American public. In the early years of the war European surrealism became an important stimulus.

The war acted as a powerful energizing force and as an agent for change, transforming regional artistic models and opening the way for new art forms. To portray the chaos and destruction of their world, many artists in California, now caught up in international modernist currents, chose a surrealist approach.[3] Man Ray, who lived in Los Angeles during the 1940s, inspired the experimentation in new genres and the crossover of popular culture and high art. Hans Burkhardt, Eugene Berman, and Rico Lebrun disseminated an expressionistic, abstract surrealism invoking war's disequilibrium. Charles Howard, who in 1940 returned to the Bay Area from London, introduced to the state an organic, abstract surrealism with the expressive emotional power of the sublime that reflected the spiritual temper of the time. Statewide few artists were well versed in the principles of automatism, however, and consequently they adopted the formal elements of surrealism rather than its methodology or intellectual tenets.

At the close of World War II the interest in international modernism intensified. Artists carried forward the spirit of surrealism and dada, adapting it to the urgencies of the postwar era. They spiritually embraced and visually articulated the rhetoric of the 1930s expressing the need to create a truly American art, but this time within a more

radical framework. European surrealism invigorated postwar American art and helped give birth to abstract expressionism.

The late 1940s marked the beginning of an era of intense experimentation in the San Francisco Bay Area. Beat poets, photographers, filmmakers, assemblage artists, figurative artists, and abstract expressionists would soon coexist and nourish each other. The postsurrealist Dynaton movement, created by the Austrian Wolfgang Paalen, the American Lee Mullican, and the Englishman Gordon Onslow-Ford, added to this incredibly complex artistic mix by awakening interest in Jungian psychology, esotericism, the nonrational, and the new physics. Surrealist ideas were "in the air," making possible an extraordinary diversity of inflection.

Post-Surrealism and the Flux: Lorser Feitelson, Helen Lundeberg, and Knud Merrild

Artistic activity in California during the 1930s and 1940s was a process of reciprocity and encounter between artists of many regions and many nationalities. Art thrives on such mixing, clashing, cross-fertilization, and critical difference. European surrealism blended with indigenous styles, enriching regional art and creating interesting hybrids.[4] One example of this crossbreeding is the Post-Surrealism inaugurated in 1934 by the Los Angeles artists Helen Lundeberg and Lorser Feitelson. Post-Surrealism differed radically from surrealism in affirming a conscious rather than unconscious use of materials and the clarification of rational ideas. It maintained a distinct identity, reflecting and invigorating the locale of its birth.

Lorser Feitelson, educated in New York, came to Southern California in 1927; he was to be one of the most influential pioneers of modern art in the region. In the early 1920s Feitelson had visited Paris, where surrealism was incipient and neoclassicism had taken hold. It was the latter that first attracted him, along with Renaissance and Mannerist art.

In 1930 in Los Angeles, Feitelson was introduced to Walter and Louise Arensberg and their European modernist collection, which included masterworks of dada and surrealism and was a nexus for the intellectual/artistic community of Los Angeles.[5] Around this time, Feitelson started teaching at Chouinard School of Art and at the Stickney Memorial Art School in Pasadena, where he met Helen Lundeberg. Thereafter, Feitelson and Lundeberg formulated ideas that crystallized in 1934 into what they called subjective classicism, new classicism, or Post-Surrealism.

In creating their new art, Lundeberg and Feitelson grafted the neoclassicism Feitelson had picked up in Paris onto the metaphysical element he found in the paintings of de Chirico (which the Stendahl Galleries had exhibited in Los Angeles in 1930). The works that followed proclaim that connection: in their theatrical intensity, their insistence on strange encounters between objects, the clarity with which chosen fragments of reality are represented, and the depiction of deep space. But while de Chirico bathed

FIGURE 66
Lorser Feitelson, *Genesis #2,* 1934. Oil
on fiberboard, 40¼ × 47⅞ in.
National Museum of American Art,
Smithsonian Institution, museum
purchase.

his enigmatic paintings in warm, late-afternoon sunlight, Feitelson and Lundeberg used
pale, cool colors to create an atmosphere conducive to calm and to contemplation.

Feitelson and Lundeberg sought to create a reasoned response in the viewer that was
profoundly at odds with Bretonian surrealism. Like the Belgian René Magritte, the
Post-Surrealists created puzzles and told stories using objects. But while Magritte's tales
were insistently unsolvable, Post-Surrealist narratives were always related to a larger
theme and therefore had little to do with surrealist incongruity. Reflecting the spirit of
the times, Feitelson and Lundeberg created paintings with a conscious message, an art
that would be "accessible to the people." But rather than use subjects reflecting the
social and political atmosphere, like artists of the American Scene, they selected meta-
physical ideas, focusing on such themes as "cosmic birth."[6]

In *Genesis #2* (1934; Fig. 66), Feitelson juxtaposed symbols of life forces analogous

in form and in function: an illuminated lightbulb, the half-round of a cut melon full of seeds, a large conch, an eggshell, a mask, and a female breast. He asks the viewer to contemplate the interrelationship of these differing emblems of existence, from the cosmic to the mineral. One of the most compelling features of the painting is the delicate ghostly outline of a woman superimposed over the scene, simultaneously receiving life and giving sustenance—an image expressive of the dialectic between presence and absence that initiates so much of the narrative in Post-Surrealist work.

Feitelson, a natural leader like Breton, assembled a loose circle of friends who had similar aims. Lundeberg, Knud Merrild, Lucien Labaudt, and Grace Clements were the core group, who exhibited together at the San Francisco Museum of Art in 1935 and the Brooklyn Museum in 1936. Because of the acclaim the exhibition received in New York, Feitelson, Lundeberg, and Merrild were included in Barr's exhibition *Fantastic Art, Dada, and Surrealism* at the Museum of Modern Art in New York.

Born in Chicago, Helen Lundeberg was raised in Pasadena, where she received her initial instruction with Feitelson at the Stickney Memorial School of Art beginning in 1930. Lundeberg began her career with exceptional technical skill and stylistic maturity: "Like Athena, she appeared on the artistic scene full-grown."[7] It was Lundeberg who wrote the manifesto of the Post-Surrealist movement.

Lundeberg was interested in a poetic contemplation of subject matter that would bring the viewer to a higher understanding of metaphysical ideas and a deeper experience of the world. Throughout her career her paintings have become increasingly more evocative and mystical. Nearly all her work is about the opening of one space into another, the juxtaposition of internal and cosmic arenas. While she did not make a study of Eastern art and philosophy while engaged in her Post-Surrealist work, she created a contemplative aesthetics of emptiness and stillness characteristic of that art. At the same time, her work showed an American predilection for definite outlines, cool precision, and microscopic attention to detail. *Cosmicide* (1935; Fig. 67) embodies many of Lundeberg's deepest aims. Believing that the shape of a painting could be dictated by its meaning, she began making shaped canvases. *Cosmicide* is a trapezoid, narrow at the top to accommodate a single planetary body, the moon. Invoking the eternal cycle of life and death, it illustrates the interrelationship of all things: the influence of the tidal action of the moon upon the smallest living creature.[8] (Lundeberg had studied astronomy and biology.) She introduces into the painting a vast dreamlike landscape reminiscent of the California desert or the infinite space of Tanguy, including the typically western symbol of the cactus. Lundeberg (and Feitelson) depicted such themes as eternal recurrence and the relationship between love and death, without erotic overtones.[9]

In *Double Portrait of the Artist in Time* (1935; Fig. 68) Lundeberg created a pristine and precisely calculated formal structure. She often incorporated her own image into her quiet interior spaces, prefiguring the feminist art that emerged in the 1970s.[10] She described the painting as follows:

FIGURE 67
Above: Helen Lundeberg, *Cosmicide,*
1935. Oil on Masonite, 40 × 24 in.
NAA-Gift of the Peter Kiewit
Foundation, Sheldon Memorial Art
Gallery, University of Nebraska-
Lincoln.

FIGURE 68
Opposite: Helen Lundeberg, *Double
Portrait of the Artist in Time,* 1935. Oil
on fiberboard, 47¾ × 40 in. National
Museum of American Art,
Smithsonian Institution, museum
purchase.

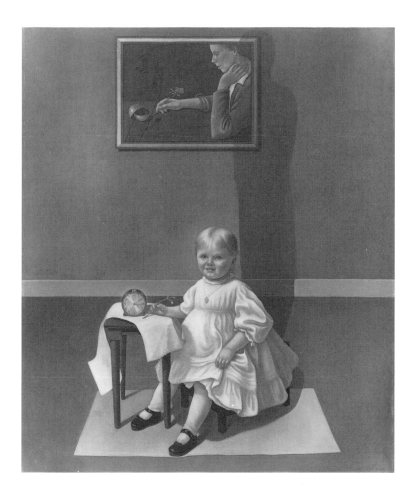

For the portrait of myself as a child I used a photograph which I still have, and though the props are a little different in the painting from the photograph, the pose is pretty much exact. I also used the clock to show that it was a quarter past two which corresponds to the child's age. And instead of presenting myself as an adult before a painting of myself as a child, in *Double Portrait in Time* I reversed this possibility where the child casts a shadow which is that of an adult who appears in the portrait on the wall.[11]

Another of the Post-Surrealists to achieve national distinction was the Danish artist Knud Merrild, who arrived in Los Angeles in 1923. Progressive in art as well as politics, Merrild was attuned to advanced European modernism and quickly found himself at the center of the art scene in Los Angeles. Man Ray and the writer Henry Miller were close friends of his, and he was one of the few American artists collected by Walter and Louise Arensberg.

FIGURE 69
Knud Merrild, *Aesthetic Function in Space,* 1928–33. Painted wood construction with painted cutouts of Masonite, painted corrugated cardboard, and silvered metal, 31 × 22¾ in. Private collection. Photograph courtesy Steve Turner Gallery, Los Angeles.

In the 1930s Merrild made surrealist paintings and collages as well as relief constructions (some of the earliest assemblages to come out of the region), which owed a debt to Ernst, Kurt Schwitters, and organic surrealism (Fig. 69).[12] His collage *Alpha and Omega* (1935; Fig. 70) is related formally and thematically to Lundeberg's shaped canvas *Cosmicide* and Feitelson's 1936 shaped collage-painting *Life Begins* (Fig. 71), expressing the natural law of regeneration: "a cycle of desire, impregnation, generation and birth."[13] It illustrates the artistic borrowings and interactions common among early Los Angeles modernists.

FIGURE 70
Above: Knud Merrild, *Alpha and Omega,* 1935. Collage: oil cloth, paper, magazine and newspaper cutouts, and ink drawing on board, 23¼ × 29¾ in. Photograph courtesy Steve Turner Gallery, Los Angeles.

FIGURE 71
Left: Lorser Feitelson, *Life Begins,* 1936. Oil and photocollage on Masonite, 22½ × 26½ in. Photograph courtesy Tobey C. Moss Gallery, Los Angeles.

In the early 1940s Merrild experimented with surrealist automatism, exploring the fortuitous and the unforeseen in his flux paintings. In works such as *Perpetual Possibility* (1942; Fig. 72) Merrild pooled and dripped house paint onto a fluid surface, which he then tipped, running the colors together to create unexpected effects. These paintings are reminiscent of Onslow-Ford's *coulages* of 1939 and Pollock's drip paintings of five years later. As Jules Langsner eloquently stated, "The impetus to invention came from the necessity to give form to a considered view of existence. For Merrild, that view was rooted in his belief in the life-giving properties of chance, of growth, of discovery, of susceptibility to that which is new, untapped, of one's own time."[14]

Other artists who periodically exhibited with the Post-Surrealists were students of Feitelson's: Philip Guston (then Goldstein) and Reuben Kadish, who together painted a 1937 fresco for the Los Angeles Tubercular Sanitorium at the City of Hope under Feitelson's supervision.[15] The fresco, which takes alchemy as its subject matter, was one of the few murals completed for the Works Progress Administration (WPA) in Southern California that shows any modernist experimentation at all. Guston and Kadish were also politically active, later becoming members of the American Artists Congress, which provided a forum for leftist political ideas.[16] Even so, Bretonian surrealism, which sought the transformation of social structures through revolution, was far more political and leftist-oriented than Post-Surrealism.[17]

"Dada of Us All": Man Ray in Hollywood

While we have become accustomed to the noir image of 1940s Los Angeles in the literature of such writers as Raymond Chandler, it is clear that there was another side to the story. Recalling his days in Hollywood, Man Ray said:

> It was like some place in the South of France with its palm-bordered streets and low stucco dwellings. Somewhat more prim, less rambling, but at the same time radiant sunshine . . . one might retire here, I thought, live and work quietly—why go any farther . . . I had a wonderful time, this was the first time in my life when I really felt like I was on vacation.[18]

Man Ray, a founder of New York dada and a central figure in the Paris surrealist group, lived from 1940 to 1951 in Los Angeles, where the artist-dealer William Copley called him "the Dada of us all."[19] Although an American, Man Ray was, in many ways, as much an expatriate on these shores as Ernst and Breton. After escaping occupied France in 1940, he drove across the United States and took up residence on Vine Street, opposite the "All Night" Ranch Market. In 1946 he married the dancer Juliet Browner in a double wedding with Max Ernst and the painter Dorothea Tanning. Walter and Louise Arensberg gave them a reception in their Hollywood home. Ernst painted *Double Wedding at Beverly Hills* to commemorate the event.[20]

Man Ray was born in Philadelphia in 1890 as Emmanuel Rudnitsky. At the age of twenty-five he met Marcel Duchamp and Francis Picabia in New York, two years after Duchamp's painting *Nude Descending a Staircase, No. 2* caused an uproar at the Armory Show. As friends, he and Duchamp directed the course of New York dada and founded the avant-garde art group Société Anonyme. When Man Ray went to Paris for the first time, in 1921, he was immediately accepted by the group that would later call themselves the surrealists.

Man Ray was extremely prolific in Los Angeles, producing there in ten years more paintings, objects, photographs, and his trademark Rayographs—many of them elaborations of former work—than he had in the prior thirty. *Night Sun—Abandoned Playground* (1943) is a disquieting narrative, a fusion of his favorite earlier themes with recent events in his California life, alluding to his difficult passage to the United States from occupied Europe. The painting contains typically western images such as a sun setting over the ocean, a white beach, and a cypress tree, but the tree has toppled against a Spanish-style bungalow, apparently the artist's own home. The molecules floating inside the house no doubt refer to Man Ray's neighbor, the Nobel Prize–winning chemist Linus Pauling.[21] Molecular arrangements also appear in other works from this period, such as the collage *Optical Longings and Illusions* (1943).

Man Ray exhibited his Los Angeles production of surrealist objects, or assemblages in the spirit of readymades, in a 1948 exhibition at the Copley Galleries. These "Objects of My Affection," as the artist called them, were notable examples of the crossover between popular culture and high art in Los Angeles, a form of proto-pop art. His *Optical Hopes and Illusions* (1944), a mixed-media object composed of a found banjo frame, ball, and mirror, is an ominous toy that makes no sound, referring to Man Ray's thwarted artistic aspirations and the fantasyland of Hollywood.[22]

La Fortune, III (1946), an assemblage composed of a wheel of fortune and a roll of toilet tissue affixed to an upright plank, similarly implied a wiping away of deceit and decay, a scrubbing clean of social veneers. This piece evoked the surrealist "penchant for chance, for the objet trouvé, and for the double entendre."[23]

In his work Man Ray constructed a dada/surrealist metaphor of the ambiguous relationship between the real and the fictive, making reference to the uncertain nature of Hollywood culture and its destinies. He was one of the few artists of the time to respond to Hollywood so directly in his work and perhaps one of the first to address the dark side of the Sunshine Muse.[24]

Man Ray exhibited and lectured extensively on the West Coast (even broadcasting lectures over the radio) beginning in the mid-1940s,[25] but he considered the 1948 exhibition at the Copley Galleries the high point of his sojourn in California. For the opening, the gallery created a Paris café atmosphere. The list of guests gives an idea of the notable artists, musicians, and film people in his circle: Josef von Sternberg, Edward G. Robinson, Harpo Marx, Fanny Brice, Lorser Feitelson, Helen Lundeberg, Peter Krasnow, George Biddle, Hans Hofmann, Isamu Noguchi, Eugene Berman, Roberto

Matta, Knud Merrild, Max Ernst, Dorothea Tanning, Igor Stravinsky, Aldous Huxley, Bertolt Brecht, Thomas Mann, Henry Miller, Luis Buñuel, Jean Renoir, and Otto Preminger.[26]

In addition to his objects and assemblages, Man Ray also exhibited a series of paintings, the *Shakespearian Equations,* derived from his 1930s photographs of the constructions illustrating algebraic equations in the Poincaré Institute in Paris. These spare depictions, which may have opened the way for abstraction in California, are particularly evocative of Lorser Feitelson's *Magical Forms* series of roughly the same date.

Journey into the Body: The Art of Charles Howard

In his painting *The Progenitors* (1947; Plate 10), Charles Howard organized his shapes in rhythmic chains extending over the entire field, with pockets of deep space opening up in the midst of them. These metallic forms from an inner biological realm are bound together as if the system were tentatively structured, not as a matter of function, but as the result of some terrible, cosmic mistake. This painting, which simultaneously expresses chaos and biological limitation, also hints at the possibility of a new order. In Howard's art everything has the power to become something else. It is this sense of potential or transformation that binds his art to that of the surrealists and of Miró.

Howard's art, which incorporated unconscious elements and exploited the automatist approach—though in a restrained manner—declared "very explicitly a balance between reasoned construction and free intuition."[27] His surrealism shared the abstract formalism of the work of Jean Arp and Alexander Calder, which favored the traditions of cubism, constructivism, and De Stijl. Howard achieved an extraordinary fusion of two opposing forces in his work, the one rational and obsessed with order, the other exploring chaos and the depths of the unconscious. It was from this dialectic that, according to surrealist belief and imagery, alternative possibilities emerge.[28]

Howard, an American expatriate who returned to San Francisco from London at the outbreak of World War II, was raised in the Bay Area.[29] In 1932 Julian Levy had presented Howard's work in the groundbreaking exhibition that introduced European surrealism to the United States. He had included only three Americans: Howard, Man Ray, and Joseph Cornell. The following year Howard moved to London, where he was active with the London surrealists from 1936 to 1938.

Though Howard's work shares surrealism's obsession with unconscious material, it is related more to the biological patterns of bodily growth and decay than to the psychological world of dreams. Howard's paintings, which inspire the dim remembrance of primordial experiences such as the moment of birth or a premonition of death, also inspire a feeling of awe arising from heightened awareness of the sensing and feeling self.

This sense of inner sublimity connects Howard's work to traditions in eighteenth- and nineteenth-century English painting.[30] A special state akin to the "marvelous" of

the surrealists, the sublime also contributes to a feeling of awe before the infinite, conveyed in Howard's work.

Movement was also a central concern of the artist. Like his lifelong friend Calder, Howard founded an art that exploited a "kind of mechanistic motion in space which grows inevitably from modern urban life."[31] Yet Howard was restrained in the employment of motion, and the dialectical nature of his art is here most apparent: he created primarily static constructions in which certain forms introduced a subtle sense of movement; in this his work shares much with the paintings of Kandinsky. In other works, Howard created a feeling of intense stillness that seemingly forebodes cataclysmic change. His paintings speak of time suspended, or a sense of déjà vu reflecting the political climate of the World War II era.[32]

Howard went through an artistic catharsis during the early blitzes in London, and his work took on a darker, more emotional quality, became more tense and dramatic. One critic compared his approach then to that of the artist Paul Nash, "who developed a kind of 'found-object' art out of the shapes of shattered buildings and splintered Messerschmitts."[33] In *First War Winter,* 1939–40 (which Howard completed in San Francisco), there is an explosion of forms, as if an architectural structure were composed of parts on the verge of collapse. Narrow filaments sag toward the center of the composition, creating the impression that everything is being sucked into a vortex.

In 1940 Howard left the chaos of wartime England and moved back to San Francisco, where his work was immediately well received by local critics and the director of the San Francisco Museum of Art, Grace McCann Morley. He acted as designing supervisor of the WPA and in 1945 took part in a lecture series on surrealism at the California School of Fine Arts that included Salvador Dalí, Man Ray, and the surrealist poet Georges Lemaître.[34]

During the war, Howard worked in a shipyard, where the symmetry of ship construction engaged him and where scrap piles provided him with streamlined forms and accidental twists of metal. He also spent hours in the library looking at books on biology. His work began to incorporate a greater sense of the biological and of the metallic and also revealed his increased interest in multispatial arrangements, though he retained an essentially flat two-dimensional space by exploiting the ambiguity of figure and ground.

The First Hypothesis (1946; Fig. 73) was completed shortly before Howard returned to live permanently in England. In it hairlike filaments spill out of an "organ" encased in other forms and positioned along a central axis or totem-pillar. A single, bladelike form protrudes into our space. Reminiscent of the symbol of infinity, it refers to the unknown, or to expansive infinite space and alternative possibilities, ideas implicit in Howard's mature work. As Howard's most eloquent critic, Douglas MacAgy, wrote:

> The abyss is a recurrent motif in the arts. It has inspired a range of responses from curiosity
> through wonder, awe, fear and dread. This abyss, with its origin of light obscured and its
> illumination lost in a periphery of darkness, may be claimed to present the unknown as a

FIGURE 73
Charles Howard, *The First Hypothesis,*
1946. Oil on canvas, 16¼ × 22⅛ in.

The Menil Collection, Houston.
Photograph by Paul Hester.

hidden power. Stability is threatened: projected movement into it might be endless and timeless. To become absorbed by it could mean that dimensions might be transformed, and with the change, a measure of faith. This unknown may be unformed, but it cannot be called formless. In a word it is that archetype of the abyss—Chaos.[35]

Howard fashioned a visceral art in which abstract forms were a potent vehicle of the sublime. He was one of California's most prominent and influential artists during the war. Afterward, when he returned to England, he continued to develop his art, creating in the 1960s ever more austere visions that paired minimalist simplicity with a great complexity, expressing the primal struggle between order and chaos intrinsic to surrealism.[36]

Isle of Possibility: Gordon Onslow-Ford and the Dynaton

San Francisco, long a haven for nonconformists and eccentrics, was in the postwar period a mecca for artists, poets, and other members of a growing counterculture.[37] Here artists with modernist leanings developed a strong sense of community. San

Francisco was also a city poised, like all of California, "between the currents of the great old cultures of the Pacific and the stirring forces of America."[38] This openness to the cultures of Mexico and the Pacific Rim, and to the stream of international modernism, provided the catalyst for the Dynaton.

The Dynaton came into being in the late 1940s. Wolfgang Paalen had been brewing the postsurrealist experiment for five years in Mexico before moving to the Bay Area in 1948. As Lee Mullican recalled, "Paalen felt that there was an intellectual climate in San Francisco where something could really happen. The war had ended. We were all enthusiastic that . . . this scene would be a growing center of culture. And the museum was sympathetic to what was happening."[39]

Some years earlier in France, prior to the outbreak of World War II, Gordon Onslow-Ford and the Chilean surrealist Roberto Matta had together developed the idea that the world of perception was only a section of a larger, invisible, order of existence in which everything was bound together into an indivisible whole.[40] When they joined André Breton's surrealist movement during its final phase in 1938, they had already developed their own approach to automatism, which had more to do with time and space than with Freud.[41] Together they reoriented the movement toward the more abstract and automatic foundation from which it had arisen in the early 1920s. This later form of abstract surrealism, which was so influential in the United States in the early 1940s, was more concerned with ideas about higher dimensions and with exploration of a fluid time-space continuum than the earlier version had been. Although surrealism is usually associated with the studies of Freud, it is clear that art at this time developed out of a matrix of influences and ideas, and that later surrealism owed as much to concepts about space and the fourth dimension as it did to psychology.[42]

When he arrived in the United States in 1941, Onslow-Ford became distinguished as surrealism's chief spokesman in the country until Breton came later that year. Onslow-Ford gave the first significant series of lectures on surrealism in the United States, at the New School for Social Research. Along with Howard Putzel, he also organized chronological exhibitions to accompany these lectures. Onslow-Ford was key to the assimilation of surrealist methodology and thought in the years when American art was coming of age.[43]

In 1941 Onslow-Ford went to Mexico, where the Austrian surrealist Wolfgang Paalen had moved two years earlier at the invitation of Diego Rivera and Frida Kahlo. Paalen's reputation had been established in 1936 in Paris, and he was one of the organizers of the *Paris International Surrealist Exhibition* in 1938, the year he met Gordon Onslow-Ford at the Café Deux Magots. Paalen's real contribution to international art came in Mexico, however, where he was inspired by the primal spirit of native American arts, the new physics, and the thought of John Dewey. In 1940 he helped Breton organize an international surrealist exhibition there.[44]

In Mexico Paalen published *Dyn,* one of the most avant-garde art journals flourishing internationally during the war. This interdisciplinary (mainly English-language)

review of art, archaeology, and science circulated theoretical and critical essays as well as illustrations of contemporary masters like Picasso and Henry Moore, and the emerging Robert Motherwell and Jackson Pollock. It especially focused on the native arts of the Americas and on art theory, advancing "an open-ended approach to art based on creativity's boundless potential."[45] Paalen saw automatism as a source of raw material for the artist but not as an end in itself. He published his "Farewell to Surrealism" in the first issue; Onslow-Ford, after officially resigning from the movement in 1943, contributed to the final issue. *Dyn* had a significant impact on expatriated European artists in the United States as well as the emergent New York School. During the war years it led many artists into surrealist phases, including Lee Mullican in 1943. Others with whom Paalen and Onslow-Ford were in close contact in Mexico were Motherwell and Matta. Motherwell recalled that "what we did . . . as then-isolated Western intellectuals in Mexico, was to encourage each other in our various aspirations and with our various bits of knowledge."[46]

Onslow-Ford moved to the San Francisco Bay Area permanently in 1947, taking with him a formidable collection of twentieth-century modernist and pre-Columbian art (Fig. 74). He had a major retrospective at the San Francisco Museum of Art in 1948,

accompanied by the publication of his book *Towards a New Subject in Painting.* Lee Mullican returned from military duty, and Paalen also moved to the Bay Area in the late 1940s, where each had a retrospective at the San Francisco Museum of Art.

Paalen, Onslow-Ford, and Mullican soon discovered they shared common aims, and in 1949 they lived together for a few months in Paalen's Mill Valley house. In 1950 the artists exhibited together at Stanford University, with lectures by Sybil Moholy-Nagy, Onslow-Ford, and Paalen. Soon thereafter the artists were shown again, this time at the San Francisco Museum of Art in an exhibition they called the *Dynaton.*[47] In one of his two essays for the exhibition catalogue, Paalen wrote:

> Our images are not meant to shock nor to relax; they are neither objects for mere aesthetic satisfaction nor for visual experimentation. Our pictures are objects for that active meditation which does not mean detachment from human purpose, but a state of self-transcending awareness, which is not an escape from reality, because it is an intuitive participation in the formative potentialities of reality.[48]

According to the group, the Dynaton (from a Greek word meaning "the possible") was a transformative art, a fusion of the artists' interests in pre-Columbian and native American cultures, shamanism, non-Western philosophies such as Zen Buddhism, the new physics (particularly wave-particle theory), and extraterrestrial life, all in an essentially meditative framework. The artists of the Dynaton espoused the principles of European surrealism—automatism and the primacy of the unconscious—and the vital quiet in California nature as their points of departure.

Nature was essential to the Dynaton. Paalen poetically referred to the work of each artist in terms of the four elements. "For Gordon the element is water and all it hides and bares, the moon, the neckline of the figurehead and the breath in the shell. . . . Air is the element for Lee, and all it carries, pollen, feathers, the dreams of birds and spikes of stars and the holy nest of winds . . . the ray of sun on the straw." Paalen referred to himself as "the fire, the places where the devil cooks his ware."[49]

Onslow-Ford's Dynaton paintings radiate a sense of the artist's preternatural intimacy with nature. In *A Stone That Dreamed* (1950; Fig. 75) a vertical surface grid of broken color creates a screen through which pulsating dots subtly move. It is as though reality were coming into focus from behind a veil of illusion. Viewers, actively meditating, situate themselves in the kinetic space of the painting.[50]

According to Mullican, the Dynaton now floats in his memory "as a softened sun."[51] His mandala-like paintings (Fig. 76), reflective of the West's wide-open spaces and possibility for intimacy with nature, invited contemplation. Capturing the essence of vast expanses of sea, land, and sky, Mullican contributed "the sunlit fields and refractions of the West" to the aesthetic of the Dynaton.[52]

Soon after the 1951 San Francisco exhibition, the group disbanded. Paalen returned

FIGURE 75
Above: Gordon Onslow-Ford, *A Stone That Dreamed,* 1950. Casein on paper mounted on board, 36 × 85 in. Collection of the artist, Inverness, California.

FIGURE 76
Left: Lee Mullican, *Peyote Candle,* 1951. Oil on canvas, 50 × 35 in. Collection of the artist, Santa Monica, California.

to Mexico and Mullican moved to the Los Angeles area, where he has lived ever since, spending much time in New Mexico as well. Onslow-Ford moved to Mill Valley and later Inverness, where he now resides.

In retrospect, Onslow-Ford feels his contribution to art was only just beginning at the time of the Dynaton exhibition. Six months later he discovered a more direct expression of the deep structures of the mind in what he called line/circle/dot. It was then he felt he had discovered the root of all things and "the depths from which things grow."[53]

Both Onslow-Ford and Mullican (who also feels his own Dynaton paintings belong to a formative stage of his art) still find inspiration in their early breakthroughs with Paalen in San Francisco. The Dynaton artists, in addition to exhibiting an interest in native American culture and meditative states of consciousness, integrated Eastern philosophies into their art, thus exemplifying an early openness to Asian culture. This openness has been a continuing influence on American art and culture since the 1960s, but for an even longer time it has been intrinsic to the art of California, because of the state's location on the Pacific Rim.[54]

Conclusions and Consequences of Surrealism

Surrealist expression in California emerged during the 1930s and 1940s from audacious experimentation and innovation at the boundaries of art forms and genres. Surrealism proved an experimental art that could be exported anywhere, taken up by others and mixed with local cultural possibilities. California artists tinkered with the international model and gave surrealism new meaning.

Surrealism is an art of internal experience and its transformation into a profound form of self-portraiture. Surrealist-inspired California art revealed the artist's encounter with the inner and outer world during a period in U.S. history when traditional certainties, boundaries, and identities were thrown into question.

Although the history of surrealism in California is inextricably tied to the depression and the events of World War II, common experiences of these crises are not always directly visible in the work of California artists. Diverse and individual expressions arose in California art during the 1930s and 1940s; their inner similarities are as striking as their formal differences. Connecting much of the work are metaphors for "interconnectedness," "potential for change," "vastness," "restriction," "elasticity in relationship to space," "dialectic between presence and absence," "the ambiguous relationship between the real and the fictive," and "the fictional nature of the culture." Some of these metaphors are those of modernist art as a whole. Others are more specifically related to California modernism and seemingly point toward a postmodern aesthetic.[55]

It was not surprising that surrealism took early hold in Los Angeles, where Hollywood movie lots often spill out into city streets. Los Angeles was surrealist by nature. Artists then, as now, could hardly evade the effects of this popular culture—a creative

force continuously reinventing itself—on their art.[56] The link between surrealist art and the popular culture of the film industry in the region was articulated as early as 1934 by the San Francisco critic and artist Glenn Wessels, who reviewed a Max Ernst exhibition at the Paul Elder Gallery: "Ernst speaks from that half-world, the subconscious, the world of dreams, the Mickey Mouse world . . . where 'almost anything is more than liable to happen.'"[57]

California surrealist expression developed outside the mainstream of modern art, in the freedom of the western frontier. The frontier lies physically and metaphorically far from artistic rules and institutional strictures, tradition, and imposed ideas. It encourages inwardness, individuality, reflection. Much of California art exhibits an obsession with the natural landscape, its light and space. Post-Surrealism, for example, evoked a sense of freedom, contemplation, and peacefulness that can be attributed to the geographic and climatic conditions of the Pacific coast. Nonetheless, it was not merely a local Los Angeles expression; its concepts were universal. Even so, the work cannot be accommodated in the framework of "international surrealist art," because its focus and priorities were radically different. It exemplifies the inevitable meeting and clashing of cultures, ideologies, and artistic styles that contribute to the stylistic eclecticism or pluralism characterizing much of California modernist art.[58]

A closer study of Man Ray's Los Angeles period and his influence on regional artists is still called for. His work was an anticipation of pop art "in the meticulous rendering of ordinary things unexpectedly isolated for our contemplation—" though invested with an enigma lacking in pop art.[59] Man Ray's California output contributed to the emergence of pop art, because it may have directly influenced the proto-pop expression of artists like Jess, who was living in Southern California and actively visiting galleries at the time.

Clearly in melding European surrealism and the popular culture of Los Angeles Man Ray helped define a regional propensity for creating art that achieved a crossover between popular culture and high art. He also brought to light the Southern California inclination to mix fantasy and the real. To harbor such opposites while simultaneously dissolving the barriers that distinguish them is a feature intrinsic to surrealism, as well as to postmodernist theory. Equally, his Rayographs and other photographic work initiated a special role for photography in regional art, beginning in the 1960s with the artists Wallace Berman and George Herms and including diverse others such as Robert Heinecken and John Baldessari. Man Ray contributed to the strain of Los Angeles art that understood the potential of the photograph-as-object and endorsed photography as a serious element of the art lexicon long before the New York postmodernist work of the artists Sherrie Levine, Richard Prince, Cindy Sherman, or others in the 1980s.[60]

Changes were also visible in the art of Lorser Feitelson beginning in the early 1940s, changes that must have been due to the wartime climate and the influx of refugees from Europe, especially Charles Howard and Man Ray. Feitelson developed his Post-Surrealism until about 1942, when his art went through a transformation and began to

reflect "the realization that certain kinds of events unexpectedly take one beyond the usual way of experiencing things."[61] In this new work, Feitelson developed surrealist abstractions in which he sought to "invent 'magical forms' at once tangible and without parallel in memory, concrete and freighted with interior sensation."[62] Thereafter he developed a spatially ambiguous art in which form and ground were indivisible, and in which shape was preeminent and wholly enigmatic, merely evocative of natural forms.

By 1950 Feitelson had become an exponent of the abstraction termed hard-edge, or abstract classicism, along with the artists John McLaughlin, Karl Benjamin, and Frederick Hammersley. While in Northern California surrealism developed toward abstract expressionism, in Southern California it developed toward geometric abstraction. Like Post-Surrealism, abstract classicism evoked a contemplative peace based in local environmental conditions and the artists' conscious absorption of Eastern philosophies. At the same time, it conveyed a sense of movement, tension, or "slippage" that expresses the mobility and artificiality of Southern California culture, thus embodying at once the two directions visible in contemporary Los Angeles art. Abstract classicism anticipated the Los Angeles finish fetish of the 1960s and the light-and-space art of the 1970s and prefigured the important artistic impulse minimalism.[63]

In the San Francisco Bay Area in the 1940s, artists were exposed to surrealism primarily through the work of Charles Howard, Dorr Bothwell, Jean Varda, Clay Spohn, Stanley William Hayter, Mark Rothko, and the artists of the Dynaton group. It is doubtful whether those artists who championed abstract expressionism, especially at the California School of Fine Arts, would have been so open to the new gestural, abstract idiom without previous exposure to surrealist principles. At any rate, their interest in surrealism waned around 1948, in part because of their exposure to the anti-surrealist sentiments of Clyfford Still.[64]

Still's distaste for surrealist automatism was endemic during the late 1940s. The San Francisco school of abstract expressionism rejected myth-conferring titles and symbols, and its work rarely showed such surrealist commonplaces as swirling arabesques and curvilinear shapes. Moreover, because automatism was not fundamental to the painting process, the work produced was somewhat less linear and gestural than abstract expressionism in New York, more "rugged and earthy."[65]

While surrealist automatism was being discouraged at the California School of Fine Arts, it was invigorating an underground scene in the Bay Area and in Los Angeles that would coalesce into the Beat generation expression of artists like Wallace Berman, George Herms, Gordon Wagner, Jay DeFeo, and Bruce Conner. The Dynaton, a conceptual rather than a perceptual art, provided a bridge between the interest in surface of the San Francisco school of abstract expressionism and the content-driven art of the Beats.

The Dynaton's use of themes and motifs inspired by non-Western art forms and primitive art, its interest in the new science and extraterrestrial life, its allusions to Zen as well as its unorthodox approaches and anti-establishment attitudes paralleled the

interests of the post-Still generation: Asian philosophy, esotericism, Mexican culture, the nonrational, jazz culture, Alan Watts, and Jungian psychology. The Dynaton helped set the tone for much of the art of Northern California in the 1950s, contributing to the emergence of Beat and funk art. Onslow-Ford, Paalen, and especilly Mullican were connected with the underground activity that had begun in San Francisco in the early 1940s.

One of the earliest and most important manifestations of this counterculture was in experimental film. James Broughton and Sidney Peterson, who produced a surrealist fantasy, *The Potted Psalm,* and Frank Stauffacher, who initiated the Art in Cinema series at the San Francisco Museum of Art, were close friends of the Dynaton artists.[66] Surrealist automatist calligraphy is also visible in the 1950s work of several of the artists who exhibited at the Six Gallery, the focal point for Beat-era artists and poets from 1954 to 1957.[67] Five of the six artists who started the gallery had drifted up from Los Angeles, following the promise of an active and close-knit art community.[68]

The impulse to merge genres and to eliminate traditional boundaries between art forms grew equally out of the dada and surrealism of the artists Knud Merrild, Max Ernst, and Man Ray, who exhibited in Southern California widely during the late 1940s. What emerges from this picture is an untidy but vigorous history of cross-pollinations and complex interconnections. European surrealism has had a powerful influence on the art of California, from the abstract expressionism of the 1940s and the assemblage of the 1950s and 1960s to contemporary expressions.

Notes

1. William Copley, "Portrait of the Artist as a Young Dealer," in *Paris—New York* (Paris: Centre national d'art et culture Georges Pompidou, Musée national d'art moderne, 1979), 6.

2. In 1944 Morley, with Sidney Janis, organized another important survey, *Abstract and Surrealist Art in the United States.* She was also responsible for organizing or bringing to San Francisco many monographic exhibitions of work by surrealists, including that of Ernst, Arshile Gorky, Charles Howard, Madge Knight, André Masson, Matta, Isamu Noguchi, Onslow-Ford, Wolfgang Paalen, Kay Sage, Clay Spohn, and Tanguy. In 1935, moreover, she organized the first museum exhibition of Los Angeles Post-Surrealism, which traveled to the Brooklyn Museum the following year. Douglas MacAgy, who later directed the California School of Fine Arts and championed abstract expressionism, worked under Morley during this period. He was then a champion of surrealism and highly supportive of the Bay Area artists Charles Howard and Clay Spohn.

3. On the relationship between surrealism and World Wars I and II, see Sidra Stich, *Anxious Visions: Surrealist Art* (University Art Museum, University of California at Berkeley, 1990); and William S. Rubin, *Dada and Surrealist Art* (New York: Harry N. Abrams, 1964), 211. By the late 1920s, the surrealists found it difficult to remain in an isolated world of ideas, aloof from political action. Many of them admitted then that social revolution was essential, that the revolution of the mind and spirit could not cope independently with problems related to social revolution,

but only in cooperation. Breton and some of the other surrealists joined the Communist Party in 1927, and in the second manifesto of 1929, surrealism was defined as a political revolution.

4. As the cultural historian Michael Meyer has noted, "Los Angeles typified and typifies modernity in its mobility and artificiality. . . . Everything and everybody is uprooted and imported . . . the intellectual elite of European culture, ever enriching, contradicting, and reinforcing the latest level of indigenous achievement and establishment" ("Traditional and Popular Culture: Los Angeles in the 1940s," *Southern California Quarterly* 69, no. 4 [Winter 1987]: 293–94).

5. See Naomi Sawelson-Gorse, "Hollywood Conversations: Duchamp and the Arensbergs," in *West Coast Duchamp,* ed. Bonnie Clearwater (Miami Beach, Fla.: Grassfield Press, 1991), 24–45, for a discussion of the Arensberg collection and its importance to the artistic development of Southern California. Through this collection many artists had direct contact with dada and surrealist art. Though the extent to which the collection fueled surrealist experimentation in Southern California has not been determined, its works by Duchamp, Ernst, Magritte, Miró, Mondrian, Brancusi, Calder, and Dalí, among others, may have influenced the direction Feitelson's art would soon take.

6. In this the Post-Surrealists were thematically allied with the late surrealist artists such as Onslow-Ford and Matta.

7. Diane Moran, "Helen Lundeberg," in *Lorser Feitelson and Helen Lundeberg: A Retrospective Exhibition* (San Francisco Museum of Modern Art, 1980), 24. Feitelson introduced his students to diverse directions: classical working methods, such as master drawing techniques, and instruction in art history: the art of the Renaissance, Mannerism, cubism, futurism, and surrealism. He also took them to see the Arensberg collection.

8. Diane Moran, "Post-Surrealism: The Art of Lorser Feitelson and Helen Lundeberg," *Arts* 57 (December 1982): 128.

9. As Whitney Chadwick has observed, the surrealist attitude toward women was always ambivalent. See her complete treatment of this subject, *Women Artists and the Surrealist Movement* (Boston: Little, Brown, 1985).

10. See Susan Ehrlich, *Turning the Tide: Early Los Angeles Modernists, 1920–1956,* exh. brochure (Laguna Art Museum, 1991), n.p. See also Joseph E. Young, "Helen Lundeberg: An American Independent," *Art International* 15 (September 1971): 47.

11. Young, "Helen Lundeberg: An American Independent," 46.

12. Susan Ehrlich, "Knud Merrild," in Paul J. Karlstrom and Susan Ehrlich, *Turning the Tide: Early Los Angeles Modernists, 1920–1956* (Santa Barbara Museum of Art, 1990), 138–41.

13. Victoria Dailey, "Knud Merrild: Change and Chance," in *Knud Merrild* (Los Angeles: Steve Turner Gallery, 1991), 10.

14. Jules Langsner, *Knud Merrild: 1894–1954* (Los Angeles County Museum of Art, 1965), 5.

15. Other artists who exhibited with the Post-Surrealists were Helen Klokke, Ethel Evans, Etienne Ret, Harold Lehman, and Elizabeth Mills. See Moran, "Post-Surrealism: The Art of Lorser Feitelson and Helen Lundeberg" (as in note 7), 125.

16. Feitelson wielded considerable political power himself as supervisor of murals, paintings, and sculpture for the Southern California Federal Art Project.

17. The ideal the surrealists sought was to transcend social and economic approaches to experience and to function independent of, though side by side with, political revolution so that the experiments of the inner life could continue.

18. Arturo Schwarz, *Man Ray: The Rigour of Imagination* (London: Thames and Hudson, 1977), 74, 75.

19. Jules Langsner, "About Man Ray: An Introduction," in the exh. cat. *Man Ray* (Los Angeles County Museum of Art, 1966), 9. Like Man Ray, Marcel Duchamp was an important presence in Los Angeles during the period, through the patronage of Walter and Louise Arensberg. Duchamp and Man Ray had been the catalysts of the Arensbergs' New York salon, which was the unofficial center of the New York dada movement in the teens. The Arensbergs revered and were deeply committed to Duchamp. His work, including *Nude Descending a Staircase, No. 2,* made up the core of their extensive and renowned art collection (Naomi Gorse, "Hollywood Conversations: Duchamp and the Arensbergs," in *West Coast Duchamp* [as in note 5], 25). Duchamp's influence also extended to Northern California artists in the 1940s through Clay Spohn, who taught at the California School of Fine Arts during the period and had met Duchamp in the 1920s in Paris through Charles Howard. When Duchamp participated in the 1949 "Western Round Table on Modern Art" in San Francisco, Spohn reconnected with him. A few months later Spohn created his *Museum of Unknown and Little-Known Objects,* a neodada installation of discrete objects at the California School of Fine Arts.

20. Schwarz, *Man Ray: The Rigour of Imagination,* 74.

21. Ibid.; and Merry Foresta, "Exile in Paradise: Man Ray in Hollywood, 1940–1951," in National Museum of American Art, *The Art of Perpetual Motif* (New York: Abbeville Press, 1989), 285.

22. Foresta, "Exile in Paradise," 297.

23. This was the interpretation of the work by Susan Ehrlich in her essay "Man Ray," in *Forty Years of California Assemblage* (Wight Art Gallery, University of California at Los Angeles, 1989), 188.

24. Fortune or chance was a popular theme with surrealist artists during the period. Many of their works alluded to the difficulties they faced in escaping from occupied France.

25. Man Ray exhibited at the Pasadena Art Institute; the Los Angeles Museum of History, Science and Art; the Circle Gallery; and the Modern Institute of Art.

26. Foresta, "Exile in Paradise," 304; and Copley, "Portrait of the Artist as a Young Dealer" (as in note 1), 32.

27. Charles Howard, quoted in *Abstract and Surrealist American Art* (Art Institute of Chicago, 1947), 16.

28. According to the art historian Sidra Stich, "In Surrealist depictions, turbulence and frenzy, not logic and control, rule the universe. The illusion of harmony and ultimate or primal stasis is disclaimed, and a conception of human dominance, especially of reason as a regulating power, is torn asunder. Instead, a struggle between order and chaos is represented in which the dark forces of rupture and the vitality of the unknown reveal new or alternative possibilities" (*Anxious Visions* [as in note 3], 108).

29. For more about the Howard family, see Stacey Moss, *The Howards: First Family of Bay Area*

Modernism (Oakland Museum, 1988), 7. See also Susan M. Anderson, *Pursuit of the Marvelous: Stanley William Hayter, Charles Howard, Gordon Onslow Ford* (Laguna Art Museum, 1990), and Douglas Dreishpoon, "Some Thoughts on the Enigmatic Charles Howard," in *Drama of the Mind: Charles Howard, 1899–1978* (New York: Hirschl and Adler Galleries, 1993).

30. Edmund Burke, *Philosophical Treatise into the Origins of the Sublime and the Beautiful (1756)* (London: Routledge and Kegan Paul, 1958), 73. See also Linda Dalrymple Henderson, "Mysticism, Romanticism, and the Fourth Dimension," in *The Spiritual Art: Abstract Painting, 1890–1985* (Los Angeles County Museum of Art, 1986), 221.

31. Gerald Cullinan, "Novel Exhibition Reflects Reactions of San Francisco Artists to Total," *San Francisco Call-Bulletin,* January 10, 1942.

32. Sidney Peterson, manuscript, ca. 1940, the Oakland Museum Art Library and Archives of California Art, n.p.

33. Basil Taylor, introduction to *Charles Howard* (London: Whitechapel Art Gallery, 1956), 9.

34. Howard was at the center of the circle of Bay Area modernists that included Adaline Kent, Robert Howard, Madge Knight, and Clay Spohn, all of whom took a surrealist approach. Until his arrival in the Bay Area few other artists were experimenting with surrealism: Matthew Barnes and Lucien Labaudt were prominent among them.

35. Douglas MacAgy, "A Margin of Chaos," *Circle* 10 (Summer 1948): 41.

36. Howard's impact on the art of California during the early 1940s may have been as important as Man Ray's but possibly not as far-reaching. It has indirectly influenced diverse artistic generations, however—even such contemporary artists as Wally Hedrick and Jeremy Anderson, whose sense of form was molded by the organic abstraction of Bay Area artists such as Howard, Adaline Kent, and Robert Howard.

37. See Rebecca Solnit, *Secret Exhibition: Six California Artists of the Cold War Era* (San Francisco: City Lights, 1990), 25–56, for an in-depth look at the Bay Area during the 1950s and the Beat poets and artists.

38. Wolfgang Paalen spoke of San Francisco in these terms. Quoted in Amy Winter, "Dynaton—the Painter/Philosophers," in *Dynaton Before and Beyond* (Malibu: Frederick R. Weisman Museum of Art, Pepperdine University, 1992), 16.

39. Lee Mullican, interviewed by Joann Phillips, Los Angeles Art Community, Group Portrait, Oral History Program, University of California at Los Angeles, 1977, 90. See also Mullican, interviewed by Paul Karlstrom, May 1992–March 1993, Archives of American Art, Smithsonian Institution. For more on the Dynaton, see Winter, *Dynaton Before and Beyond.*

40. Matta and Onslow-Ford wanted to show the interrelationship between the perceived world and the higher dimensions. See Gordon Onslow-Ford, *Towards a New Subject in Painting* (San Francisco Museum of Art, 1948); and Anderson, *Pursuit of the Marvelous* (as in note 29), for more thorough discussions of the interaction between Matta and Onslow-Ford.

41. See Martica Sawin, "'The Third Man,' or Automatism American Style," *Art Journal* 47, no. 3 (Fall 1988): 184. In Paris in 1939, shortly before the outbreak of the war, Onslow-Ford created chance patterns by freely pouring Ripolin enamel on canvas laid on the ground and watching the colors run together, sometimes peeling off layers to enhance the illusion of depth. These paintings, which he called *coulages* (from the French verb "to pour" or "to flow"), predated by some years both Knud Merrild's and Jackson Pollock's poured paintings. The exploration of chance in automatic processes had been central to surrealism's inception.

42. See Henderson, "Mysticism" (as in note 30), 229; and Anderson, *Pursuit of the Marvelous,* for more about the contribution of later surrealism.

43. See Marica Sawin, "'The Third Man,'" 181–86; and *The Interpretive Link: Abstract Surrealism into Abstract Expressionism* (Newport Harbor Art Museum, 1986).

44. In Mexico until the late 1940s Onslow-Ford created inner psychological dramas or journeys through vast cosmic landscapes in which beings, or *personnages,* having a reality of their own, interacted. Although the paintings, like the *personnages,* underwent changes over a period of several years, they can be seen as a continuum of transformative imagery striving to express the cosmic interrelatedness of all things.

45. Henry Hopkins, "Visionaries," *Antiques and Fine Art* 9, no. 3 (March/April 1992): 76.

46. Robert Motherwell, quoted by Sylvia Fink, "Dynaton Revisited," in the exh. cat. *California: Five Footnotes to Modern Art History* (Los Angeles County Museum of Art, 1977), 36.

47. The writer and poet Jacqueline Johnson, married to Onslow-Ford, also participated in the group, contributing an essay for the catalogue *Dynaton 1951* (San Francisco Museum of Art, 1951), published to accompany the exhibition.

48. Paalen essay in *Dynaton 1951,* 26.

49. Ibid.

50. The viewer's encounter with the artwork was intrinsic to the Dynaton as advanced by the theories of Paalen. According to Lee Mullican, *Time* magazine published an article on Paalen that was widely quoted: "Paalen put the future of Modern Art into focus when he suggested that, just as the spectator may *question the painting,* in turn, the painting may examine the viewer, and as well ask, 'what do *you represent?*'" (Mullican, interview as in note 39, 65–66).

51. Lee Mullican, "Thoughts on the Dynaton, 1976," in *California: Five Footnotes,* 41.

52. Ibid., 36, 39.

53. Gordon Onslow-Ford, interviewed by Ted Lindberg, March 26, 1984, Archives of American Art, Smithsonian Institution, 41.

54. California has always been more open to the influence of Mexico and the Pacific Rim than to that of New York or Europe. The art and philosophy of Eastern religions and pre-Columbian and Mexican native cultures have consistently informed art-making in the state.

55. While frontier living usually lacks the energetic intensity of city life, popular culture and the film industry in Southern California have provided some of the same dynamics. Moreover, the sense of being outsiders on a cultural frontier has more closely bound artists and intellectuals together in the region. "Low culture" and the freedom to experiment fostered an environment in which artists less concerned than those in the East with the stature of their work created a less self-conscious art. Popular culture and fine art merged and distinctions between art categories and media dissolved. Experimentation in the region has been the rule rather than the exception, and hybrids of opposing styles have been not only possible but natural. Los Angeles thus has been hailed as the prototypical postmodern city. See Paul J. Karlstrom, "Modernism in Southern California, 1920–1956: Reflections on the Art and the Times," in Karlstrom and Ehrlich, *Turning the Tide* (as in note 12), 13–42.

56. The European surrealists had been the first generation of artists to grow up on cinema. In the beginning the movies had helped shape surrealism; later, the direction of influence was reversed. Surrealism in the arts affected not only the underground film scene in California

(the films of Wallace Berman and Bruce Conner, for example) but the entire film industry in Southern California and popular culture as a whole.

57. Glenn Wessels, *Art Digest* (October 15, 1934): 17.

58. California gave birth to Post-Surrealism in an egalitarian and didactic era in American culture. Although the region may have been surrealist by bent, it was striving less for absolute freedom or political liberty than for democratic and economic equilibrium. While surrealism posited a radical break with all tradition and institutional structure, 1930s Post-Surrealism paradoxically embraced the American Scene and the objectives of the federal art projects. Aspects of Post-Surrealism fall within the parameters of American regionalism, though the movement indisputably belongs to the modernist dialogue.

59. Jules Langsner, *Man Ray* (as in note 19), 9.

60. For a complete discussion of the art of Los Angeles artists of the 1960s and 1970s, see Charles Desmarais, *Proof: Los Angeles Art and the Photograph, 1960–1980* (Laguna Art Museum, 1992).

61. Jules Langsner, "Permanence and Change in the Art of Lorser Feitelson," *Art International* 7 (September 1963): 75.

62. Ibid.

63. In particular, John McLaughlin, in his search for absolute void, created an aesthetics of the desert and sea, of emptiness and absolute stillness.

64. During the early years of Douglas MacAgy's directorship at the school, before the arrival of Still, numerous faculty members had worked in a semiabstract or surrealist style. MacAgy's wife, Jermayne MacAgy, who was acting director of the California Palace of the Legion of Honor during the war period, showed Jackson Pollock in 1945 and Rothko in 1946—both artists were then making paintings heavily influenced by surrealism. These exhibitions had an impact on Bay Area art. For example, Elmer Bischoff's 1946 painting *The Gifts of Jermayne MacAgy* was reminiscent of Rothko's *Slow Swirl by the Edge of the Sea*. Rothko taught summer sessions at the California School of Fine Arts in 1947 and 1949. His positive attitude toward surrealism helped offset some of Still's negativity. See Michael Leonard, "A History of Painting at the California School of Fine Arts, 1940–1960," master's thesis, San Francisco State University, 1985, 42 and 50–56 passim.

65. Susan Landauer, "Clyfford Still and Abstract Expressionism in San Francisco," in Michael Auping et al., *Clyfford Still* (Munich: Prestel, 1992), 97. According to Landauer, in a letter to me, July 29, 1990, when the prominent printmaker Stanley William Hayter introduced surrealist automatic principles and thought to Bay Area artists in 1948 through a series of public lectures and classes at the California School of Fine Arts, John Hultberg and Frank Lobdell walked out of his painting class. Although Hayter and his teachings were still very much in favor in New York at this time, he was apparently not very popular at the school. Even so, it is likely that Hayter inspired artists in the Bay Area to visually and graphically express wartime horrors. The artist Reuben Kadish was one of those who studied with Hayter in 1940 at the California School of Fine Arts. See Anderson, *Pursuit of the Marvelous* (as in note 29), 14–25, for more about Hayter's California contribution.

66. Among the other friends of the Dynaton artists were Richard Bowman, Mark Tobey, Morris Graves, Kenneth Rexroth, Philip Lamantia, Harry Partch, Alan Watts, Adaline Kent, Robert Howard, Charles Howard, and Stanley William Hayter.

67. Artists who exhibited their work at the Six Gallery include Deborah Remington, Peter Shoemaker, David Simpson, Leo Vallador, Sonia Gechtoff, William Morehouse, Sandra Carlson, and Hayward King.

68. Anderson, *Pursuit of the Marvelous* (as in note 29), 35.

William Moritz

VISUAL MUSIC

AND FILM-AS-AN-ART

BEFORE 1950

During the silent film era, when everything had to be expressed visually, the trick effects of Georges Méliès, the zany "surreal" improbabilities of comedies, the experimental decor of *The Cabinet of Dr. Caligari,* the expressionistic camera movement of *The Last Laugh,* or the shock editing of *Potemkin* were all played and found their way into the vocabulary of commercial features. Yet a distinctly modernist, avant-garde, or "experimental" film also emerged, partly through the participation of artists such as Man Ray, Marcel Duchamp, Francis Picabia, and Salvador Dalí, and partly because of the vigor with which filmmakers like Germaine Dulac and Sergei Eisenstein wrote about the viability of cinema as a vehicle for a modernist art that could add the dimension of time (including controlled duration of viewing, complex juxtaposition, and so forth) to the other elements that concerned contemporary painters and sculptors: abstraction, expressionism, significant form, integrity of materials, heightened perception, new technology.

The borderline between "experimental film" and "the movies" thus remained ill-defined: "art films" or "avant-garde films" were more the question, since expressive, experimental techniques distinguished certain films as more artfully, consciously made, more advanced than the run-of-the-mill commercial products, and those "art films"—including animation and live action, long and short, older and more recent films from all around the world—formed the basis of a critical and popular cult of film art that by 1930 was celebrated internationally in cineclubs and theaters, magazines and books.

Since European art films, classic silent films, or the avant-garde shorts of the 1920s were not screened at every theater, the visually literate of Los Angeles kept track of what was showing at the Filmarte Theatre on Vine Street. During the 1930s art films occupied a permanent place on the Filmarte screening schedules—and if you were lucky, Dudley Murphy, the primary filmmaker of the famous *Ballet Mécanique,* might show his personal copy of that film (with the brief erotic flashes still intact among the

pumping machines), which James Whitney, Harry Hay, and Man Ray saw there.[1] Or in the 1940s, at Clara Grossman's American Contemporary Gallery (the linear descendant of Stanley Rose's bookshop and gallery, located in the Artisan's Patio on Hollywood Boulevard near Las Palmas), you might well sit next to D. W. Griffith or Lillian Gish or Man Ray or the Whitney brothers while watching a classic art film.

California produced a stream of experimental films paralleling those made by the emerging European avant-garde. One of the earliest experimental filmmakers in California was Dudley Murphy, who studied at M.I.T. and served as a pilot in Europe during World War I before coming to Hollywood to work as an art director and apprentice cameraman at the studios—as well as writing movie reviews for the *Los Angeles Evening Herald.* Inspired by Theosophy, he longed to make "Visual Symphonies" that would combine the best of music, dance, and the visual arts through the unique capabilities of film. In the summer of 1920, he shot his first film, *The Soul of the Cypress,* on the rocky shoreline around Point Lobos. It was synchronized to Debussy's *Afternoon of a Faun* and starred his wife, Chase. Critics greeted the premiere of the film, July 10, 1921, at the Rivoli Theatre in New York, with lavish praise: the critic for *Film Daily* noted how "it breaks away completely from the stuff that has been repeated so often, and makes a decided step forward both in the artistic sense, and in pictorial qualities"; the critic for the *New York Times* named it among the best films of the year, saying it was good to see that "the camera can still charm by purely photographic effects."

Murphy made two more "Visual Symphonies" in California— *Aphrodite* (shot on the beach at La Jolla and Los Angeles, with Katherine Hawley, a dancer of the Duncan/St. Denis schools) and *Anywhere out of the World* (again with Chase, at Palm Springs)—and then three in New York. In 1923 he went to Paris, where he worked on the experimental short *Ballet Mécanique* (which was partly funded by Fernand Léger). Afterward, he returned to Hollywood, where he made a dozen features and several musical shorts, including *St. Louis Blues* with Bessie Smith, *Black and Tan* with Duke Ellington, and *Emperor Jones* with Paul Robeson. These commercial films (and two features he shot in Mexico during the 1940s) show imaginative modernist touches in montage and dance sequences despite the occasional banality of their studio scripts. In 1941 Murphy helped pioneer "soundies," three-minute films of jazz and popular songs that were shown on small screens attached to juke boxes—a predecessor of MTV.

Alla Nazimova's screen version of Oscar Wilde's *Salomé* (Fig. 77) counts as not only one of the earliest but also one of the most notorious art films produced in California. Nazimova's popular success onstage and in movies gave her the financial means to make this personal film, which she directed and scripted. She also performed the role of Salomé. Her lover, Natacha Rambova, designed extravagant black-and-white costumes and sets that suggested the Aubrey Beardsley illustrations for the original edition of Wilde's play. Nazimova carefully assembled a cast of homosexual actors (as befitting a work by Oscar Wilde) and encouraged them to perform with stylized, abstracted

F I G U R E 7 7
Alla Nazimova as Salomé and Samson
DeBrier as the Page in Nazimova's
Salomé (1922). Photograph courtesy of
the Academy of Motion Picture Arts
and Sciences.

gestures and poses. The film was shot during 1922 in a small independent studio just a block away from the huge set for the walls of Babylon from D. W. Griffith's *Intolerance* (1916) that was still standing then.[2] At its December 31, 1922, premiere, both critics and audiences found *Salomé* a decadent, quasi-humorous curiosity, and it has remained a camp classic, its images appearing on 1960s psychedelic rock posters and contemporary greeting cards.[3]

Exactly how radical the abstraction in Nazimova's film was can be judged from comparison with the Theda Bara version of *Salomé* from 1918. While Bara's decor and costumes also attempt to give the flavor of Beardsley, they are hopelessly cluttered with Victorian "orientalism," and while the acting of Bara's players seems stagey, it also aspires to conventional realism—Griffith's *Intolerance* would supply a close parallel. By contrast, Nazimova's production boasts a spare elegance as well as fanciful extravagance that defies any specific historical reference and suggests (for example, in the cluster of white spheres that float about Nazimova's head in one scene) an abstract timelessness. In their expressionistic performances, Nazimova's actors display iconic moods rather than simulate realistic psychology.

Nazimova's *Salomé* is best understood in the context of the art film: on one side *The Cabinet of Dr. Caligari* (which premiered in Germany in February 1920, in the United States in April 1921), which adapts avant-garde stage styling to create a stunningly eccentric movie experience, credible in its own terms, and on the other side later experimental films (involving such diverse filmmakers as James Broughton, Jack Smith, Kenneth Anger, the Kuchar brothers and Andy Warhol), which use elaborate, deliberately stylized decor and acting to explore forbidden sexuality. Perhaps, then, it is no accident that Samson DeBrier, the protagonist of Kenneth Anger's 1954 film *Inauguration of the Pleasure Dome,* played the anguished page boy in Nazimova's *Salomé,* under the stage name Arthur Jasmine.

The Los Angeles painter Warren Newcombe developed a special process for using painted backgrounds in films and worked as a special effects expert, first for D. W. Griffith and David O. Selznick, then at MGM, where he won an Academy Award in 1948 for his work on *Green Dolphin Street.*[4] In 1922 and 1923 he shot two imaginative short films, *The Enchanted City* and *The Sea of Dreams,* both of which employed the Newcombe process: all the backgrounds were paintings. The *New York Times,* February 6, 1922, praised *The Enchanted City* (Fig. 78), a futuristic fantasy, for its "impressive" camerawork, "compositions of masses and lines, expressively shaded and lighted." The reviewer complains, however, that the "fantastic story lacks vitality" and recommends that "you just look at the different scenes as you would view pictures in a gallery," because "they have a strong appeal to the eye." In the context of later experimental films (for example, those of Gregory Markopoulos or Joseph Vogel), perhaps the "story" was less important than the painterly values of images.

That these film artists established relationships with the commercial movie world is hardly surprising: 35mm filmmaking was cumbersome and expensive—and to a certain

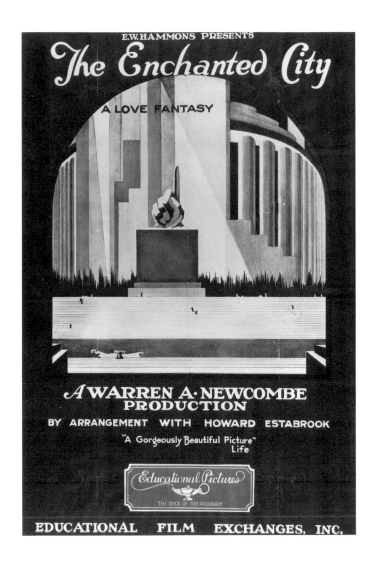

extent kept as a trade secret by commercial enterprises—so most people would need to learn the craft professionally, and once they had demonstrated their mastery of film with an imaginative, dazzling short, they would find it hard to resist offers to work in the industry. Several artists went into commercial filmmaking after making a single experimental film: Charles Klein (*The Tell-Tale Heart,* 1928), Dr. Paul Fejos (*The Last Moment,* 1928), Charles Vidor (*The Bridge,* 1929).

Robert Florey and Slavko Vorkapich, the makers of perhaps the most famous American experimental film of the 1920s, *The Life and Death of 9413—A Hollywood*

FIGURE 79
Right and opposite: The Life and Death of 9413—A Hollywood Extra (1928), by Robert Florey and Slavko Vorkapich: Vorkapich's model sets; Jules Raucourt as 9413, with his Actor's face; Waiting for the call; The death of 9413.

Extra (Fig. 79a–d), also enjoyed long careers in Hollywood. Florey came to Los Angeles from France in 1921 to be a Hollywood correspondent for European film magazines but quickly became involved as an assistant in studio films.[5] Vorkapich, a Yugoslavian, was studying painting in Paris when he saw Griffith's *Intolerance* and decided cinema was the art form of the twentieth century; he came to Hollywood, where he worked as an extra. He eventually sold one of his oil paintings for enough money to buy a camera, which he and Florey used to make *Hollywood Extra*. Florey wrote, directed, and acted in the film. Vorkapich designed the models and trick effects, edited the film, and shot much of the footage, although the live actors were filmed by Gregg Toland, who would later be cameraman for *Citizen Kane*. The twelve-minute film, a genuine little masterpiece, cost less than one hundred dollars. Using expressionistic miniature sets and dramatic moving lighting, imaginatively combined with live-action shots of Hollywood and stylized comic acting, Florey and Vorkapich effectively convey the plight of the hundreds of people who flock to Hollywood hoping for stardom. The brilliance of *Hollywood Extra* lies in its use of cinematic potential, not only in blending live action with trick shots, but also in conceptualizing rhythms (the actor's repeated climb up the staircase to success, like the washerwoman loop in *Ballet Mécanique*) and camera viewpoints (the low-angle shots against a black void to suggest the power of producers and critics, used again later in *Citizen Kane*). The comic acting and Florey's genuinely witty, ironic touches—the absurd masks, "blah-blah-blah" as the only spoken words, the *CASTING* and *NO CASTING TODAY* signs at the gates of Heaven—linger satisfyingly in the viewer's mind.

Following the great success of *Hollywood Extra* in June 1928, Robert Florey quickly made two similar expressionistic shorts, *Loves of Zero* and *Jonathan the Coffin Maker*, before becoming a feature director at Universal, Warner Brothers, and Paramount. Slavko Vorkapich became one of the great Hollywood editors, creating montage

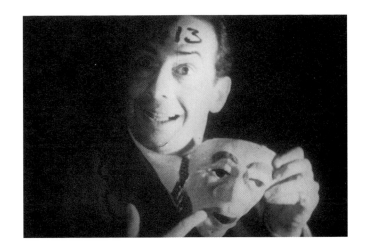

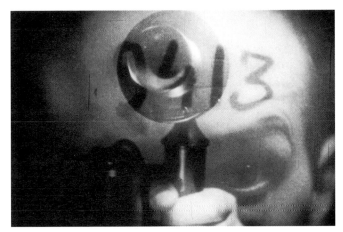

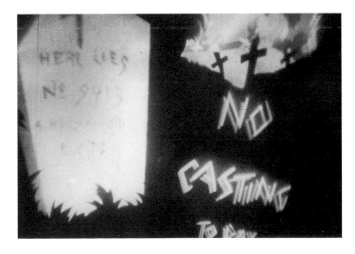

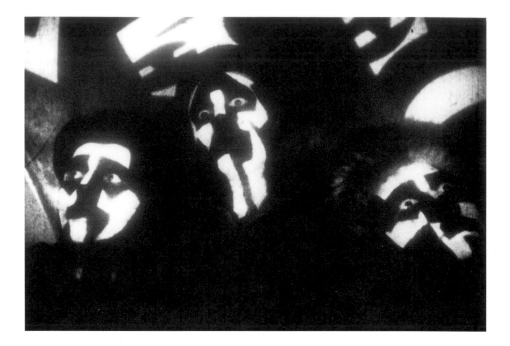

sequences for many MGM features. In 1940 he collaborated with John Hoffman
on two experimental short films, *Moods of the Sea* and *Forest Murmurs,* which synchro-
nized beautiful nature photography with classical music through dynamic editing.
Hoffman, a Hungarian-born MGM editor responsible for such montage sequences as
the famous earthquake in the 1936 film *San Francisco,* had also made a lyrical landscape
film, *Prelude to Spring.* He later directed features, including the 3-D production *Bwana
Devil.*

In the wake of the much-publicized low-budget *Hollywood Extra,* the painter Boris
Deutsch also made a low-budget personal art film in Los Angeles. He was born in Riga,
studied painting in Kiev and Berlin, and fled across Russia in 1916 to the United States,
where he worked in a Hollywood studio from 1919 until 1922.[6] Although hired at first
as a designer, he gradually acquired a familiarity with the whole filmmaking process
that allowed him to make, early in 1929, the fifteen-minute film *Lullaby* (Fig. 80) pri-
vately, for less than five-hundred dollars, some of it borrowed from the Russian refugee
actor Michael Visaroff, who also played the villain in the film.[7] *Lullaby* depicts
the psychological trauma of a Jewish woman (well acted by Deutsch's wife, Riva)
employed as a servant in the house of demanding and abusive Christian Russians. The
servant is charged with keeping the baby quiet during a drunken party, and when she

is slow to serve at table as well (and loath to uncover her hair, following Jewish custom), she is beaten. As the tension mounts, she is seized by a momentary urge to kill the baby but flees the house instead.

Deutsch uses the moody expressionistic visuals and symbolic touches characteristic of the art film to convey the heroine's psychological state. During her crucial bout with hysterical madness, images of her face are intercut rhythmically with abstract patterns in writhing turmoil and with the faces of demons, expressionistically painted in the style of experimental Yiddish theater.[8] And as she flees her house of employment, through Deutsch's special-effects photography the twisted buildings of the village seem to weigh down on her and assume the face of her tormentor. Deutsch also develops the cinematic potential of many scenes, by intercutting the similar faces of the Virgin Mary in an icon (painted by Deutsch) and the servant, or by shooting the accordionist in some nearly abstract diagonal compositions. Unfortunately, the only known print of the film is in poor condition—even the end title is spliced on from another source, so it is not clear that the print is complete. But enough fine touches are visible to establish that Deutsch's work prefigures the "psychodramas" of California experimental film of the 1940s.

While European art film styles and techniques permeated experimental films in Los Angeles, a brilliant 1937 satire, *Even as You and I* (Fig. 81a–c), definitively rejected that influence—at the same time that Los Angeles painters such as Helen Lundeberg, Lorser Feitelson, and Knud Merrild, with their postsurrealist manifesto, celebrated their independence from European trends.[9] The 1936 exhibition of dada and surrealist art at New York's Museum of Modern Art splashed fantastic images across the pages of American newspapers and magazines: the newly founded *Life* magazine, in its fourth issue, December 14, 1936, gave it a four-page spread (with color), including Meret Oppenheim's fur teacup and Dalí's *Persistence of Memory*. And *Time* put Dalí on the cover of the December 14, 1936, issue.

Far from the world of limp watches and fur teacups, the Hollywood Film and Foto League, in a decaying mansion that provided cheap lodging, working space, and social activities for dozens of young leftist artists, sometimes screened Soviet films and promoted documentaries about poverty and workers' problems.[10] Three artists who often met there (and at the Filmarte Theatre)—the Works Progress Administration (WPA) photographers Roger Barlow and LeRoy Robbins and the agitprop actor Harry Hay—were struck by the incongruity of the surrealist fine arts juxtaposed in a magazine with an advertisement for a Pete Smith contest for the best short film, the prize for which was a trip to Hollywood. They decided to make a spoof film chronicling what might happen if innocent amateurs tried to enter a "fine art" short surrealist film in this contest. The three men play naive versions of themselves in the frame story about the contest and filmmaking, and they collaborated on episodes in the film-within-a-film, *The Afternoon of a Rubber Band,* a pungent send-up of avant-garde clichés, including balloon heads from René Clair's *Entr'acte,* pistol games from Hans Richter's *Ghosts*

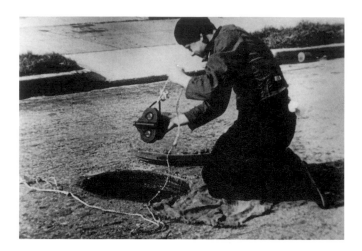

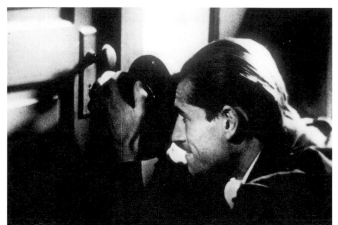

FIGURE 81

Even as You and I, by LeRoy Robbins,
Roger Barlow, and Harry Hay (1937):
Harry Hay lowering his camera down
a manhole; Roger Barlow shooting
through a keyhole; the terrified
observer.

before Noon, and the rival editing theories of G. W. Pabst (the cannibalization of a baby implied by clever cutting together of many brief shots) and Sergei Eisenstein (a steamroller running over a snail puffed into an epic confrontation through paced intercutting of actions and reactions).

In the film another friend of theirs, Hy Hirsh (a cameraman and still photographer who had been working in the Hollywood studios; he would have a distinguished career as an experimental filmmaker in the 1950s), played the role of a grinning idiot savant who periodically admonishes the audience to be quiet (Fig. 82)—a bit they had seen in one of the Soviet films that played frequently in Los Angeles. The hilarious satire in *Even as You and I* contains a serious implication: that the European masters like Salvador Dalí and Luis Buñuel may have "done it all," leaving no room for fresh experiments, aside from parody.

Harry Hay and LeRoy Robbins, however, collaborated in 1938 on a second film, *Suicide,* in which Hay played an emotionally tortured actor who, confusing his own emotions with those of various characters he has played, contemplates killing himself. Hay recalls that some of the shots were single long takes in which he had to portray several different thoughts and feelings overtaking the actor. Other scenes showed him in the makeup and costumes of stage roles, but he is not sure how they were blended, since he was in New York when the film was completed and did not see it projected. Perhaps in making *Suicide,* Hay and Robbins found a fresh formula for expressing this personal psychological drama, and thus showed a way out of the Los Angeles

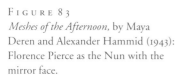

FIGURE 83
Meshes of the Afternoon, by Maya
Deren and Alexander Hammid (1943):
Florence Pierce as the Nun with the
mirror face.

experimental film's aesthetic cul-de-sac. But unfortunately, all copies of the film may
be lost.

Lacking copies of Hay and Robbins's *Suicide,* we must credit another artist with
finding the way out of the cul-de-sac: a remarkable woman named Maya Deren,
who was born in Russia but came to Syracuse, New York, at age five when her psychia-
trist father took a job there.[11] In the 1930s, after graduating from the University of
Syracuse, she became deeply involved in leftist politics, married and divorced, and then
became interested in anthropology. A fascination with the mythic/ritual aspects of hu-
man behavior led her to Haitian Vodoun as a living religion and to Katherine Dunham's
black dance troupe, which incorporated traditional rituals into their art (Dunham had
done her master's thesis on Haitian Vodoun and dance).[12] Deren traveled with the
dancers in 1941, when the troupe moved from New York to Los Angeles, where, at a
party given by the art dealer Galka Scheyer, she met a Czech immigrant filmmaker,
Alexander Hammid (originally Hackenschmied), whom she married in 1942. Hammid
had been active in experimental filmmaking in Prague around 1930 and had made a
subtle and fascinating film, *Aimless Walk,* which followed a young man who wants to
get out of the city for an afternoon. At each point when he equivocates about going
farther, he splits into two figures, one of which goes on while the other observes and
turns back.

Although the refugee Hammid had no print of this film to show, his enthusiasm for
personal, imaginative filmmaking encouraged Maya Deren to undertake a film that in
many ways is similar: *Meshes of the Afternoon,* which bears the title card "Hollywood
1943." *Meshes* visualizes the feelings and thoughts of a young woman (played stunningly
by Deren herself) who at a turning point in her life and relationships pursues a myste-
rious nun with a mirror hiding her face (played by the New Mexico painter Florence
Pierce; Fig. 83). We see the protagonist as three different women performing the same

everyday actions, and each time a sequence recurs, we become more sensitive to the mythic/ritual aspects of these simple deeds and objects. The three women differ in essential ways: one is so light that she seems to float upstairs, another is so heavy that she moves in lugubrious slow motion, and the third is so inept or imbalanced that she staggers intermittently.

While *Meshes* uses the camera tricks, dramatic lighting, and symbolic gestures of the European avant-garde and refers overtly to the surrealist Freudianism of films like Cocteau's *Blood of a Poet* and Dalí-Buñuel's *Chien Andalou,* Deren and Hammid manage to surpass their European prototypes in both technical excellence (their camerawork and editing are brilliant) and conceptual ingenuity, for Deren achieves true ambiguity and moodiness that continually suggest more—approximating Jung's quasi-mystical theory of the archetype rather than the simplistic Freudian symbolism of the surrealists.

After finishing *Meshes,* Deren returned to New York, where she created two films, *At Land* and *Ritual in Transfigured Time,* that form a trilogy with *Meshes.* She also made three other films, wrote numerous articles about film as an art form, toured tirelessly with her films, and helped to establish a circuit of distribution and exhibition for experimental short films.

Deren's work in Los Angeles had dynamic repercussions, for she encouraged several young men there, including Kenneth Anger, Curtis Harrington, and Gregory Markopoulos, who had been toying with "amateur" film and vaguely hoping for careers as directors in Hollywood, to begin making 16mm experimental films that were artworks in and of themselves. Anger's *Fireworks* (1947), Harrington's *Fragment of Seeking* (1946) and *On the Edge* (1949), and Markopoulos's *Psyche* (1948) all treated aspects of homosexuality in a frank yet lyrical fashion that exposed experiences of both terror and beauty. In the manner of Maya Deren, they all made imaginative use of cinematic devices to suggest a surreal dream world. And each man played the protagonist in his own "psychodramas," as this type of film came to be known.

All three filmmakers enjoyed international acclaim for their uncompromising, experimental work—an alternative version of "Hollywood" that was poetic and imaginative, honest and uncensored. Anger and Markopoulos would both make experimental film their life's work, but after a half-dozen successful shorts, Curtis Harrington became an independent Hollywood feature director with such distinguished credits as *Night Tide, Games,* and *What's the Matter with Helen?* Harrington's features brought to seemingly conventional genre films touches of surrealistic irony and bizarre juxtaposition—astonishing, vivid images that confront a mass audience with an uncanny, unexpected mirror image of themselves rather than superheroes, ravishing beauties, and grotesque villains.

One of the finest artistic achievements of modernist California, the cultivation of the preeminent school of "visual music," developed at the same time as live-action experi-

mental film. Indeed, visual music has a history that parallels that of cinema itself. For centuries artists and philosophers theorized that there should be a visual art form as subtle, supple, and dynamic as auditory music—an abstract art form, since auditory music is basically an art of abstract sounds. As early as 1730, the Jesuit priest Father Louis-Bertrand Castel invented an Ocular Harpsichord, which linked each note on the keyboard with a corresponding flash of colored light.[13] Many other mechanical light-projection inventions followed, but none could capture the nuanced fluidity of auditory music, since light cannot be modulated as easily as "air." The best instrument for modulating light took the form of the motion picture projector.

In any case, the movie industry provided a major reason for the growth and flourishing of visual music in Los Angeles. Movie musicals, especially those lavish semi-abstract Busby Berkeley numbers,[14] are a form of visual music, and the industry supplies ready access to technology. Furthermore, during the 1930s and 1940s a plethora of talent passed through or settled in Los Angeles in hopes of gleaning some benefits, contacts, or fulfillment from the boomtown. The rise of fascism in Europe quickened the influx of artists.

It may be hard for us to imagine the immigrant artist community of those decades. In March 1939 Paul Hindemith played as guest violist with the Los Angeles Philharmonic Orchestra under the baton of regular conductor Otto Klemperer. After the performance a lively crowd assembled backstage, including such famous figures as the movie director William Dieterle, the composers Ernst Toch and Arnold Schoenberg, the novelists Vicki Baum and Thomas Mann, and a dozen more, all merrily chatting in German. Suddenly Klemperer cried out (in German), "Are we, then, actually in Berlin, not in Hollywood?" Also present at this historic occasion was one of Hindemith's best friends, Oskar Fischinger (Fig. 84), the foremost influence on the development of visual music in California.

Born in Germany in 1900, Fischinger began making abstract films in Frankfurt in 1922, and by 1926 he was performing multiple-projection "light shows" in his Munich studio.[15] In the late 1920s, he began sychronizing nonobjective imagery to popular records; the resulting films were shown in theaters as advertisements for the records—the first music videos. After a successful series of sixteen of these black-and-white *Studies* (some were screened in the United States as well as in Japan and South America), he made the first full-spectrum color films in Europe: *Circles* (1933) and *Composition in Blue* (1935). At the same time, he also produced the famous walking cigarette commercial, which was copied internationally. He was able to immigrate to Hollywood in 1936 under contract to Paramount (for *Allegretto,* released in 1943) and in 1937 produced for MGM the abstract film *An Optical Poem,* which was distributed as a short in theaters everywhere. In fall of 1938, Fischinger was hired to design and animate portions of Disney's *Fantasia,* and his films were screened weekly for a year to the entire staff of Disney Studios, where they made a lasting impression.[16] Although Fischinger quit Disney after a year because staff committees changed all his designs and ideas, his touch

FIGURE 84
Oskar Fischinger with the original
paintings for the film *Motion*

Painting No. 1, 1949. Photograph by
William G. Hewitt, Jr.

is still visible in the opening Bach episode of *Fantasia.* Examples of Fischinger's work were thus shown to a broad American public.

Fischinger himself, however, found it difficult to work in the factory environment of the studio, and he encountered even more difficulty raising money for independent film projects, so he turned increasingly to easel painting as an outlet for his creative energy. In Germany he had purposely refused to paint since he believed that kinetic abstraction—visual music—would be the art of the future. But he did not begin oil painting as a novice, for he had made thousands of paintings as the basis of his anima-

tion films, many of which prefigure the serial work of artists like Josef Albers and Frank Stella. Fischinger also knew many painters from Germany—including great artists like László Moholy-Nagy and Lyonel Feininger and the not-so-great artist Rudolf Bauer. (The art dealer Karl Nierendorf, a good friend of Fischinger's, took him to visit the pompous Bauer's studio, named Das Geistreich, "Realm of the Spirit," near Berlin, and they shared a good laugh on the way home.)

In 1938 Fischinger was invited to New York for two one-man shows of his intricate, layered oil paintings (at the Boyer and Nierendorf galleries) and a film screening at the Fifth Avenue Playhouse. In New York he met Baroness Hilla Rebay von Ehrenwiesen, curator of the Solomon Guggenheim Foundation and founder of the Museum of Non-Objective Painting (now the Guggenheim Museum). During the difficult war years (Fischinger was still an "enemy alien" and so could not work in any media-related job) Rebay helped support Fischinger both by giving him grants and by purchasing his films. Screened regularly at the museum, these films were seen by a whole range of future New York School abstract painters—not least among them Jackson Pollock, who was employed there. A number of Fischinger's canvases were also exhibited at the museum. But his relationship with Rebay was tortured, to say the least, and he suffered mental anguish at her teasing, tantrums, and insults as often as he gained peace enough to work.[17]

On his meager income Fischinger finished two more film masterpieces: *Radio Dynamics* and *Motion Painting No. 1* (Fig. 85). *Radio Dynamics,* an intentionally silent film meant as a contemplative, meditational aid, contains both hypnotically pulsating mandalas and brilliantly flickering single-frame images. As the title implies, *Motion Painting* records the growth of a specific oil painting, with one frame of film shot each time a brush stroke was made. The film is distinguished not only for this novel idea but also for the intrinsic fascination of the developing design, which moves through soft amorphous shapes to hard-edge geometric forms and culminates in a serene, irresistible mandala. Although *Motion Painting* won the grand prize at the International Experimental Film Festival at Brussels in 1949, Rebay failed to understand its dynamic structure or even its innovative documentation of a painter's working process and gesture. She simply hated the film and refused to extend Fischinger any further aid. Discouraged, and unable to obtain financial backing from other sources, Fischinger withdrew from active film production.

As much as Fischinger was harassed and denigrated by Rebay's tirades, he was sustained and encouraged by the remarkable Galka Scheyer, who allowed him to study the superb Klees, Kandinskys, and other abstract paintings that passed through her hands—and made sure he had full access to other caches of abstract art in Los Angeles: the magnificent collection of the Arensbergs (now in Philadelphia) as well as those of Ruth Maitland, Merle Armitage, Marjorie Eaton, and others. She also sent younger artists to visit Fischinger, including the fledgling John Cage, who credits Fischinger with crucial formative influence on his conceptual music theory.[18]

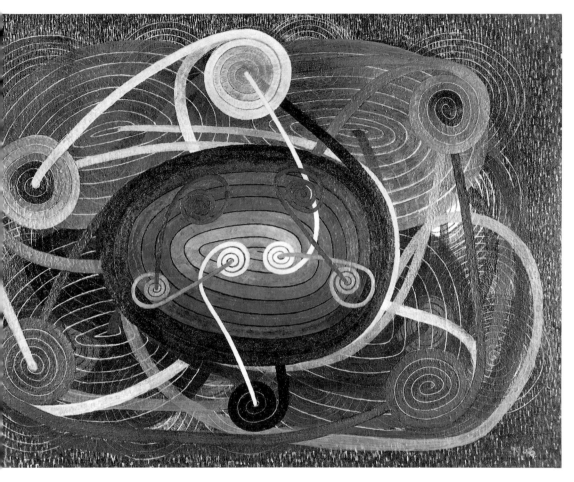

Fischinger's films also screened regularly in Los Angeles—at the Art Center School, Otis Art Institute, and Chouinard Art Institute, the three best art colleges in the area, where Lorser Feitelson, Helen Lundeberg, Helen Wurdeman, the ceramist Al King, and the photographer Frank Judson sponsored Fischinger and became devoted friends.[19] Between 1946 and 1950 Al King also screened Fischinger's films at the California Color Society, where other painters fell under Fischinger's spell, among them the movie star Harold Lloyd, whose 1953 exhibition of "Landscapades" at the Frank Perls Gallery showed a marked turn toward abstraction.[20] Fischinger also exhibited at the Stendahl Art Galleries and the American Contemporary Gallery, among others.

At the Stendahl show in the fall of 1939, the Whitney brothers encountered Fischinger's work.[21] James (then eighteen) and John (twenty-two) had just returned from Europe, where they were extending their studies in painting and music, respectively. John (like John Cage) had attended the Claremont Colleges, and in Paris John Whitney had met René Leibowitz, who introduced him to the twelve-tone principles of Arnold Schoenberg (who, ironically, had been teaching at the University of Southern California since 1934). Although John Whitney never studied directly with Schoenberg himself, the composer's progressive theories fascinated both the brothers, who in their first eight films offered visual equivalents of his tone rows and permutations. Their first four films, shot in 8mm, were made in their studio in Pasadena from 1940 to 1942. These lovely silent works are astonishingly accomplished for first films by young men. They have the vigor and delicacy of fine chamber music, and perhaps their maturity stems in part from the Schoenbergian rigor they chose for their exemplar and process.

Although the brothers had been inspired by Fischinger to make films, they were somewhat bothered by the tight relationship between known music and the visual imagery in Fischinger's films—something that bothered Fischinger as well. His early films, from the 1920s, were either silent or had new music composed for them. He became involved with tight synchronization partly because of his commercial ties with record advertising and partly because he found that audiences would more easily accept abstract visual art if it were linked to known music (abstract auditory art) they already approved of. After the international success of Fischinger's synchronized films producers, distributors, and audiences demanded more. But Fischinger longed to have his visual music appreciated as art separate from (albeit equivalent to) auditory music, and from 1941 to 1943, worked on an intentionally silent masterpiece, *Radio Dynamics*. Moreover, although Rebay's commission for the 1947 *Motion Painting* specified that it should be synchronized with Bach's Brandenburg Concerto no. 3, Fischinger constructed the visual imagery as a loose parallel, with no note-for-note correspondence, and often screened the film as a silent movie. It is unfortunate and ironic that the Whitney brothers were too polite to discuss synchronization with Fischinger, who might have found such an aesthetic debate beneficial and encouraging.

The Whitney brothers proved with their 8mm *Variations* that they could compose successful silent visual music, and in the last film of this series, *Variations on a Circle* (1942), James Whitney showed that he could create a little masterpiece comparable to *Radio Dynamics*.

John Whitney's memorable contact with René Leibowitz made him long to compose auditory music as novel as their visual imagery. He invented a system of pendulums that could be calibrated to draw directly on the soundtrack area of the film precise oscillations that would play back as pure tones (Fig. 86). With this system the Whitneys could compose music and abstract visual imagery simultaneously. During 1943 and 1944, John made *Film Exercise No. 1* and *Film Exercise No. 5,* while James made *Film Exercises Nos. 2 and 3* and *No. 4,* which combined pendulum music with geometric

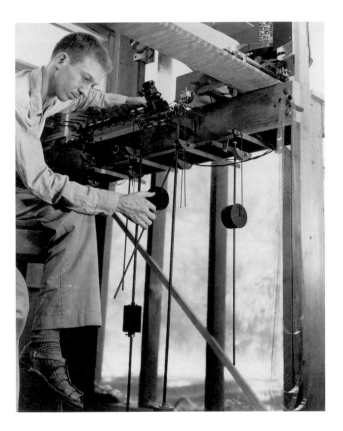

shapes cut out of paper matte boards so that the camera could film, from the resultant openings, pure light rather than reflections of a drawn artwork. The effect was shocking and "electrifying": the visual imagery had the eerie glow of neon lights, and the sound introduced many ears to the pure sine waves, aggressive tonal attacks, and the extravagant range of sound placements and seamless glissandi that a decade later would become familiar as electronic music. With these pioneer electronic sound scores of their own composition, they also won a first prize at the Brussels Festival in 1949.

While working on the *Exercises,* the brothers visited the Frank Lloyd Wright buildings designed for Aline Barnsdall on Olive Hill in Hollywood. The photographer Edmund Teske, an artist-in-residence at a guest cottage there, had already met them at a screening in the American Contemporary Gallery, and he encouraged them to join him as artists-in-residence, since other cottages were available. In this central location,

they quickly became artistic celebrities, since the buildings attracted such neighbors as Man Ray and the sculptor Tony Smith, who instantly recognized the extraordinary quality of the young men's work and became frequent visitors and friends, as well as such casual, curious visitors as Bertolt Brecht. James Whitney's and Teske's fascination with spiritual disciplines brought them to the Vedanta Center, where they became friends with the British expatriates Christopher Isherwood, Gerald Heard, and Aldous Huxley. Their Olive Hill salon also served as a screening place for such experimental filmmakers as Maya Deren, Curtis Harrington, and Kenneth Anger.

In 1944, with the *Exercises* completed, James traveled to New York to see if Baroness Rebay might also include their work in the Guggenheim collection and possibly fund a new film. Rebay did purchase prints of the *Exercises,* and both the 8mm *Variations* and the 16mm *Exercises* were screened several times in New York during 1944 and early 1945. James's first audience included such old friends as Tony Smith, John Cage, and Sidney and Harriet Janis, as well as such diverse celebrities as Tennessee Williams and Marcel Duchamp—luckily, since as soon as *Film Exercise No. 1* began, the Baroness flew from the room screaming "What's wrong with the projector?" and forced the projectionist to shut off the film, and the showing resumed only when the distinguished audience intervened. Jackson Pollock (a drinking buddy of Tony Smith's) was at this screening, and the Guggenheim prints of the Whitney films were shown regularly at the museum thereafter, so they were, like Fischinger's films, accessible to the future New York School abstract painters, who would have appreciated their aggressive colors and action as well as their uncompromising sound.

Although Baroness Rebay offered to continue the Whitneys' stipend, they found her manner and aesthetic opinions oppressive and declined it. Charles Dockum, on the other hand, like Fischinger, had no recourse but to endure Rebay's foibles, since he absolutely needed the Guggenheim support to continue his work. Born in Texas in 1904, Dockum was forced to move to Prescott, Arizona, after college, because of his delicate health. There, in 1935, he constructed his first small color organ, a seminal version of his later MobilColor Projectors. And there he met (through the photographer Fred Sommer) the man who became a lifelong friend and artistic influence: the Ukrainian-born painter and sculptor Peter Krasnow, who had lived in Los Angeles since 1922. Krasnow introduced Dockum to Galka Scheyer after Dockum moved to Los Angeles in 1940. With an improved MobilColor Projector, Dockum performed at the California Institute of Technology and the Pasadena Playhouse (where the Whitney brothers and Sara Kathryn Arledge met him), as well as at the Art Center School and the University of Southern California, where Frank Judson, a friend of Krasnow's, was head of the Cinema Department (where Gregory Markopoulos and Curtis Harrington studied).

In February 1942 Dockum wrote the Guggenheim Foundation, requesting a grant to prepare a more complex and effective MobilColor Projector.[22] At first Rebay was reluctant. Thomas Wilfred, an older and more established color-organ artist, had attempted to interest her in one of his instruments, but she had not liked it because she

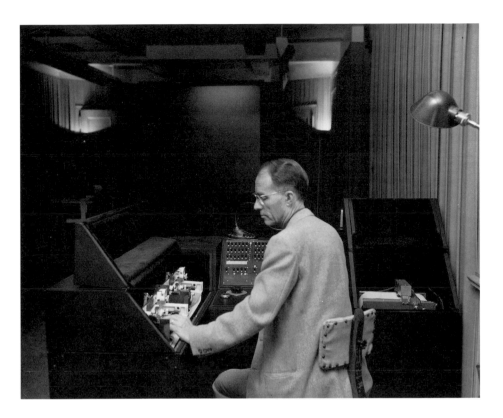

FIGURE 87

Charles Dockum playing his
Guggenheim MobilColor Projector
for the last time, in 1953, at the

Guggenheim Museum of Non-
Objective Painting, New York.

felt the soft polymorphous flow of Wilfred's subtly nuanced imagery was not precise and controlled like the hard-edge geometric paintings of her favorite painter, Rudolf Bauer. Although Wilfred explained that he did carefully design the imagery and could program both his clavilux projectors and his internal projection Lumia boxes to repeat exact compositions, Rebay wanted none of his sensuous delicacy. Fortunately for Dockum, Rebay's arch-rival, the Museum of Modern Art, purchased one of Wilfred's major Lumia compositions for permanent display in their galleries, thus piquing the baroness's urge to possess a color organ. She paid for Dockum to bring his MobilColor Projector to New York, where he spent the month of June 1942. Rebay reported that an audience of "expert" painters and filmmakers was "enchanted" by one of his performances—so again Dockum's work may have been seen by Jackson Pollock and the New York School.

Rebay awarded Dockum a stipend to build a MobilColor Projector for permanent installation at the Museum of Non-Objective Painting (Fig. 87). But with her he fell

into the same depressing turmoil Fischinger and the Whitneys had experienced. She asked him several times to spy on Fischinger to find out if he was really working on the Bach Brandenburg Concerto project. The two artists became friends, although Fischinger adamantly refused to let Dockum into his studio. (He was in fact having trouble with the Bach project and was not working on it every day.) In September 1942, when Dockum tried to interest Rebay in the abstract sculpture of Peter Krasnow, she haughtily replied that she and "several very great artists" did not like his work at all. She informed him that sculpture was a second-rate art form anyway, and he should not really associate with an "average" person like Krasnow, but rather strive to "impress a master like Bauer."

Rebay also monopolized much of Dockum's time, having him write letters and perform other useless tasks. She had him spend considerable time drawing up elaborate plans for Frank Lloyd Wright to incorporate into the new museum building, but Dockum's suggestions were never used. Fischinger had similarly been charged with designing film projection rooms and studio spaces where animators could work, but none were ever built; Fischinger's demand for projection onto an overhead dome, however, contributed to the final shape of the museum building, even though fire regulations prohibited the ground-floor horizontal projection booth that would have allowed films to be screened on the dome.

Dockum's Guggenheim episode has a more tragic ending than that of either the Whitneys or Fischinger. Dockum spent the ten prime creative years of his life constructing the Guggnheim MobilColor Projector and composing a series of pieces to be played on it. When the museum directors found that the instrument would not really play continuously without supervision, they determined that it could not be exhibited and should be dismantled. Some of the lighting elements were used for track lighting in the galleries; other parts were donated to Yale University. The instrument legally belonged to them, so Dockum could do nothing—but his compositions, created specifically for that mechanism, could be played on no other and thus were useless, "destroyed."

Ted Nemeth and Mary Ellen Bute, who had produced a series of abstract films in New York beginning in the mid-1930s, attempted to film the Dockum compositions once before the instrument was dismantled. Part of Dockum's artistry, his very reason for working with a color organ rather than film, involved the subtle modulation of color from nearly invisible hints to blinding, saturated intensities; he also layered colors, playing upon the resulting push-pull effects and optical mixtures. These subtle details could hardly be captured on film, especially since the light needed for a good film exposure can exceed what seems dazzlingly saturated during a live performance in a darkened room because of the complicity of the spectator's eye. The Bute-Nemeth documentary, even if much of the color and nuance are lost, nonetheless shows that Dockum's MobilColor compositions involved simultaneous movement in three different directions, and an effective precision in the layering.

Back in his studio in Altadena (the suburb of Los Angeles where James Whitney was born), Dockum set about building another MobilColor Projector, but at the time of his death in 1977, he had composed only three pieces, a total of some fifteen minutes' playing time, for his new instrument. The serene luminous beauty of these works cannot be seen without a twinge of regret for the art that the art world fails to support.

The end of World War II brought a flurry of activity to the experimental film and visual music scene—so much so that an official MGM Studio memo to Jean Hersholt, dated May 14, 1946, lists three venues for art cinema in Los Angeles: the American Contemporary Gallery, the Great Film Society, and Paul Ballard's Film Society.[23] Within a year there would be two more—Creative Film Associates (run by Curtis Harrington and Kenneth Anger) and the Experimental Film Society (where Maya Deren and Sasha Hammid appeared for a screening of their films April 13, 1947)—and then three more: the Society of Cinema Arts (1948), Bob Chatterton's Film Society, and Raymond Rohauer's Film Society, which in 1950 would take over the Coronet Theatre (where Stan Brakhage, later famous as an experimental filmmaker, worked as projectionist) and in 1957 the Riviera/Capri Theatre, both as cinemas showing a repertory of experimental and art films.

The first experimental film made in San Francisco was probably *The Potted Psalm,* a surrealistic comedy made in collaboration by two writers, James Broughton and Sidney Peterson, who in 1946 were suffering from writer's block and turned to cinema as a recourse.[24] Their film premiered as the finale to Frank Stauffacher's first experimental film series at the San Francisco Museum of Art.

Stauffacher's series of Art in Cinema festivals began in October 1946 and continued through a sixth series, in 1950.[25] When the initial series brought the Whitney brothers and Oskar Fischinger to San Francisco, two young painters, Jordan Belson and Harry Smith, were inspired to begin abstract filmmaking, and their subsequent distinguished careers helped to confirm the existence of a California school of visual music (which itself engendered a number of minor filmmakers such as Robert Howard, Hal McCormick, Elwood Decker, Ralph Luce, Leonard Tregillus, Dorsey Alexander, Martin Metal, Denver Sutton, and Curtis Opliger). Stauffacher had sent Harry Smith to Los Angeles to talk Fischinger and the Whitneys into coming to San Francisco for the first Art in Cinema, and Smith was so smitten with their work that he began to make his own. He drew directly on film stock since he did not have a camera, animation stand, or optical printer. His first five films, all hand-drawn (they include some footage Smith shot with Hy Hirsh's camera moving quickly past lights at nighttime), were closely allied to the new bop music; they premiered at subsequent Art in Cinema festivals, accompanied by live jazz ensembles. Smith painted large abstract murals at the nightclub Bop City (Fig. 88) and screened his film there as a "light show" accompanying such musicians as Dizzy Gillespie and Thelonius Monk. Jordan Belson has withdrawn his earliest films from the 1940s, which were greatly admired at that time;

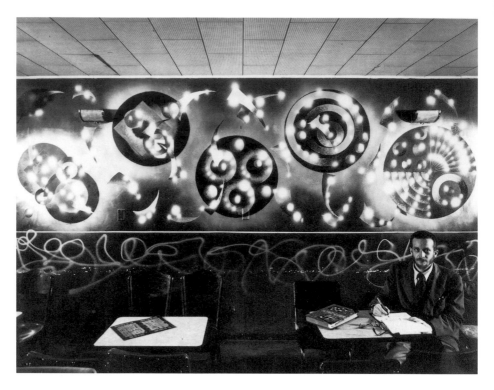

Fischinger, after seeing his first film, *Transmutation,* at Art in Cinema, recommended Belson for a Guggenheim Fellowship. After his spectacular Vortex Concerts of the late 1950s, which sychronized electronic music with abstract imagery projected on a planetarium dome, and after seeing some of Wilfred's sensuous Lumia compositions, Belson became more sophisticated in his films, which as a result better expressed his spiritual aims.

Similarly, Maya Deren's trilogy, shown at Art in Cinema, inspired a raft of new film psychodramas. In Northern California, Sidney Peterson and James Broughton continued their filmmaking separately and began to offer an experimental filmmaking course at the California School of Fine Arts (now the San Francisco Art Institute). James Broughton's *Mother's Day* (1948) was particularly successful, capturing the ironic ambiguity of the adult's nostalgic remembrance of his childhood and the sexual-social politics foisted upon children that mark them for life.[26] Hy Hirsh worked on some psychodramas (*Horror Dream* and *Clinic of Stumble,* both in collaboration with Sidney

FIGURE 89
Sara Kathryn Arledge's *Introspection*
(1941 and 1946).

Peterson) before turning to visual music after 1950, and Chester Kessler prepared a remarkable quasi-animated version of Kenneth Patchen's *Journal of Albion Moonlight,* entitled *Plague Summer*. Nor were all the new films psychodramas. Frank Stauffacher, for example, produced three fine lyrical landscape films (or city symphonies, as such films were called by the German experimental filmmaker Walther Ruttmann): *Sausalito, Zig Zag,* and *Notes on the Port of St. Francis.* In Southern California, in addition to work by Kenneth Anger, Curtis Harrington, and Gregory Markopoulos, the painter Joseph Vogel in 1947 made *All the News* and *House of Cards,* for which the Whitney brothers optically printed his paintings as the background for a "psychodancer."

In 1941 in Pasadena (where the Whitney brothers worked) Sara Kathryn Arledge had begun an abstract dance film, *Introspection* (Fig. 89), which involved dancers in black tights with only one body part in color so that against a black background it seemed as if arms or torsos or clusters of superimposed legs had taken on a life of their own and could dance unconstrained by gravity. Unfortunately, her lead dancer, Jim

Mitchell, was drafted into World War II, so she abandoned the project. Living in San Francisco in 1947, Arledge was reinspired by Art in Cinema, and she finished the film, which premiered May 2, 1947, during the second series. In the summer of 1947 she also published a key essay, "The Experimental Film: A New Art in Transition," which treats Fischinger, the Whitney brothers, Maya Deren, and Charles Dockum in the context of the earlier avant-garde film.[27] The program notes to the first series of Art in Cinema, including invaluable statements by Deren, Fischinger, and the Whitneys, were also published as a catalogue by the San Francisco Museum of Art in 1947.[28] In the same year, the film historian Lewis Jacobs also published "Experimental Cinema in America" in the new journal *Hollywood Quarterly* (now *Film Quarterly*).[29] A new American experimental film movement, heavily based in California, had come of age and would flourish during the coming decades in the work of Christopher Maclaine, Larry Jordan, Bruce Conner, Bruce Baillie and Canyon Cinema, Gunvor Nelson, Robert Nelson, Chick Strand, Pat O'Neill, and many others.

California experimental film and visual music clearly inspired new underground, independent, personal, and/or avant-garde work in film in both New York and Europe. But another influence, which I have already alluded to, may link New York abstract expressionist gestural painting to Southern California. Jackson Pollock first studied art at Manual Arts High School in Los Angeles, 1928–30. His teacher there, Frederick Schwankovsky, had a powerful mystically oriented personality, which displayed itself in frequent lectures, radio broadcasts, newspaper articles, and exhibitions in Los Angeles.[30]

Schwankovsky's devotion to Theosophy and Krishnamurti formed an integral part of his artwork and his teaching. In his brilliant painting *Modern Music* (Fig. 90), from about 1914, we can see a relationship with the hermetic color-music theories of other theosophically inspired painters (e.g., František Kupka, in his *Piano Keys—Lake,* 1909). But even a novice, with no knowledge of that tradition—like Pollock, perhaps, when he saw the painting (it remained in Schwankovsky's possession until 1940)—can appreciate the sense of dynamic color expressing inner perceptions and emotions. The woman playing the piano while pentangles of color arise from the keys might well be Schwankovsky's wife, Nelly, who would play certain notes on the piano while "Schwanny" (as Pollock affectionately called him) would paint the corresponding colors, a living visual music performance.

Schwankovsky published a booklet, which he distributed to his students, explaining the mystical qualities of colors and the correspondences between colors, musical notes, emotional propensities, and astrological signs.[31] He generously introduced his students to as much mystical theory as possible: he drove Pollock to Ojai to hear Krishnamurti speak and took groups of students to visit Manly P. Hall's Philosophical Research Society library of rare hermetic incunabula and grimoires. At the same time, Schwankovsky introduced his students to a variety of art techniques, encouraging experiments mixing oils, water, and alcohol. And in his scenic design classes, which built sets for local theatrical productions, he taught the students (including Pollock) to lay canvas on

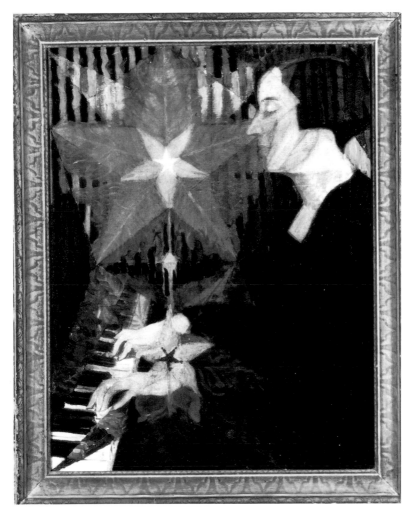

the ground and dance around it, dripping and splattering paint to create starscapes and tropical lianas.

What Pollock learned from Schwankovsky in California made him see things differently in New York. During the early 1930s, while Pollock studied at the Art Students League, he often went to visit Thomas Wilfred's studio (named Institute of Light), where he sat for hours watching the gradual trajectories of colored light in Wilfred's Lumia compositions, swinging his head around to follow as if he recognized the tra-

jectories as Wilfred's gestures. In 1943, when he was working for Baroness Rebay at the Museum of Non-Objective Painting, he saw the Fischinger films, which were screened regularly, and probably Dockum's MobilColor Projections as well. When James Whitney had screenings at the museum in late 1944 and early 1945, Tony Smith (who before leaving Los Angeles had done some remarkable poured and dripped paintings, possibly in rapport with Knud Merrild's flux paintings) took his new buddy Pollock to see them. These repeated, reinforcing exposures to the kinetic abstraction of visual music (mostly from California), in which gestures of light splash, ooze, and layer across the large screen, must have contributed to Jackson Pollock's crucial change from semirepresentational easel painting to large nonobjective canvases created by expressionistic gestures of the painter.

California visual music influenced a number of other artists. Oskar Fischinger, for example, inspired the sculptor Harry Bertoia to make sounding brasses—abstract sculptures with movable parts that create musical sounds when they touch—which he would assemble in a large space and play symphonically by dancing among them to set off various harmonious patterns. And visual music covertly reached a mass audience in the form of United Productions of America (UPA) cartoons.[32] UPA was founded in the mid-1940s largely by artists who had worked for Disney on *Fantasia* and thus had been "indoctrinated" by Fischinger's work at the studio. Some of these artists shared Fischinger's interest in abstract painting—Herb Klynn, Jules Engel, and Fischinger, for example, had a three-man show together at the American Contemporary Gallery in 1947. The artists formed UPA as a cooperative animation studio with the express purpose of making films that would combine modern art, contemporary literature, and new music. In 1948 they received their first Academy Award nomination, and in 1950, when *Gerald McBoing Boing,* with art direction by Jules Engel, won an Academy Award, UPA was world famous for modernist animation presented in a visual and auditory style that expressed the subject matter at hand, whether it was children's stories or classic literature (*The Tell-Tale Heart*), social satire (*The Jaywalker, Fudget's Budget*), contemporary art (two films about abstract expressionism, *Blues Pattern* and *Performing Painter,* animated by John Whitney in collaboration with Fred Crippen and the Oscar winner Ernie Pintoff), or biographies of famous artists (*Sharaku, Raoul Dufy,* and *Henri Rousseau,* all written by Sidney Peterson). Much of the worldwide flourishing of artistic animation in the 1950s and 1960s owes a debt to the modernist strivings of UPA, which in turn derived from visual music and film-as-an-art in California before 1950.

Notes

1. William Moritz, "Americans and Paris," in *Lovers of Cinema: The First American Film Avant-Garde, 1919–1945,* ed. Jan-Christopher Horak (Madison: University of Wisconsin Press, 1995). Clifford Howard, the Hollywood correspondent for the British magazine *Close Up* (3, no. 1 [July

1928]: 74), reports that the recently opened Filmarte was the third such art film cinema in Hollywood.

2. Alexander Walker, *Rudolph Valentino* (New York: Stein and Day, 1976), 34; Kenneth Anger, *Hollywood Babylon* (San Francisco: Straight Arrow Books, 1975), 108–13. All information about Nazimova's *Salomé* was corroborated in my interviews with Samson DeBrier, 1973–75.

3. Exact dating of early films can be difficult. Nazimova's *Salomé* was screened long before its official premiere. Robert E. Sherwood declared the film (*Life* 80, no. 2071 [July 13, 1922]: 22) "exceptional in every noteworthy sense of the word" and observed that "the persons responsible deserve the whole-souled gratitude of everyone who believes in the possibilities of the movies as an art." After the official premiere, Sherwood noted (*Life* 81, no. 2099 [January 25, 1923]: 24) that the film had been waiting eight months for a distributor. Similarly, Warren Newcombe's *Enchanted City* played for a week at the Rivoli Theatre in New York as a novelty item on the vaudeville program before the feature; it received extravagant praise, including an editorial (unheard-of for a short) in *Motion Picture World* 54, no. 5 (February 4, 1922): 492, claiming the film "has demonstrated that the surface of picture possibilities has only been scratched and that the field of endeavor is limited solely by human imagination." Despite dozens of favorable reviews, it was some eight months before *The Enchanted City* received official distribution and a formal premiere, at Grauman's Rialto Theatre in Los Angeles October 17, 1922 (*Motion Picture News* 26, no. 19 [November 4, 1922]: 2314). Newcombe may have shot *The Enchanted City* in New York, since he had offices there, but he had also been working on Hollywood features such as the Rudolph Valentino *Four Horsemen of the Apocalypse* prior to that, and certainly after 1925 lived and worked exclusively in Los Angeles, considering himself a "Los Angeles painter."

4. Documents on Warren Newcombe are in the Ferdinand Perret papers, Archives of American Art, Smithsonian Institution, roll 3861.

5. Brian Taves, *Robert Florey: The French Expressionist* (Metuchen, N.J.: Scarecrow Press, 1987).

6. Boris Deutsch, "Autobiographical Sketch," *Jewish Community Press,* November 18, 1938. The Skirball Museum of Hebrew Union College in Los Angeles has an album of clippings about Deutsch's painting from 1926 to 1947 that contains this article. This and other Deutsch clippings are also in the Ferdinand Perret papers, Archives of American Art, Smithsonian Institution, roll 3855.

7. "Lullaby or Nightmare?" *Los Angeles Record* 32, no. 10631 (March 7, 1929): 2A. A copy of this article is in the Boris Deutsch papers, Archives of American Art, Smithsonian Institution.

8. Demons from Hell, from Alexander Granovsky's production of Avrom Goldfadn's *Tenth Commandment,* wore facial makeup similar to that of the demons in *Lullaby;* see Nahma Sandrow, *Vagabond Stars: A World History of Yiddish Theater* (New York: Harper and Row, 1977), 228. Even if Deutsch had not seen the modernist expressionist productions of the Vilna Troupe before he fled Russia, Michael Visaroff would certainly have been familiar with this new trend in Soviet Yiddish theater as well as the New York Yiddish Art Theater (Sandrow, 50).

9. "Postsurrealism, the Supermodern: From California Comes an Answer to Old World Innovators," *Literary Digest* 122, no. 2 (July 11, 1936): 23.

10. Stuart Timmons, *The Trouble with Harry Hay* (Boston: Alyson, 1990), 74–75, 86–87.

11. Most relevant documents pertaining to the life and works of Maya Deren were published in a multivolume set: *The Legend of Maya Deren* (New York: Anthology Film Archive, 1984).

12. Lynne Fauley Emery, *Black Dance from 1619 to Today* (Princeton, N.J.: Dance Horizons, 1988), 252–55.

13. William Moritz, "Towards a Visual Music," *Cantrills Filmnotes,* nos. 47–48 (August 1985): 35–42.

14. Robert Pike, *The Genius of Busby Berkeley* (Reseda, Calif.: Creative Film Society, 1973).

15. William Moritz, "The Films of Oskar Fischinger," *Film Culture* 58–60 (1974): 37–188.

16. William Moritz, "Fischinger at Disney, or Oskar in the Mousetrap," *Millimeter* 5, no. 2 (February 1977): 25–28, 65–67.

17. William Moritz, "You Can't Get Then from Now," *Los Angeles Institute of Contemporary Art Journal* 29 (Summer 1981): 26–40, 70–72. Joan Lukach, *Hilla Rebay: In Search of the Spirit in Art* (New York: Braziller, 1983), gives a good picture of Baroness Rebay's achievement in furthering abstract art and creating the Guggenheim Museum; since the book was produced under the auspices of the museum and the Hilla Rebay Foundation, however, the many documents quoted are carefully excerpted to avoid any suggestion of Rebay's sudden mood shifts, petulant and vituperative rants, and outrageous demands. In the section dealing with visual music, pages 211–25, there are numerous factual errors. For example, Viking Eggeling's *Diagonal Symphony* was made in 1924; Oskar Fischinger's *Study No. 7* dates from 1931 and his *Composition in Blue* from 1935; he hoped to make a film, not for John Ford, but for Henry Ford (that is, the Ford Motors Pavilion at the 1939 New York World's Fair), and his *Motion Painting No. 1* is not a silent film.

18. Calvin Tomkins, *The Bride and the Bachelors* (New York: Viking, 1968), 86–87.

19. Frank Judson and Jake Zeitlin were among the sponsors of the Southern California Film Society, which held morning screenings of unusual art films and early silents at the Filmarte Theatre during the late 1930s.

20. Jack Quigg, "Fantastic Canvases: Lloyd Shows Thirty-five Paintings," *Hollywood Citizen News,* January 16, 1953, 2.

21. Moritz, "You Can't Get Then from Now" (as in note 17), 35–40.

22. Moritz, "Towards a Visual Music" (as in note 13), 40–42. The documents quoted here are in the archive of the Dockum Research Laboratory, Altadena, California, Greta Dockum, curator.

23. Memo from Jack Donahue to Jean Hersholt, in the Margaret Herrick Library of the Academy of Motion Pictures Arts and Sciences, Beverly Hills, California.

24. James Broughton, "Experimental Film in San Francisco," in *Rolling Renaissance: San Francisco Underground Art in Celebration, 1945–1968* (San Francisco: Intersection, 1976), 25–26.

25. Frank Stauffacher's papers have been acquired by the Archives of American Art, Smithsonian Institution. His brother, Jack Stauffacher, was interviewed by Paul Karlstrom on February 8, 1993, for the Archives of American Art oral history program.

26. James Broughton, *Coming Unbuttoned: A Memoir* (San Francisco: City Lights, 1993), 85–100.

27. Sara Kathryn Arledge, "The Experimental Film: A New Art in Transition," *Arizona Quarterly* 3, no. 2 (Summer 1947): 101–12.

28. Frank Stauffacher, ed., *Art in Cinema,* exh. cat. (San Francisco Museum of Art, 1947). This also appeared later as an Arno reprint.

29. Lewis Jacobs, "Experimental Cinema in America (Part 1: 1921–1941)," *Hollywood Quarterly* 3, no. 2 (Winter 1947): 111–24; and "Experimental Cinema, Part 2: The Postwar Revival," *Hollywood Quarterly* 3, no. 3 (Spring 1948): 278–92. The two parts were reprinted in *Experiment in the Film,* ed. Roger Manvell (London: Grey Walls Press, 1949), 113–52.

30. William Moritz, "Abstract Film and Color Music," in *The Spiritual in Art: Abstract Painting, 1890–1985,* exh. cat. (Los Angeles County Museum of Art; New York: Abbeville, 1986), 296–311. Key documents on Pollock in California can be found in the Archives of American Art, Smithsonian Institution, including interviews with Manuel Tolegian, February 12, 1965, and Frederick Schwankovsky, March 1, 1965, both by Betty Hoag. I interviewed Tony Smith in 1977 and Palmer Schoppe (an art student with Pollock in New York who visited Wilfred's studio with him) in 1985.

31. A copy of this booklet is in the Archives of American Art, Smithsonian Institution, Frederick Schwankovsky papers, roll LA7, beginning at frame 754.

32. William Moritz, "United Productions of America: Reminiscing 30 Years Later," *ASIFA [Association Internationale du Film d'Animation] Canada Bulletin* 12, no. 3 (December 1984): 14–22.

Therese Thau Heyman

MODERNIST PHOTOGRAPHY

AND THE GROUP F.64

In California, modernism gained its first impetus among groups of like-minded artists who gathered to propound their ideas. Traveling exhibitions, publications, and catalogues kept the relatively remote Californians in touch with advanced art ideas from Europe. Among artists, photographers were at the fore in shaping the state's distinctively modern image. This fact will surprise no one who has taken time to consider the essential modernism of photography as a medium, or has taken the opportunity to reflect on the close association of the medium with this particular place. Photography played a decisive role in California culture beginning in the Gold Rush days, and it has continued to do so throughout the twentieth century. Still, the history of photography in the United States underwent a transformation in the early 1930s, and this change was recognized and named by a group of California photographers who sought a new, essentially modernist, perspective through their art.

John Paul Edwards, a pictorialist photographer in the thirties, recalled the spirit of change that distinguished these years: "It was in August 1932 that a group of photographic purists met informally in a fellow-worker's studio for a discussion of the modern movement in photography."[1] For Edwards and his colleagues, like Edward Weston, modernist ideas, although intriguing, were identified mainly with fine arts issues that related to other media. Debates about modernist painting, for example, tended to revolve around representational issues of clear, flat color and the picture plane. By contrast, photographers saw reality as palpably modern. Still-life objects appeared architectural, even heroic, in scale.

The New Deal, Reporting, and Straight Photography

In late 1932, even before Franklin D. Roosevelt assumed the presidency, advisers were framing programs to lift the country out of the debilitating economic depression. The New Deal, promised during Roosevelt's campaign, represented a new philosophy of

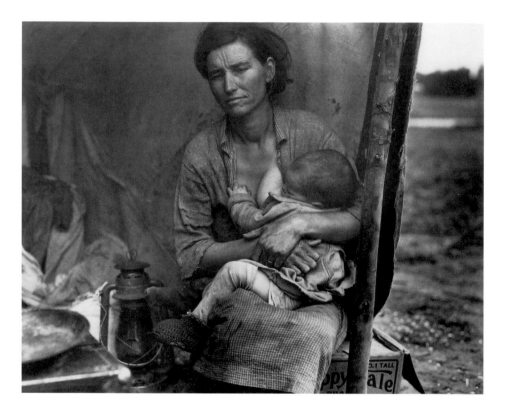

FIGURE 91
Dorothea Lange, *Migrant Mother, Nipomo, California,* 1936. Courtesy The Oakland Museum, Dorothea Lange Collection, gift of Paul S. Taylor.

government and drew the administration directly into the theoretical and aesthetic preserve of contemporary life. An important step toward ending the economic decline was the creation of agencies to assist thousands of displaced workers and rural families.

To gain public and congressional support, proponents of any aid program had to state its rationale clearly and memorably. Urban voters and elected officials had to be educated about conditions in rural areas where they did not venture. Roosevelt turned for help to two Columbia University academics, Rexford Tugwell and Roy Stryker, who were assembling cultural histories and were beginning to realize that the almost century-old medium of photography could transform written government reports into dynamic evidence. Photography, intensifying the impact of facts, could perhaps provide the novel means to gain sympathetic and immediate political attention. Photography was considered to be a truthful record, an independent eye viewing an undeniable reality.

The photographs that eventually accompanied reports of the Farm Security Administration (FSA) in the late 1930s were direct, clear, and in many respects like the work of the photographers who had formed Group f.64 in the San Francisco Bay Area the year of Roosevelt's election. Although the FSA work was decidedly not "art," its elements of composition and selection were essential to effective reporting. This photographic work was accomplished at a time when it was assumed that the photographer found—that is, did not invent—the reality whose image he captured, an approach that soon came to be called "documentary photography." Most people believed that photographs could constitute accurate records of events and conditions, and they had sound reasons for their belief (Fig. 91).

Photographic veracity had a long-established tradition in the United States. Nineteenth-century photographers had created a picture of the American West that confirmed the stories of mountainous scenes inspiring wonder and awe. Their views verified the astonishing news that gold had been discovered in Northern California and validated for distant families the safe arrival of hordes of adventurers who had gone west to make their fortune.

By the turn of the century, the government-commissioned photographic surveys of federal land holdings were complete, published, and widely available. Photography had become a populist phenomenon, practiced by a select and growing amateur group that accepted these 20-by-24-inch glass-plate exploration records and thousands of pocket-sized portraits as the plainspoken and truthful language of pictures. Photography preserved memory, created records, validated personal genealogies, and stopped time in ways heretofore not accessible to the average person. When in the late nineteenth century the invention of the handheld camera gave photography to the populace at large, its place in the American social fabric was already ingrained.

Photographers began to expand the basic syntax of representation and validation to create an elegant form of romantic photographic language, one they hoped would be fully recognizable as fine art (Fig. 92). Their painterly visions, embodied in soft-focus, manipulated prints and tonalist studies, suggested quasi-literary narratives. They hand-colored surfaces and used inky pigments on textured matte papers to achieve self-consciously artistic images conveying personal and interpretive content. Their images created a busy interchange among camera-club juries.[2] In the West large numbers of pictorialist photographers (Fig. 93) continued to take prizes at Bay Area salons as Roosevelt was preparing to take the oath of office. In the next few years, however, a revolution in photography started to brew, one that was more widespread and potent than has been recognized.

Pictorialist thinking and theory were at their most articulate in the mid-1920s. William Mortensen, a leading pictorialist, later explained, "The business of a work of art is to make an effect, not to report a fact." Creating effects was pictorialism's high calling. Mortensen went on: "Photography must learn to avail itself of selection to the same comprehensive degree that older arts do: by this it must stand or fall as art. Otherwise . . . the camera has no more artistic potentiality than a gas-meter."[3]

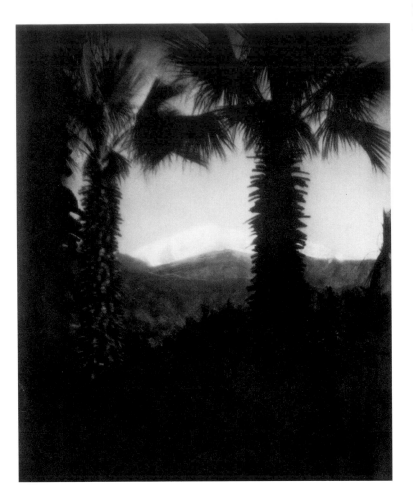

FIGURE 92
Karl Struss, *In the Southland,*
Mt. Baldy, California, ca. 1921.

The Oakland Museum, gift of the
Knott Fund.

Such claims, outrageous to some, fired a debate that soon became acrimonious, and Bay Area photographers who engaged in it did not simply return to recording facts. They countered old-style pictorialism with a revolutionary style—"seeing straight." The lines were drawn: one observer noted that Edward Weston had "dared more than the legion of brittle sophisticates and polished romanticists ever dreamed."[4]

Eight or nine years before Group f.64 was formed, Weston had turned away from pictorial practices, proclaiming his change in aesthetics in a series of briefly stated technical steps in his daybooks. He minced no words in this 1930 entry:

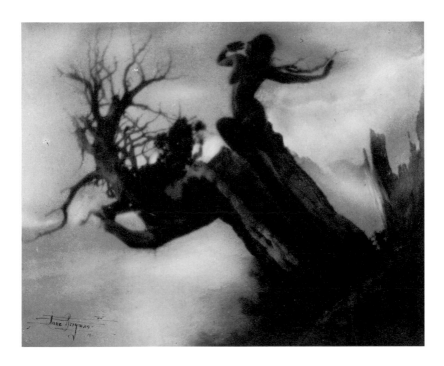

F I G U R E 9 3
Anne Brigman, *The Storm Tree,*
1912. The Oakland Museum, gift of
Mr. and Mrs. Willard M. Knott.

I wrote an article, published this July with examples of my work in *Camera Craft,* a photo magazine which offers its readers just what they want. . . . I tempered my words, fearing the editor might not stand up under full blast. But seeing some unusually awful reproductions in the same issue by one Boris, with a laudatory article by the editor, I spent an hour writing him my mind. These cheap abortions which need no description other than their titles, "Pray," "Greek Slave," "Orphans," "Unlucky Day," have nothing to do with Art, nor Life, nor Photography. So I not very gently explained. But why did I waste my time? I know the Editor's policy, his outlook from his writing and magazine in general: backing my work and opinions, his publication would fail!

I am in a mood to stir things up![5]

As a reformed pictorialist, Weston often led the attack against shimmer and simper, crusading to attain the "straight" image Willard Van Dyke came to call "pure photography." Earlier in 1927, Weston had promised:

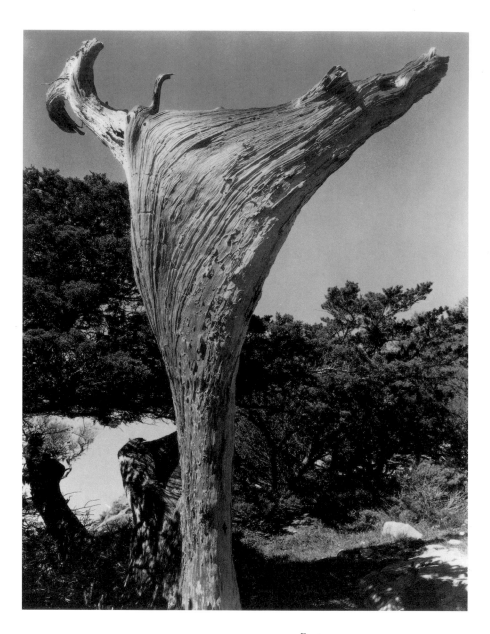

FIGURE 94
Edward Weston, *Monterey Cypress,*
1932. The Oakland Museum, Prints
and Photo Fund purchase. © 1981
Center for Creative Photography,
University of Arizona Board of
Regents.

Sometime I want to give an exhibit printed on glossy paper. This shall be my gesture of disapproval for those who try to hide their weakness in "arty" presentation. [This long-held plan received fresh impetus after he viewed the International Salon of Photography at Exposition Park in Los Angeles.] Unable to definitely use Form these pictorialists resort to artistic printing. . . .

That exhibit, excepting two or three prints, if reprinted on glossy paper, stripped of all subterfuge, would no longer interest even those who now respond. . . .

Those "pictorialists" were deadly serious, I grant,—so serious that the result was often comic. I took Brett, hoping to find material for discussion: there was nothing to discuss. . . . After noting the numbers of four photographs that had some value I referred to the catalogue, finding that each one was by a Japanese. Perhaps my exhibit in the Japanese colony has borne some fruit,—I could feel my influence [Fig. 94].[6]

None of the move away from pictorialism occurred in isolation from the other arts during these years. Important exhibitions of Bauhaus abstract art at the Oakland Art Gallery included a Lyonel Feininger solo show (April–May 1930), a show of German posters (September 1930)—which apparently included photographic material—and a Blue Four exhibition (1931). Galka Scheyer,[7] who identified herself on gallery letterhead as the "foreign representative of the Oakland Art Gallery," actively promoted German expressionist painters in the Bay Area; and in 1930 Rudolph Schindler also spoke at the Art Gallery on the relationship of architecture to the Bauhaus show.

The nexus from which change proceeded in Bay Area photography may well have been the activities of Galka Scheyer. She visited Weston in Carmel on more than one occasion in the late 1920s, and in 1930 he noted that she was a "dynamo of energy"; her insight was "of unusual clarity"; she had "an ability to express herself in words, brilliantly. . . . She is an ideal 'go between' for the artist and his public."[8] But we cannot know whether to attribute to Scheyer the full awareness of a new aesthetic for photography. Weston, in any event, saw himself in the forefront of a revolution. "Yesterday [March 7, 1930] I made photographic history: for I have every reason and belief that two negatives of kelp done in the morning will someday be sought as examples of my finest expression and understanding."[9]

Weston's diary entries allowed him to date his artistic growth, confident of his own originality, and he took on the pictorialists at every turn: "I have already made a showing, and hope that my next exhibit will be on glossy paper. What a storm it will arouse from the 'Salon Pictorialists.' . . . Now all reactions on every plane must come directly from the original seeing of the thing, no secondhand emotion from exquisite paper surfaces or color: only rhythm, form and perfect detail to consider."[10]

The Origin of Group f.64

Group f.64 was initiated by Willard Van Dyke and his friend Preston Holder (Fig. 95), of whom Van Dyke wrote:

FIGURE 95
Willard Van Dyke, *Preston Holder,*
ca. 1934. Collection of Barbara M.
Van Dyke.

[He] saw things much the way I did. I had gone back to the University [of California at
Berkeley] after five years [in 1931] to take a few courses that interested me. A student in one
of the courses happened to see a few of my photographs in a local bookstore . . . and intro-
duced himself. We became close friends, drank wine and read Hart Crane and Robinson
Jeffers together. Of course we both had blue-papered covers of James Joyce's *Ulysses* and
carried them everywhere as a protest against the Philistines.[11]

Holder soon acquired a camera, and the two men took trips:

After one afternoon of art and wine . . . Preston suggested that we ought to form a group of
like-minded Western photographers and begin to exhibit our work together. I was excited
about the idea; it appeared to me that this would provide an opportunity to make a strong
group statement about our work. . . . I, for one, felt that it was time for the Eastern estab-
lishment to acknowledge our existence.[12]

Van Dyke knew that Alfred Stieglitz had been patronizing to Weston when Weston went to New York in 1922. He also believed that Weston's photographs were superior to Paul Strand's, that Imogen Cunningham's plant forms and nudes were very fine, and that Ansel Adams (Fig. 96) was beginning to understand the Sierra Nevada. Not long after the talk with Holder, when Weston was in town and a party was arranged for him at the 683 Brockhurst gallery in Oakland, Van Dyke brought up the question of forming a group. In addition to Weston, Van Dyke, and Holder, the party guests included Ansel Adams, Sonya Noskowiak, Imogen Cunningham, Mary Jeannette and John Paul Edwards, and Henry Swift.

"Here [at 683 Brockhurst] we named the f.64," Van Dyke remembered. "Photography opened a whole new world to me. I was so excited that there were other photographers around this area who saw things much the same way." Several names were tried in the liquid party atmosphere of that first discussion:

We got together one night . . . and I presented the idea of our working together. I said besides that I've got a wonderful name for it, U.S. 256 [after the old rapid rectilinear lens that Weston used to get the maximum depth of field and to make his negatives appear sharper]. Well there was this kind of blank look around the room and then Ansel who was the scholar of the group, said, "Oh, you mean in the uniform system 256 equals f 64. But don't you think f 64 would be a better name. Nobody is going to be using the uniform system much longer and besides that beautiful f followed by a 6 and 4," and he drew it out, like that and you could suddenly see the cover of the catalogue or the announcement and the graphics were there and Ansel won.[13]

James Alinder's lively interview with Preston Holder in 1975 includes that photographer's memory of the naming of the group. He describes a drunken ferryboat ride with Van Dyke from San Francisco back to Oakland, during which they talked about how the f would produce nice Bauhaus-inspired graphics. Holder said the group should be called "f/64, because that's what you want to stop down to anyway and that's a good rationale for it, a catchy name and a good symbol."[14]

The Group's Exhibition Statement

Despite the diverse activities of the leading members of Group f.64, they crafted a strong unifying statement, as did other avant-garde art movements. Their six-paragraph proclamation is notice of a revolution. It appeared at the group's first exhibition at the M. H. de Young Memorial Museum in San Francisco and was issued in the name of the group to make its ideas directly available to museum visitors and, more pointedly, to photographers—especially pictorialists, whose style was then still publicly accepted—and to their critics. It was purposely framed in plain language, with few technical terms. It was a rallying cry to the

> great number of serious workers in photography whose style and technic does not relate to the *métier* of the Group. . . . The members of Group f.64 believe that Photography, as an art-form, must develop along lines defined by the actualities and limitations of the photographic medium, and must always remain independent of ideological conventions of art and aesthetics that are reminiscent of a period and culture antedating the growth of the medium itself.

It is likely that the statement was written and produced by Van Dyke, with help on the wording from Holder. A clue to authorship is the Americanization of "technic," since Van Dyke uses this form in letters to Weston. Van Dyke, particularly in his early writing, shows a clear, precise style that avoided the doctrinaire yet was audacious.[15]

Weston's few references to the group occur in a short chapter that the editor of his daybooks, Nancy Newhall, entitled "F64"; many readers have been led to these two

pages. There Weston noted, "Some have expressed astonishment that I should join a group, having gone my own way for years." This short entry has led many later authors to assume that at this time Weston was more preoccupied with personal achievement than with the goals of Group f.64. In his introduction to his solo show in New York in 1932, Weston cautioned, "Too often theories crystallize into academic dullness—bind one in a straitjacket of logic,—of common sense, very common sense."[16] With that, he explained that in an uprooted society the camera can be a means of self-development. If there was one idea that held the group together, it was this belief in the power of photography as a means of personal expression.

As to how well individual members accomplished this goal, opinion varied. Years later, Adams (Fig. 97) remembered: "In the wild heat of formation . . . mutual excitement, wonderful things happen. And then the thermostat goes on. The f 64 group made a great contribution, [an] affirmation of certain basic facts in photography that

would not have been needed if the general level of photography had been high enough."[17] Adams saw Group f.64 as "an organization of serious photographers without formal ritual of procedure, incorporation, or any of the limiting restrictions of artistic secret societies, Salons, clubs or cliques." The group would accept "any photographer who in the mutual favorable opinion of all of us, evidences a serious attitude, a good straight photographic technique, and an approach that is basically contemporary," admitting that "friendly but frank disagreements exist among us."[18] Surprisingly, Adams named seven photographers who had been considered for membership, among them Consuelo Kanaga and Dorothea Lange (who was not invited to join); in his own gallery show he did not include Sonya Noskowiak.

The Exhibition

The group of photographic friends came together as a loose organization sometime after a solo exhibition of Edward Weston's work opened at the M. H. de Young Memorial Museum in San Francisco's Golden Gate Park in December 1931. The seven original members were Ansel Adams, Imogen Cunningham, John Paul Edwards, Sonya Noskowiak, Henry Swift, Willard Van Dyke, and Edward Weston. They arranged to exhibit their work collectively at the de Young, inviting four other like-minded artists to participate: Preston Holder, Consuelo Kanaga, Alma Lavenson, and Brett Weston.

The exhibition, which opened on November 15, 1932, and was on view for six weeks, was composed of eighty photographs: each of the seven group members showed nine prints (Adams had ten), their guests four apiece. The museum's checklist was arranged by artist, suggesting that the gallery spaces were similarly arranged. Seen together, the images established a varied but mostly singular point of view. For the most part, objects were seen up close, framed by the sky or another neutral background. Nothing was moving, and there was great attention to the finely detailed surface textures of the subjects. There was little in the photographs to suggest either the modern industrial world or the troubles of the times.

Most accounts of Group f.64 note that it was primarily social and short-lived; that it exhibited only once; that after that first venue the group disbanded and the works were not seen together again; and that the audience was therefore limited to those who saw the show at the de Young Museum between November 15 and December 31, 1932. Yet interviews with these now-famous photographers, their own notes and letters, and newspaper reviews beginning with the exhibition reveal a *different* history. Hurried notes, a few initials in exhibition lists, and recently discovered letters refer not to one show but to a series. Los Angeles, Portland, Carmel, Seattle, and still other cities are mentioned as venues where the photographs were seen before they were finally returned to the lenders in late 1935. Even with the newly discovered letters from Weston to Van Dyke and Adams's notes, it is still not possible to know precisely how the first show was augmented when it traveled. Reviews suggest a larger show of one hundred works in Portland.

The storm of written protest that soon arose in the pictorialist and camera-club press also suggests that the exhibition had *multiple* venues; one showing at the de Young would hardly have provoked the number of articles that were eventually published. Furthermore, the group's statement of purpose called for frequent shows. It is therefore more likely that the group owed its impact and the published responses to the photographs and premises of the group to the appearance of the show, or versions of it, in other West Coast cities where photography was an important and current amateur interest.

The *San Francisco Chronicle* reviewed the exhibition at the de Young Museum on November 27, 1932. Neglecting either to assess the significance of this initial exhibition or to discuss the group's statement, the reviewer nonetheless praised the "beautiful work on view. . . . These photographers, like other talented brethren of the lens, are admirable portrait artists, imaginative creators of abstract patterns, who look for charm in boats, in scenery, in every small growing thing that is nourished at the bosom of Mother Earth." [19]

An annual report of the Seattle Museum of Art lists a Group f.64 exhibition from October 4 to November 6, 1933.[20] This exhibition apparently went on to the Portland Museum of Art; two printed discussions reviewed f.64 work as well as that of a complement of Oregon photographers exhibiting at the same time. In November 1933 a reviewer noted in the *Spectator* that "from the viewpoint of the artist, the display of prints in the downstairs galleries at the Museum of Art is one of the most interesting exhibitions of photographic art ever shown at the museum. . . . The work of Edward Weston particularly shows fine technical composition and artistic viewpoint. . . . The entire group seems to feature the objective representation of carefully selected form." [21]

In addition to these northern venues, portions of the Group f.64 exhibition appeared at the 683 Brockhurst gallery and at Mills College in Oakland,[22] at Ansel Adams's Geary Street gallery in San Francisco, and at the Denny-Watrous Gallery in Carmel, as well as in Los Angeles. There is mention of a possible New York venue. Weston, who had shown work in New York, wrote to Van Dyke on January 27, 1933, questioning the wisdom of going there with an exhibition "that may be a bad move or gesture for me to make this year. . . . don't you think that the group is a bit hasty in wanting to show this year?"[23]

A New Direction

A confirmed pictorialist, the reviewer Sigismund Blumann, writing in *Camera Craft* in May 1933, provided the first considered review of Group f.64's premier exhibition:

> The name of the organization was intriguing. The show was recommended to us as something new, not as individual work might go but as a concerted effort specifically aimed at exploiting the trend. We went with a determined and preconceived intention of being

amused and, if need be, adversely critical. We came away with several ideals badly bent and not a few opinions wholly destroyed. . . . The Group is creating a place for photographic freedom.

. . . [Y]ou will enjoy these prints. You will be impressed, astounded.[24]

Although Blumann revealed that he preferred the familiar and the romantic view, he clearly recognized a new force abroad in photography.

Blumann's encouraging words were countered, however, by other voices. Albert Jourdan, a little-known and quite bitter photographer from Portland, Oregon, condemned the straight photography movement as unoriginal. In his aptly titled essay "Sidelight #16: The Impurities of Purism," he dismissed Group f.64.[25] He recounted his own initiation into pure photography in 1931, describing how "the carcass" of the "Latter Day Purist" movement, which originated in Germany, was brought "across the Atlantic and the continent, [given] a few shots . . . and, very recently, proclaimed . . . a 'definite renaissance,' "—an account he concocted out of whole cloth because some German photographers' works were on view in Oakland in 1930. In Jourdan's view, "Moholy-Nagy is one originator of Pure photography, along with other Bauhaus members," all of whom, Jourdan noted, worked before Weston. While it is not surprising that the transmission of European and East Coast ideas to the West Coast would take time (in painting it often did), European photographers recognized that several Americans had taken the lead sometime between 1913 and 1920. That it took Weston eight or nine years to "convert" hardly seems reason for Jourdan to impugn his work or his goals.

Probably because contemporary events overshadowed the activities of artists, most histories have overlooked the subsequent versions of the initial Group f.64 exhibition. Despite the group's marked activity during 1932 and 1933, the newspapers, generally preoccupied with the seriously depressed economy, gave only the briefest attention to announcements about art. Publicity for Group f.64, therefore, may not have been what one would expect. To compound the problem, the newspaper the *Carmelite* had gone out of business, making it more difficult to give the Denny-Watrous exhibition adequate notice in Carmel, where Weston was based.

In addition to their involvement with Group f.64, members were actively pursuing their own careers. In 1933 Ansel Adams went to New York and had a momentous meeting with Alfred Stieglitz, the acknowledged leader of fine art photography and owner of the influential gallery An American Place. On the West Coast, Willard Van Dyke and Mary Jeanette Edwards had taken on the demanding task of establishing their gallery at 683 Brockhurst in Oakland as a center and forum for West Coast photographers, in an attempt to bring national and specifically East Coast attention to their work. And during the months before the de Young opening, Edward Weston was engaged in the production of his beautiful new book *The Art of Edward Weston,* which

was on press in late September 1932 and available for signing when the Group f.64 exhibition opened in San Francisco in mid-November. *California Arts and Architecture* magazine carried a prominent picture endorsement for the book in its November 1932 issue—just the kind of publicity the group would have wanted for its show.

Perhaps the most likely reason for the curious silence about the later six versions of the Group f.64 exhibition can be traced to Lloyd La Page Rollins, then director of the de Young Museum. Although he was the sponsor of Group f.64, the museum's board of directors did not support his championing of photography, and Rollins ran into trouble because of the space photography had come to occupy in the galleries. It seems that he had replaced many of the not-very-distinguished paintings the board had donated to the museum with new photography exhibitions. The board asked him to resign in April 1933, just five months after the opening of the Group f.64 exhibition.

Although the f.64 show was sent to its subsequent venues and was listed in *Camera Craft* as an exhibition available for travel, both promotional materials for the touring museums and dedication to the project were probably in short supply once Rollins had resigned. In his daybooks Weston had earlier explained that the show would go to the de Young "out of consideration for Rollins," who had requested that the group not open its own gallery to compete with his program. After his departure, however, the issue of competition was moot. Necessity now required a gallery to promote "straight seeing." The first in the Bay Area to take up this challenge was 683 Brockhurst.

The Group's Aesthetics

If we analyze the de Young checklist of the Group f.64 show, we find images of still life; bits of landscape, posts, bones, and sky; a few industrial buildings; portraits; and nudes or figure studies. The subjects were ordinary, yet most had a commanding presence when photographed. The emerging aesthetic proved broader than the group's manifesto, more generous in its means; filters, dodging, and arranging still lifes were all accepted in one case or another.[26] Isolated instances of technical manipulation evidently met the group's ideal of an art form obtained by "simple and direct presentation through purely photographic methods."

Although Group f.64 distanced itself from the pictorialist tradition, at least four of its members had produced fine pictorial work in the 1920s, and three continued to do so until 1931. Their established friendships, moreover, clearly went back to the pictorial days. Roger Sturtevant, a close friend of many Bay Area photographers, remembered a congenial opening in the mid-1920s when Edward Weston was in San Francisco. It drew many photographers, who were themselves photographed there in a series of hilarious pantomimes. Weston and Anne Brigman posed in costume as the father and mother of photography, with the "children"—Roger Sturtevant, Johan Hagemeyer, and Imogen Cunningham—framing them in adulatory, prayerful poses. Roi Partridge, Imogen's husband, took the photographs.[27]

Willard Van Dyke, a central figure in founding Group f.64, continued to provide a focus for Bay Area photography. In 1928, two years after he left the University of California at Berkeley, Van Dyke assisted in making and showing lantern slides for lectures by the much-honored but unconventional tonalist photographer Anne Brigman. Her studio at 683 Brockhurst Street in Oakland was a center of creative activity and a meeting place for artists.

Brigman's ardent love of nature surfaced even in domestic decisions:

> When the barn at 683 Brockhurst was remodeled, as a studio, a problem arose in building the bathroom. The only logical place to put it had a lovely tree happily growing in that exact spot . . . of course there could be no question of removing the tree. All the carpenters had to do was build the walls around it, provide a hole in the roof for its trunk, and then hang the shower from one of the lower branches. A true daughter of Zeus, Annie never interfered with nature.[28]

Van Dyke and his friend Mary Jeannette Edwards, whom he wanted to marry, had taken over this studio by 1930, intending to establish a gallery for photography. Brigman had gone to live in Southern California to be near her sister and rented it to them for twelve dollars a month. Van Dyke stated that while he and Mary Jeannette certainly did not consider themselves in competition with Stieglitz, they felt that by establishing a gallery for photographers, they could provide "an atmosphere on the West Coast that could be useful to Western artists. I think . . . our first exhibition, on July 28, 1933, was a retrospective of Edward's [Edward Weston's] work. The prints were displayed in chronological order . . . from 1903 when he began . . . to his most recent photographs."[29]

Although the couple changed little of the charming character of 683, its board-and-batten walls presented an aesthetic problem in the exhibition of photographs. A photographer friend of Mary Jeannette Edward's father, a talented designer, helped to solve it. Van Dyke describes the process: "First he covered the whole surface with monk's cloth . . . that he pasted over the wood. Then he brought enough tea paper to cover the surfaces . . . with the gold or silver metallic material. Then he sponged water paint in colors of violet and blue over the tea paper and wiped it lightly before it dried. This left a colored, textured surface with flecks of glowing metal shining through." The gallery in this renovated space, as its stationery stated, was "devoted to contemporary expression in black and white."[30]

Camera Club Notes, a column in *Camera Craft*, in reporting on the opening exhibition, hailed "this charming little gallery . . . opened by two young people with a splendid enthusiasm for photography. For a long time we have felt that the Pacific Coast is a particularly fertile field . . . that here are many of the finest photographers."[31]

Weston's new landscapes caught the attention of the reviewer, who then listed the gallery owners' future plans for shows by Adolph Dehn, a lithographer; twenty-five prints by Ansel Adams, "well-known for his sympathetic photographs of this city and for his splendid prints of the high Sierra"; and works by Willard Van Dyke and Imogen Cunningham. Van Dyke closed the season with a juried show of what he defiantly called the "First Salon of Pure Photography." He remembered that "Weston laughed at the word, 'pure,' but we all were astounded at the response."[32] The hundreds of works submitted for consideration indicated that many photographers shared the group's ideals, suggesting too that after the period of innovation and diffusion f.64 had had an effect. Many photographers had accepted the premise of unmanipulated image making.

Edward Weston made it possible for Van Dyke to justify continuing in photography and opening the gallery. When Van Dyke told him he had been offered a job as district manager for an oil company, Weston replied, "To work at something just to have financial security could be compared to the life of a cow that spent its whole life filling its belly." Extrapolating from this thought, Van Dyke recalled, "He knew that I had talent but if I decided to go on and develop it, I had to realize it would require sacrifice and uncertainty." Weston referred to this as the decision to "turn down the bitch goddess Success."[33]

Women in Group f.64

The members and associates of Group f.64 were generally well educated in the ways of commercial photography by the early 1930s. They were mainly self-taught, although two were experienced darkroom assistants to more mature photographers (Noskowiak for Weston, Mary Jeannette Edwards for Lange). Their ages in 1932 ranged from forty-nine (Edwards) to twenty-one (Brett Weston), but most were in their thirties or early forties. They all tended to accept the authority of Edward Weston's years of photographic experience. And, notably, women were strongly represented among them.

The study of Group f.64 invites speculation about why so many women were empowered through their association with a predominantly male friendship group that might have ideologically subjugated women as darkroom assistants and mere receptors for male creativity.

Very likely the acceptance of women into the group was made possible after World War I by the emergence of the "New Woman," demanding the right to work and vote. As early as 1913 eager women writers explained admiringly that Anne Brigman and Laura Adams, a successful San Francisco portrait photographer, could be independent in photography, as this work was "suitable" for women, needing no large capital outlay, no long schooling or learning beyond the usual education of women. Women's "intuition" was cited as justifying their special talent for portraiture, particularly—it comes as no surprise—of children.[34]

Imogen Cunningham, on her own after European study and schooling in chemistry, began an innovative and provocative series of male nude studies of her husband, Roi Partridge, who was pictured faunlike in settings of the Washington hills and mist-covered lakes. For financial support she also pursued studio portrait work, photographing children and their families, while continuing to keep in touch with the magazines and shows that led the way toward modernism (Fig. 98).[35] Cunningham's direct, no-nonsense personality led to her willful decision in 1934 to go to New York despite Roi's disapproval. The trip resulted in divorce. (Anne Brigman had taken a similar trip, with similar results, in 1910.) Cunningham continued executing portrait commissions to support her twin sons and a slightly older son, all under the age of nine. Perhaps because she assumed these responsibilities, her male colleagues considered her a professional, a fine art photographer, an equal, and a friend. In 1928 Weston sent her a gloriously complimentary letter, telling her that her photographs were the best in the San Francisco salon.[36] Possibly her sense of fun and her sharp wit gave her powerful weapons in any struggle for parity with men in the group. Cunningham was always treated with respect.

Sonya Noskowiak's initial position in the group was as a dependent. Her progression from receptionist in Johan Hagemeyer's Carmel studio, where she met Weston, to Weston's general helper, darkroom assistant, and then model, mistress, and companion is well known. The daybooks chart the circumstances of their relationship as well as Weston's egocentric appreciation of Noskowiak's photographs in January 1930, almost her very first: "A negative of Neil's hands, the back of a chair, and a halved red cabbage. Any one of these I would sign as my own. And I could not give higher praise. She is a surprise."[37]

Consuelo Kanaga was an unusual participant in the f.64 exhibition of 1932. Young, naive, and working on her own for newspapers, she was dependent on her patron and sponsor, Albert Bender, who was also important to the careers of many members of Group f.64. She knew them but was shy, reluctant to become involved. In her letters to Bender she repeats her reservations and doubts.[38] Even her early pictures were of social themes. For example, she made black-and-white photographs illustrating blacks and whites holding hands (Fig. 99). Her 1928 portrait *Frances,* of a sweet-looking black

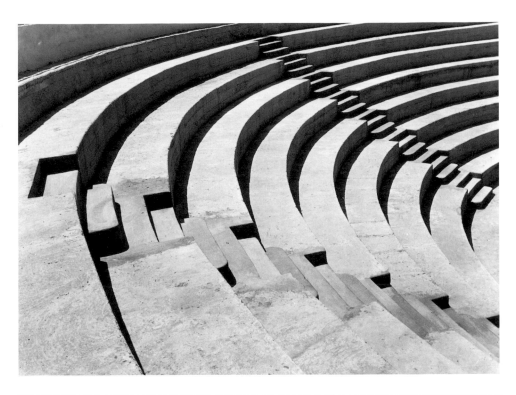

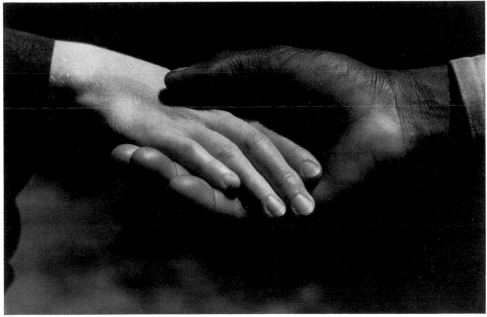

child, was considered out of the ordinary, as the Bay Area black population was then small. Unlike Arnold Genthe, who sought the exotic and alien "other," Kanaga pictures Frances as a child who happens to be black. Kanaga's picture conveyed an innocent message of racial understanding in which potential conflicts are easily resolved. Kanaga was interested in the way black-and-white photography could make social statements; only in passing did she consider photography a fine art.[39]

When Alma Lavenson went to Carmel in 1930 to meet Weston, he urged her to reconsider the soft-focus atmosphere of her prints.[40] She was self-taught, and like the others in Group f.64 she had learned the craft thoroughly. She renovated a childhood playhouse as a darkroom and created photographs by first visualizing them in her mind. She accompanied friends who painted and etched scenes at the Oakland waterfront, photographing that active port. Its warehouse buildings and ships' riggings became a favorite f.64 subject.[41] From the outset, Lavenson's pictures were successful in competitions.[42] Although she did not know other photographers at first, she did subscribe to camera magazines, and she had good equipment; her family, through a successful mercantile business, was well able to afford it. With letters of introduction from Albert Bender, a family friend, she met Imogen Cunningham, Consuelo Kanaga, and Edward Weston. Although her contact with Weston was most significant for her photography, Cunningham had greatest influence on Lavenson's activity as a photographer: "I met her in 1930, somehow or other we became close friends and we remained close friends until she died forty years later. I photographed with her and we travelled together. . . . She never criticized my work, she never praised it."[43]

These remarkable women were acknowledged as peers by their Group f.64 male contemporaries. Only later did a silence come to surround their work—a silence created by exhibition curators, art dealers, and photographic historians in the 1950s. Although Lavenson and Cunningham continued to live and photograph in the Bay Area, they were not singled out for solo shows until their careers were validated by their remarkably long lives. As Cunningham noted, she and other women photographers in their fifties were invisible; only when she reached seventy did she become a celebrity.[44]

Art and Life

The basis of the group's manifesto began with light; its chemical action on sensitized surfaces described the process of photography. Light was the only legitimate medium for photography, and much of the success of an artist photographer lay in controlling it. In the West, light meant sunlight, filtered sunlight—in Weston's case, cheesecloth was stretched like a tent roof over the open porch outside Hagemeyer's studio. Here Weston obtained a beautiful high, strong light and made the portraits that earned him his living. Charis Wilson, who later became Weston's wife, remembered that the light there pleased him, and he photographed such local notables as Robinson Jeffers and Lincoln Steffens.[45] The cheesecloth over the porch was equally good for still lifes. Every

time Weston waited for a sitter to arrive, he turned to setups. Most of the images from 1930 to 1932 that Weston included in the Group f.64 show were made on this porch.[46]

Weston's controversial 1931 set-up image, *Rock and Shell Arrangement,* appeared to alter the scale of reality, for the shell filled the mouth of an enormous mountainscape. Weston insisted on including the photograph in Merle Armitage's book *The Art of Edward Weston* and in the de Young's Group f.64 exhibition. It provoked furious letters, which Weston ignored, from those who expected pictures to be "true to nature." Weston's friend Ramiel McGehee said to him: "It is a stunt and if the book was mine, I would neatly with a safety razor blade remove the print from the book. It's the first time I've known you to make nature talk a language not her own."[47] Weston denied the "stunt": "I don't have to please the public" (a brave statement but hardly consistent with his pleasure in good reviews). Weston explained the motive for publishing the picture: "It deeply moved an intelligent audience as I was moved when I first saw its presentation on my ground glass." This image is a still life set out-of-doors. In using the word "arrangement," Weston signaled to the viewer what the picture was: his own placement of elements. He noted, "I did not add that word as an apology, rather to forestall criticism from *naturalists* that thought I was 'nature-faking.'"[48]

As the decade continued, the problems of the depression became more widespread, affecting artists and photographers already accustomed to existing on meager commissions and few sales. In San Francisco, and even in Carmel, critics questioned the premise of art. They accused the members of Group f.64 of failing to consider economic or social problems in their photography, which continued to center on things seen for their beauty. As Weston noted in February 1932, he knew that he was on uncertain ground, and that there were "right thinkers" who would have preferred that art function as a missionary to improve sanitary conditions; in 1933 he added, "I am 'old fashioned' enough to believe that beauty—whether in art or nature, exists as an end in itself. . . . If the Indian decorating a jar adds nothing to its utility, I cannot see why nature must be considered strictly utilitarian when she bedecks herself in gorgeous color, assumes magnificent forms."[49]

The matter may have seemed clear to Weston, but Van Dyke and others found compelling the argument that photography could describe social concerns. Van Dyke wrote a long and appreciatively perceptive article on Dorothea Lange, whose work he included in a show at 683. He accompanied Paul Taylor and other photographers on a significant visit to the self-help cooperative United Exchange Association (UXA) in Oroville, California. A trained agricultural economist, Taylor was an effective advocate for liberal economic views and the necessity for new jobs. Drawn to the photographers involved in 683, particularly Dorothea Lange, whose innate sympathy and direct vision in photography matched his own, he provided the clear example of what photography could accomplish if it were made to function politically, as it did when Lange's photographs led to the funding of a migrant workers' camp.

Despite their differences of opinion on photography as a political tool, Adams and

the others kept in close contact with Lange and Taylor. Later Adams developed many of Lange's Farm Security Administration negatives for her in his Yosemite studio, both Lange and Adams disagreeing with the FSA policy of insisting that photographers send their film to Washington for processing.

Weston's and Adams's strongly held belief in art for art's sake was often condemned, however. Weston wrote in his daybook that his kind of photographing could be compared to the work of a "Bohemian dabbler . . . frittering away on daubs and baubles to decorate the homes of our great democracy, using art as an excuse to loaf, to be supported like poodles, and petted by sexually unemployed dowagers—art patrons!"[50] Willard Van Dyke, socially aware and impressionable, had changed his outlook. He and Paul Taylor applied for a Guggenheim grant for a film on the UXA but were turned down. Ironically, in 1937 Weston received the first such grant awarded to a photographer—to photograph landscape.

The Legacy of Group f.64

Many factors, including the departure of several members from the Pacific Coast and Carmel, caused Group f.64 to break apart.[51] Weston went to Santa Barbara to be with his son; Willard Van Dyke (Fig. 100) left for New York and a career making movies (beginning with *The River*). Although Mary Jeannette Edwards stayed at 683 Brockhurst, it is clear that she felt deserted. Returning some prints to Weston, she remarked in a letter, "I think the only course open to the group is not to show as f.64, but as a group of Western Photographers. There is such diversity in work and point of view."[52] In August 1935 she added, "Now I realize that my little 683 must be given up, as soon as I am economically able to make the move."[53]

Did the photographers who continued to be active evolve new ways of seeing and composing their photographs? Or did their increasing fame rest on the growing understanding of the general and museum-going public that photography, the pervasive language of the times, was uniquely significant? Ansel Adams evolved as a photographer, building on his extraordinary vision and technique, his passionate feeling for California land, and his ability to enlarge the meaning of landscape photography as central to environmental concerns. Weston applied his straight photography to a broader landscape on his Guggenheim trip and, in a darker view, to the final pictures of Point Lobos, but illness overcame him before major change could develop and be resolved in his work. The photographs he showed at the f.64 exhibitions constituted, as he thought, many of his most successful pictures.

Group f.64 provided a rallying place for like-minded photographers to gather, state their aims, and exhibit their carefully composed black-and-white images (Fig. 101) in defiance of the then reigning pictorialist tradition. That the proponents were young, bold, and optimistic about their chosen medium was important to the group's success. As an informal Oakland meeting place and gallery, 683 Brockhurst encouraged the

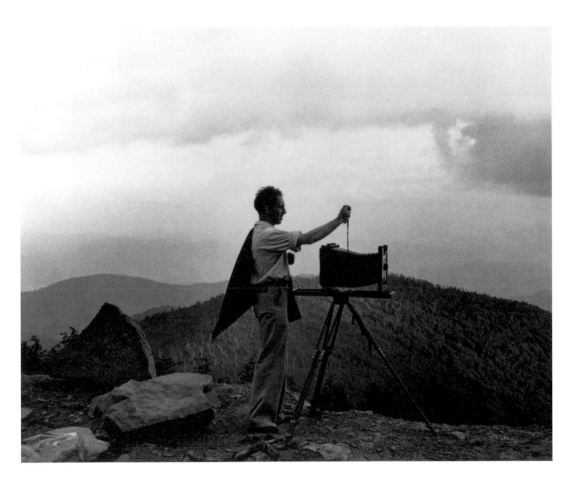

FIGURE 100
Peter Stackpole, *Willard Van Dyke
with View Camera*, 1930s. The
Oakland Museum, gift of Douglas

Elliott. Photograph courtesy Peter
Stackpole.

revolutionary Bay Area modernist aesthetics that resulted in straight seeing and "pure photography."

Individually, four f.64 members combined their shared vision, adapting straight, clearly seen images for diverse purposes, from picturing California's stark beauty to addressing social issues. More remarkable, from this group of eight, four of the best-known and most celebrated photographers of the period emerged—Edward Weston, Willard Van Dyke, Imogen Cunningham, and Ansel Adams. One can postulate that although each of them was committed to making photographs, their collaborative effort, their entwined relationships, and their spirit of rebellion clearly benefited the

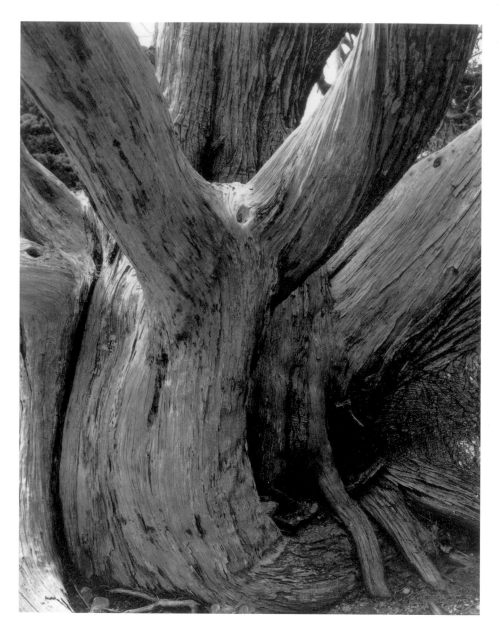

younger members. The f.64 photographers gave an intriguing name and a specific location to a modernist movement that for the next forty years characterized American fine art photography. Cunningham captured the irony of their love of photography with humor and a determination to undermine pompous aims when she observed, "You have to be really crazy to stay in it, the way a photographer is treated. . . . You really have to be a mad person to stick to it. We did all seem to stick."[54]

Despite the pervasive and elegant modernism of a photography grounded in seeing straight and in a purist's modernist idiom, younger photographers changed, experimenting by revisiting mixed media and by striving for pictorial effects in their work. Perhaps manipulation, hand-coloring, and collage—all despised by the modernists of the 1930s—came to be acceptable once more as natural to artistic expression. Modernism in California first narrowed its focus to the purely photographic and then, by the 1950s, broadened it once more to encompass the wide range of media and images that could be imposed on paper.

Notes

This chapter, although revised, is substantially based on my essay "Perspective on Seeing Straight," in *Seeing Straight: The f.64 Revolution in Photography,* ed. Therese Thau Heyman (Oakland, Calif.: Oakland Museum, and Seattle: University of Washington Press, 1992). Permission to reprint was graciously provided by the Oakland Museum. The abbreviation CCP refers to the Center for Creative Photography, University of Arizona, Tucson.

1. Heyman, "Perspective on Seeing Straight," 60.

2. In most large cities by the early 1900s amateur photography enthusiasts gathered together in camera clubs, which provided technical support, social activities, and juried exhibitions.

3. William Mortensen, "Venus and Vulcan," *Camera Craft* (May 1934): 206. Mortensen contributed five installments of this article from March to July 1934.

4. Ansel Adams, Book Review, *Creative Art* (May 1933): 386.

5. *The Daybooks of Edward Weston: Two Volumes in One,* vol. 1, *Mexico;* vol. 2, *California,* ed. Nancy Newhall (New York: Aperture Foundation, 1981), 2:174.

6. Ibid., 1:8.

7. An ardent proponent of avant-garde art, Galka Scheyer introduced European works to the Oakland area, including constructivist and abstract paintings plus works by the Blue Four; organized lectures and exhibitions; and proposed purchases to the Oakland City Council while continuing to teach at Anna Head, a private girls' school in Berkeley.

8. *Daybooks of Edward Weston,* 2:151.

9. Ibid., 2:146.

10. Ibid., 2:147. Weston does not seem to recognize that Paul Strand had presented these ideas in his 1923 lecture to the Clarence White School.

11. Willard Van Dyke, "Unpublished Autobiography," 52; collection of CCP, courtesy of Barbara M. Van Dyke.

12. Ibid., 54.

13. Willard Van Dyke, transcript of a lecture given at the Oakland Museum, July 14, 1978, 5.

14. James Alinder, "The Preston Holder Story," *Exposure* 13, no. 1 (February 1975): 4.

15. Undated letter from Willard Van Dyke to Edward Weston, envelope postmarked September 8, 1933; collection of CCP, courtesy of Barbara M. Van Dyke. See also Willard Van Dyke's introduction to Weston's 1933 show at 683 Brockhurst and his article on Dorothea Lange's documentary style, "The Photographs of Dorothea Lange," *Camera Craft* 41 (October 1934): 461–67. Mary Alinder believes that Adams's typewriter was the one used and that he may have been the author; in my opinion, however, Adams, in his writing style at this time, simplified and overstated for emphasis in teaching. Imogen Cunningham states unequivocally, "In the main, the person who started this was Willard. I've been told that Ansel Adams claims he started it, but I would swear on my last penny that it was Willard who did it" (University of California Oral History, Regional Cultural History Project, Bancroft Library, Berkeley, 1961, 11). This uncertainty of authorship reflects the imperfect recollections of the artists themselves; moreover, the manifesto was essentially a consensus document.

16. *Daybooks of Edward Weston,* 2:246.

17. Adams, quoted in Ira Latour, "West Coast Photography: Does It Really Exist?" *Photography* [London] (May 1960): 20–25. Van Dyke credits a West Coast aesthetic as the goal of his photography in a 1934 statement for his show at 683 Brockhurst.

18. Ansel Adams, unpublished typescript statement in the collection of Amy Conger, found also in the papers of Beaumont Newhall. This four-page piece appears to have been a draft to introduce the f.64 show at Adams's Geary Street gallery.

19. *San Francisco Chronicle,* November 27, 1932, Music and Art Section.

20. The *Seattle Times* announced the Group f.64 exhibition at the Seattle Art Museum on October 1, 1933, in the Art Museum column.

21. Review, *Spectator* 54, no. 13 (November 4, 1933): 16. Naomi Rosenblum points out that "objective" is the very word Strand used in 1917 to discuss the new realist style.

22. The Mills College exhibition, February 11–28, 1934, included work by Lavenson, Cunningham, Van Dyke, Adams, and Weston, as well as Dorothea Lange and Margaret Bourke-White. It was reviewed in "A Record of Actuality," *San Francisco Argonaut,* March 8, 1934.

23. Undated letter from Edward Weston to Willard Van Dyke, envelope postmarked January 27, 1933; collection of CCP, courtesy of Barbara M. Van Dyke. "The f.64 exhibition shows up well at Denny-Watrous. They wish to give us another (free) week, O.K.?" He adds, "I do not want to hold up the group."

24. Sigismund Blumann, "The F.64 Group Exhibition," *Camera Craft* 40 (May 1933): 199–200.

25. Albert Jourdan, "Sidelight #16: The Impurities of Purism," *American Photography* 29 (June 1935): 348–56.

26. John Paul Edwards, "Group f 64," *Camera Craft* 42 (March 1935): 107–12.

27. Roger Sturtevant, transcript of interview on his collection and on Dorothea Lange (with whom he shared a studio at one time), the Oakland Museum, February 1977, 1–5. Although

Sturtevant was unable to locate this set of pictures at the time he gave his photographic archive to the Oakland Museum, I have seen some of them in Michael Wilson's collection and also at the J. Paul Getty Museum.

28. Van Dyke, "Autobiography," 32.

29. Ibid., 50.

30. Statement printed on the 683 gallery stationery; courtesy of Barbara M. Van Dyke.

31. Camera Club Notes, *Camera Craft* 40 (September 1933): 388.

32. Van Dyke, "Autobiography," 50. Curiously, the word "Salon" suggests the pictorial tradition they wanted to leave behind.

33. Ibid., 48. Although Van Dyke writes of this period, Naomi Rosenblum told me about another account of Van Dyke's decision to leave the Shell Company and commit himself to photography, one that was related by William Alexander in *Film on the Left: American Documentary Film from 1931 to 1942* (Princeton, N.J.: Princeton University Press, 1981), 130–44. In that interview Alexander notes that Van Dyke was radicalized when, after trying to organize a union at Shell, he was forced to choose between working a sixty-hour week and losing his job. Recently, when he compiled material for his autobiography, Van Dyke recalled the influence of Edward Weston; it is likely that both Weston and the circumstances at Shell led to his choosing photography.

34. Laverne Mae Dicker, "Laura Adams Armer, California Photographer," *California Historical Society Quarterly* (Summer 1977): 139.

35. Imogen Cunningham, University of California Oral History, Regional Cultural History Project, Bancroft Library, Berkeley, 100–104.

36. *Daybooks of Edward Weston,* 2:4. Imogen Cunningham papers, Archives of American Art, Smithsonian Institution, no roll number.

37. *Daybooks of Edward Weston,* 2:141. Years later Noskowiak moved away and worked for the *San Francisco Chronicle* and the Public Works of Art Project.

38. The letters Consuelo Kanaga wrote to Albert Bender, in the Bender Collection, Mills College Library, Oakland, generally refer to her mental state, not her photographic activities. I am grateful to Barbara Millstein of the Brooklyn Museum, curator of the 1992 Kanaga exhibition and author of the accompanying catalogue, for suggesting this source to me as well as sharing many of her valuable insights on Kanaga.

39. "A Visit with Consuelo Kanaga, from the Icehouse," *Camera* 35 (December 1972): 53. Kanaga recalled beginning in photography at the *San Francisco Chronicle:* "When I started on the newspaper, I learned just the fundamentals of printing and developing; no nuances. Everything had to be sharp, etched on the glass plates. The editor would look up and down the row to see the sharp cut line. And, if anything wasn't so sharp he'd say, 'what's the matter, losing your eyesight?'" Then, with her interest in photography whetted, she joined the California Camera Club, where she met many "wonderful" people, including Dorothea Lange, the innovative documentary photographer of San Francisco depression-era street scenes. Lange later described Kanaga as "unconventional with great courage and an ability to go anywhere and do anything" (interview with Dorothea Lange by S. Reiss, University of California Oral History, Regional Cultural History Project, Bancroft Library, Berkeley, 1968, 87).

40. See Susan Ehrens, *Alma Lavenson: Photographs* (Berkeley, Calif.: Wildwood Arts, 1990), 5.

41. Ibid., 90.

42. Ibid., 4.

43. Charis Wilson, in "Founders of Photography" symposium transcript, the Oakland Museum, March 9, 1986, 9.

44. Imogen Cunningham, lecture at the Oakland Museum, 1974, author's notes.

45. Wilson, in "Founders of Photography," 2.

46. Ibid.

47. Ibid., 5.

48. *Daybooks of Edward Weston,* 2:267.

49. Ibid., 2:243.

50. Ibid.

51. For a compelling discussion of the breakup, see Michel Oren, "On the Impurity of Group f.64 Photography," *History of Photography* (Summer 1991): 119–27.

52. Letter from Mary Jeannette Edwards to Edward Weston, undated but probably 1935; Edward Weston Archive, collection of CCP.

53. Letter from Mary Jeannette Edwards to Edward Weston, August 3, 1935; collection of CCP.

54. Imogen Cunningham, quoted in Latour, "West Coast Photography" (as in note 17), 62.

Derrick R. Cartwright

APPENDIX: A CHRONOLOGY

OF INSTITUTIONS, EVENTS,

AND INDIVIDUALS

The preceding essays survey the complex conditions of modernism in California during the first half of the twentieth century. Each author has brought different criteria to the task of mapping California's distinctive cultural terrain and, accordingly, each has identified his or her own critical vantage points. Such a large grouping of perspectives is bound to be diverse and, as such, the assembled narratives resist efforts to keep facts in strict chronological order. Still, the usefulness of a chronology for a volume like this one is not simply that it submits an abundance of historical information about artistic practice in California to the organizing device of a calendar, but also that it may offer a separate, independent space for further comparison of seemingly disparate activities. The possibility of making new connections between entries makes this chronological effort worthwhile.

This chronology traces the founding of art institutions, the establishment of new markets for modern art, and the uninterrupted migration of artists to the state. From 1900 to 1950 the state's population rose from approximately 1.5 to 10.5 million, and cultural developments reflect this phenomenal growth. While many entries reflect indisputably modernist tendencies, others plainly do not. What should be emphasized, therefore, is the sheer number of cultural issues—that is, the events, institutions, and individuals that shaped artistic life in California throughout this period. Although it is hoped that the art-historical significance of the entries will be clear, the chronology is not comprehensive. It cannot acknowledge every person who contributed to the development of a modernist culture in California any more than it can indicate the real impact of every institution or exhibition. It does, however, sketch broadly the characteristics that enable us to interpret this modernism as something unique.

A chronology mounts a narrative that should not be confused with a complete or disinterested column of events. Decisions about what to include (and exclude) inevitably serve to construct (or, equally, obscure) a particular version of history. In making selections here, in addition to underscoring themes presented by the essays, I have

drawn upon many existing chronologies,[1] as well as important period studies of California art.[2] Finally, a survey of the documents collected for more than twenty years now by the West Coast Regional Center of the Archives of American Art constituted another invaluable source for the chronicle presented below.

Note: Entries for the various institutions listed below reflect their founding dates unless otherwise specified.

1900	·	California Camera Club begins its publication of *Camera Craft*
	·	Stanton Macdonald-Wright moves to Los Angeles with parents

1901	·	College of Fine Arts at Garvanza, a division of the University of Southern California, founded by William L. Judson (destroyed by fire, 1910)
	·	First San Francisco Photo Salon

1902	·	Art Department at the University of California at Berkeley
	·	California Society of Artists, San Francisco
	·	First Secessional Art Exhibition, San Francisco

1903	·	Carmel-by-the-Sea established by real estate developers intent on creating an artists' colony
	·	Chiura Obata moves to San Francisco from Japan

1904	·	San Diego Art Association
	·	Julia Morgan becomes first registered woman architect in the state (opens office in San Francisco in 1905)

1905	·	Los Angeles Arts and Crafts Society
	·	Carmel Arts and Crafts Society
	·	Daniel H. Burnham submits plan for City and County of San Francisco to the city's board of supervisors
	·	Arthur B. Davies visits Northern California

1906	·	First motion picture studio in Los Angeles founded by George Van Guysling and Otis M. Grove
	·	*Los Angeles Times* begins publishing weekly Art Review column, written by Antony Anderson
	·	Painters' Club of Los Angeles
	·	Los Angeles Art Institute

	·	Art Students League of Los Angeles founded by Hanson Duvall Puthuff
	·	Fine Arts League, Los Angeles
	·	Edward Weston moves to California
	·	Arthur F. Mathews and John Zeile begin to publish *Philopolis,* a journal devoted to San Francisco arts and city planning
1907	·	California School of Arts and Crafts founded by Frederick H. Meyer in Berkeley (later moved to Oakland; became California College of Arts and Crafts in 1936)
	·	*California Arts* begins publication in Los Angeles
	·	The Southwest Museum, Los Angeles
	·	Del Monte Art Gallery, Monterey
	·	Greene & Greene, David B. Gamble House, Pasadena (completed 1908)
	·	Mark Hopkins Institute of Art (rebuilt after 1906 earthquake) reopens as the San Francisco Institute of Art
1908	·	Temple of Art, Los Angeles
	·	Childe Hassam visits Northern California (returns 1914–15; visits Southern California in 1927)
1909	·	California Art Club, Los Angeles (previously Painters' Club)
	·	Cannon Art School, Los Angeles
	·	State Normal School of Manual Arts, Santa Barbara
	·	Women Painters of California, formed in Southern California
	·	The Arroyo Guild of Fellow Craftsmen
	·	Rex Slinkard begins teaching at Art Students League in Los Angeles
	·	Nelbert Chouinard moves to Los Angeles, where she joins faculty of Throop Polytechnic Institute and later Otis Art Institute, prior to opening her own art school in 1921
	·	Bernard Maybeck's First Church of Christ Scientist, Berkeley (completed 1911)
1910	·	San Diego Art Students' League
	·	San Diego Academy of Art founded by Maurice Braun
	·	Lucien Labaudt emigrates from France to San Francisco
1911	·	*Pacific Arts and Crafts News* begins publication
	·	California Society of Etchers, San Francisco
	·	Los Angeles Sketch Club
	·	Painter and muralist Frank van Sloun moves to San Francisco after visiting in 1907–8; brings Ashcan painting to region; joins art faculty, University of California at Berkeley, in 1926
	·	Municipal Arts Commission of Los Angeles

1912	·	Occidental College Art Department, Los Angeles
	·	Stickney Memorial Art School, Pasadena, opens under direction of Raffaello Mataboddi and Jean Mannheim
	·	San Diego Society of Arts and Crafts
	·	Southwestern Academy of Fine Arts
	·	Helen Lundeberg moves to Pasadena with family, at age 4

1913
- Los Angeles Museum of History, Science and Art (Los Angeles County Museum of Art opens in 1965 as separate facility in present Hancock Park location) holds its first art exhibition in its new building in Exposition Park
- Frederick C. Torrey purchases Marcel Duchamp's *Nude Descending a Staircase, No. 2* from the Armory Show for his Berkeley home
- Alexander Calder moves to San Francisco with family, at age 15, when his father, Alexander Stirling Calder, is appointed Chief of Sculpture at Panama-Pacific International Exposition (stays until 1919)
- Henrietta Shore moves to Los Angeles; stays until 1920 (returns in 1923; establishes a painting studio in San Francisco in 1925; moves permanently to Carmel around 1930)

1914
- Los Angeles Camera Pictorialists
- Printmakers of Los Angeles
- School of Illustration and Painting, Los Angeles, begun by William V. Cahill and J. H. Rich
- Vickery, Atkins & Torrey, San Francisco print and antiques gallery, exhibits Duchamp's *Nude Descending a Staircase, No. 2*
- Beatrice Krombach begins publication of *Western Art* in Los Angeles
- Robert Henri visits San Diego at the invitation of former student Alice Klauber; assists with planning of *Modern American Art* exhibition at the Panama California International Exposition
- Muralist Joseph Jacinto Mora moves to San Francisco from Uruguay
- Irving Gill begins Walter Luther Dodge House, Los Angeles (completed 1916)
- Henry Cowell, at age 16, gives first performance in San Francisco; hailed as a pioneer in experimental music

1915
- Beniamino Bufano first visits San Francisco (settles in 1921)
- Sculptor Sargent Johnson moves to San Francisco
- The San Diego Art Guild
- Brush and Pencil Club of Los Angeles
- Panama-Pacific International Exposition, San Francisco
- Panama California International Exposition, San Diego, at Balboa Park
- William Preston Harrison moves to Los Angeles from Chicago; becomes important art patron and donor to Los Angeles Museum of History, Science and Art
- Henrietta Shore moves to Los Angeles (stays until 1920; returns to Carmel in 1928)

1916	·	San Francisco Society of Artists merges with San Francisco Art Association
	·	Oakland Art Association
	·	Oakland Art Gallery
	·	Modern Art Society, Los Angeles
	·	Arnold Genthe publishes influential book of pictorialist photographs, *Pictures of Old Chinatown*
	·	Sculptor Donal Hord moves to San Diego for health reasons at age 14; during the 1930s, he becomes one of Southern California's most renowned public artists
	·	California School of Fine Arts, San Francisco

1917	·	Art Teachers Association of California
	·	Bivouac Art Club, Los Angeles
	·	Frank Lloyd Wright begins work on the first of twenty-five structures he would build in California: Hollyhock House, Hollywood, for Aline Barnsdall (completed 1921)
	·	Imogen Cunningham and Roi Partridge move to San Francisco
	·	George Bellows visits and paints the California coastline
	·	Jackson Pollock moves to Chico

1918	·	Laguna Beach Art Association
	·	Otis Art Institute (affiliated with the Los Angeles Museum of History, Science and Art) established by Harrison Gray Otis, founder of *Los Angeles Times*
	·	Sunset Boulevard Art School founded by C. Lillian Hounsel
	·	MacDowell Club of Allied Arts, Los Angeles
	·	Helena Dunlap and Henrietta Shore are given two-woman show at Los Angeles Museum of History, Science and Art
	·	Dorothea Lange establishes a photographic studio in San Francisco
	·	Johan Hagemeyer moves to San Francisco

1919	·	Henry E. Huntington Library and Art Gallery founded in San Marino; endowed with $10.5 million by its namesake (building opens in 1928)
	·	Santa Cruz Art League (formerly Jolly Daubers)
	·	La Jolla Art Association
	·	California Progressive Group's only exhibition, at Lafayette Tea Room, Los Angeles
	·	Rex Slinkard memorial exhibition at Los Angeles Museum of Art
	·	Willard Huntington Wright begins writing weekly column on art in *San Francisco Bulletin*
	·	Philip (Goldstein) Guston moves with his family to Los Angeles; attends Manual Arts High School, 1927–28, where he befriends Jackson Pollock

1920	·	Hollywood Art Association
	·	San Diego Friends of Art

- Los Angeles Print Group
- Santa Barbara School of the Arts founded by Ferdnand Lungren
- Three Arts Club, Los Angeles
- *Exhibition of Modern American Painters* (same artists as the 1916 *Forum Exhibition* in New York) opens in Los Angeles (February) and San Francisco (March)
- R. M. Schindler arrives in Southern California; establishes his own office in 1922

1921
- San Francisco Museum of Art
- Chouinard Art Institute, Los Angeles (to 1971)
- San Diego Academy of Fine Arts
- West Coast Arts, Inc. (Women's Art Club), Laguna Beach
- Earl Stendahl forms Stendahl Art Galleries in the Ambassador Hotel, Los Angeles
- Sculptors' Guild of Southern California
- California Watercolor Society, Los Angeles
- Palo Alto Art Club (now Pacific Art League)
- Printmakers Society of California, Los Angeles
- Simon (Sabato) Rodia begins work on Watts Towers (to 1954)
- Yun Gee emigrates from China to San Francisco (stays until 1927)

1922
- Community Arts Association of Santa Barbara
- Glendale Art Association
- Potboiler Art Center, Los Angeles
- Arthur Wesley Dow Foundation begins publishing *Dark and Light,* a journal devoted to modern aesthetics
- Peter Krasnow moves to Glendale (formerly Tropico, site of an art colony) at invitation of Edward Weston
- Rudolph M. Schindler begins designing Lovell Beach House, Newport Beach (completed 1925)

1923
- Painters' and Sculptors' Club of Los Angeles
- Berkeley League of Fine Arts
- Long Beach Art Association
- Group of Independent Artists exhibition, including Charles Austin, Ben Berlin, Nick Brigante, Boris Deutsch, Peter Krasnow, Stanton Macdonald-Wright, Max Reno, Morgan Russell, and Edouard Vysekal
- Frank Lloyd Wright builds his first "textile block"/usonian brick house in Pasadena, La Miniatura
- First Society of Six exhibition at Oakland Art Gallery
- Free Lance Art Club of Los Angeles
- Biltmore Salon (also known as Biltmore Galeria Real) in downtown Los Angeles
- *For Art's Sake* begins publication in Los Angeles

- Knud Merrild moves to Los Angeles
- Walt Disney moves to Los Angeles
- Sadakichi Hartmann moves to Los Angeles
- Japanese Camera Pictorialists of California, Los Angeles

1924
- Painters of the West, Los Angeles
- Santa Barbara Art Club
- Los Angeles Public Library Building begins construction; designed by Bertram G. Goodhue, with murals by Albert Herter and Dean Cornwell
- International Artists' Club of Los Angeles
- California Palace of the Legion of Honor, San Francisco
- Pasadena Art Institute
- Arts and Crafts Society of Southern California
- Goldsworthy-Clark School of Allied Arts, Los Angeles

1925
- San Francisco Society of Women Artists
- Pan-American Exhibition, Los Angeles
- Pasadena Society of Artists
- Commercial Artists' Club of Los Angeles
- Galerie Beaux Arts, San Francisco (first commercial gallery devoted exclusively to modern art on West Coast), founded by Beatrice Judd Ryan
- San Diego Fine Arts Society
- Modern Art Workers, Southern California
- Oxnard Art Club
- Artland Club, Los Angeles; published journal *Artland* (1926–27)
- Dalzell-Hatfield Gallery, Los Angeles
- Jacob Zeitlin moves to Los Angeles; in 1927, opens At the Sign of the Grasshopper bookstore, which became a center of bohemian cultural activity
- Robert Henri visits Los Angeles
- Mills College Art Gallery

1926
- First Blue Four exhibition at Oakland Art Gallery, organized by Galka Scheyer
- Stone International Gallery (modern American art), Monrovia
- Fine Arts Gallery of San Diego opens in Balboa Park (later renamed San Diego Museum of Art)
- Hollywood Art Center School
- Los Angeles Art League
- Rudolph Schaeffer School of Design, San Francisco
- Otis Oldfield and Yun Gee open the Modern Gallery in San Francisco (later becomes the Art Center) as a vanguard exhibition space; Gee founds Chinese Revolutionary Artists' Club in the city at about the same time

- Arthur Millier begins writing a regular art column for *Los Angeles Times*
- Walter and Louise Arensberg, influential patrons of modern art, move to Los Angeles
- Krishnamurti makes Ojai his home; spiritual leader attracts numerous artists to region
- Architect Richard Neutra moves to Los Angeles

1927
- First successful television transmission accomplished by Philo T. Farnsworth, in San Francisco
- *Synchromism,* exhibition of works by Stanton Macdonald-Wright and Morgan Russell, at Los Angeles County Museum (February) and Oakland Art Gallery (June)
- Carmel Art Association
- San Diego Society of Arts and Crafts
- Marin Society of Artists
- *Argus* begins publication in San Francisco
- Lorser Feitelson moves to Los Angeles
- Beatrice Wood moves to Los Angeles at Arensbergs' invitation
- Belle Baranceanu moves to Los Angeles (stays until 1928; returns to San Diego in 1933)
- Poet Kenneth Rexroth moves to San Francisco

1928
- Pasadena Society of Women Painters and Sculptors
- Scripps College Art Department, Claremont
- Los Angeles Print Group
- Younger Painters of Los Angeles
- Santa Monica Bay Art Association
- Academy of Modern Art, Hollywood
- Pacific Southwest Exposition, Long Beach
- East West Gallery of Fine Arts, San Francisco, mounts exhibition *Ecole de Paris,* which includes work by Picasso, Georges Braque, Georges Rouault, and André Derain
- Students at Manual Arts High School, Los Angeles, including Jackson Pollock, Philip Guston, and Reuben Kadish, publish a satirical broadside, entitled *Journal of Liberty,* which results in their expulsion from the school

1929
- Younger Painters exhibition, Los Angeles
- Long Beach Businessmen's Sketch Club
- Associated Artists of San Diego (changed name to Contemporary Artists of San Diego in same year)
- Art Students' League of San Pedro
- Women Painters of the West, Los Angeles
- Southern California Art Dealers' Association
- Oakland Art Gallery opens exhibition *European Modernists,* including work by Emil Nolde, Carl Hofer, Erich Heckel, Karl Schmidt-Rottluff, Max Pechstein, Oskar Kokoschka, and Lyonel Feininger

- Charles Erskine Scott Wood moves to Saratoga with his wife, Sara Bard Field
- Alfredo Ramos Martínez moves to Los Angeles; paints murals in Apple Valley (1931), Beverly Hills (1933), Santa Barbara (1934), Los Angeles (1935), San Diego (1937), and Claremont (1945)

1930
- Harmon Foundation of New York sponsors exhibition of work by contemporary black artists at Oakland Art Gallery
- Japanese Camera Club of San Francisco
- *Giorgio de Chirico* exhibition at Stendahl Art Galleries, Los Angeles
- Hans Hofmann invited by Worth Ryder (one of his former students) to teach in Art Department, University of California at Berkeley
- José Clemente Orozco arrives in Southern California, paints *Prometheus* at Pomona College dining hall
- Diego Rivera and Frida Kahlo arrive in San Francisco; large exhibition of Rivera's work at California Palace of the Legion of Honor that travels to Dalzell-Hatfield Gallery in Los Angeles
- Sergei Eisenstein arrives at Paramount Studios
- Lucien Labaudt hosts Henri Matisse in San Francisco
- Mabel Dodge Luhan, author and important patron of American avant-garde artists, visits Edward Weston in Carmel
- Art Center School, Los Angeles, founded by Edward A. ("Tink") Adams

1931
- William Preston Harrison gives his art collection to Los Angeles Museum of History, Science and Art
- Rivera completes two San Francisco murals: one for the stairwell of the Stock Exchange Lunch Club (now the City Club) and one at the California School of Fine Arts
- Hans Hofmann has one-man show at California Palace of the Legion of Honor; teaches at Chouinard Art Institute
- Philip Guston and Reuben Kadish paint portable mural cycle *American Negro* for Los Angeles chapter of John Reed Club (mural, inspired by Scotsboro Boys incident, later destroyed in a police raid)
- Morgan Russell moves to Hollywood and teaches at Chouinard Art Institute (to 1932)
- Agnes Pelton settles in Cathedral City (near Palm Springs)

1932
- San Diego Moderns
- Mortensen School of Photography, Laguna Beach (to 1955)
- Group f.64 formed in Oakland (to 1938). Original members include Willard Van Dyke, Ansel Adams, Edward Weston, Imogen Cunningham, Sonya Noskowiak, Henry Swift, John Paul Edwards; first exhibition of their modernist photography at M. H. de Young Memorial Museum, San Francisco; others invited to exhibit with the group include Preston Holder, Consuelo Kanaga, Alma Lavenson, Brett Weston

David Alfaro Siqueiros teaches course on mural painting at Chouinard Art Institute, gives lecture to John Reed Club of Los Angeles entitled "The Vehicles of Dialectic-Subversive Painting," and completes mural *Tropical America* at Plaza Art Center in Los Angeles

1933
· Foundation of Western Art, Los Angeles
· Los Angeles Art Association (originally the Museum Patrons Association)
· Public Works of Art Project (PWAP; to 1934)
· Centaur Gallery (specializing in surrealist works) opened by Stanley Rose in Hollywood
· Sculptor Alexander Archipenko teaches at Mills College
· John Gutmann moves to San Francisco from Germany

1934
· Section of Fine Arts of the Treasury Department (to 1943)
· Coit Tower murals painted in San Francisco at total cost of $24,300
· *Public Works of Art Project Exhibition* at Los Angeles Museum of History, Science and Art attracts record-breaking number of visitors
· *Joan Miró* exhibition at East West Gallery of Fine Arts in San Francisco
· Post-Surrealism movement originates in Southern California; Lorser Feitelson, Lucien Labaudt, Harold Lehman, Helen Lundeberg, Knud Merrild, and Etienne Ret show their "New Classicist" works at the Centaur Gallery
· Barrows Lane Gallery opens at University of California at Berkeley (among first campus exhibition spaces devoted to modern art)
· Humboldt Art Club
· Los Surenos Center (gallery and art center), San Diego
· Grace L. McCann Morley named director of San Francisco Museum of Art
· Composer Arnold Schoenberg arrives in Los Angeles to teach (first at University of Southern California, later at University of California at Los Angeles)
· John Cage returns to his birthplace, Los Angeles, to study with Schoenberg and later teaches at Mills College
· Painter Hilaire Hiler moves to San Francisco (publishes *Why Abstract?* in 1945)
· Alfred Frankenstein begins reviewing exhibitions in San Francisco

1935
· Works Progress Administration (WPA; to 1943)
· Treasury Relief Art Project (TRAP; to 1938)
· California-Pacific International Exhibition, San Diego
· San Francisco Museum of Art moves into new home in Civic Center
· Hollywood Gallery of Modern Art opens
· Pan-Pacific Auditorium Building, Los Angeles (Walter Wurdeman and Welton Becket, architects)
· Max Ernst exhibits in San Francisco and Hollywood (at Howard Putzel's galleries)
· Stanton Macdonald-Wright completes multipanel mural *Motion Picture Industry* for Santa Monica Public Library

1936	·	Ansel Adams has one-man show of photographs at Alfred Stieglitz's An American Place gallery, New York
	·	Yves Tanguy exhibits his surrealist paintings at San Francisco Museum of Art
	·	Lyonel Feininger teaches at Mills College (and again in 1937)
	·	Marcel Duchamp visits San Francisco and Los Angeles
	·	Filmmaker Oskar Fischinger moves to Hollywood to work for Paramount
1937	·	California Art Research Project (part of WPA) sponsors art-historical writing on the region
	·	Los Angeles Negro Art Foundation
	·	Spanish Village Art Center, San Diego
	·	California Graduate School of Design, Pasadena
	·	*Fantastic Art, Dada, and Surrealism* exhibit at San Francisco Museum of Art
	·	Robert Motherwell graduates from Stanford University
	·	Ansel Adams moves to Yosemite
	·	Hans Burkhardt moves to Los Angeles
	·	Aldous Huxley moves to Hollywood
	·	André Malraux visits Los Angeles
	·	Thomas Hart Benton visits Los Angeles on assignment from *Life* magazine
1938	·	Rico Lebrun moves to Santa Barbara
	·	Luis Buñuel works on films in Hollywood
1939	·	Golden Gate International Exposition, Treasure Island
	·	Composer Paul Hindemith plays with Los Angeles Philharmonic
	·	John Cage organizes a percussion orchestra in San Francisco (to 1941)
	·	Hilaire Hiler and Sargent Johnson paint murals at San Francisco Aquatic Park building (now Maritime Museum)
	·	Frank Perl opens West Coast branch of Perl's Gallery on Sunset Boulevard
	·	Igor Stravinsky conducts concert of his music in Los Angeles (moves to L.A. in 1940; stays until 1949)
	·	Carmel Institute of Art
	·	Society for Sanity in Art, San Francisco (formerly Society of Western Artists); this conservative, fundamentally antimodernist group of artists continues until 1947
1940	·	Man Ray moves to Southern California (remains until 1951), where he meets his wife, Juliet Browner
	·	Darius Milhaud joins Music Department at Mills College (to 1947 full-time; to 1971 part-time)
	·	László Moholy-Nagy teaches at Mills College with other former Bauhaus faculty members
	·	Anton Refregier receives a large Treasury Section commission ($26,000) to paint Rincon Annex Post Office murals in San Francisco

· William Gaw becomes chair of Mills College Art Department

· Diego Rivera paints mural at Golden Gate International Exposition as part of the Art in Action Program

1941

· Santa Barbara Museum of Art

· La Jolla Art Center opens to the public in the home of Ellen Browning Scripps, designed by Irving Gill (renamed La Jolla Museum of Art in 1964)

· *California Arts and Architecture* begins publication (to 1962)

· Man Ray exhibits at Frank Perl's Gallery in Los Angeles, and at M. H. de Young Memorial Museum

· Bertolt Brecht moves to Los Angeles (to 1947)

· Thomas Mann moves to Pacific Palisades (remains in California to 1952)

· Theodor Adorno moves to Los Angeles

· Clyfford Still moves to Bay Area from Washington state

· David Park returns to San Francisco from Boston, begins teaching at California School of Fine Arts

· Arshile Gorky spends summer in San Francisco, exhibits his surrealist paintings at San Francisco Museum of Art

· Fernand Léger teaches at Mills College, exhibits his work at Mills and at San Francisco Museum of Art

· Max Ernst and Peggy Guggenheim visit Los Angeles in search of a gallery space

· Julian Levy temporarily leases a gallery space on Sunset Boulevard, Los Angeles, where he exhibits Duchamp's *Bride Stripped Bare by Her Bachelors, Even,* as well as works by Salvador Dalí and Max Ernst

· Edward Hopper visits Bay Area

1942

· Dorothea Lange photographs interned Japanese Americans

· International Art Gallery opens in Los Angeles (to 1947)

· *Sawdust and Spangles* exhibition, organized by Douglas MacAgy, at San Francisco Museum of Art

· *Thirty-one Women* show at San Francisco Museum of Art (traveled from Peggy Guggenheim's Art of This Century Gallery, New York)

· Clay Spohn exhibition *Fantastic War Machines and Guerragraphs* at San Francisco Museum of Art

· Salvador Dalí exhibition at California Palace of the Legion of Honor

· Stanton Macdonald-Wright begins teaching at University of California at Los Angeles (to 1955)

· Henry Miller moves to Los Angeles (to Big Sur in 1943)

1943

· Man Ray exhibition at Santa Barbara Museum of Art

· Clyfford Still has first solo exhibition at San Francisco Museum of Art (then at Museum of Modern Art, New York, in 1944)

· Edmund Teske moves to Hollywood

1944	·	*Circle* magazine begins publication in Berkeley
	·	Grace McCann Morley and Sidney Janis organize exhibition *Abstract and Surrealist Art in the United States,* first major survey of contemporary art by European refugees
	·	Man Ray exhibits at Pasadena Art Institute
	·	Salvador Dalí works in Hollywood on dream sequence for Hitchcock's *Spellbound* (remains, intermittently, until 1948); attempts short animated film for Disney Studios (*Destino,* unfinished)

1945	·	*Duchamp and Villon* exhibition at California School of Fine Arts
	·	Jepson Art Institute founded, Los Angeles
	·	Douglas MacAgy leaves San Francisco Museum of Art to become director of California School of Fine Arts; Jermayne MacAgy becomes assistant director (in charge of contemporary art exhibitions) at California Palace of the Legion of Honor
	·	Man Ray and Salvador Dalí lecture at California School of Fine Arts
	·	Jackson Pollock has his first West Coast solo exhibition at San Francisco Museum of Art

1946	·	Mark Rothko visits San Francisco; teaches summers at California School of Fine Arts, 1947 and 1949; has exhibition at Santa Barbara Museum of Art
	·	Photography Department at California School of Fine Arts formed with Ansel Adams as chairman; Minor White invited to teach
	·	Max Ernst marries Dorothea Tanning, Man Ray marries Juliet Browner in double ceremony in Beverly Hills
	·	John McLaughlin moves to Dana Point
	·	Frank Stauffacher begins experimental Art in Cinema series in San Francisco
	·	Thomas Hart Benton visits Walt Disney in Los Angeles to work on (unrealized) film about Davy Crockett
	·	Festival of Modern Poetry in San Francisco

1947	·	Modern Institute of Art, Beverly Hills, founded by Vincent Price and Sam Jaffe
	·	Associated American Artists opens branch in Beverly Hills
	·	Bertolt Brecht–Charles Laughton production of Brecht's *Galileo* at Coronet Theater in Hollywood
	·	Richard Diebenkorn joins faculty at California School of Fine Arts
	·	Rico Lebrun and Eugene Berman teach at Jepson Art Institute in Los Angeles
	·	Gordon Onslow-Ford begins painting in San Francisco, moves to Inverness (has first show at San Francisco Museum of Art in 1948)

1948	·	Edward Weston takes his last photographs at Point Lobos
	·	William Copley opens gallery in Beverly Hills, presents first West Coast exhibition of surrealist works by Joseph Cornell
	·	Robert McChesney and Hassel Smith illustrate *The Communist Manifesto in Pictures,* published in San Francisco

1949	·	"Western Round Table on Modern Art" at San Francisco Museum of Art (April 8–11), symposium with participants Gregory Bateson, Kenneth Burke, George Boas, Marcel Duchamp, Alfred Frankenstein, Robert Goldwater, Darius Milhaud, Andrew Ritchie, Mark Tobey, and Frank Lloyd Wright
	·	Metart Gallery, an artists' cooperative, founded by California School of Fine Arts students under guidance of Clyfford Still
	·	Max Ernst exhibition at San Francisco Museum of Art
	·	David Park returns to painting figuratively after more than a decade of abstraction; reportedly takes all his abstract work to Berkeley dump
1950	·	Max Beckmann teaches at Mills College
	·	Ad Reinhardt teaches at California School of Fine Arts
	·	Wolfgang Paalen settles in Mill Valley; Dynaton exhibition (with Gordon Onslow-Ford and Lee Mullican) at San Francisco Museum of Art, 1951
	·	Dylan Thomas visits San Francisco and Los Angeles
	·	Clyfford Still moves to New York City

Notes

1. In particular, see Joseph Armstrong Baird, Jr., *Northern California Art: An Interpretive Bibliography* (privately published, 1977); James D. Hart, *A Companion to California* (Berkeley and Los Angeles: University of California Press, 1987), 579–91; Nancy D. W. Moure, *Dictionary of Art and Artists in Southern California before 1930* (Los Angeles: privately printed, 1975), xv–xix; Caroline A. Jones, *Bay Area Figurative Art, 1950–1965* (San Francisco: San Francisco Museum of Modern Art; and Berkeley and Los Angeles: University of California Press, 1990), 182–91; Edan Milton Hughes, *Artists in California*, 2d ed. (San Francisco: Hughes Publishing Company, 1989), 3–10; Bonnie Clearwater, ed., *West Coast Duchamp* (Miami Beach, Fla.: Grassfield Press, 1991), 102–5; Bram Dijkstra et al., *San Diego Artists* (Encinitas, Calif.: Artra Publishing, 1988), 11–23. Additionally, Whitney Chadwick generously shared an unpublished chronology of surrealist activity in California with me, for which I am grateful.

2. The numerous contributions of Kevin Starr merit special mention here, in particular *Inventing the Dream: California through the Progressive Era* (Oxford: Oxford University Press, 1985), *Material Dreams: Southern California through the 1920s* (Oxford: Oxford University Press, 1990), and *Endangered Dreams: The Great Depression in California* (Oxford: Oxford University Press, 1996). This chronology also draws upon the following sources: Richard Cándida Smith, *Utopia and Dissent: Art, Poetry, and Politics in California* (Berkeley and Los Angeles: University of California Press, 1995); Steven A. Nash, *Facing Eden: 100 Years of Landscape Art in the Bay Area* (San Francisco: Fine Arts Museums of San Francisco; and Berkeley and Los Angeles: University of California Press, 1995); Patricia Trenton, ed., *Independent Spirits: Women Painters of the American West, 1890–1945* (Berkeley and Los Angeles: University of California Press, 1995); *Pacific Dreams: Currents of Surrealism and Fantasy in California Art, 1934–1957,* ed. Susan Ehrlich (Los Angeles: UCLA at the Armand Hammer Museum of Art and Cultural Center, 1995); Burton Benedict, *The Anthropology of World's Fairs: San Francisco's Panama Pacific International Exposition of 1915*

(Berkeley: Scolar Press, 1983); Ruth Lilly Westphal, ed., *Plein Air Painters of California: The Southland* (Irvine, Calif.: Westphal Publishing, 1982), and *Plein Air Painters of California: The North* (Irvine, Calif.: Westphal Publishing, 1986); John Russell Taylor, *Strangers in Paradise* (New York: Holt, Rinehart and Winston, 1983); Paul J. Karlstrom and Susan Ehrlich, *Turning the Tide: Early Los Angeles Modernists, 1920–1956* (Santa Barbara Museum of Art, 1990); Thomas Albright, *Art in the San Francisco Bay Area, 1945–1980: An Illustrated History* (Berkeley and Los Angeles: University of California Press, 1986); David Gebhard and Harriette von Breton, *L.A. in the 1930s, 1931–1941* (Salt Lake City: Peregrine Smith, 1975); Sally B. Woodbridge, *California Architecture* (San Francisco: Chronicle Books, 1988); Peter Plagens, *Sunshine Muse: Contemporary Art on the West Coast* (New York: Praeger Publishers, 1974); Henry T. Hopkins, *Painting and Sculpture in California: The Modern Era* (San Francisco Museum of Modern Art, 1977); Christina Orr-Cahall, ed., *The Art of California: Selected Works from the Collection of the Oakland Museum* (Oakland Museum, 1984); Susan M. Anderson, *Regionalism: The California View* (Santa Barbara Museum of Art, 1988); Laurence P. Hurlburt, *The Mexican Muralists in the United States* (Albuquerque: University of New Mexico Press, 1989); Paolo Polledri, ed., *Visionary San Francisco* (Munich: Prestel, 1990); Patricia Trenton and William H. Gerdts, eds., *California Light, 1900–1930* (Laguna Beach Art Museum, 1990); Rebecca Solnit, *Secret Exhibition: Six California Artists of the Cold War Era* (San Francisco: City Lights, 1990); Therese Thau Heyman, ed., *Seeing Straight: The f.64 Revolution in Photography* (Oakland, Calif.: Oakland Museum, and Seattle: University of Washington Press, 1992); Thomas Weston Fels, Therese Heyman, David Travis, and Derrick Cartwright, *Watkins to Weston: 101 Years of California Photography* (Santa Barbara Museum of Art, 1992); Jonathan Spaulding, *Ansel Adams and the American Landscape* (Berkeley and Los Angeles: University of California Press, 1995); and Susan Landaner, *The San Francisco School of Abstract Expressionism* (Berkeley and Los Angeles: University of California Press; and Laguna Beach, Calif.: Laguna Art Museum, 1996).

Boldface type indicates illustrations. Page references in square brackets indicate textual references to endnotes. Institutions named after persons are alphabetized by last name; for example, the Solomon R. Guggenheim Museum is listed in the *G*s. Titles of works are alphabetized by strict title; for example, *Joan Miró* (an exhibition) is listed in the *J*s.

Cage, John, 11, 226, 282, 283
Calder, Alexander, 52, 193, 276
Calder, Alexander Stirling, 276
California: anti-Mexican bias in, 126; artist émigrés in, 42; eastern perspective on, 1, 15n.2, 157, 159; European influences on, 8, 10; invented traditions of, 4, 15n.3; isolation of, 13, 34, 158–59, 160, 166; promotional art of, 92n.33; reverence for settlers of, 69–70, 79; transformation into cosmopolitan center, 34, 42
California Art Club (Los Angeles; *formerly* Painters' Club), 275
California Art Research Project, 283
California Arts, 275
California Arts and Architecture magazine, 126, 257, 284
California Camera Club, 269n.39; *Camera Craft* magazine, 247, 255, 257, 258–59, 274
California College of Arts and Crafts (Oakland; *formerly* California School of Arts and Crafts), 275
California Color Society, 227
California Data (Shore), 170
California Graduate School of Design (Pasadena), 283
California Industrial Scenes (Howard), 105
California Landscape (Macdonald-Wright), **plate 3**
California-Pacific International Exhibition (San Diego), 282
California Palace of the Legion of Honor (San Francisco), 102, 103, 279; exhibitions of abstract expressionism, 114–115 (*see also specific artists*)
California Progressive Group, 277
California School of Arts and Crafts (Oakland; *later* California College of Arts and Crafts), 275
California School of Fine Arts (San Francisco; *formerly* Mark

Hopkins Institute of Art *and* San Francisco Institute of Art), 55–61, 114, 208n.64, 277, 285; antiauthoritarianism ethos at, 57; rejection of surrealist automatism, 202, 208n.65
California Society of Artists (San Francisco), 274
California Society of Etchers (San Francisco), 275
California watercolor school, 62
California Watercolor Society (Los Angeles), 278
Callahan, Kenneth, 104
camera clubs, 245, 267n.2
Camera Craft magazine, 247, 255, 257, 258–59, 274
Cándida Smith, Richard, 10
Cannon Art School (Los Angeles), 275
Cantú, Federico, 122
Carey, Paul, 16n.9
Carmel Art Association, 280
Carmel Arts and Crafts Society, 274
Carmel-by-the-Sea artists' colony, 274
Carmel Institute of Art, 283
cartoon books, 64n.39
cartoons, 238
Castel, Father Louis-Bertrand, 224
Catholic Church, 75
Centaur Gallery (Hollywood), 134, 181, 282
Cézanne, Paul, 108
Chadwick, Whitney, 204n.9
chance, theme of, 205n.24, 206n.41
chaos, theme of, 195
Charlot, Jean, 122, 123, 129, **133**; *The History of Art from the Mayas to Walt Disney,* 132; *Luz,* 133; Mayan influence on, 132; Ministry of Education murals, 130; *Picture Book No. 1,* 133
Bob Chatterton's Film Society, 233
Cheney, Sheldon, 15n.6
Un Chien Andalou (Dalí and Buñuel), 223

Chinese Revolutionary Artists' Club (San Francisco), 279
Chirico, Giorgio de, 183–84; exhibition at Stendahl Art Galleries, 281
Chouinard School of Art (Los Angeles; *later* Chouinard Art Institute), 166, 227, 278
chronology of modern art in California, 273–87
cinema. *See* film; film-as-an-art
Cinema Arts, Society of, 233
Circle Gallery (Hollywood), 181
Circle magazine, 285
Circles (Fischinger), 224
Citizen's Committee to Protect the Rincon Annex Murals, 92n.43
city symphonies, 235
The Civil War (Refregier), 81
Clair, René: *Entr'acte,* 219
Clapp, William, 100, 102
Clarke, Alson, 123, 135n.6
Clarke House (Santa Fe Springs, Calif.; Gill), 149
class struggle, theme of, 77
Clements, Grace, 185
Clinic of Stumble (Hirsh and Peterson), 234
Coate, Roland E., 139
Cocteau, Jean: *Blood of a Poet,* 223
cognitive art vs. perceptual art, 37n.16
cognitive association, 24
Coit Memorial Tower murals (San Francisco), 73–74, 100, 105–6, 282
Cold War, 78
College of Fine Arts (University of Southern California at Garvanza), 274
color: abstractions in, 26–27; and harmony, 26
colorism, 16n.8
color organs, 230–31
Commercial Artists' Club of Los Angeles, 279
The Communist Manifesto (Marx), 66n.70
The Communist Manifesto in

Designer: Steve Renick
Compositor G&S Typesetters, Inc.
Text and Display: Garamond
Printer and Binder: Tien Wah Press